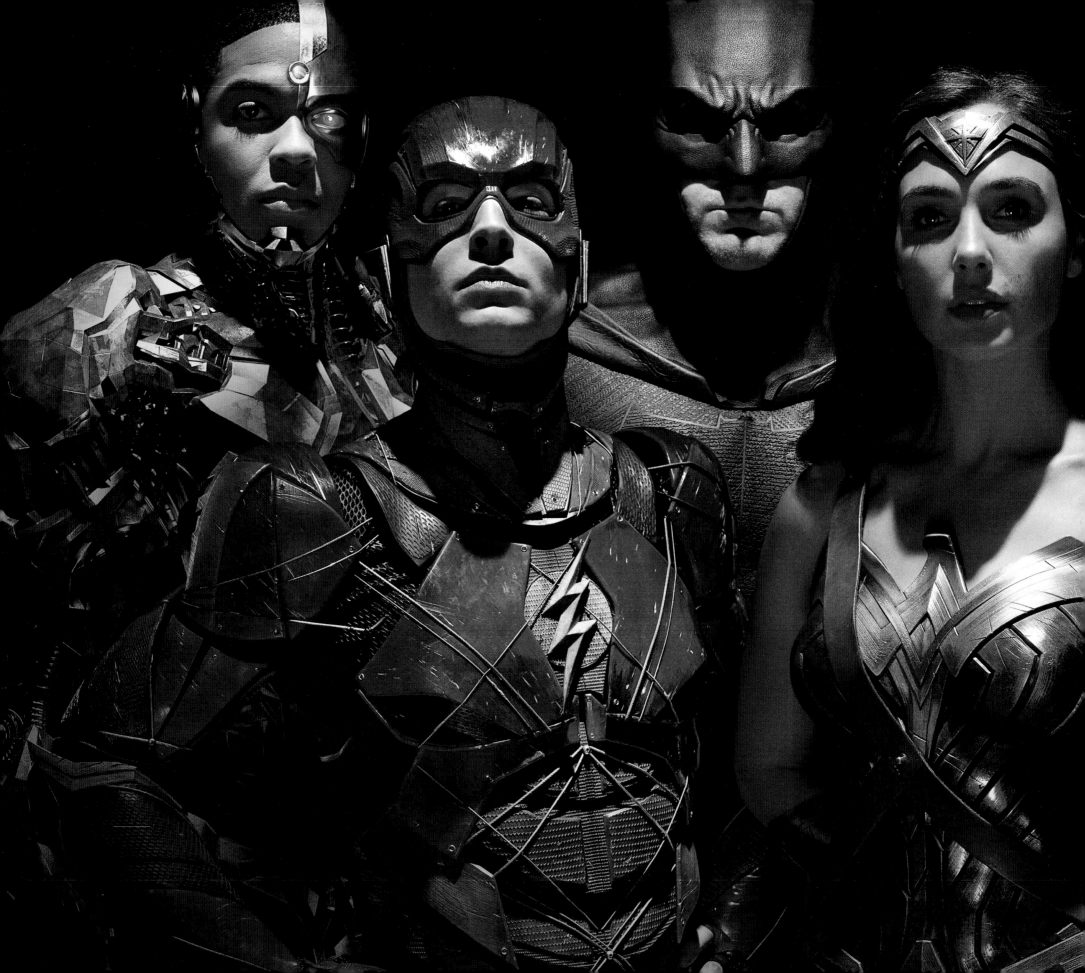

JUSTICE LEAGUE

THE ART OF THE FILM

ABBIE BERNSTEIN

FOREWORD BY GEOFF JOHNS INTRODUCTION BY CHARLES ROVEN

TITANBOOKS

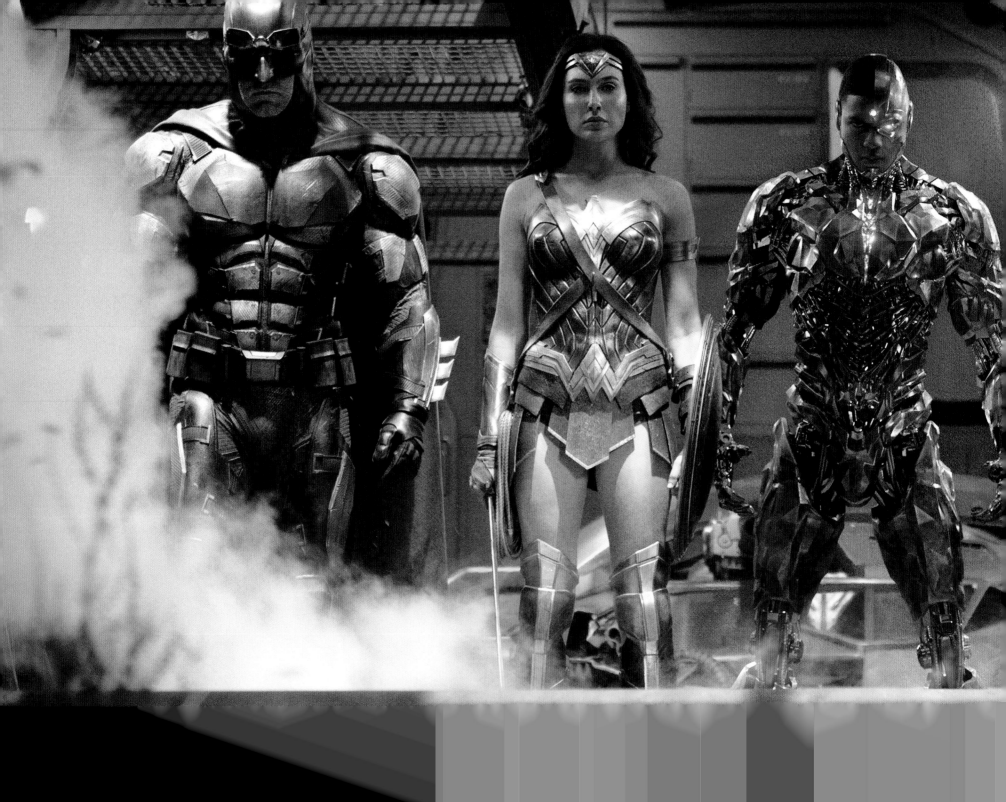

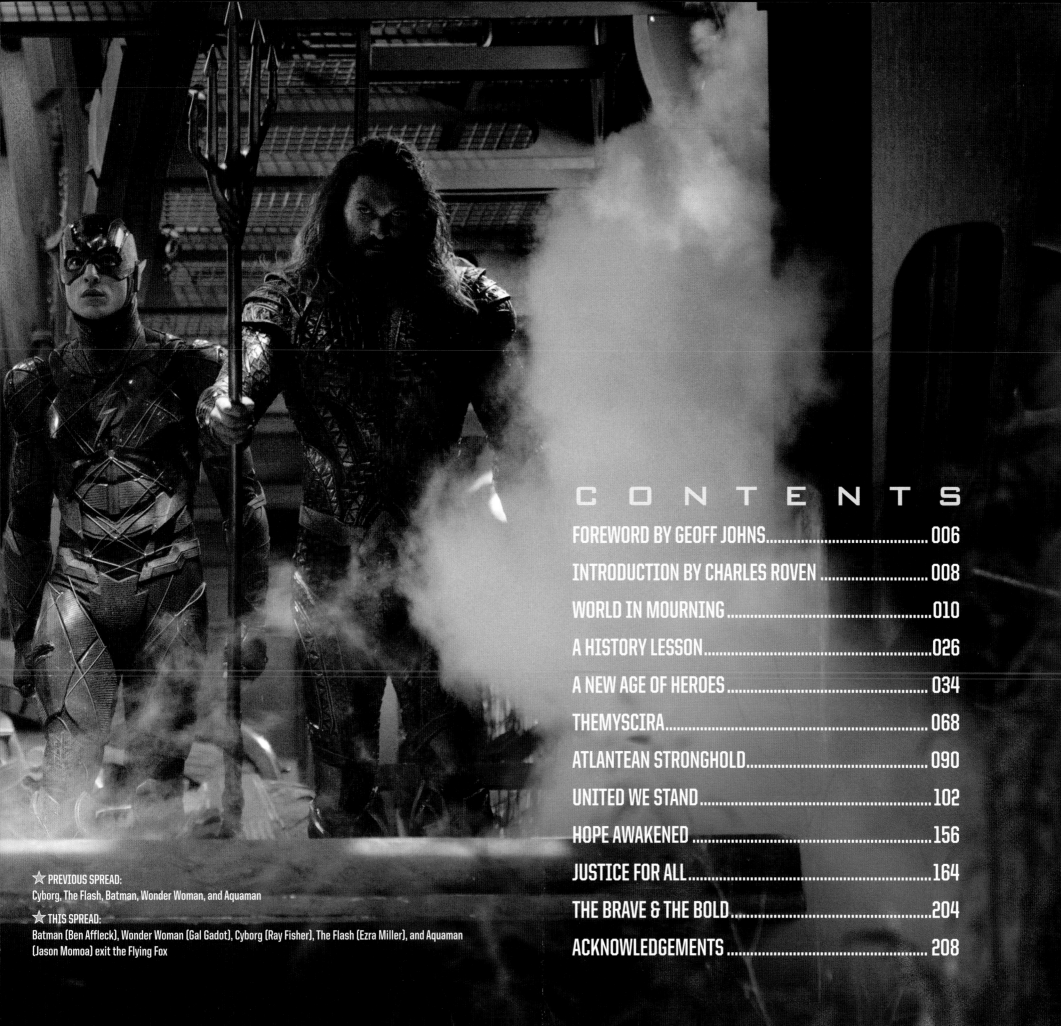

CONTENTS

☆ PREVIOUS SPREAD:
Cyborg, The Flash, Batman, Wonder Woman, and Aquaman

☆ THIS SPREAD:
Batman (Ben Affleck), Wonder Woman (Gal Gadot), Cyborg (Ray Fisher), The Flash (Ezra Miller), and Aquaman
(Jason Momoa) exit the Flying Fox

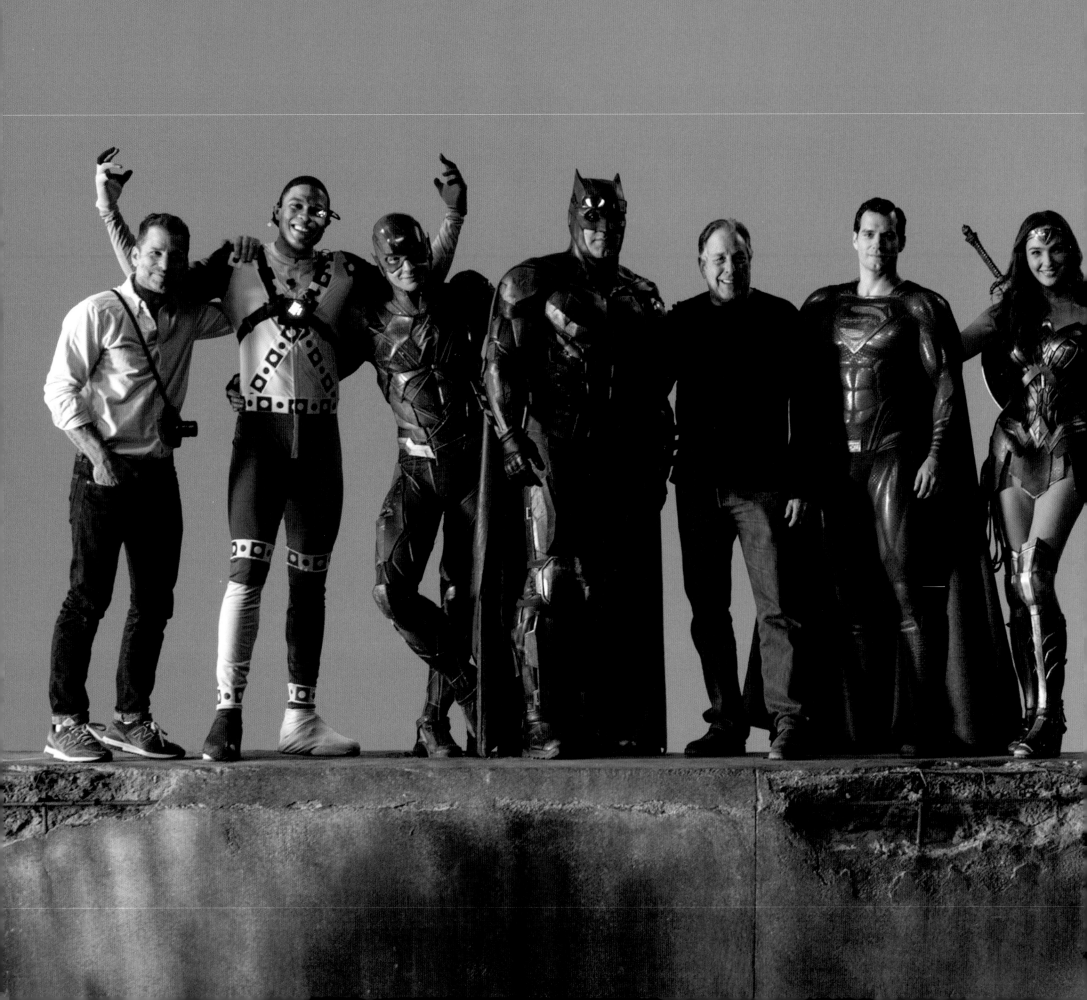

FOREWORD BY
GEOFF JOHNS

CHIEF CREATIVE OFFICER, DC ENTERTAINMENT

Although the word "hero" may conjure up immediate images of spandex and capes, the word itself speaks to a far greater being. A hero is someone willing to take every extra step to ensure the safety and care of others, regardless of their own fears or circumstance. I believe that we live in a world that is always in need of its heroes, both real and fictional, and it is a privilege to present this art book and its characters as the world's greatest Super Heroes. These are the characters we know, in a way they haven't been seen before, and yet presented in a light that you might remember.

The film *Justice League* returns us to a world without Superman, without hope, and without justice. A troubled Lois Lane is writing puff pieces far away from the real world, and citizens grieve and revel in a society that is now entirely self-aware of its alien visitors. In fact, the world has become so bleak that it is none other than the Dark Knight himself, Batman, left looking for the light. Determined to save humanity from its newest threat, a powerful mythic being named Steppenwolf and his army of fear-thirsty Parademons, Batman is prepared to pay the ultimate price... even if that means playing nicely with others.

Alongside Batman returns Wonder Woman, or as the rest of the world knows her, Diana Prince. Together, they recruit The Flash, Cyborg, and Aquaman to fight for the survival of the very things that Superman once proudly defended. When you see this league standing together, they are more than a wall of muscle – they are each uniquely motivated and equipped to handle the forces of evil that await them. They are a team in every sense of the word, and they well-beyond earn the respect of us calling them "heroes." Something that none of them ever do.

My ultimate hope for *Justice League* is that these characters – both their triumphs and their failures – will bring light and sincerity back to our definition of "hero" when it comes to DC. This art book is a glimpse of that rediscovery, and it includes dozens of beautiful images and design work that champions the contributions of our real-life team. Please enjoy, and join us.

INTRODUCTION BY
CHARLES ROVEN

PRODUCER, *JUSTICE LEAGUE*

When I was a preteen of 11 years old, the counter-culture years of the Sixties were just beginning and I was already a rebellious lad. I didn't realize until much later that my father, who I fought with constantly back then, was a real-life hero and I really didn't have any heroes to speak of. So, I would go to the local liquor store that had a comic book section made up of 2 circular racks and look for the latest editions of my favorite Super Heroes. DC Comics was my favorite and in particular it was Batman, Superman, Wonder Woman, The Flash, Aquaman, and Green Lantern. Cyborg hadn't been created yet.

Batman and Superman Serials from the late Forties were also still running as part of the weekend matinees at my local movie theaters, The Fairfax and The Gordon, in Los Angeles.

Those Serials, but in particular DC Comics', inspired me to dream of somehow growing up to become someone who at least strived to make a difference, who strived to give to others that same feeling that those Super Hero characters did for me; that I could overcome my preteen angst and achieve something.

It didn't matter to any of the Justice League what personal adversity was placed in their path, they would conquer it. And if they could, somehow so could I.

Little did I know that my life's journey would intersect with these very same characters in such an intimate way.

What an honor to hopefully be able to bring to others some part of the same emotions that so positively gripped me.

And what a joy it is to work with the artistic talents of those women and men who bring their individual passion every day both in front of and behind the camera. This art of book memorializes that experience and celebrates those artists. It also gives both the educated fan and the new one a look behind the scenes of the creative process that goes into making a movie about these aspirational characters.

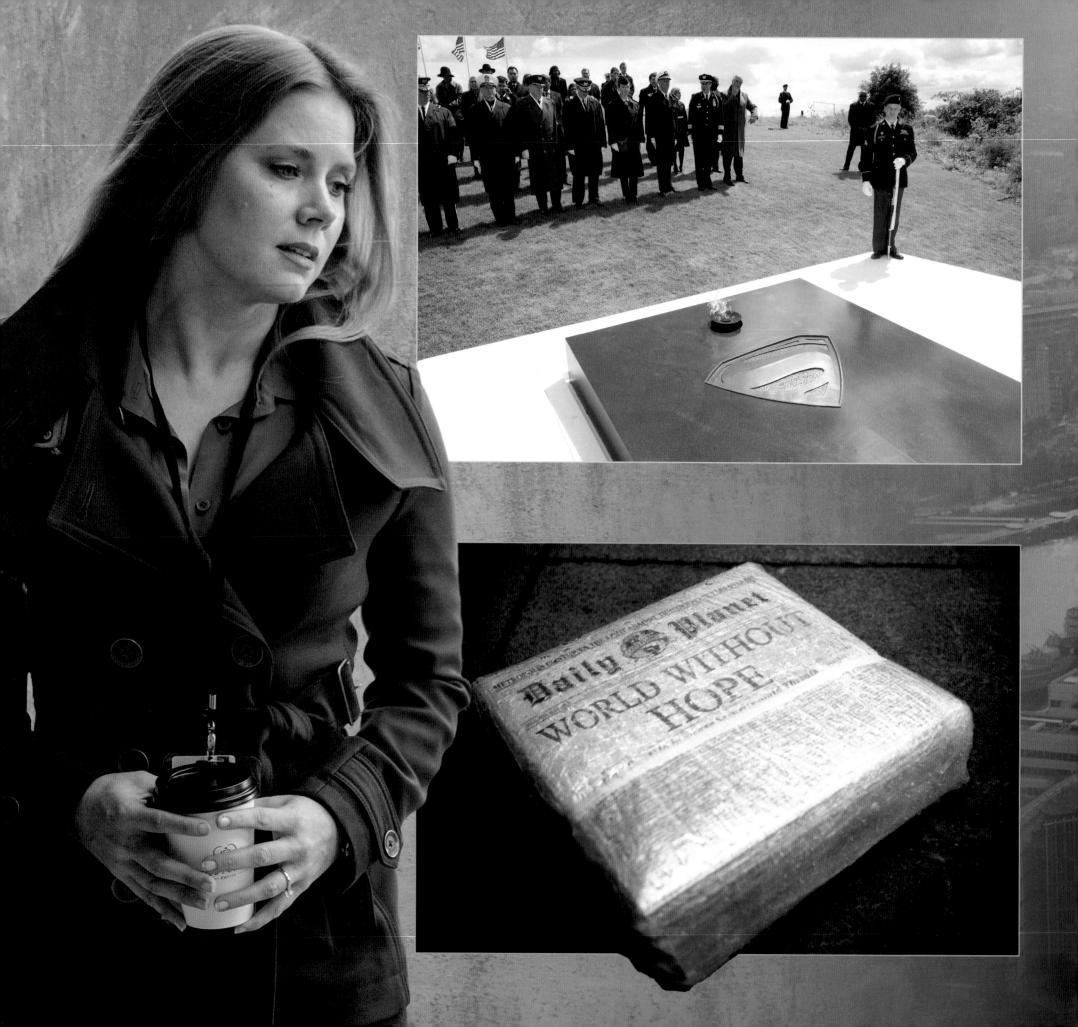

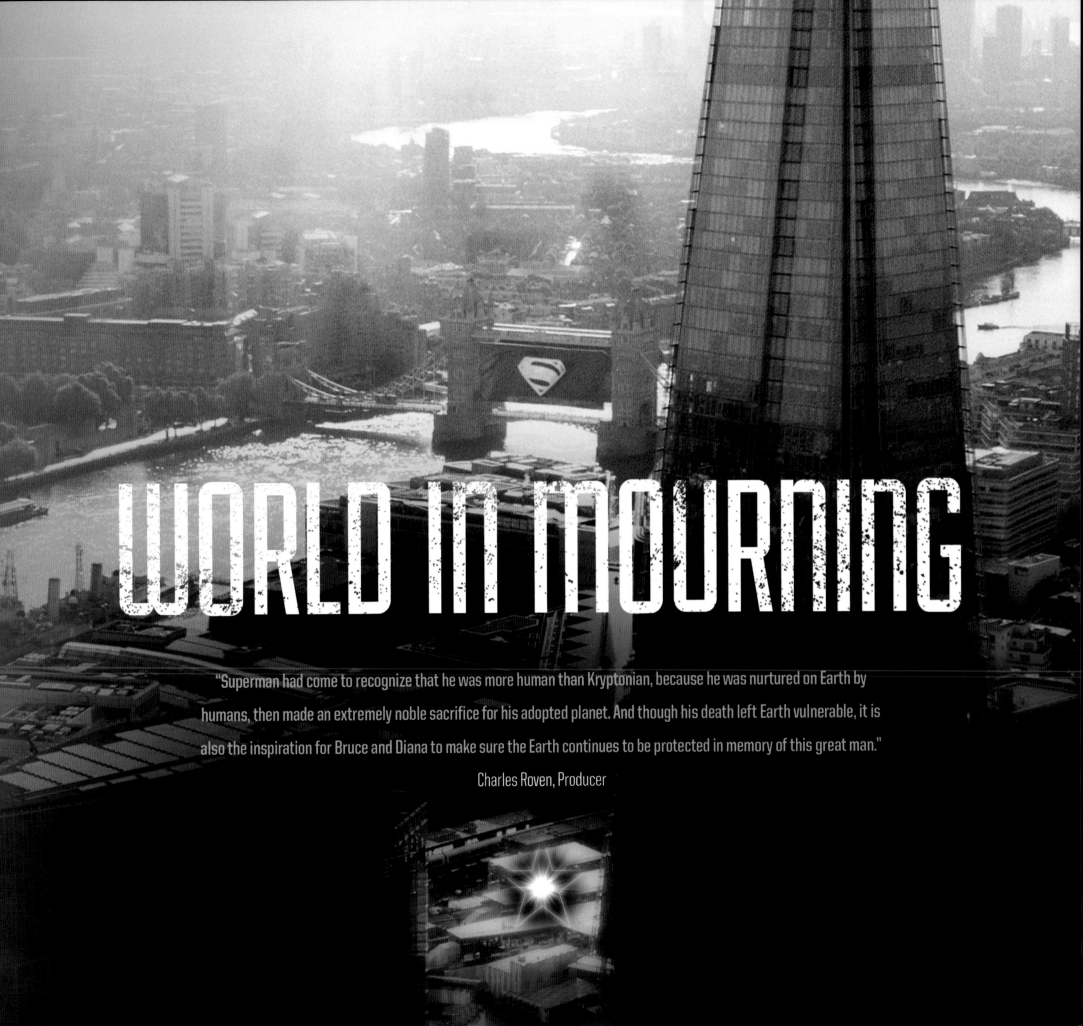

WORLD IN MOURNING

"Superman had come to recognize that he was more human than Kryptonian, because he was nurtured on Earth by humans, then made an extremely noble sacrifice for his adopted planet. And though his death left Earth vulnerable, it is also the inspiration for Bruce and Diana to make sure the Earth continues to be protected in memory of this great man."

Charles Roven, Producer

Reporting on the Planet Daily

★ PREVIOUS SPREAD LEFT & ABOVE:
Lois Lane (Amy Adams) visits Heroes Park
& The Superman memorial in Metropolis

★ PREVIOUS SPREAD BELOW & RIGHT:
The Daily Planet front page & A Superman
tribute banner hangs from London's
Tower Bridge

★ THIS SPREAD:
Martha Kent (Diane Lane) visits
Lois Lane at the Daily Planet

STORY DEADLINES

TO NATIONAL EDITORIAL DESKS

EVENING EDITION	3:00 PM
MORNING EDITION	5:00 PM
DOMESTIC EDITORIAL	2:30 PM
NATIONAL EDITORIAL	2:30 PM
SATURDAY EDITION	4:00 PM
SUNDAY EDITION	2:00 PM

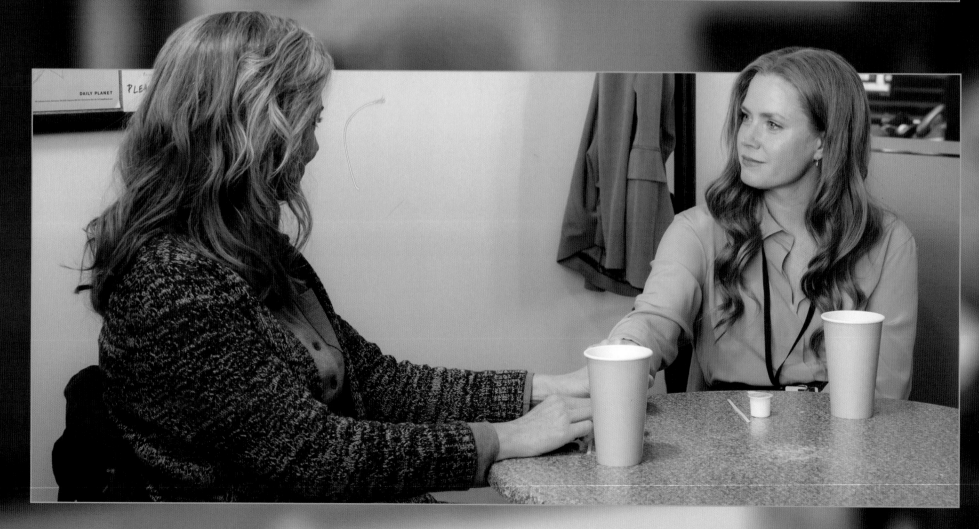

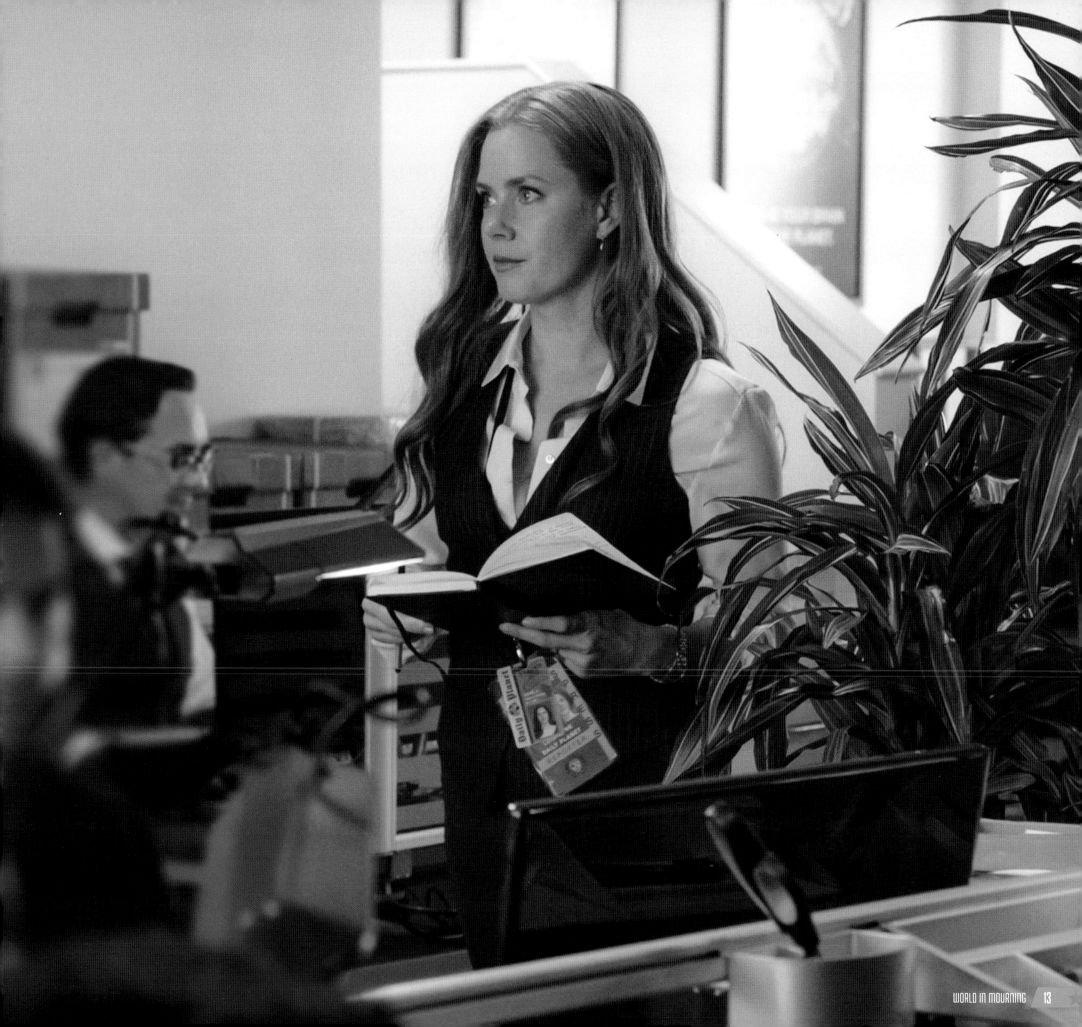

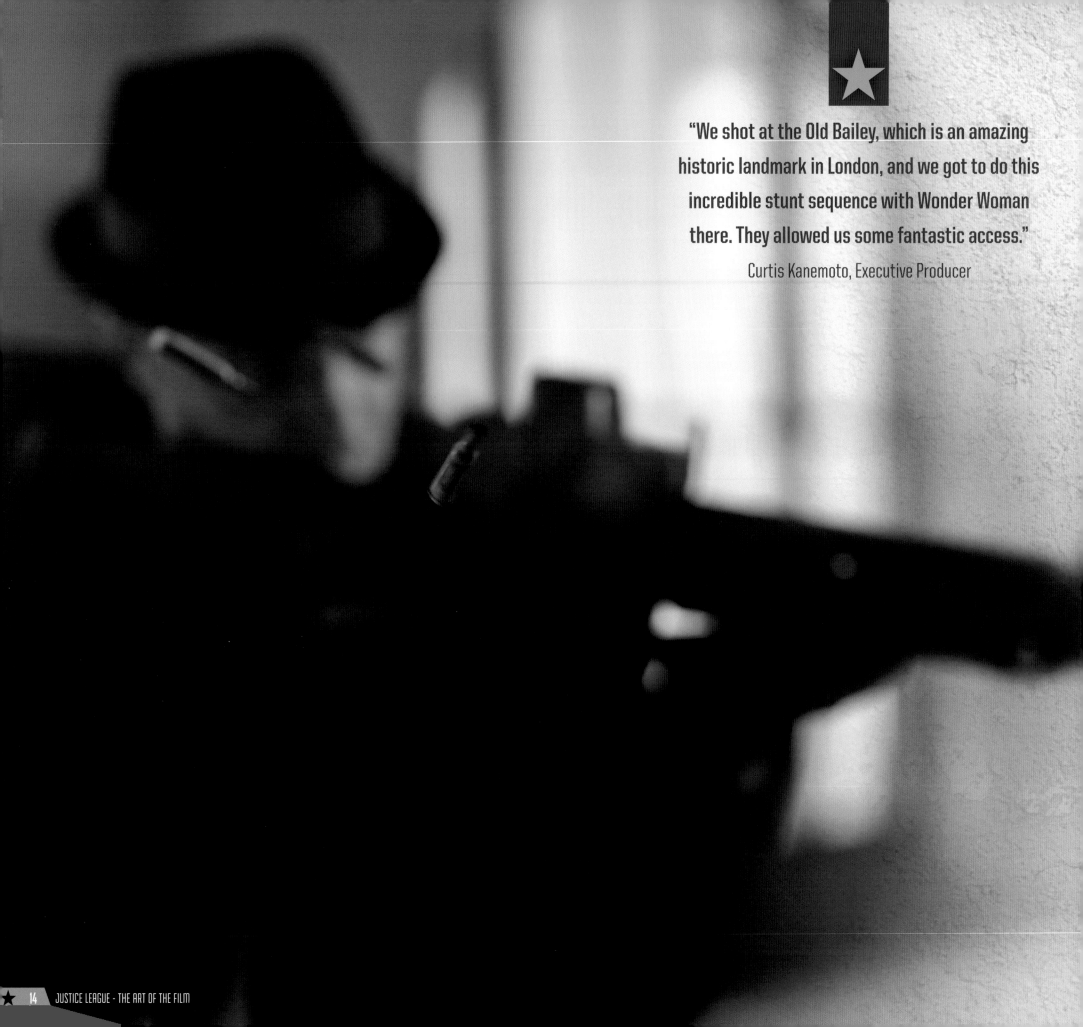

"We shot at the Old Bailey, which is an amazing historic landmark in London, and we got to do this incredible stunt sequence with Wonder Woman there. They allowed us some fantastic access."

Curtis Kanemoto, Executive Producer

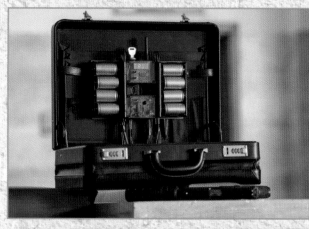

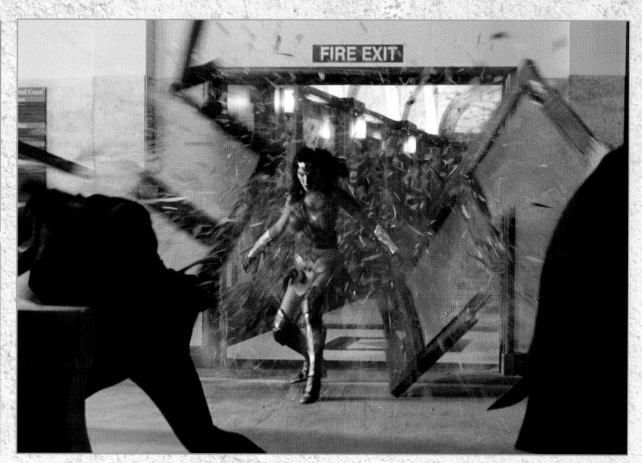

☆ THIS SPREAD:
Wonder Woman defeats a terrorist attack at the Old Bailey in London

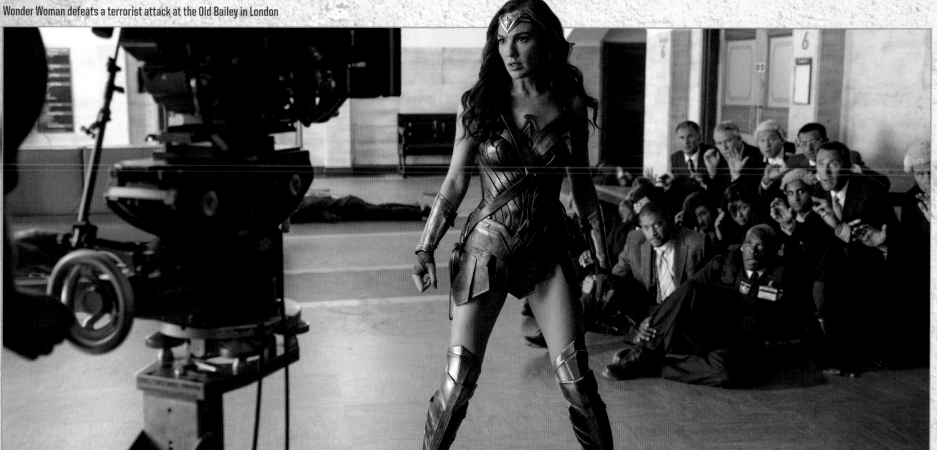

★ THIS PAGE:
The Old Bailey exterior

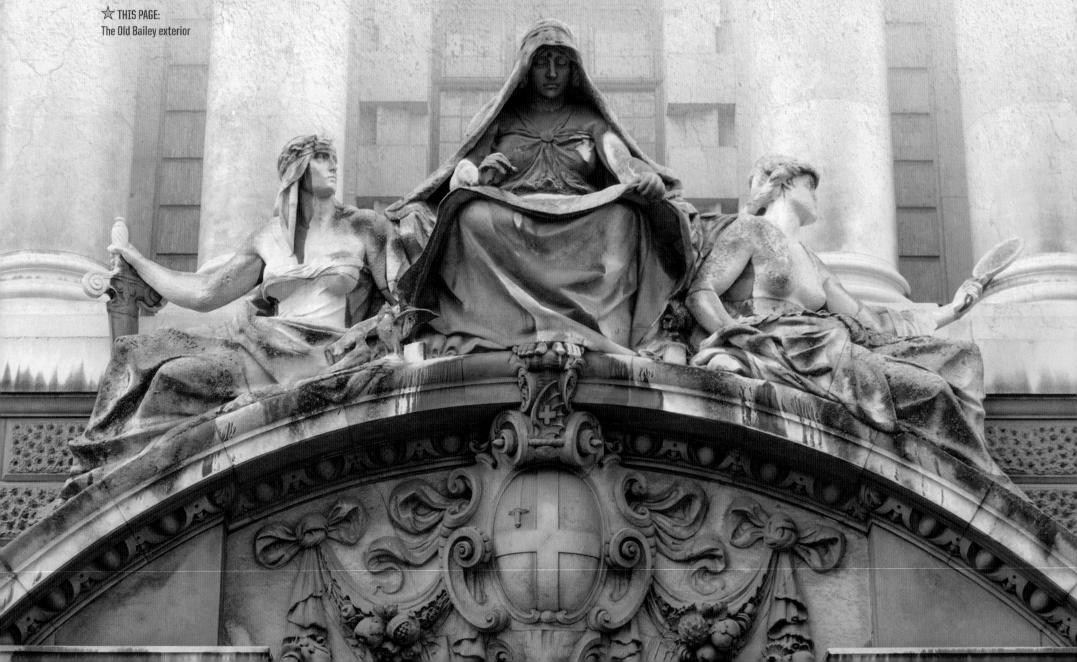

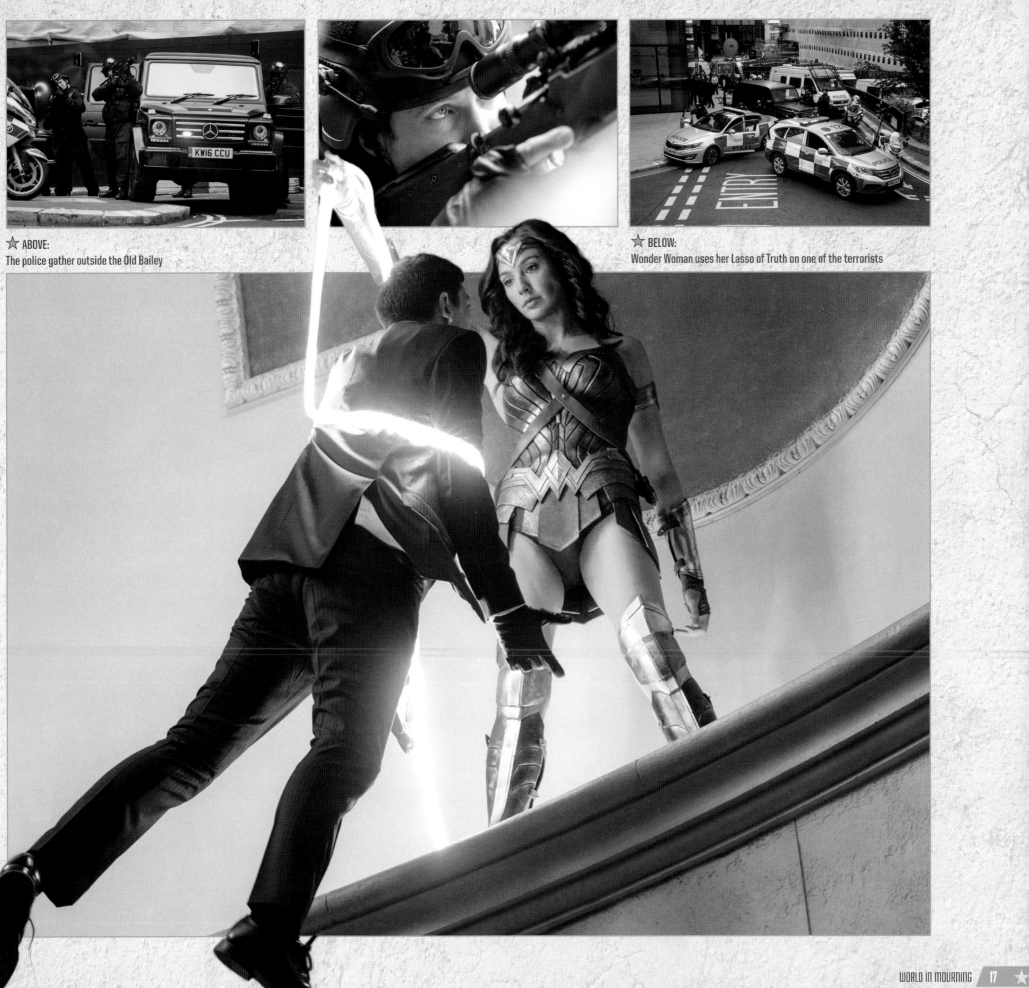

The police gather outside the Old Bailey

☆ BELOW:
Wonder Woman uses her Lasso of Truth on one of the terrorists

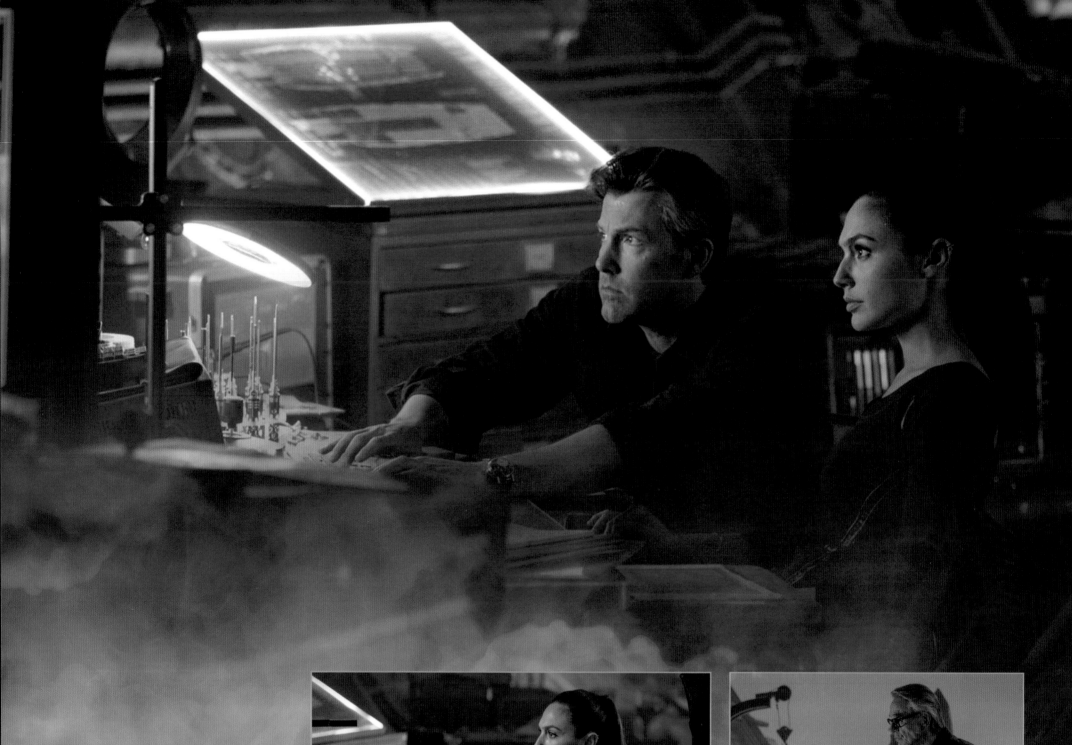

☆ THIS SPREAD: :
Bruce Wayne, Diana Prince, and Alfred
Pennyworth (Jeremy Irons) searching for
metahumans

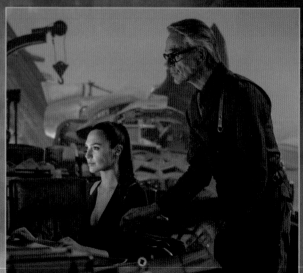

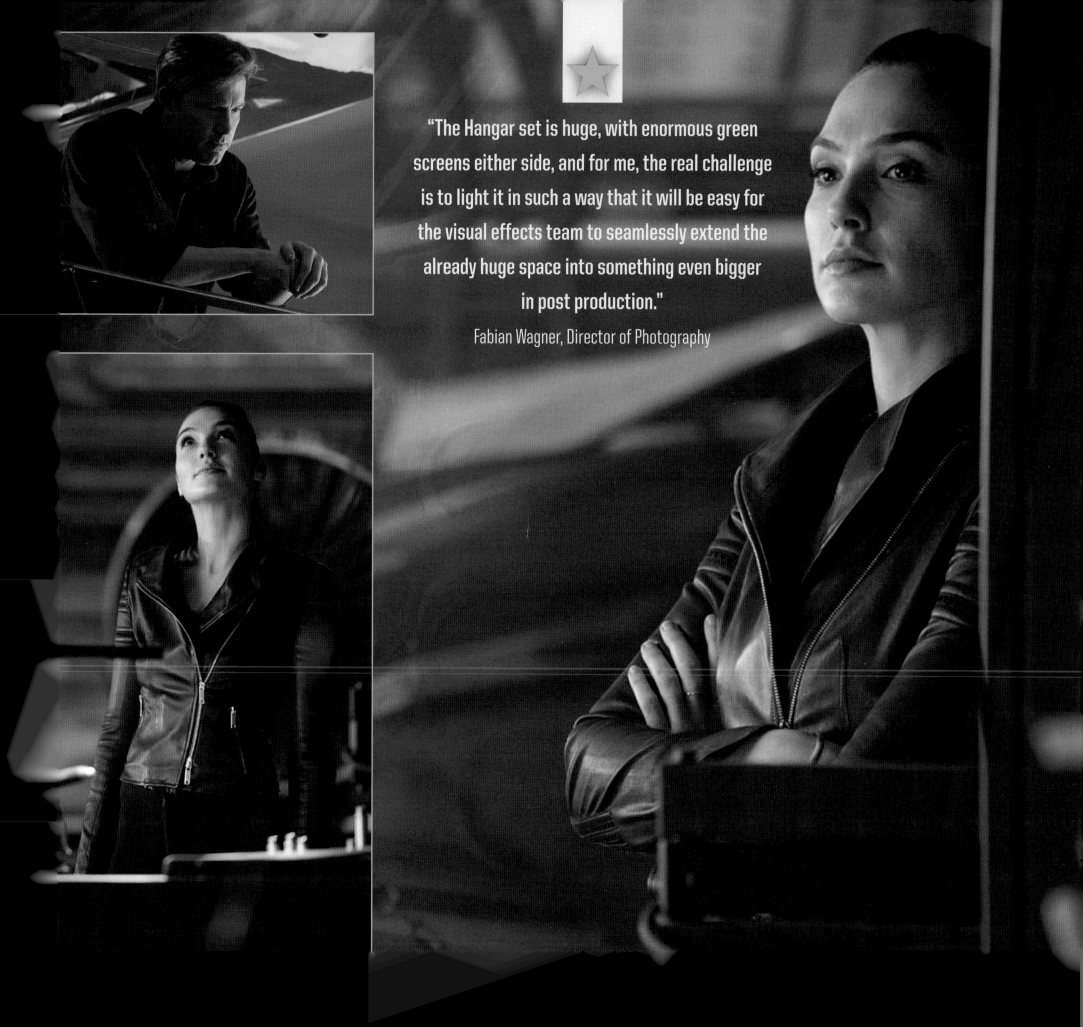

"The Hangar set is huge, with enormous green screens either side, and for me, the real challenge is to light it in such a way that it will be easy for the visual effects team to seamlessly extend the already huge space into something even bigger in post production."

Fabian Wagner, Director of Photography

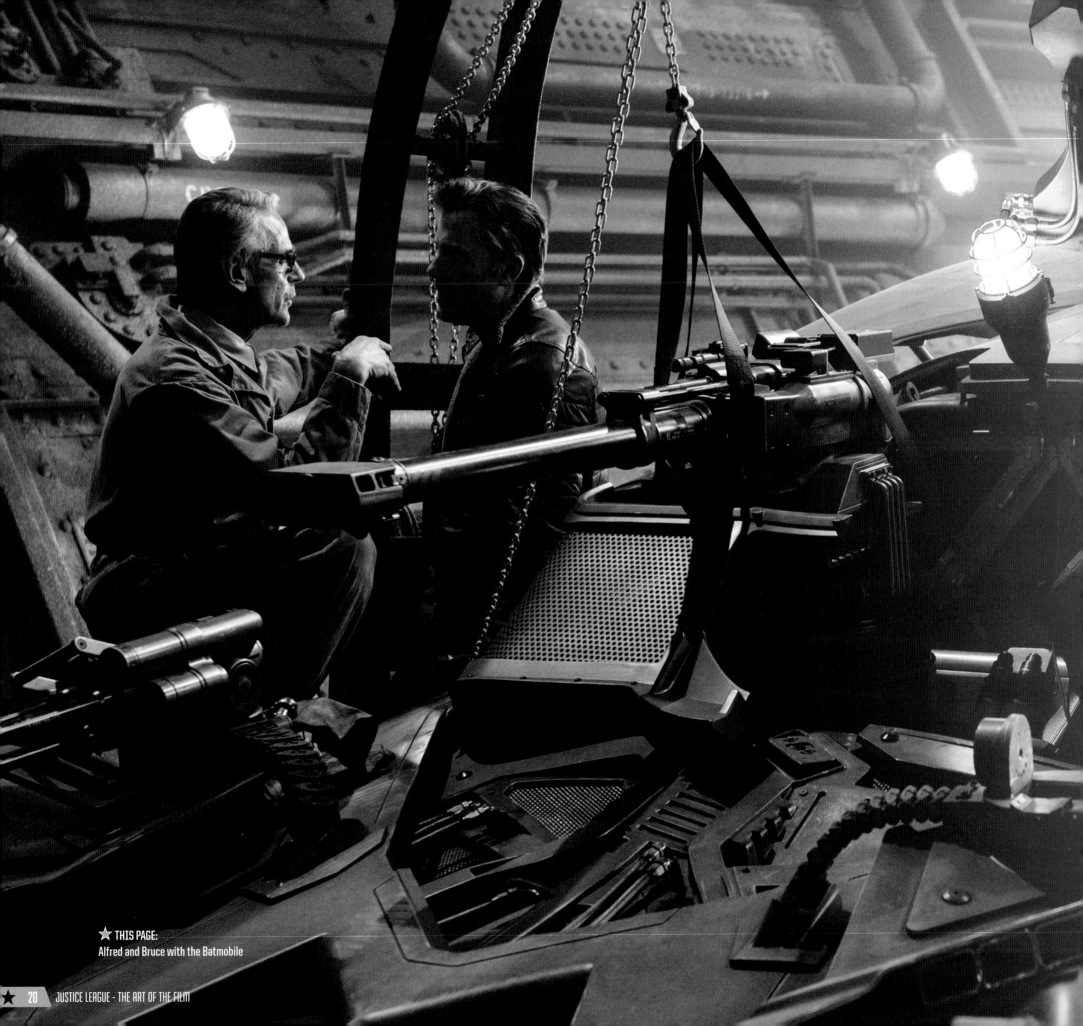

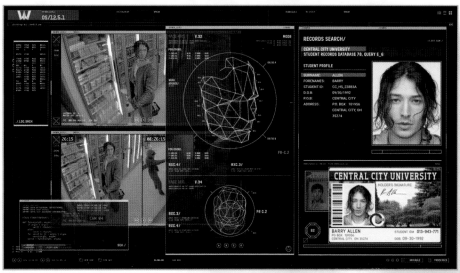
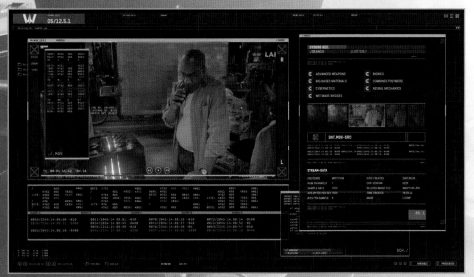
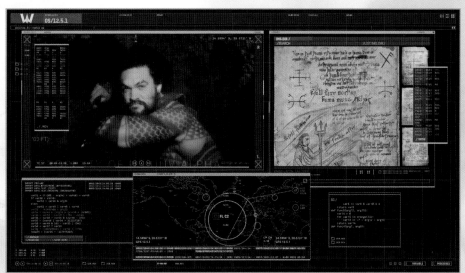

☆ ABOVE:
Some of Bruce's video research data on The Flash, Aquaman, and Cyborg

" *Justice League* starts shortly after the passing of Superman, with Bruce and Diana trying to put together a team. We see Bruce find inspiration in the sacrifice Superman made; it renews his faith in humanity."

Wesley Coller, Executive Producer

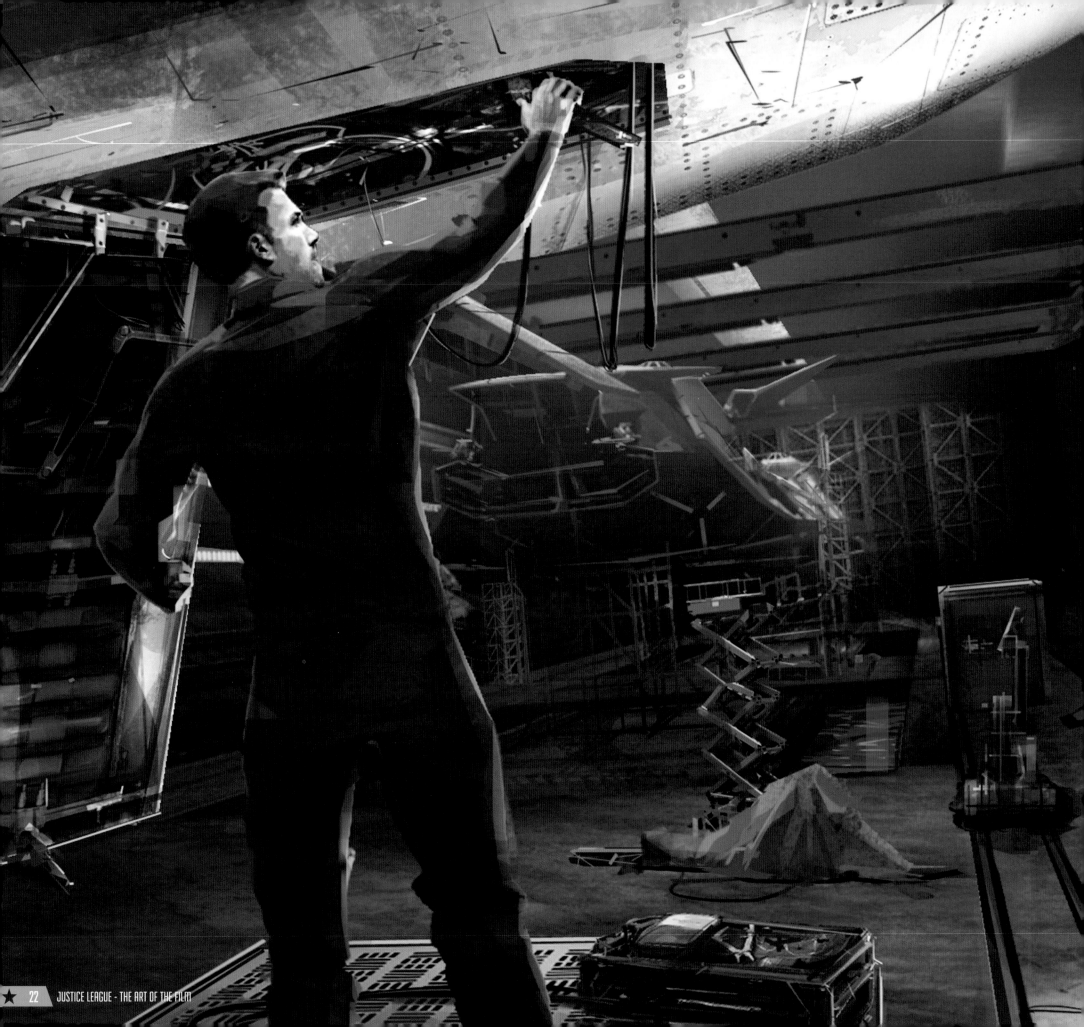

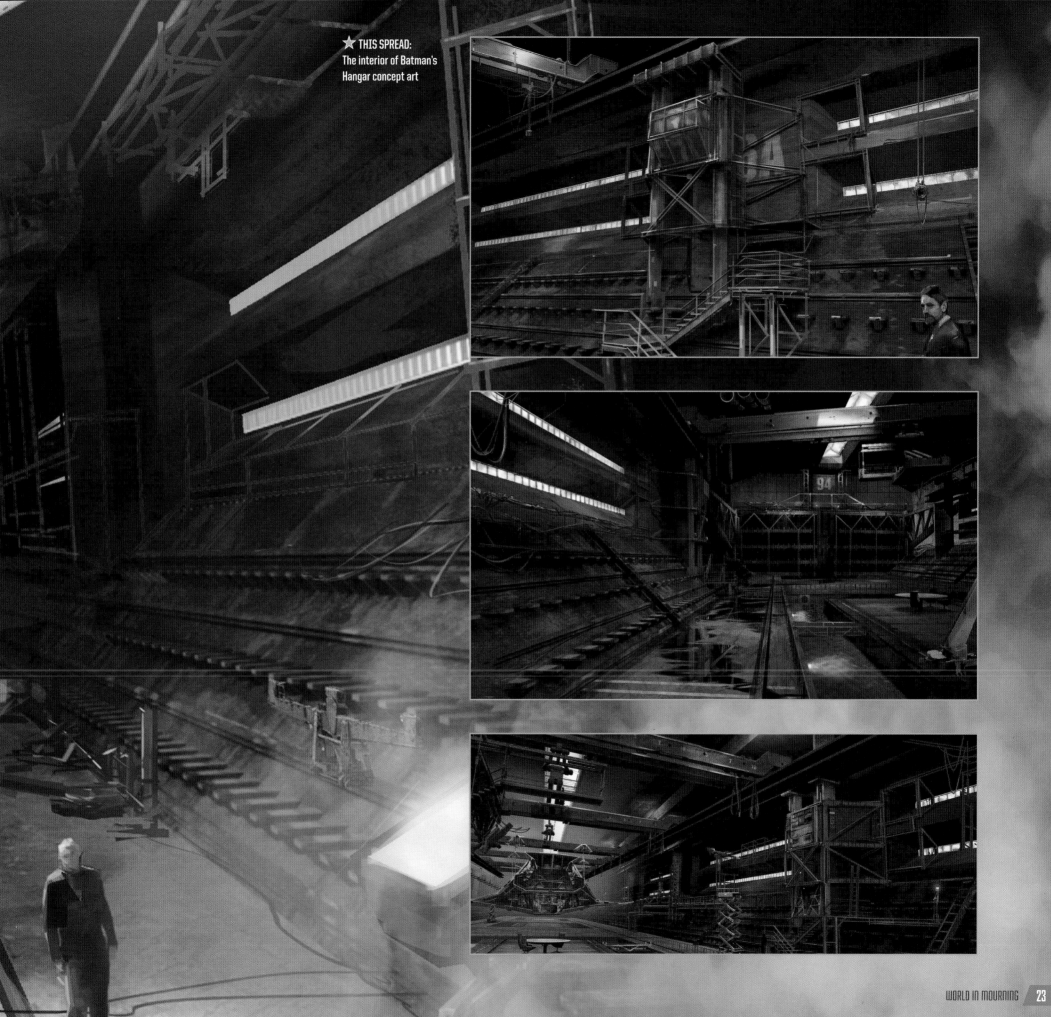

The interior of Batman's
Hangar concept art

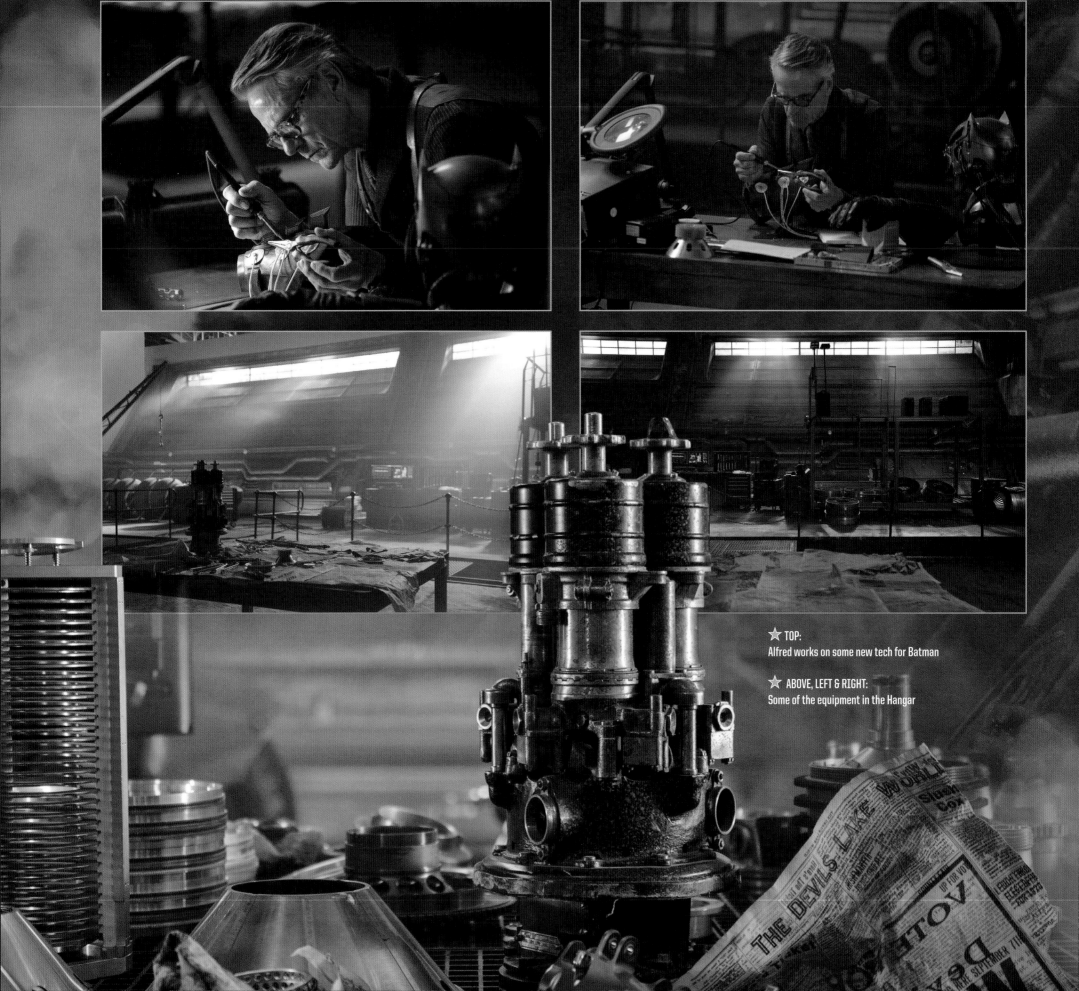

☆ TOP:
Alfred works on some new tech for Batman

☆ ABOVE, LEFT & RIGHT:
Some of the equipment in the Hangar

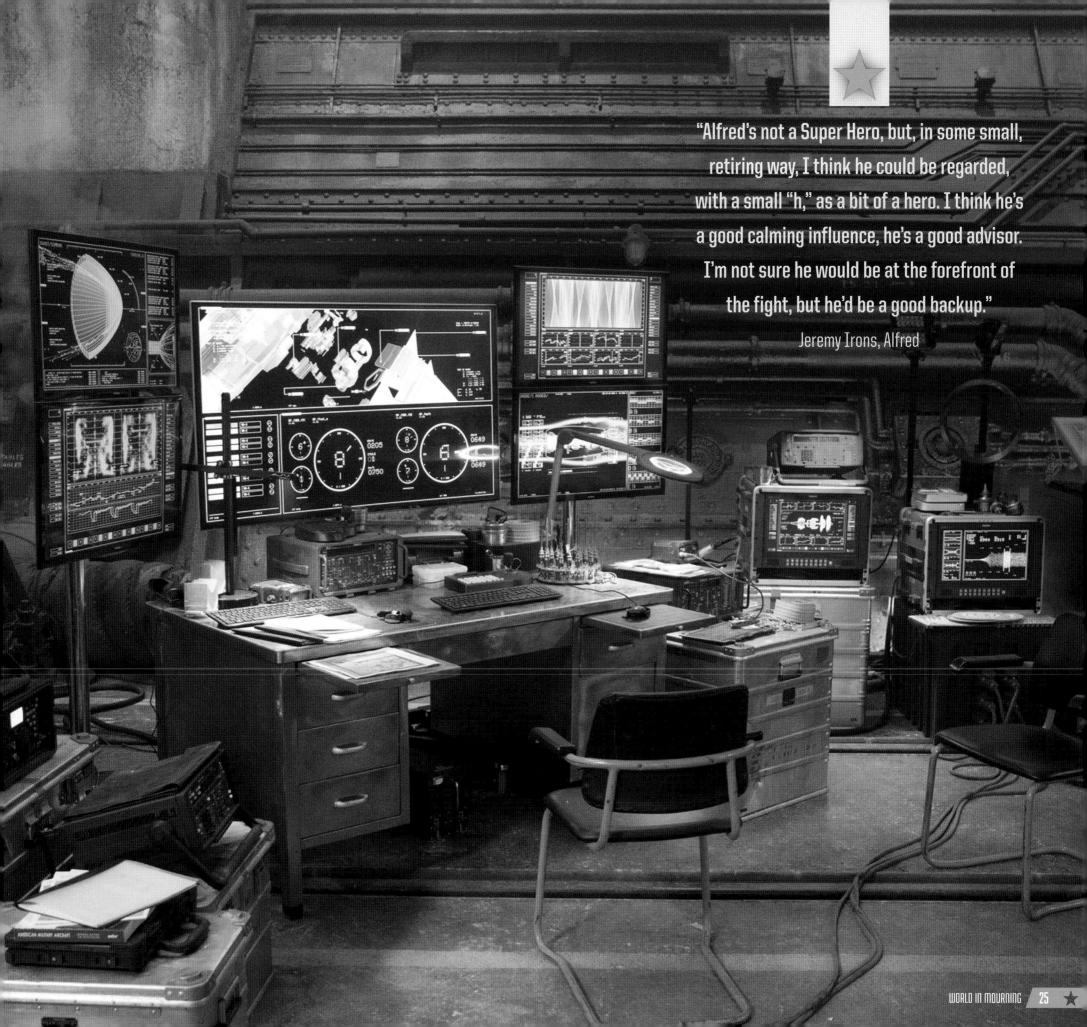

"Alfred's not a Super Hero, but, in some small, retiring way, I think he could be regarded, with a small "h," as a bit of a hero. I think he's a good calming influence, he's a good advisor. I'm not sure he would be at the forefront of the fight, but he'd be a good backup."

Jeremy Irons, Alfred

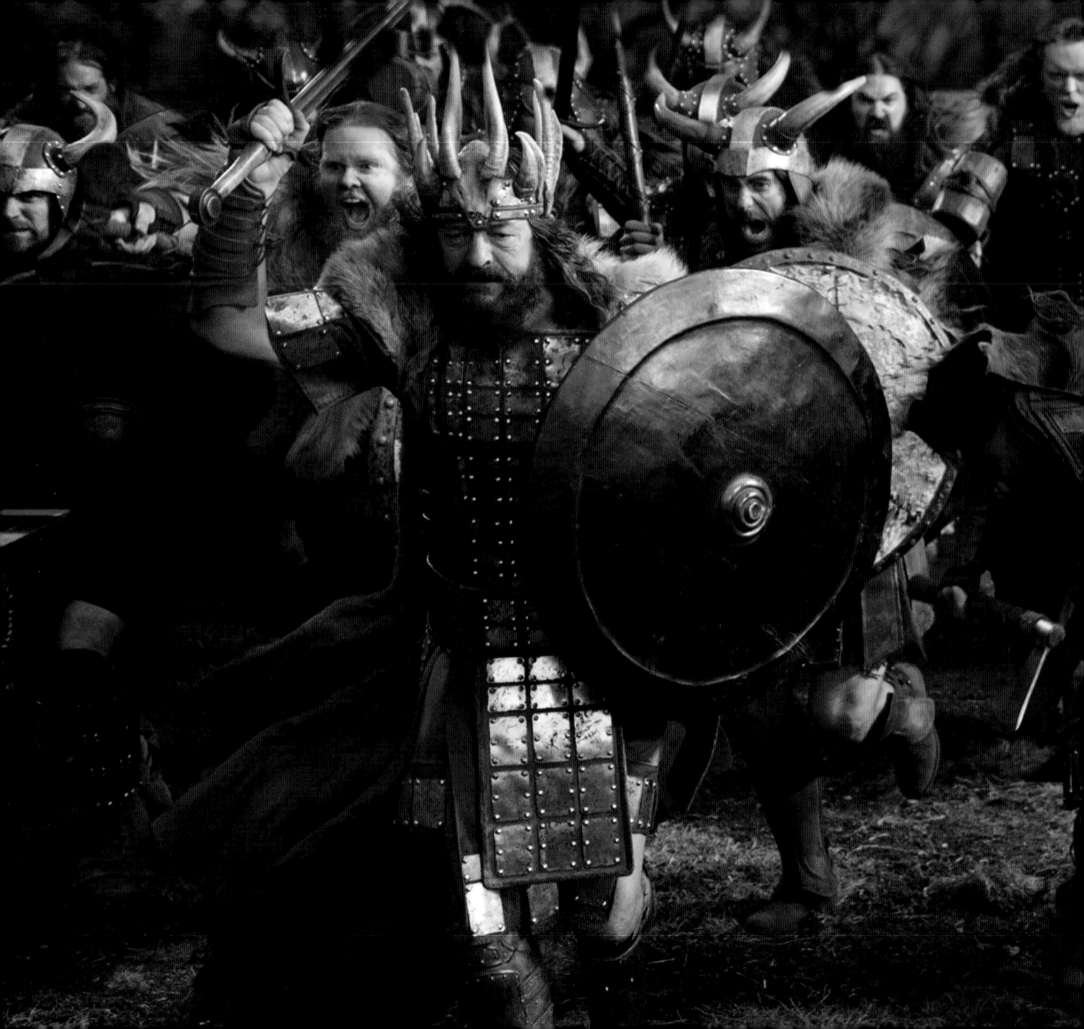

A HISTORY LESSON

"What inspires Bruce and Diana to put together a team is an initially unidentified looming, larger threat.

Ultimately, we find out that it has to do with the history lesson about the Mother Boxes, which exist on

Earth, and the danger of the formation of a Unity if the three of them are put together."

Wesley Coller, Executive Producer

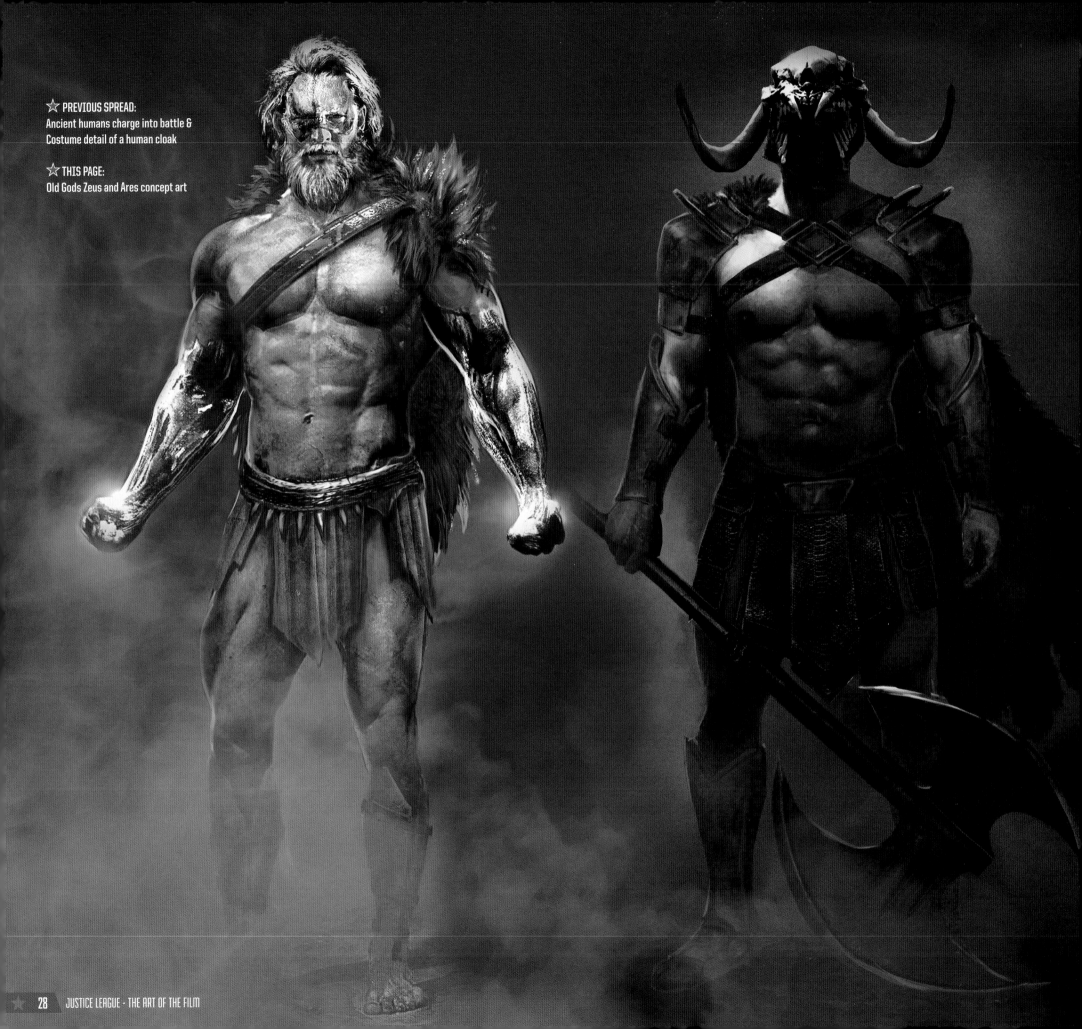

☆ PREVIOUS SPREAD:
Ancient humans charge into battle &
Costume detail of a human cloak

☆ THIS PAGE:
Old Gods Zeus and Ares concept art

"Steppenwolf comes from a different planet for the Mother Boxes and to have his revenge, because last time he came to Earth with the Mother Boxes, the Amazons, the Atlanteans, mankind, the Old Gods themselves, and allies from other planets fought together and repelled him."

Gal Gadot, Diana Prince/Wonder Woman

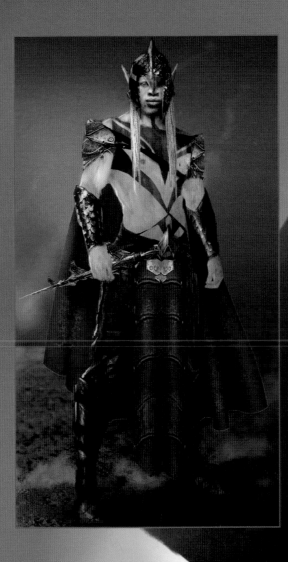
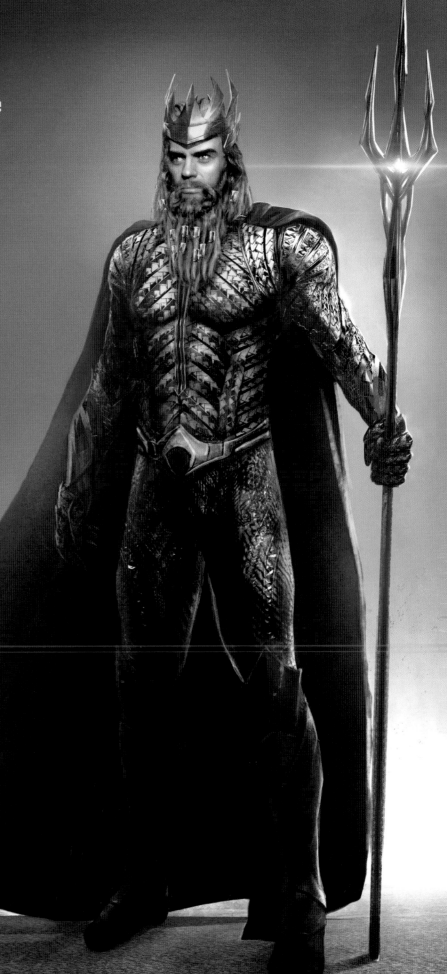

☆ THIS PAGE:
Ancient Atlanteans concept art

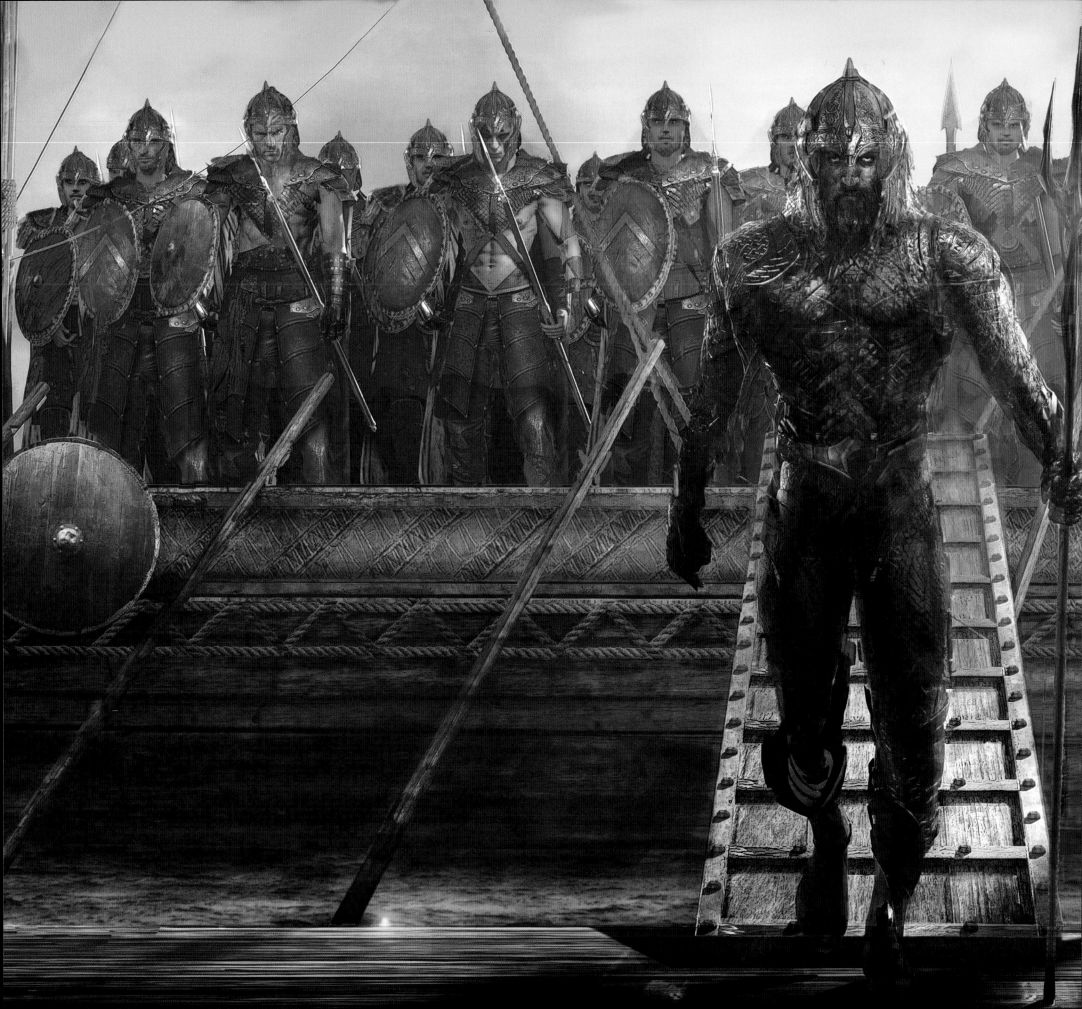

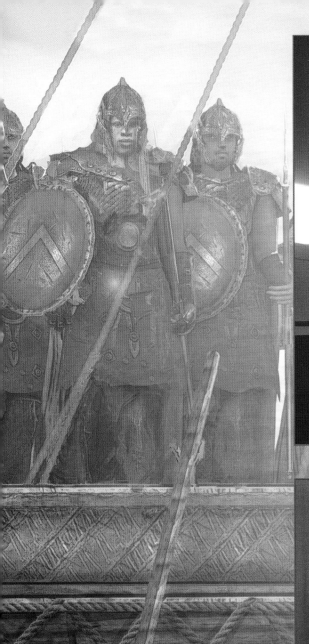

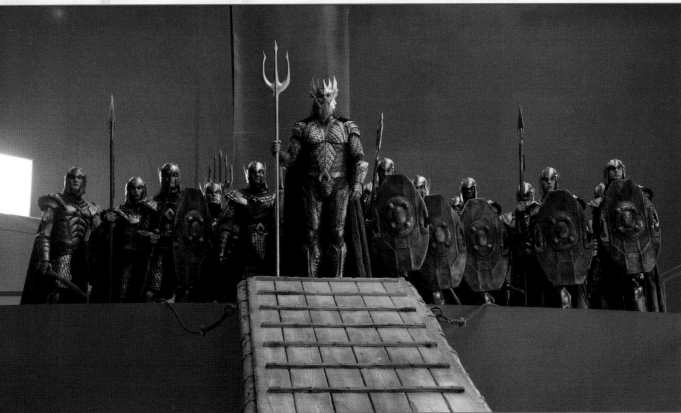

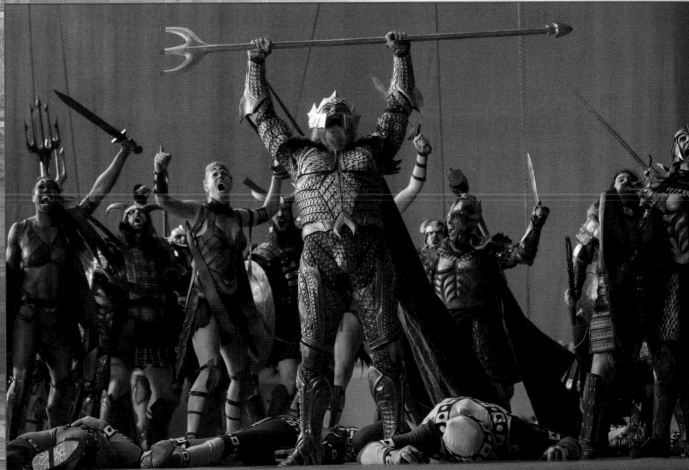

☆ LEFT:
Ancient Atlanteans concept art

☆ TOP RIGHT:
Ancient Atlanteans

☆ RIGHT:
Ancient Amazons, humans, and
Atlanteans celebrate victory

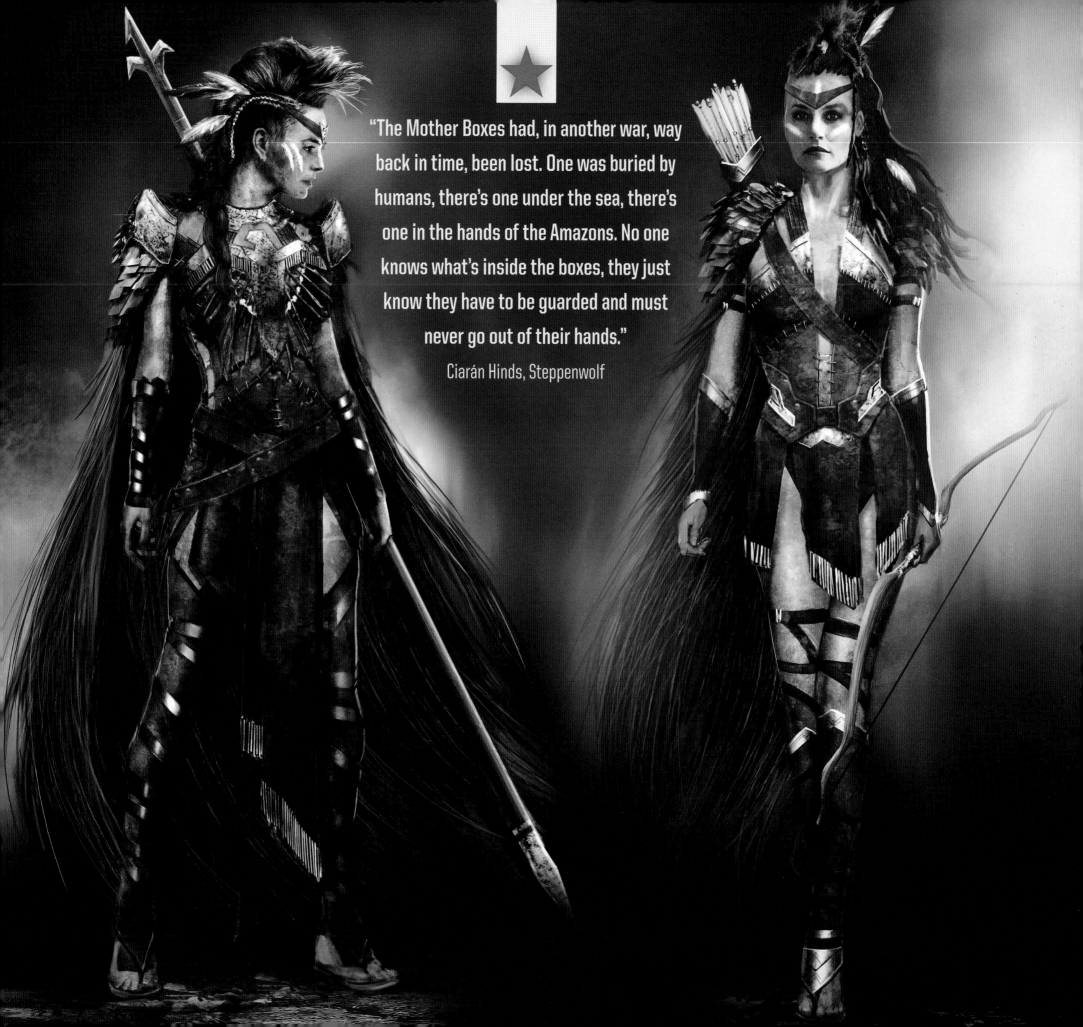

"The Mother Boxes had, in another war, way back in time, been lost. One was buried by humans, there's one under the sea, there's one in the hands of the Amazons. No one knows what's inside the boxes, they just know they have to be guarded and must never go out of their hands."

Ciarán Hinds, Steppenwolf

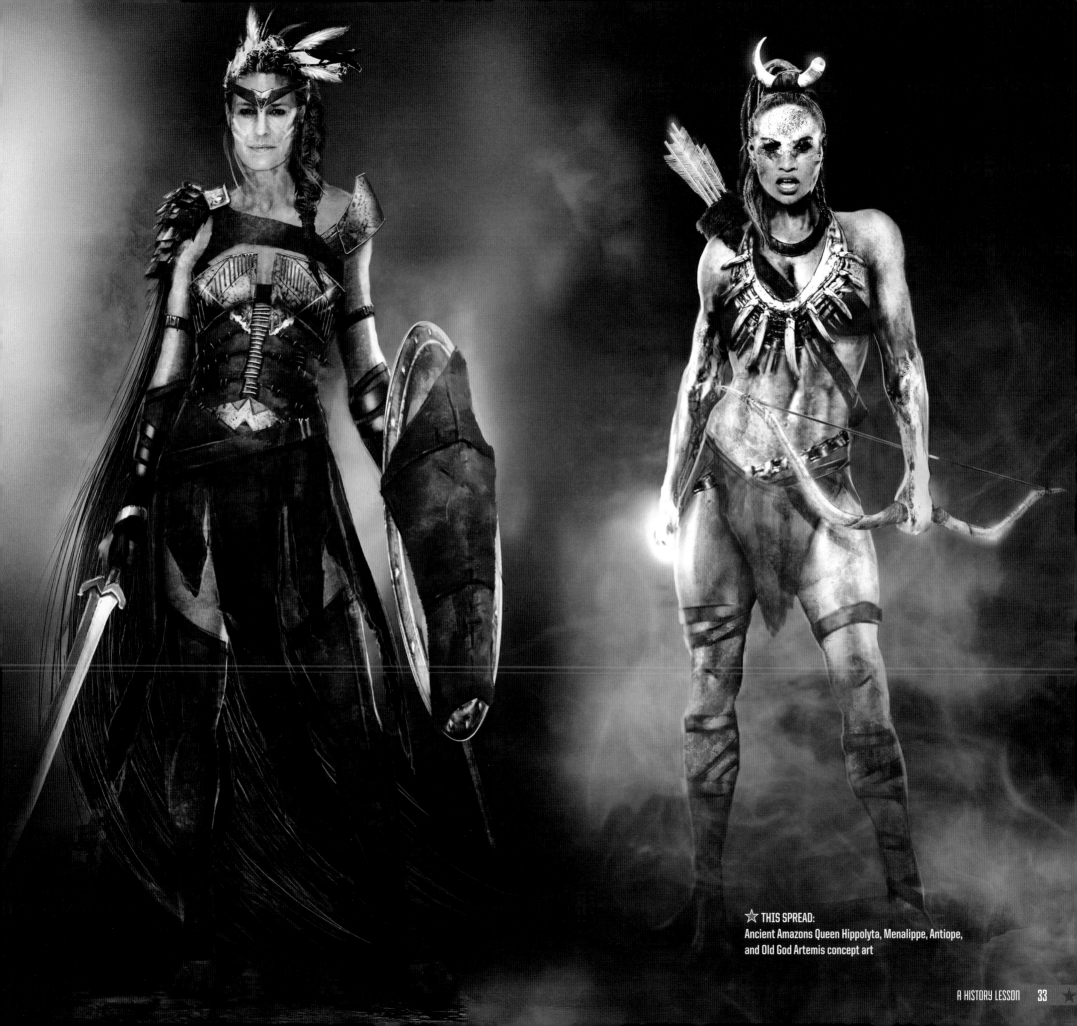

☆ THIS SPREAD:
Ancient Amazons Queen Hippolyta, Menalippe, Antiope, and Old God Artemis concept art

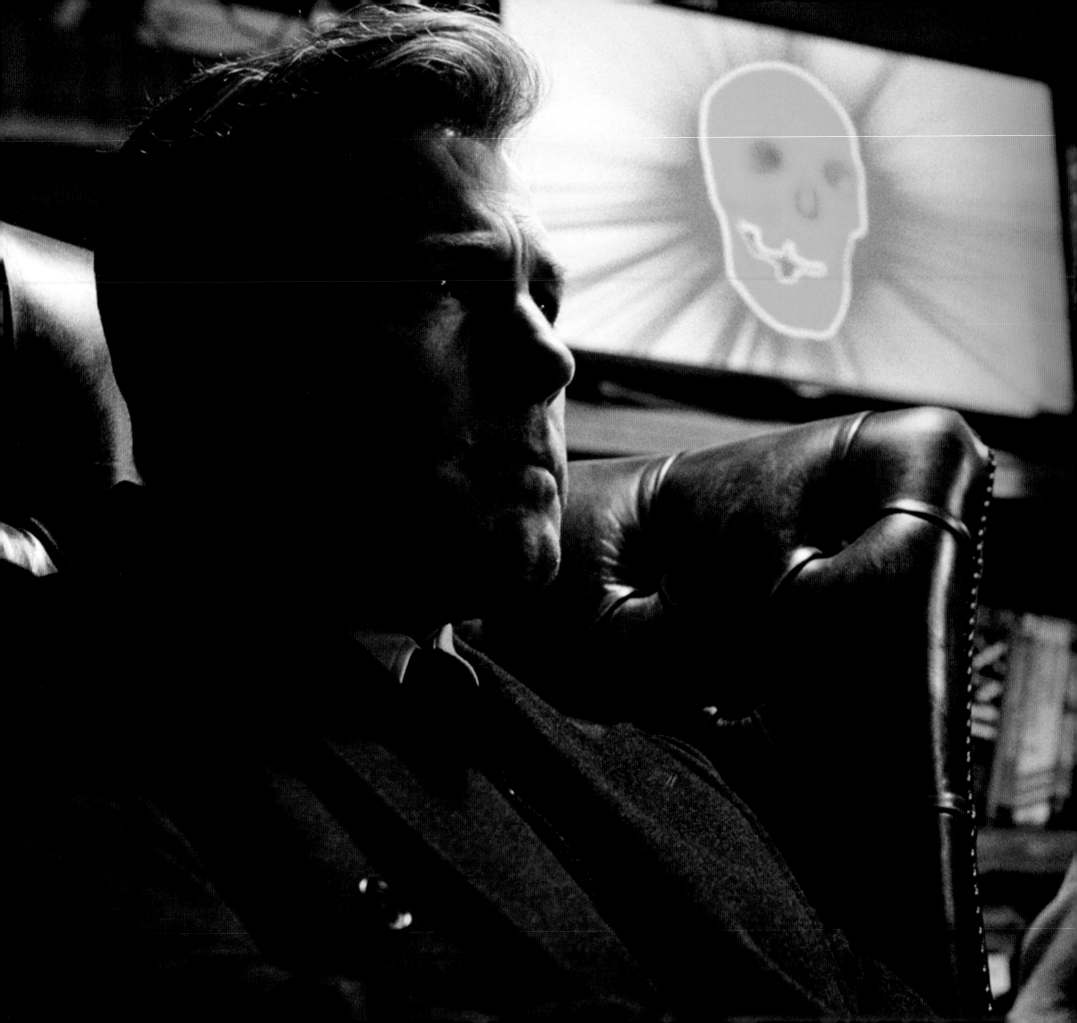

A NEW AGE OF HEROES

"Bruce Wayne decides that he has a responsibility to protect the world, because there's a huge threat that's coming. Now the Earth doesn't have Superman, these metahumans, these amazing people, or gods, with powers need to band together and form a team to save the world."

Deborah Snyder, Producer

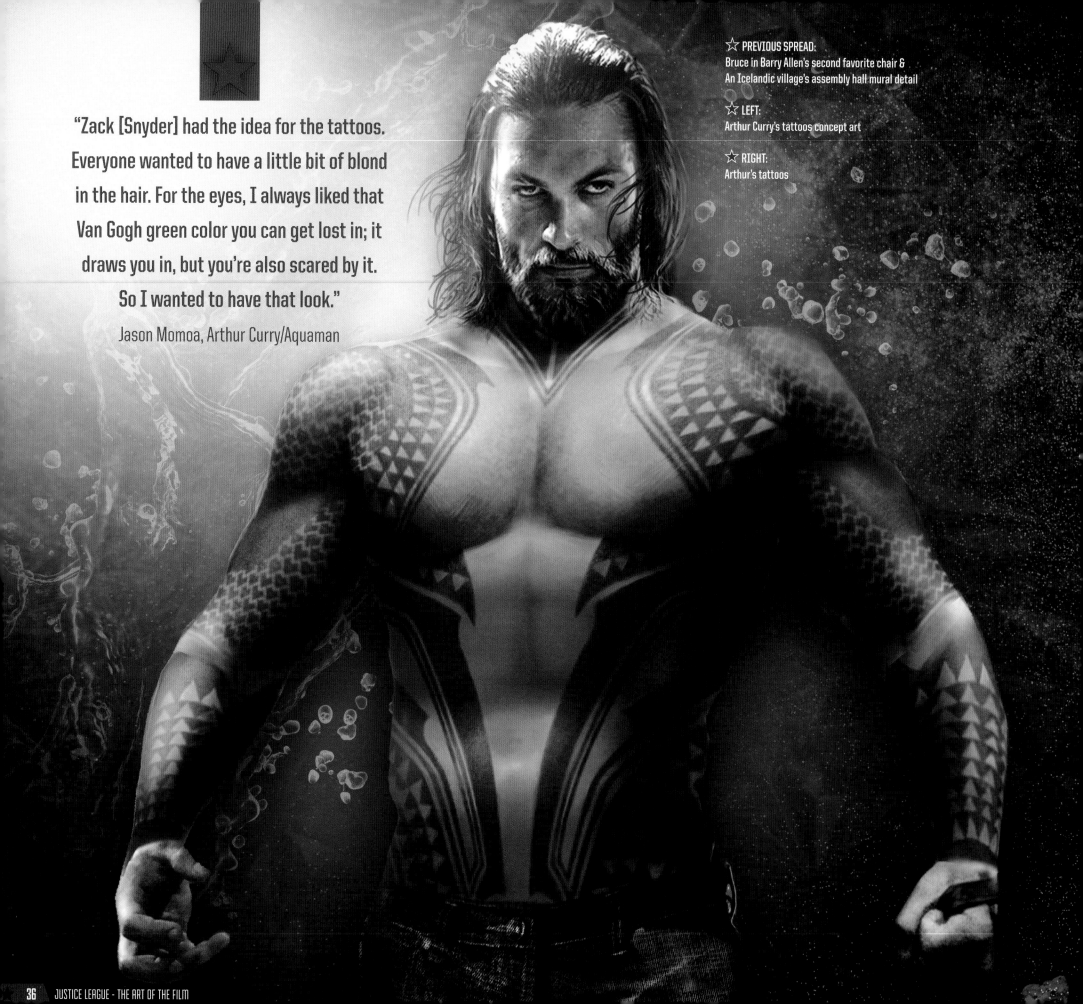

"Zack [Snyder] had the idea for the tattoos. Everyone wanted to have a little bit of blond in the hair. For the eyes, I always liked that Van Gogh green color you can get lost in; it draws you in, but you're also scared by it. So I wanted to have that look."

Jason Momoa, Arthur Curry/Aquaman

☆ PREVIOUS SPREAD:
Bruce in Barry Allen's second favorite chair &
An Icelandic village's assembly hall mural detail

☆ LEFT:
Arthur Curry's tattoos concept art

☆ RIGHT:
Arthur's tattoos

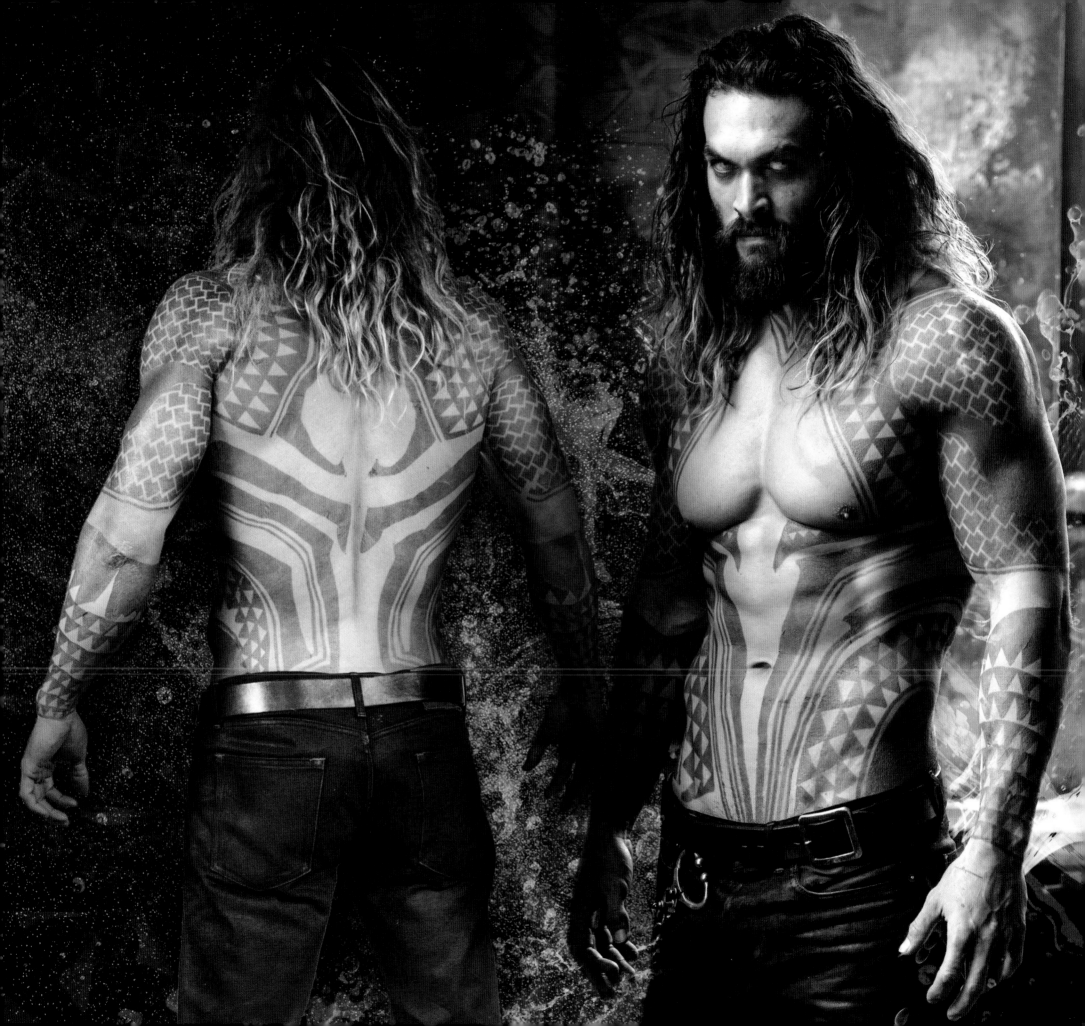

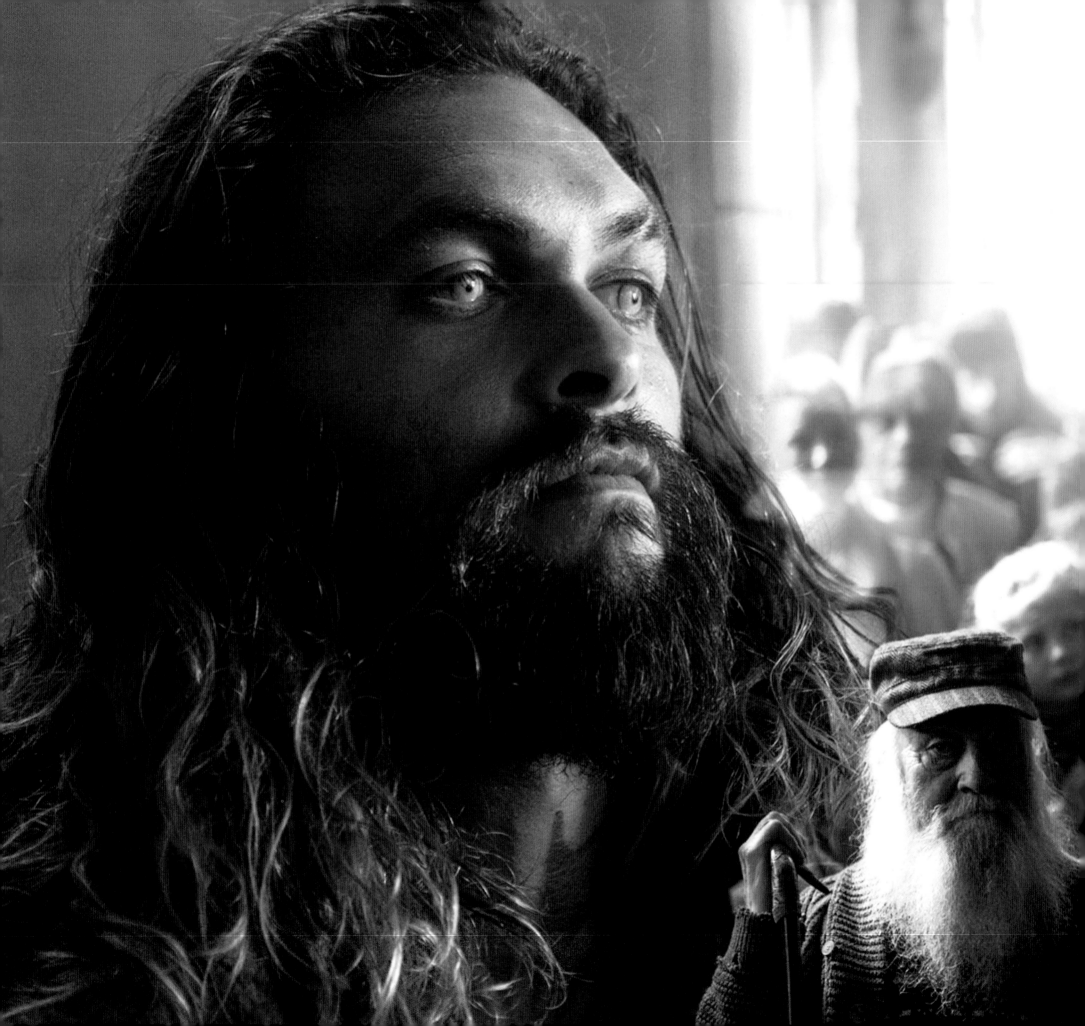

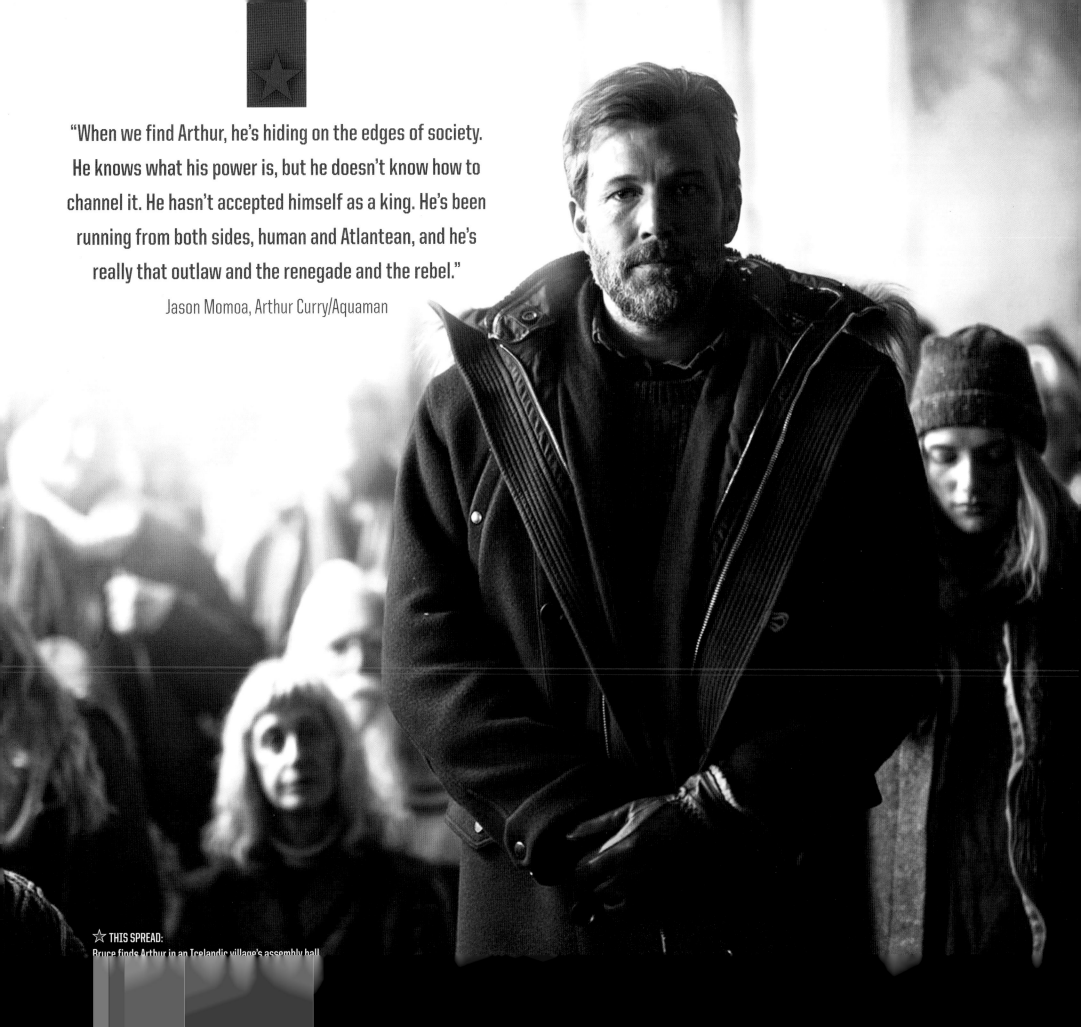

"When we find Arthur, he's hiding on the edges of society. He knows what his power is, but he doesn't know how to channel it. He hasn't accepted himself as a king. He's been running from both sides, human and Atlantean, and he's really that outlaw and the renegade and the rebel."

Jason Momoa, Arthur Curry/Aquaman

☆ **THIS SPREAD:**
Bruce finds Arthur in an Icelandic village's assembly hall.

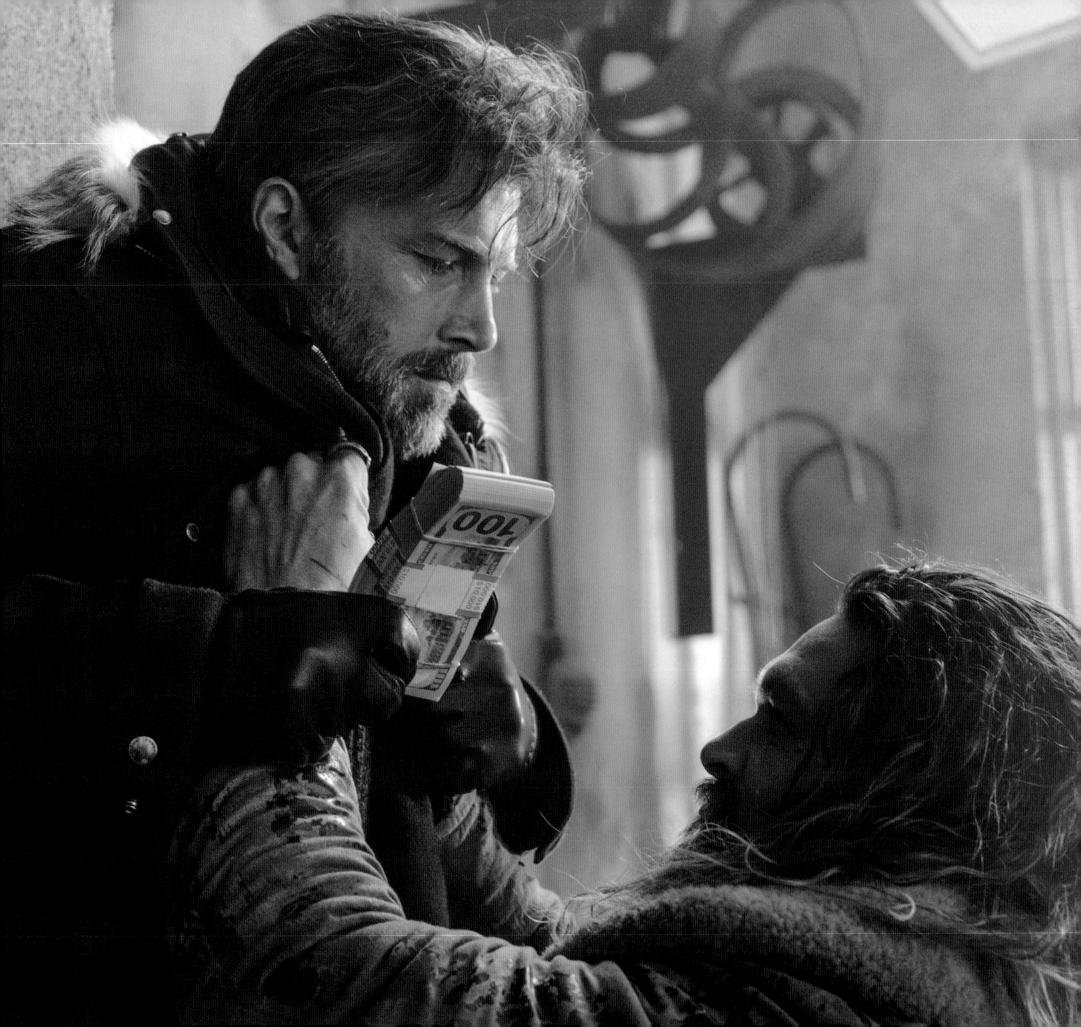

★ LEFT:
Arthur is not impressed by Bruce

★ ABOVE:
Bruce's business card & A mural in the Icelandic meeting hall

★ BELOW:
Details of the Icelandic meeting hall interior

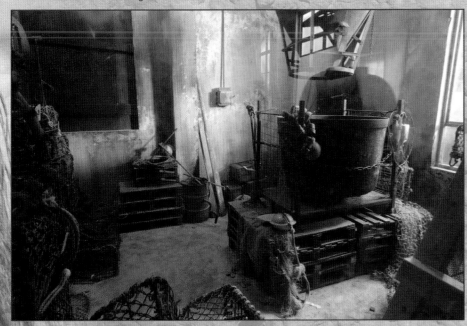

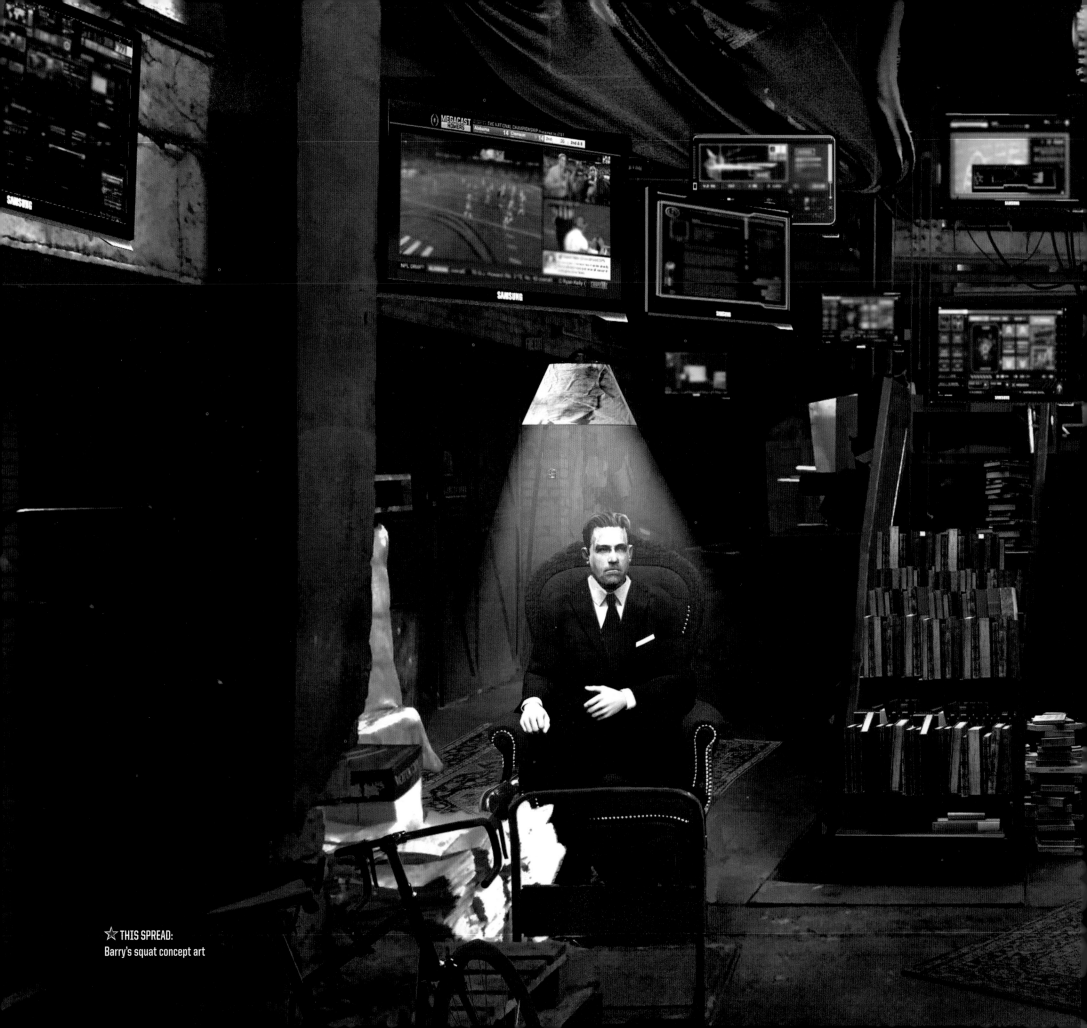

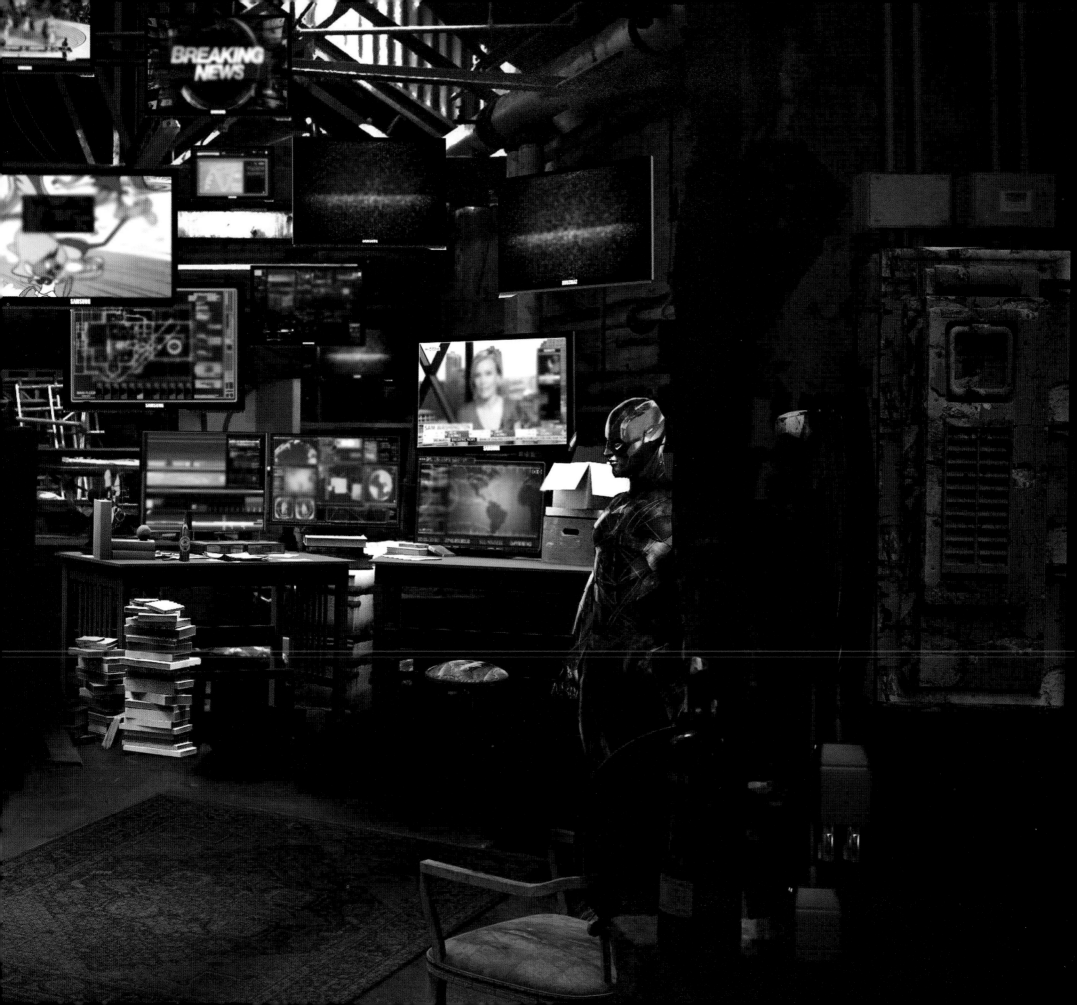

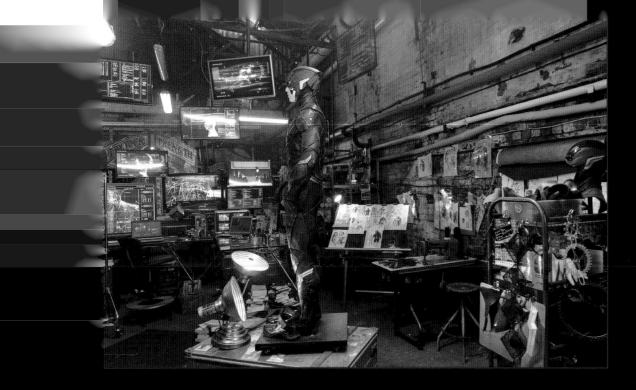

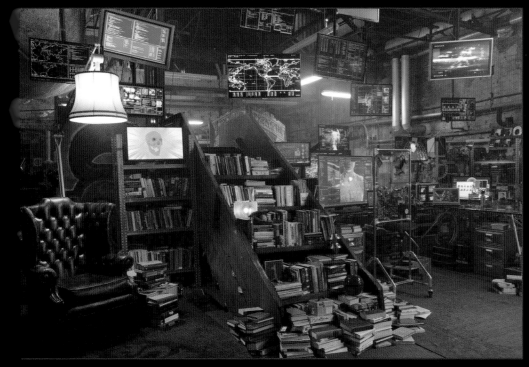

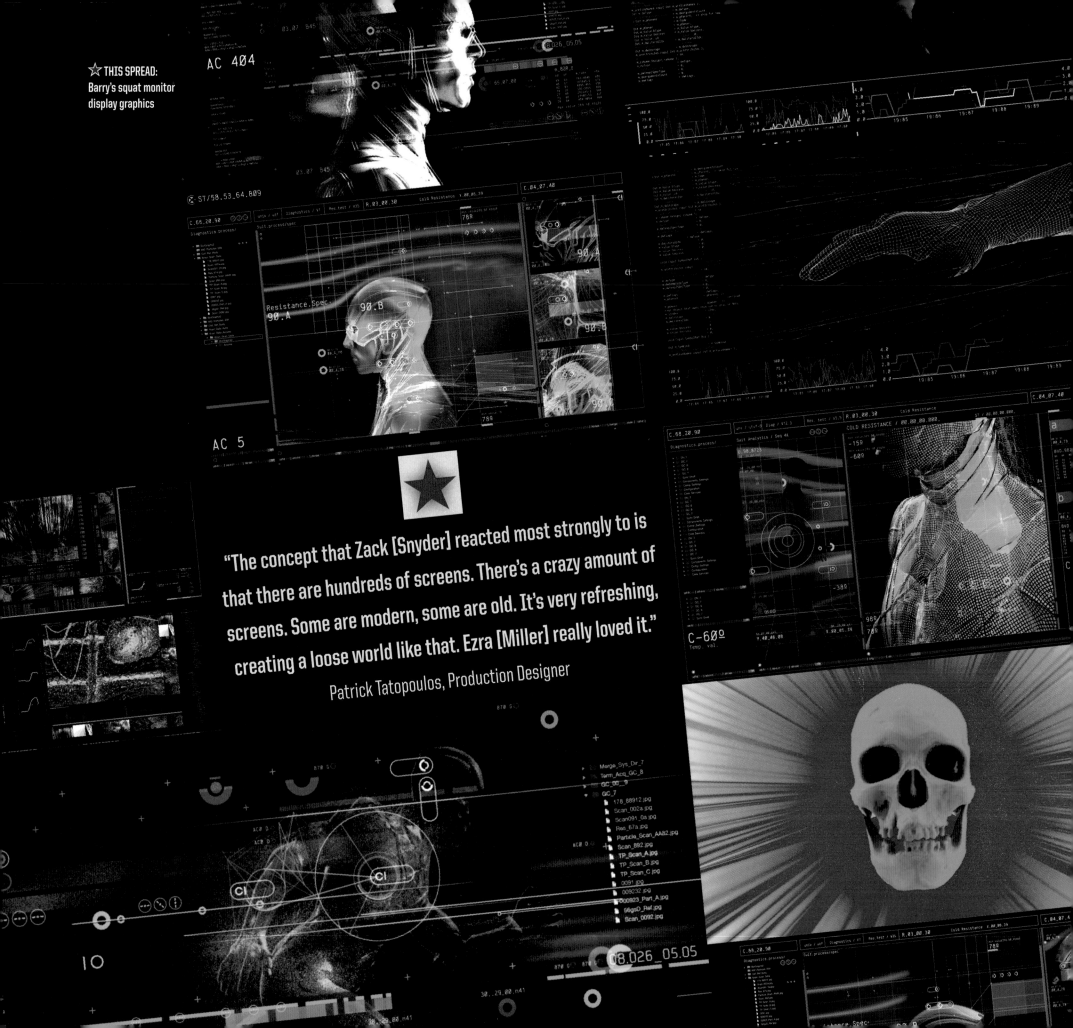

"The concept that Zack [Snyder] reacted most strongly to is that there are hundreds of screens. There's a crazy amount of screens. Some are modern, some are old. It's very refreshing, creating a loose world like that. Ezra [Miller] really loved it."

Patrick Tatopoulos, Production Designer

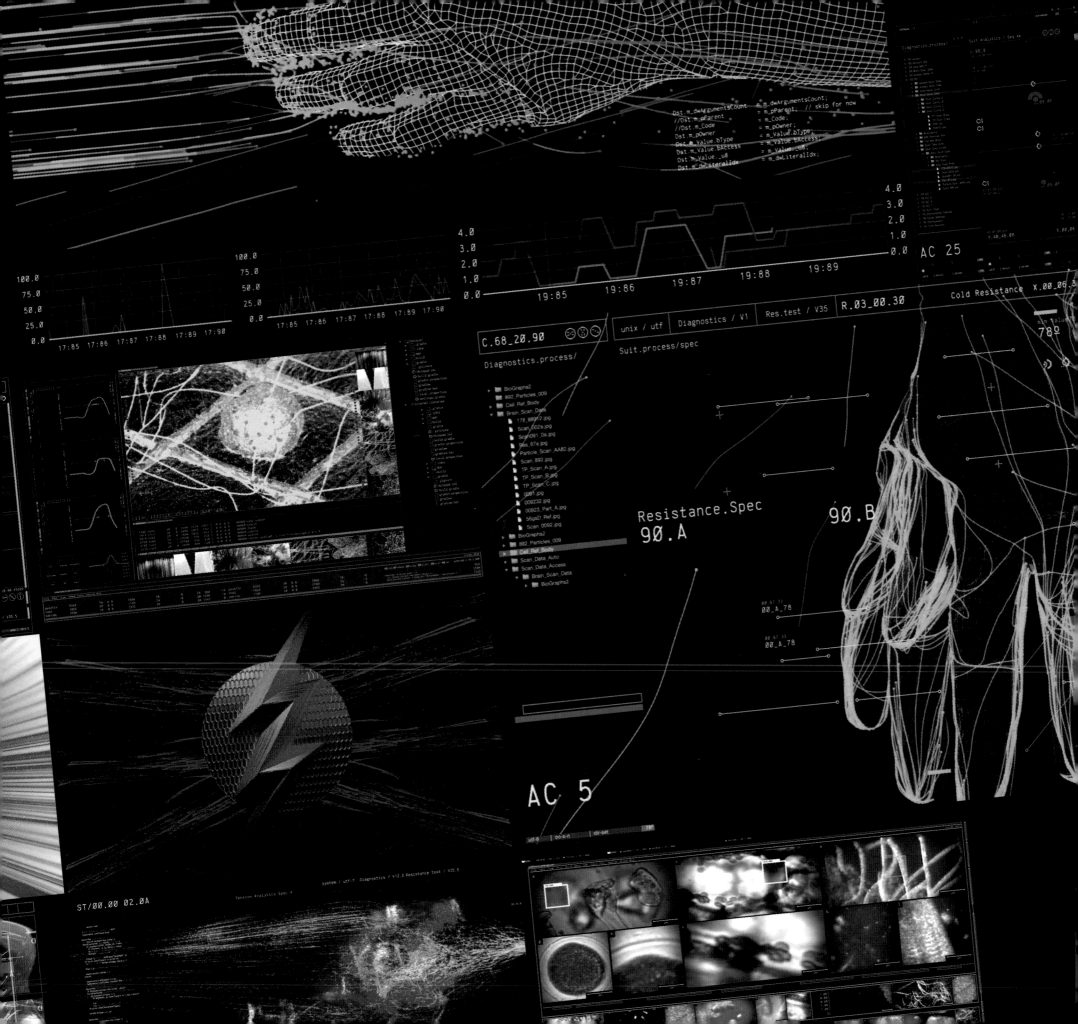

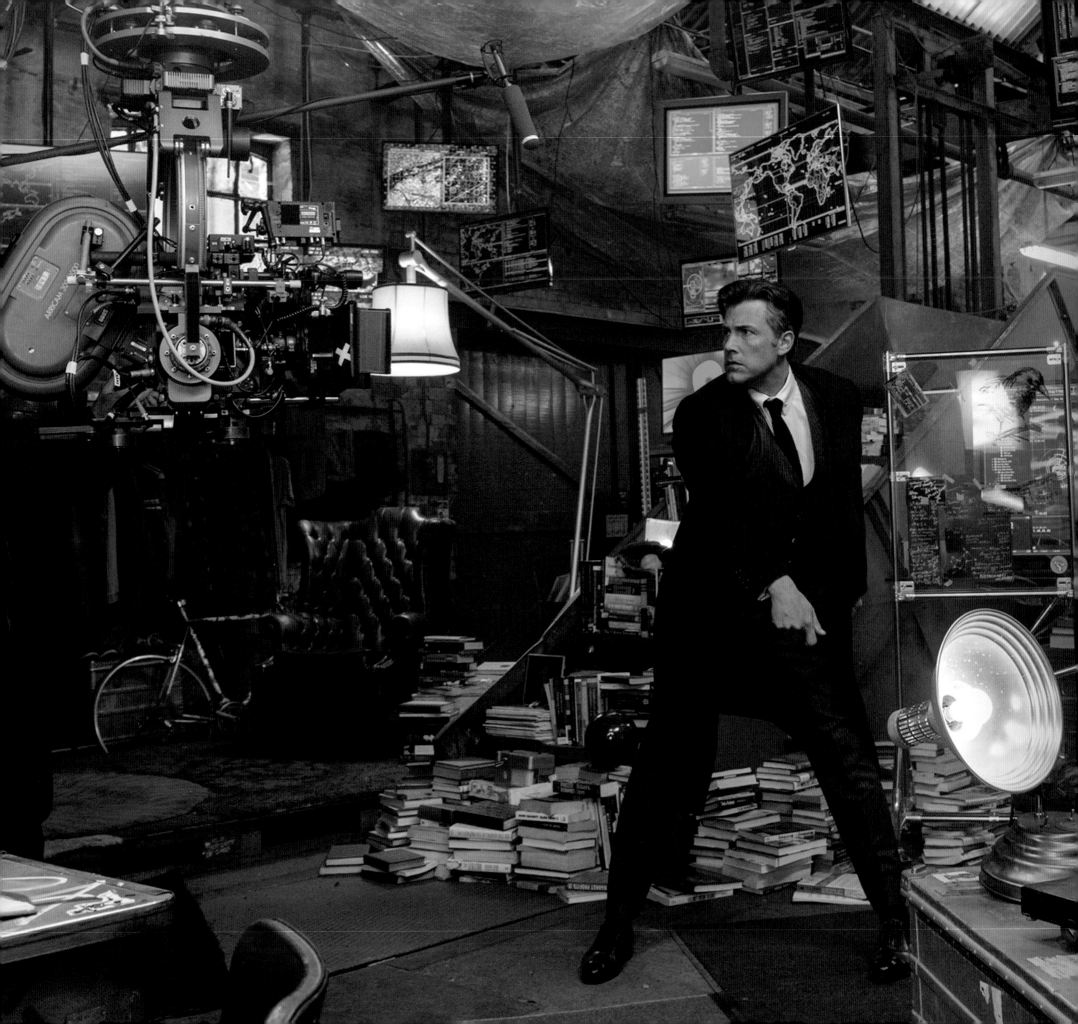

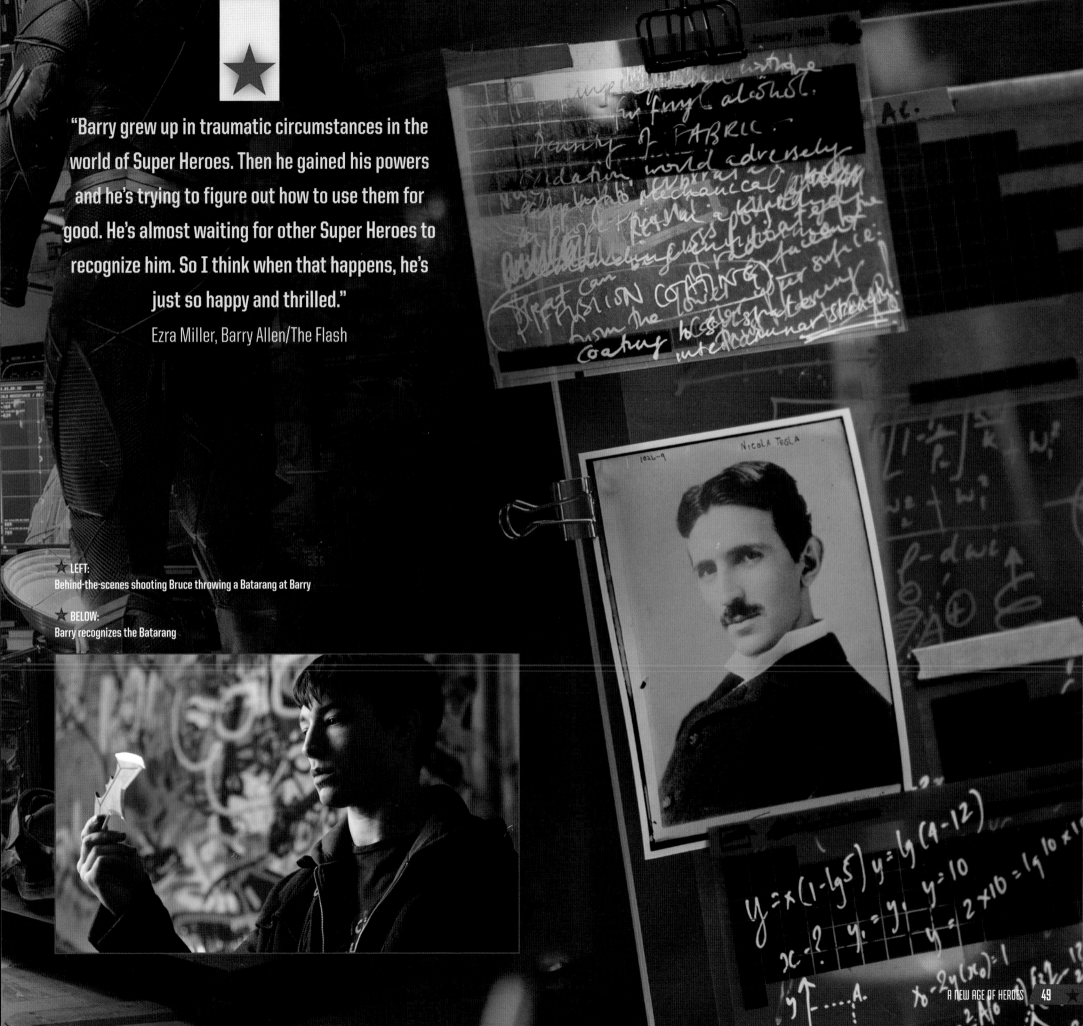

"Barry grew up in traumatic circumstances in the world of Super Heroes. Then he gained his powers and he's trying to figure out how to use them for good. He's almost waiting for other Super Heroes to recognize him. So I think when that happens, he's just so happy and thrilled."

Ezra Miller, Barry Allen/The Flash

★ LEFT:
Behind-the-scenes shooting Bruce throwing a Batarang at Barry

★ BELOW:
Barry recognizes the Batarang

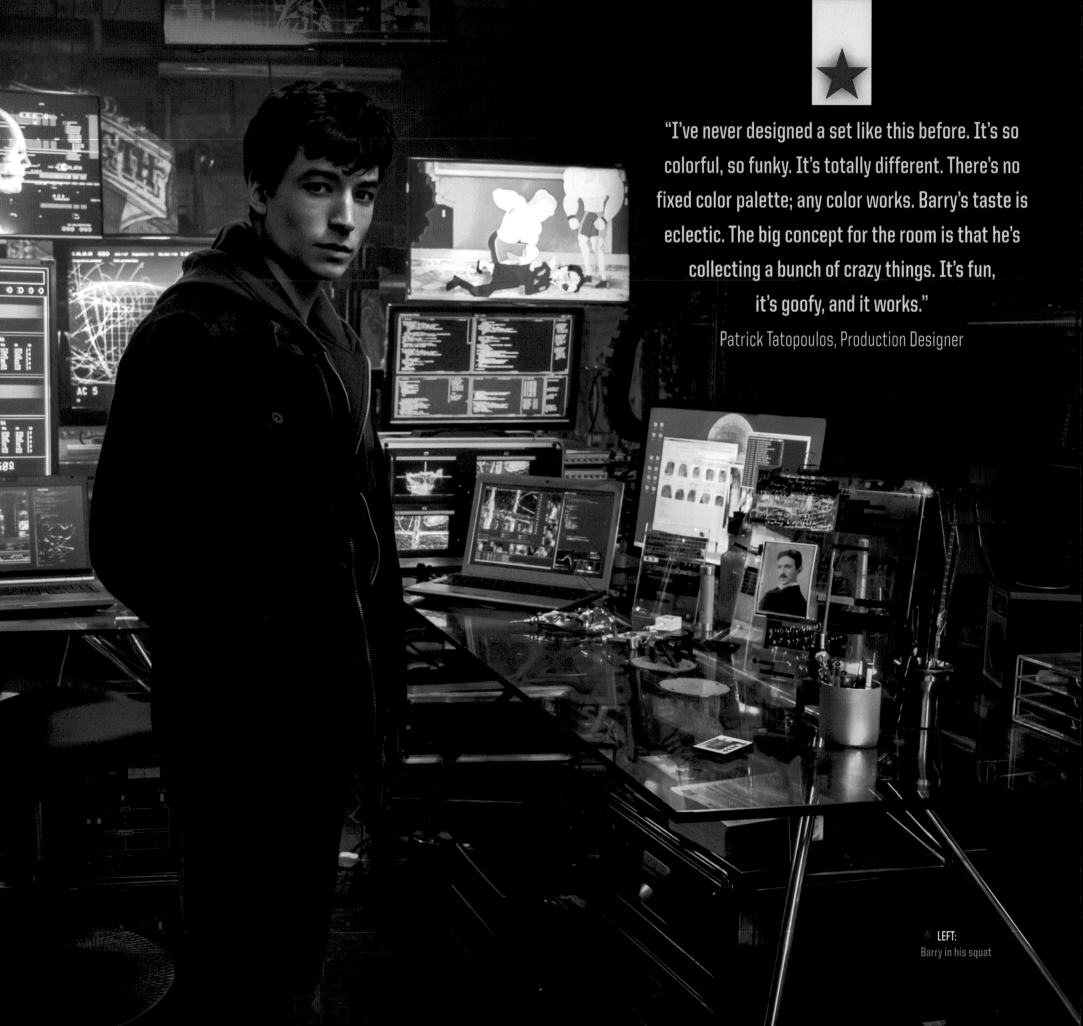

"I've never designed a set like this before. It's so colorful, so funky. It's totally different. There's no fixed color palette; any color works. Barry's taste is eclectic. The big concept for the room is that he's collecting a bunch of crazy things. It's fun, it's goofy, and it works."

Patrick Tatopoulos, Production Designer

★ LEFT:
Barry in his squat

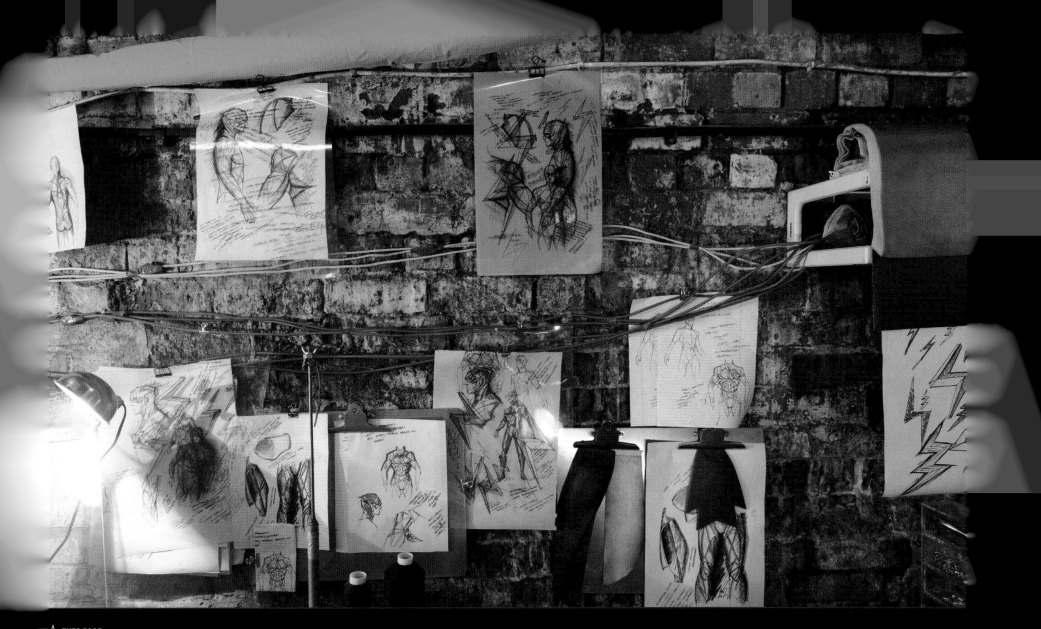

☆ THIS PAGE:
Barry's design sketches for his protoype Flash suit

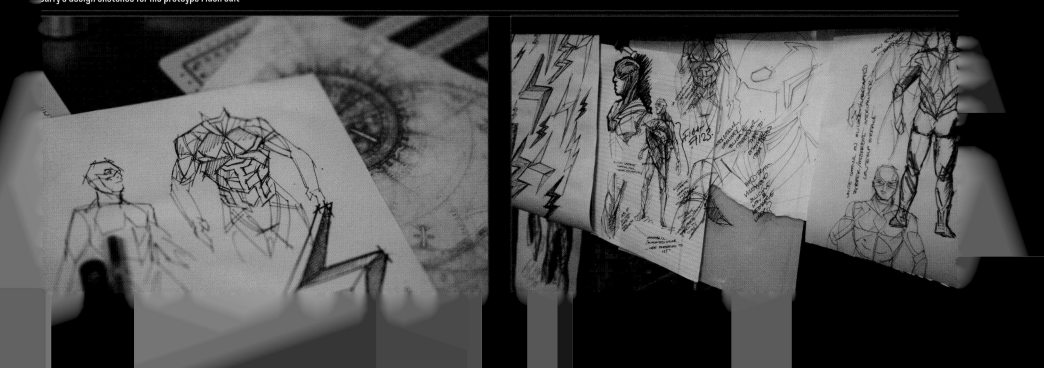

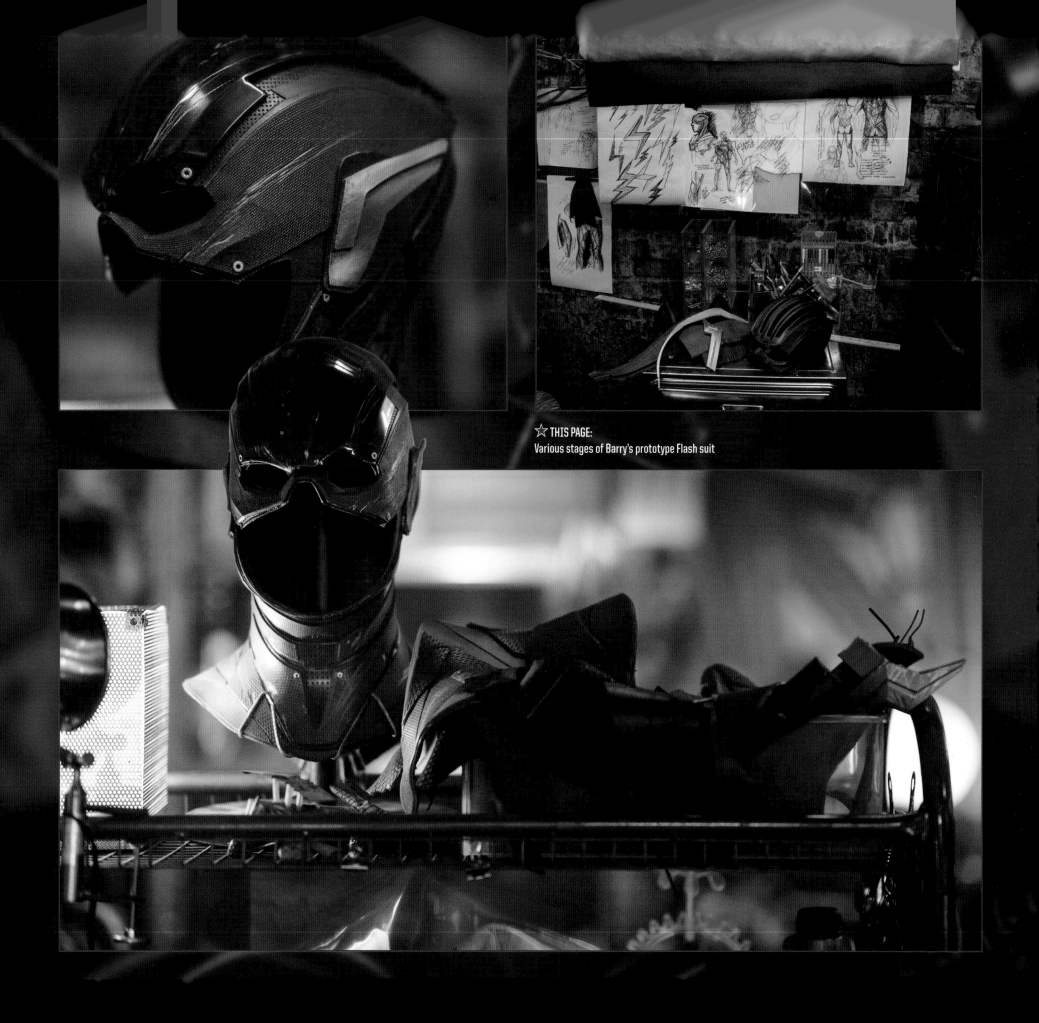

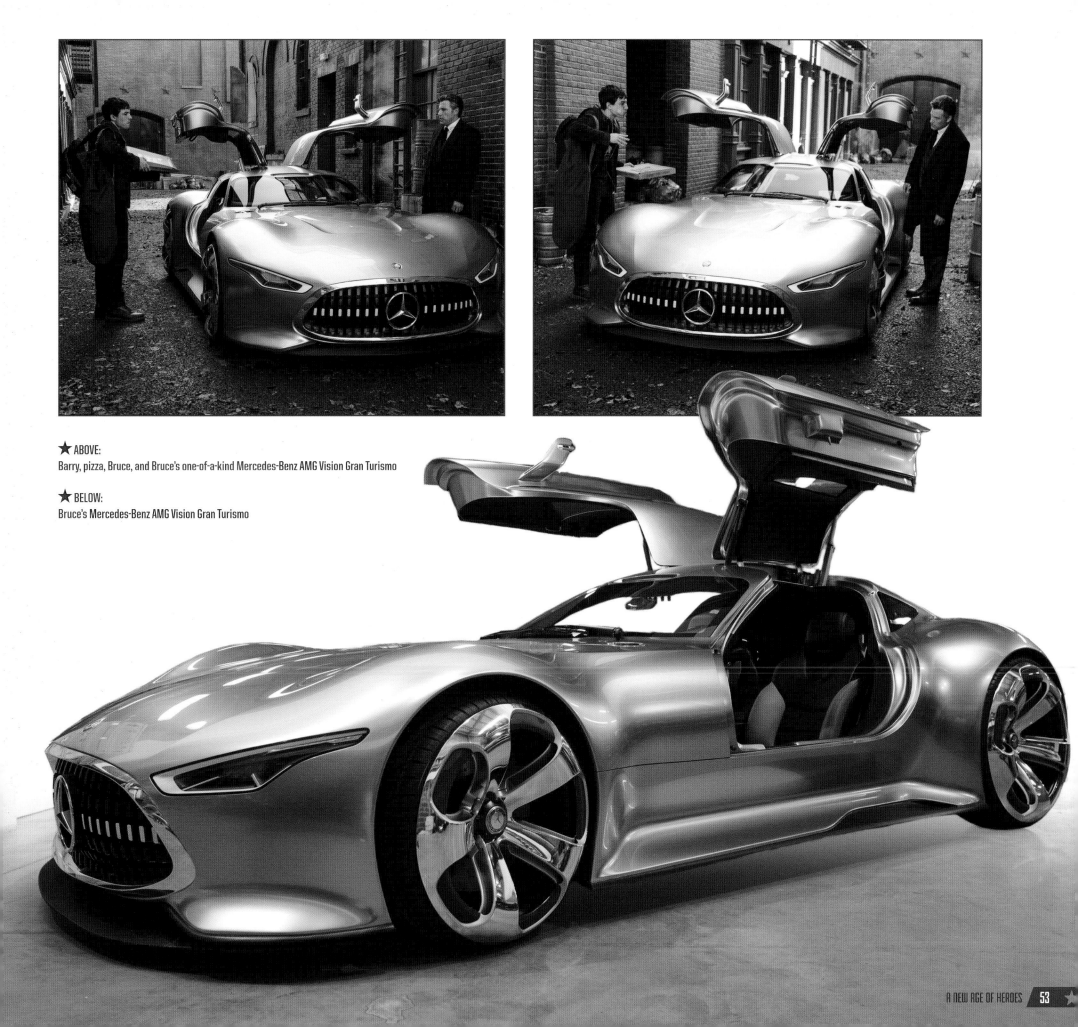

★ ABOVE:
Barry, pizza, Bruce, and Bruce's one-of-a-kind Mercedes-Benz AMG Vision Gran Turismo

★ BELOW:
Bruce's Mercedes-Benz AMG Vision Gran Turismo

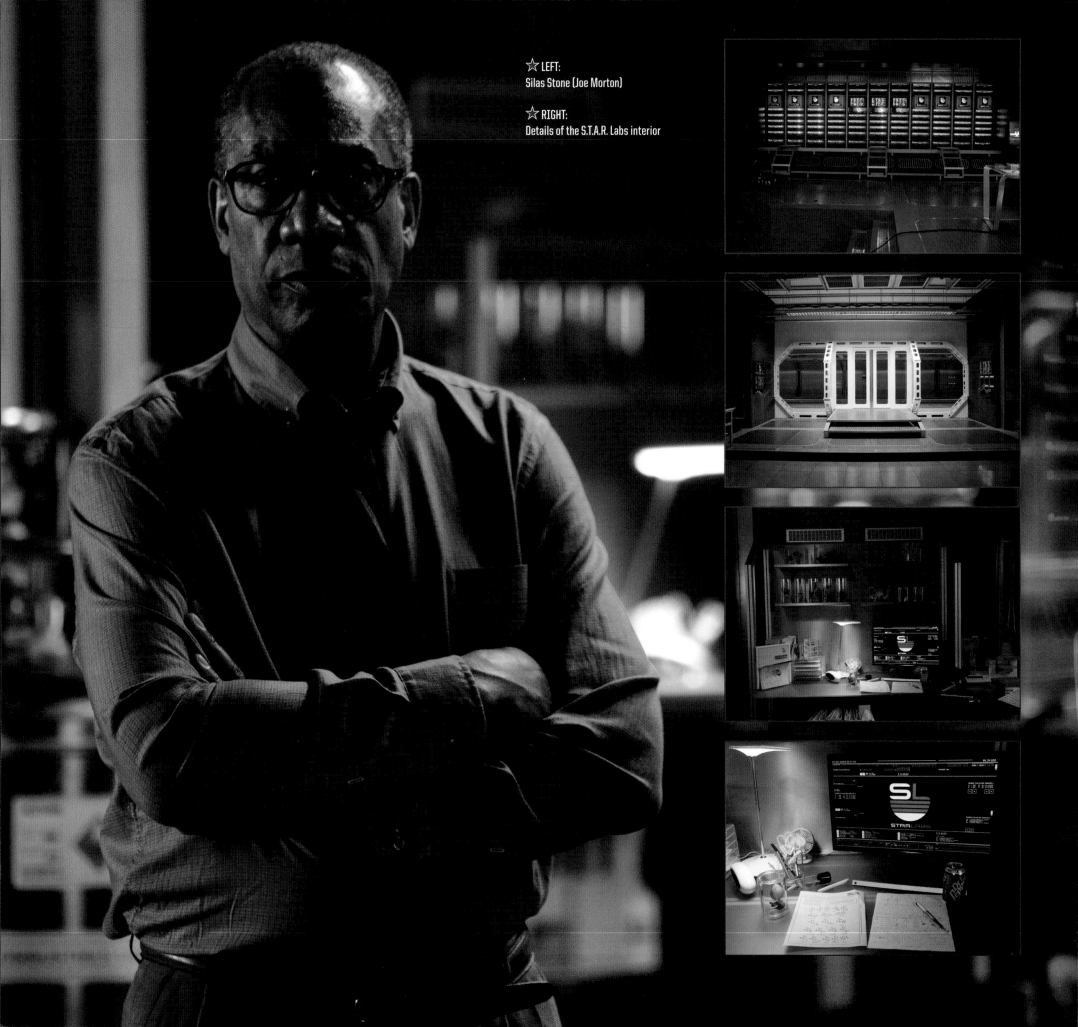

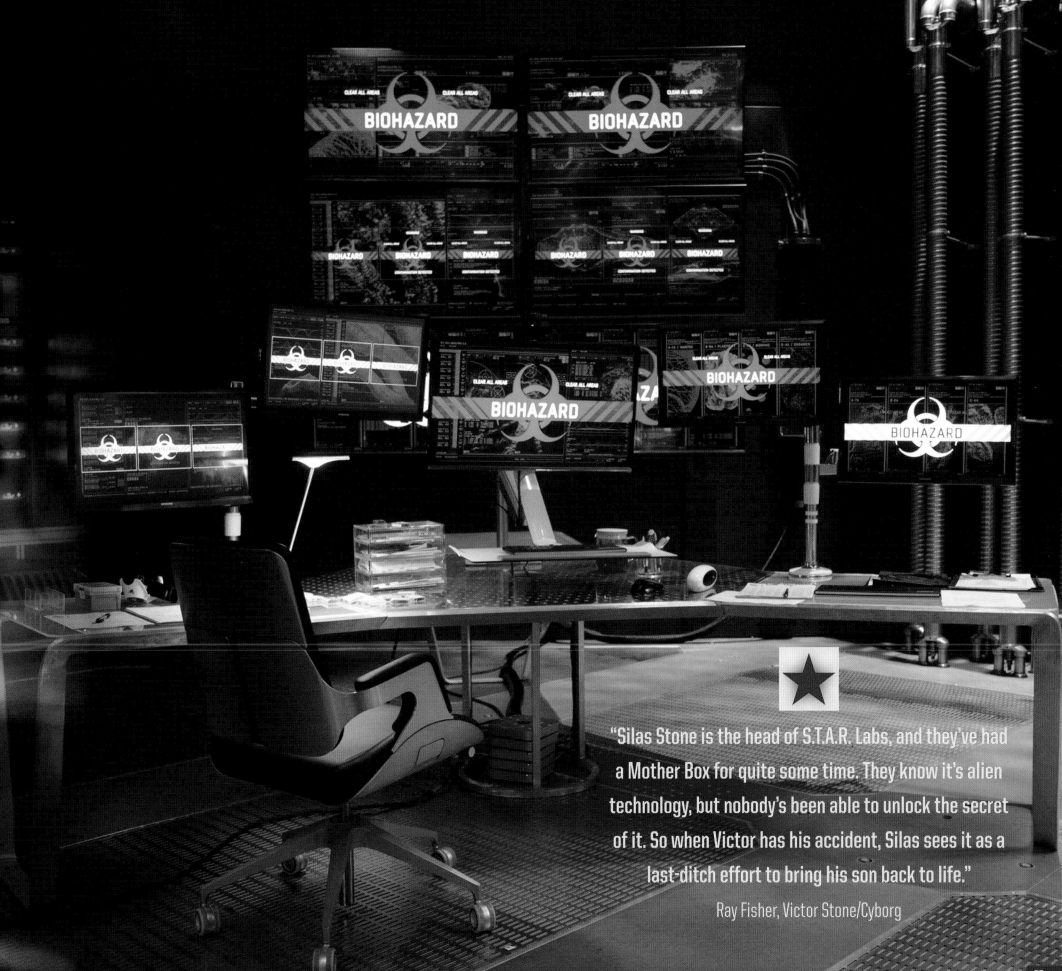

"Silas Stone is the head of S.T.A.R. Labs, and they've had a Mother Box for quite some time. They know it's alien technology, but nobody's been able to unlock the secret of it. So when Victor has his accident, Silas sees it as a last-ditch effort to bring his son back to life."

Ray Fisher, Victor Stone/Cyborg

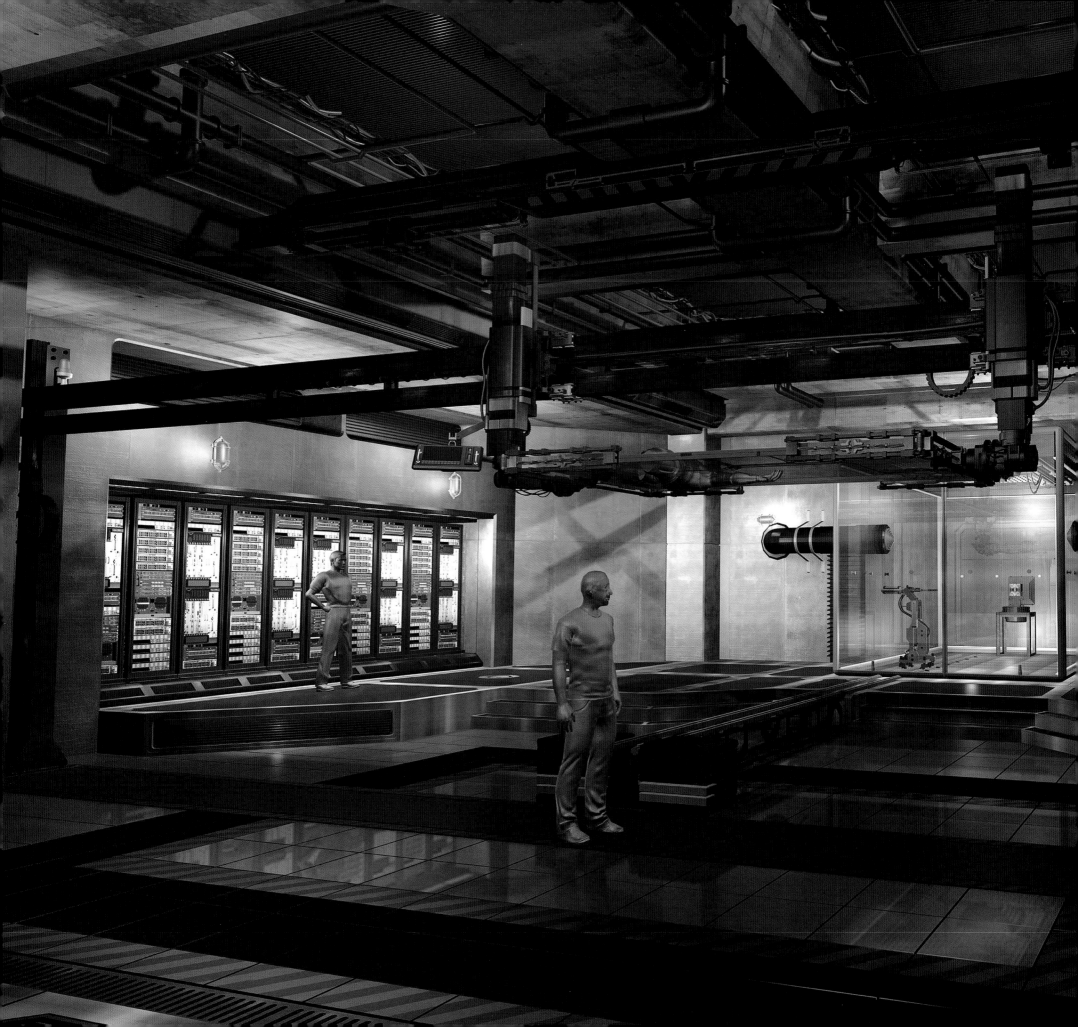

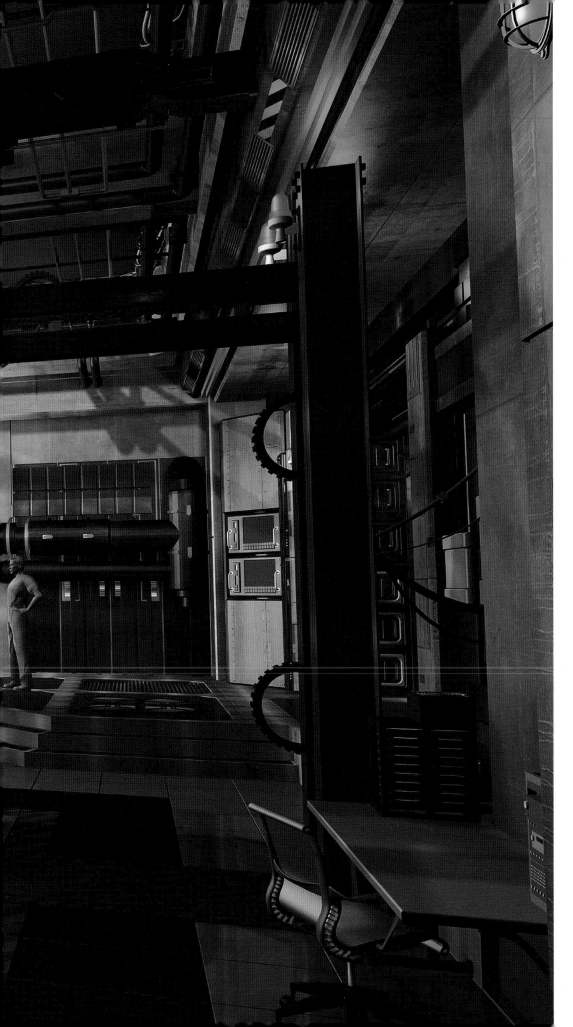

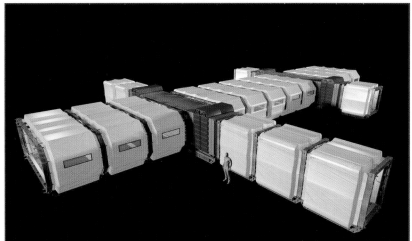

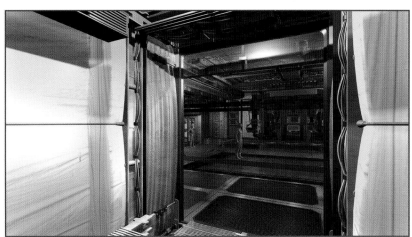

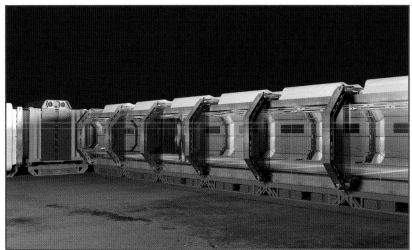

★ THIS SPREAD:
S.T.A.R. Labs interior concept art

"S.T.A.R. Labs is set up within the big containment area, seen in *Batman v Superman*, where the Kryptonian scout ship is sitting. This is our high-tech side of the film. Zack [Snyder] wanted the red walls as a call-back to some of the early comic books. It's a big space that we created practically, 360-degrees except for the ceiling."

Patrick Tatopoulos, Production Designer

★ LEFT:
S.T.A.R. Labs interior layout sketch

★ RIGHT:
S.T.A.R. Labs interior concept art

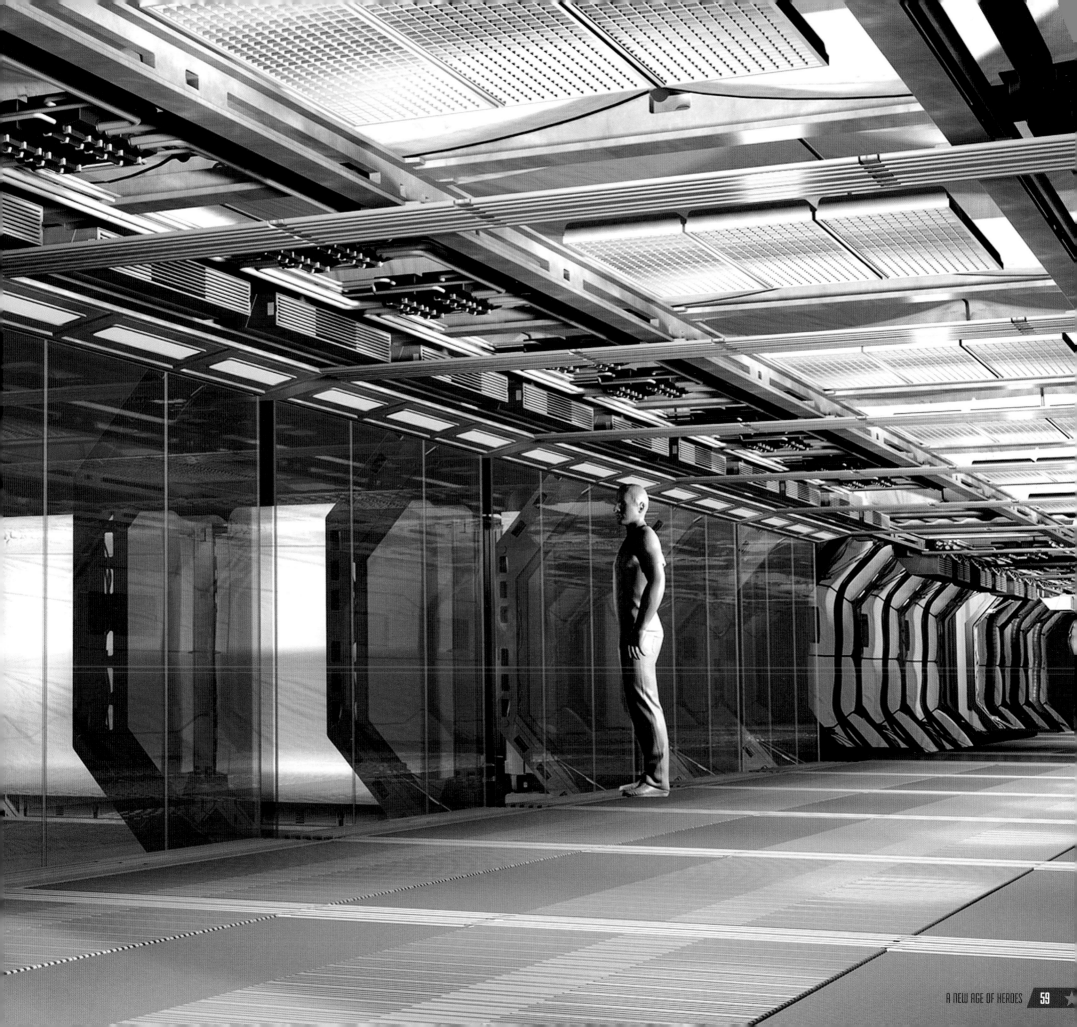

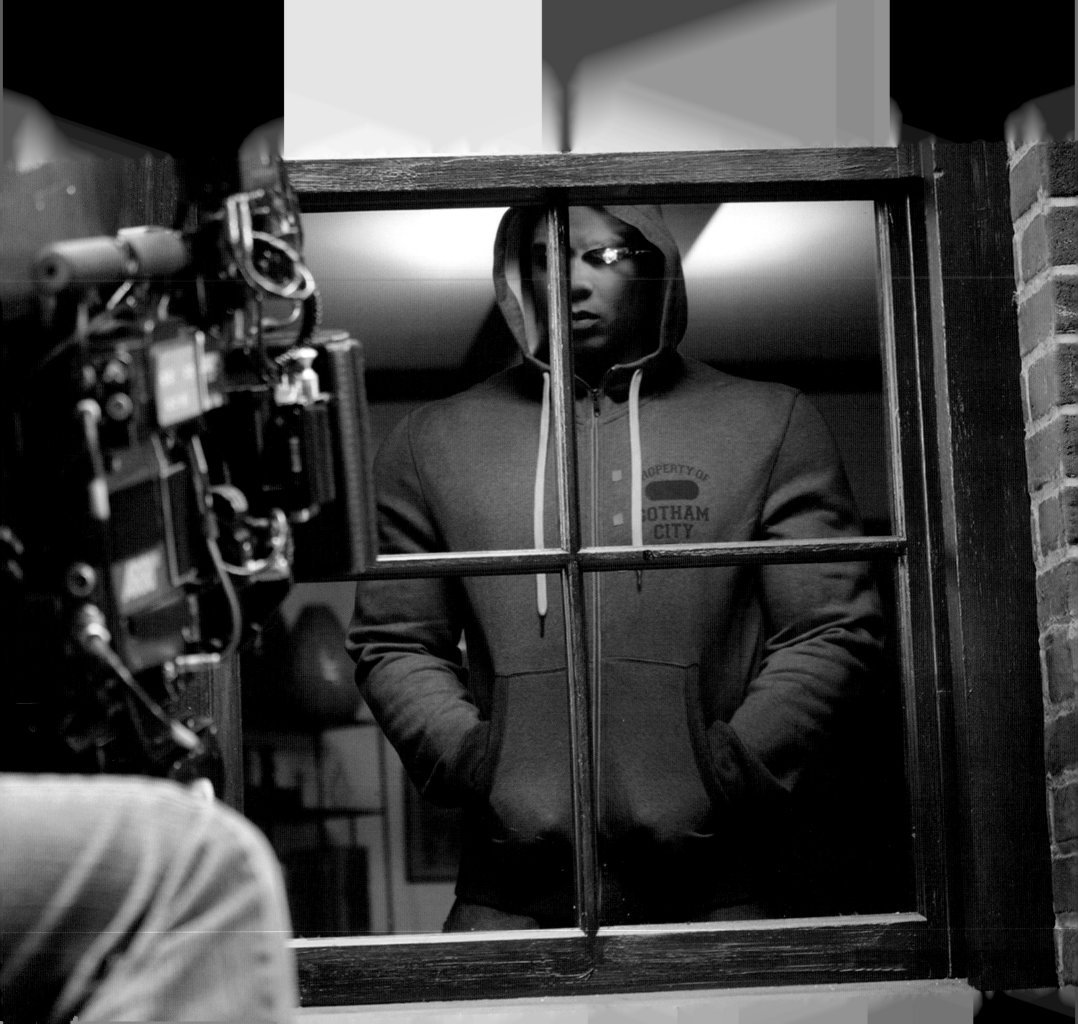

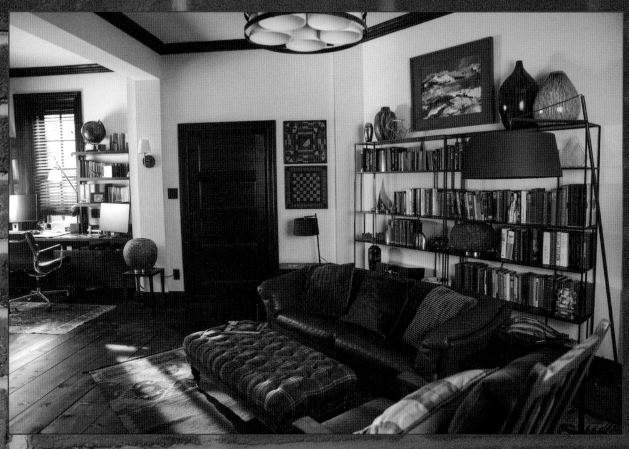

☆ LEFT:
Behind-the-scenes shooting Victor Stone in the Stones' apartment

☆ THIS PAGE:
Details of the Stones' apartment interior

THIS IS YOUR BRAIN ON THE PLANET.

Daily Planet
DailyPlanet.com

Reporting on the Planet, Daily.

Daily Planet
DailyPlanet.com

Reporting on the Planet, Daily.

Daily Planet
DailyPlanet.com

INSANE SPORTS COVERAGE

Daily Planet
DailyPlanet.com

LightTracer

NEW ALBUM OUT NOW

NEW ALBUM OUT NOW

NEXUS

available in all good record shops
and on digital download

STONESTAR

NORTH AMERICAN TOUR

15 SAN DIEGO
16 LOS ANGELES
17 LOS ANGELES
18 LOS ANGELES
20 SAN FRANCISCO
21 SAN FRANCISCO
22 PORTLAND
23 SEATTLE
25 SEATTLE
26 PHILADELPHIA
27 PHILADELPHIA
28 GOTHAM CITY
29 GOTHAM CITY
30 NEW YORK

STONESTAR
NEW ALBUM OUT NOW

TICKETS ON SALE NOW

METROPOLIS CABS
PRIVATE HIRE

CALL (958) 126 0287

☆ THIS SPREAD:
Graphics for Metropolis and Gotham set designs

EXPRESS cafe

MAIN STREET, METROPOLIS

SEEING DOUBLE?
GET 2 FOR 1 AT SONIA AND LOUI'S

Sonia & Loui's
DELICATESSEN

WEBBER'S **SALE** BOOKS

HURRY UP!

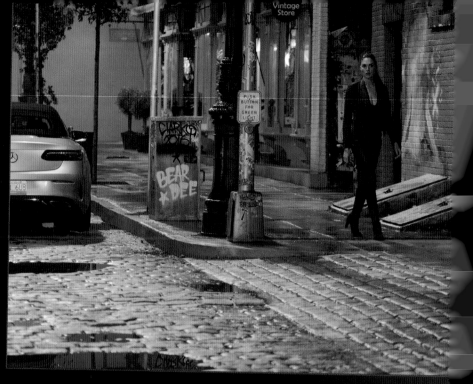

☆ **THIS PAGE:**
Behind-the-scenes shooting the Gotham street set where Victor and Diana meet

☆ **RIGHT:**
Diana meets Victor

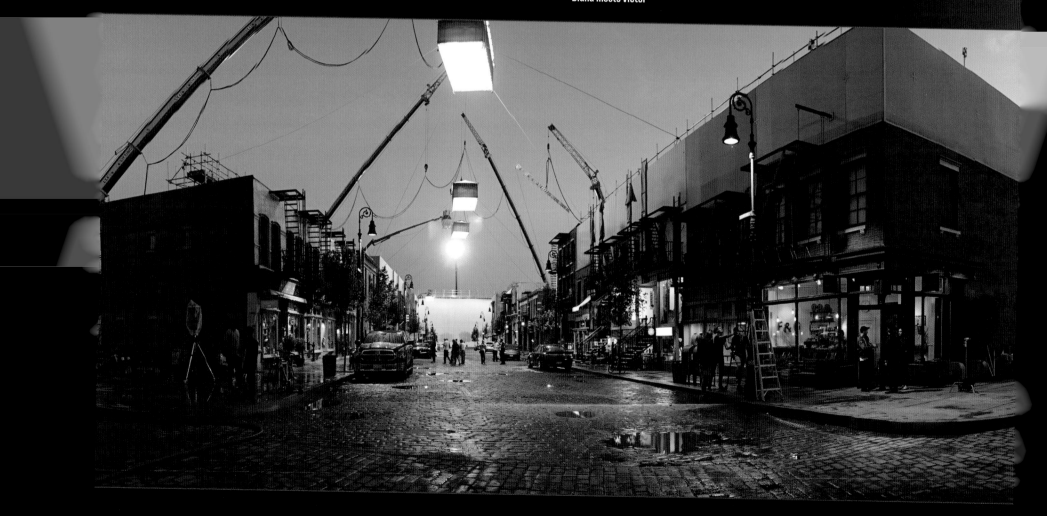

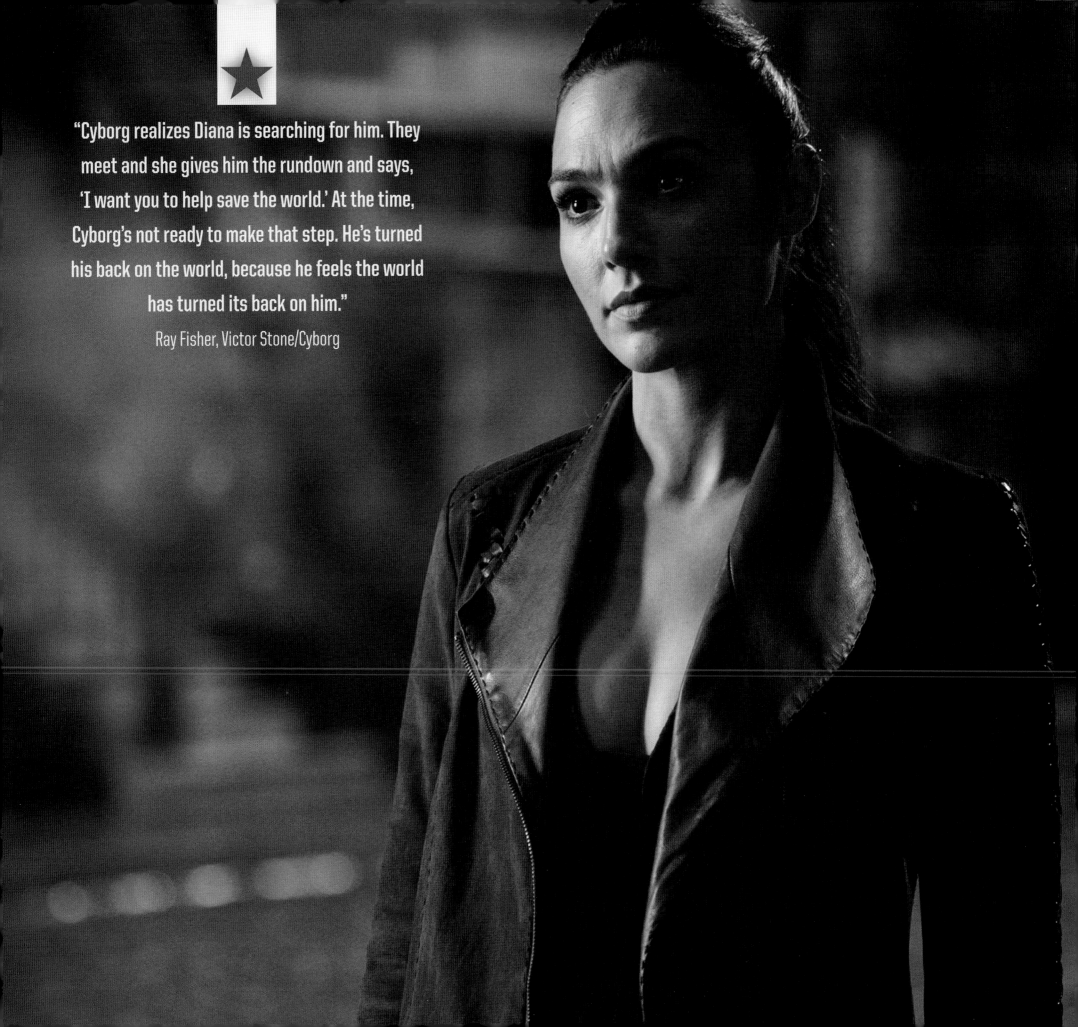

"Cyborg realizes Diana is searching for him. They meet and she gives him the rundown and says, 'I want you to help save the world.' At the time, Cyborg's not ready to make that step. He's turned his back on the world, because he feels the world has turned its back on him."

Ray Fisher, Victor Stone/Cyborg

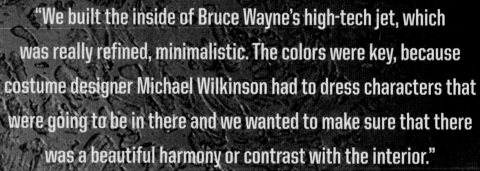

"We built the inside of Bruce Wayne's high-tech jet, which was really refined, minimalistic. The colors were key, because costume designer Michael Wilkinson had to dress characters that were going to be in there and we wanted to make sure that there was a beautiful harmony or contrast with the interior."

Patrick Tatopoulos, Production Designer

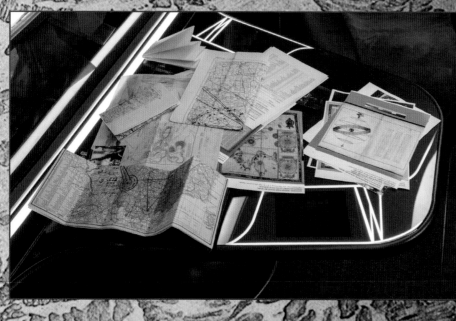

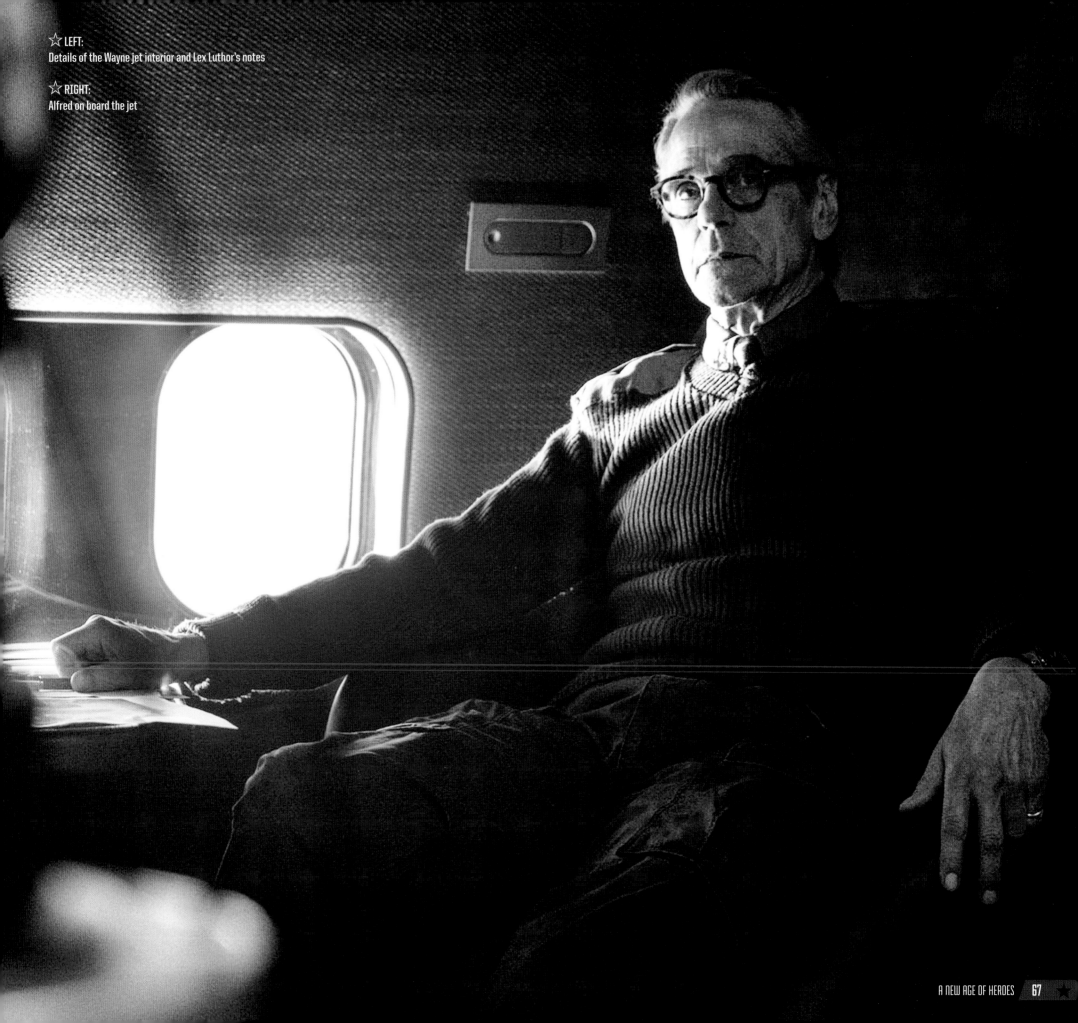

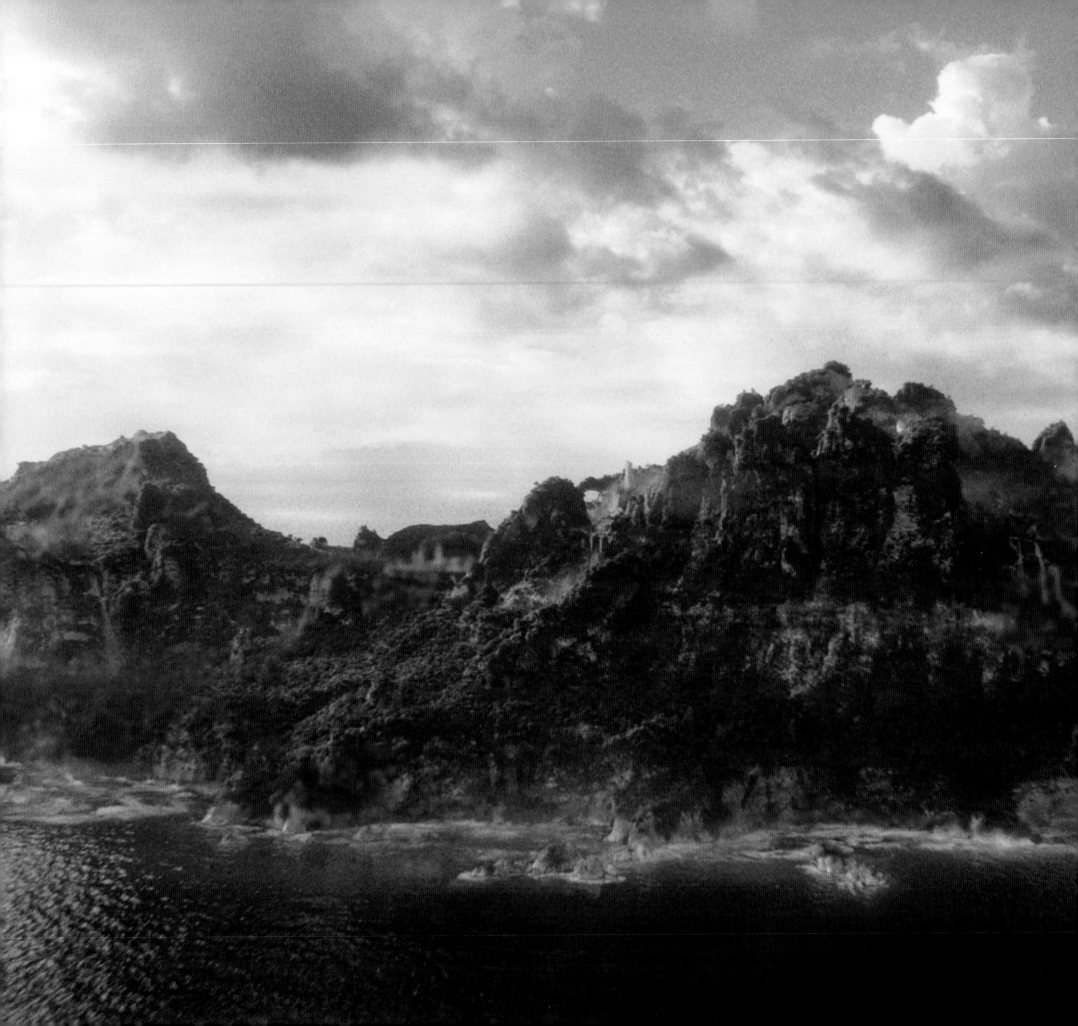

THEMYSCIRA

"The Mother Boxes begin signaling. Maybe it's time to create chaos or for things to change. And Steppenwolf suddenly finds himself on Earth again, after thousands of years. The first things he sees are these Amazonian women, who he's gone to war with before."

Ciarán Hinds, Steppenwolf

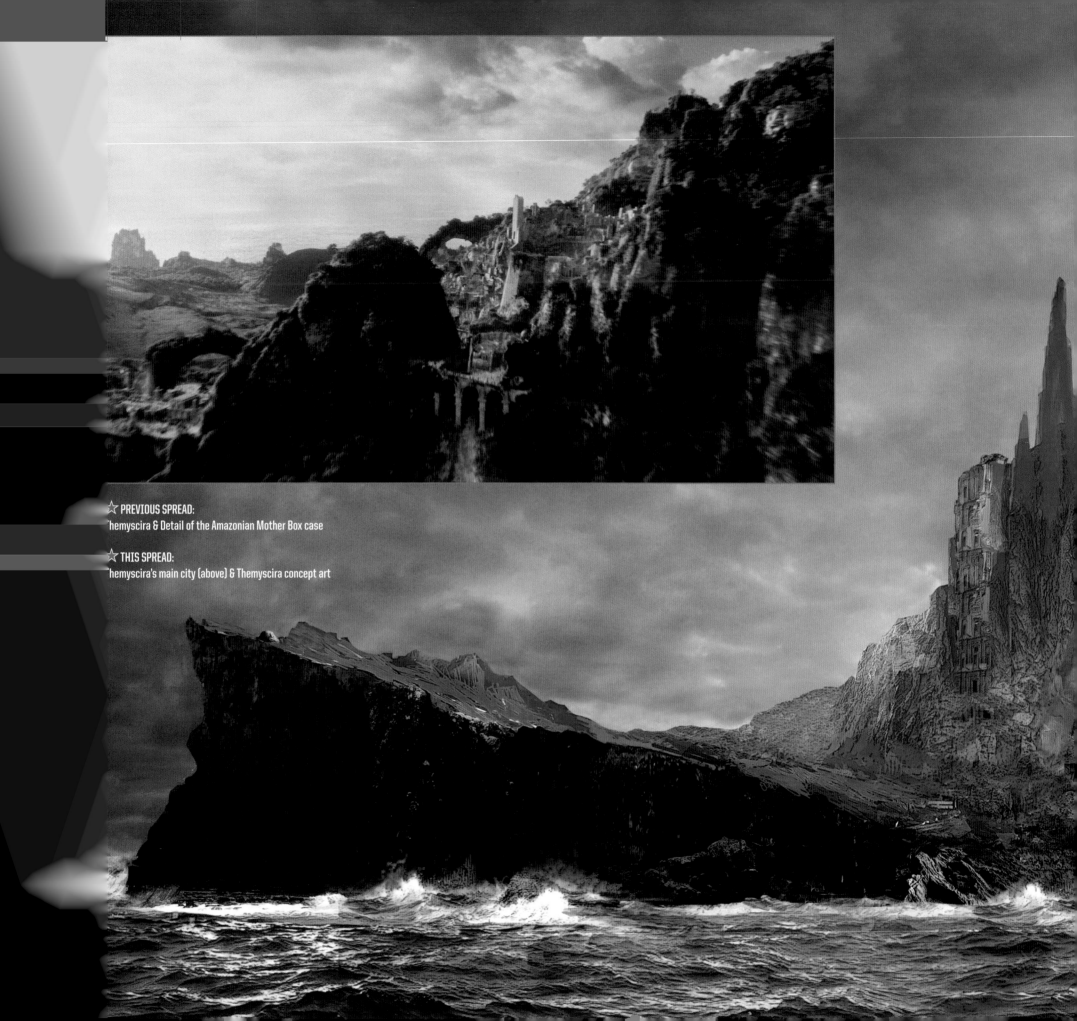

☆ PREVIOUS SPREAD:
Themyscira & Detail of the Amazonian Mother Box case

☆ THIS SPREAD:
Themyscira's main city (above) & Themyscira concept art

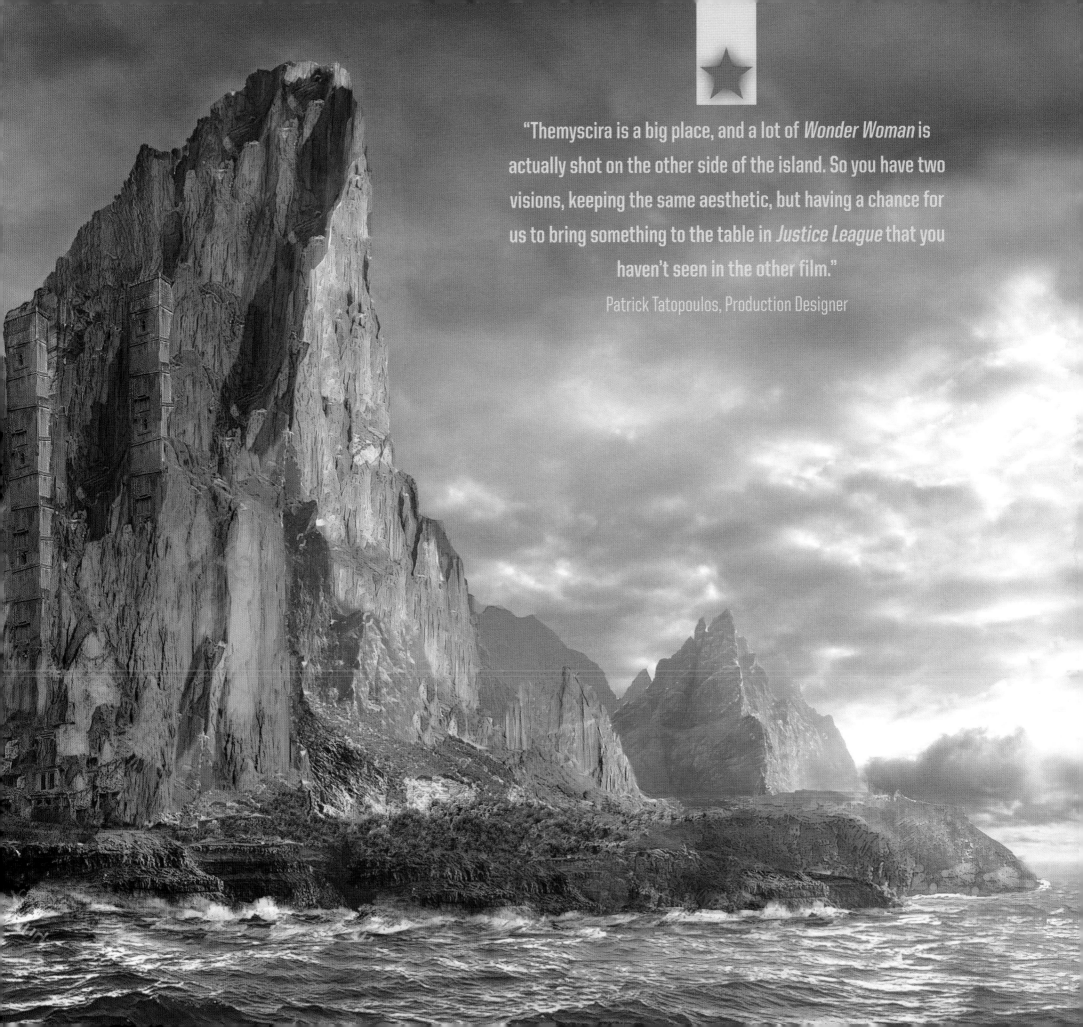

"Themyscira is a big place, and a lot of *Wonder Woman* is actually shot on the other side of the island. So you have two visions, keeping the same aesthetic, but having a chance for us to bring something to the table in *Justice League* that you haven't seen in the other film."

Patrick Tatopoulos, Production Designer

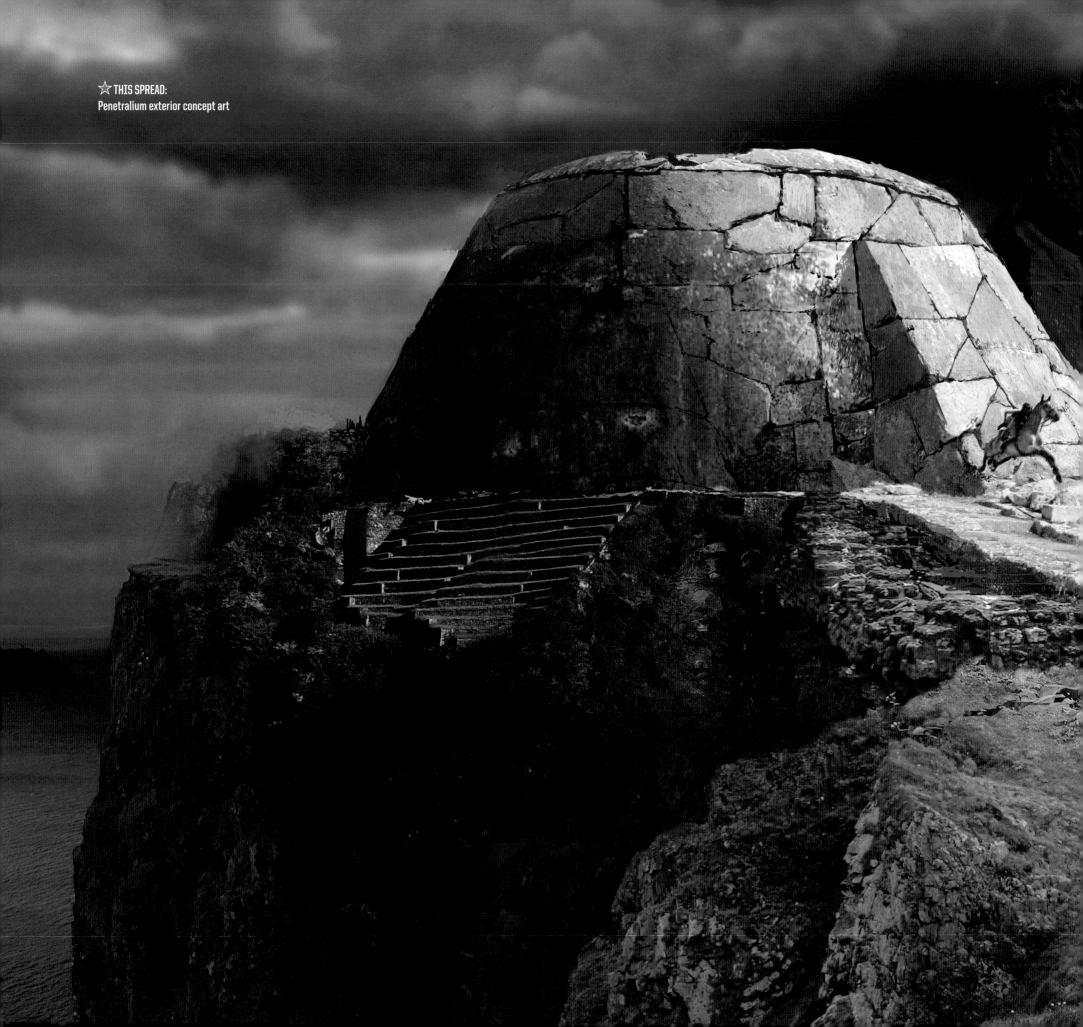

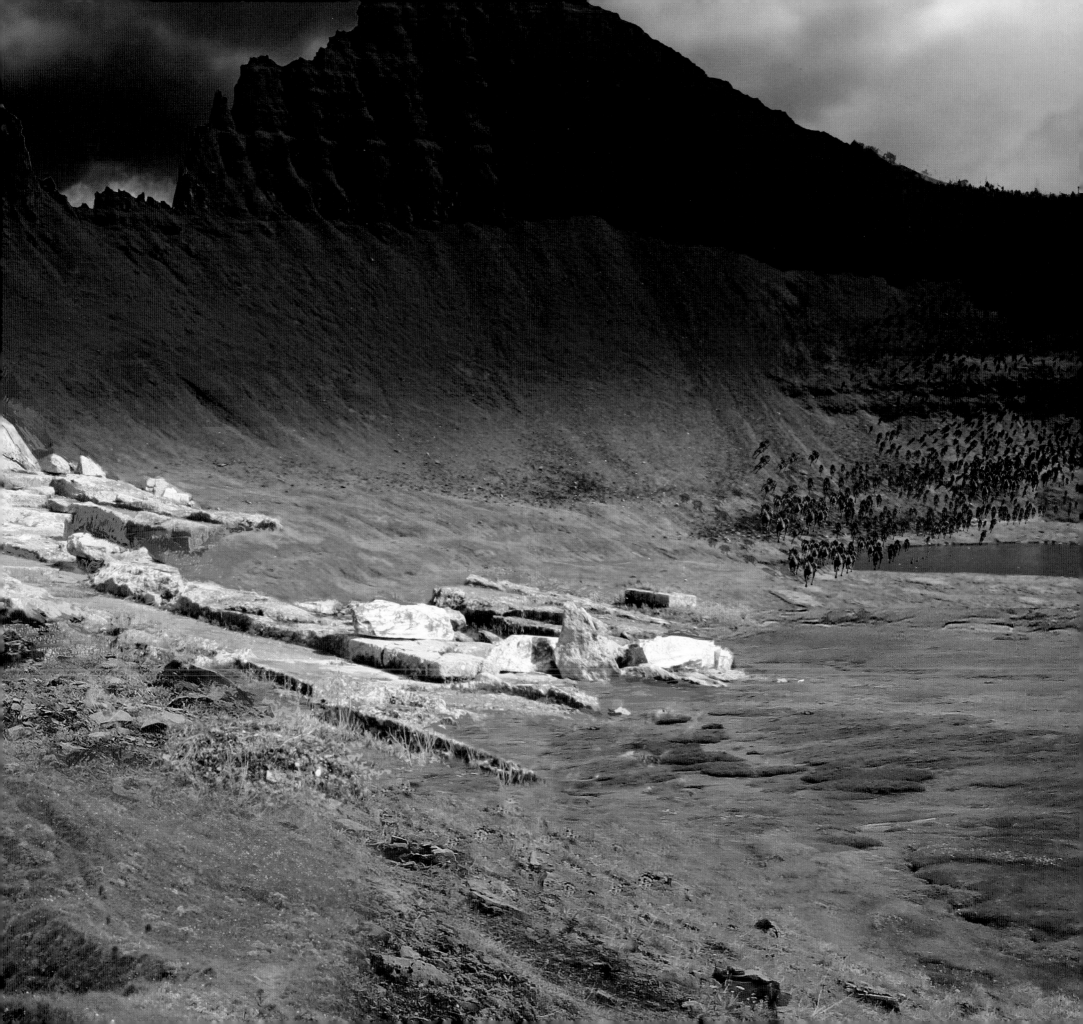

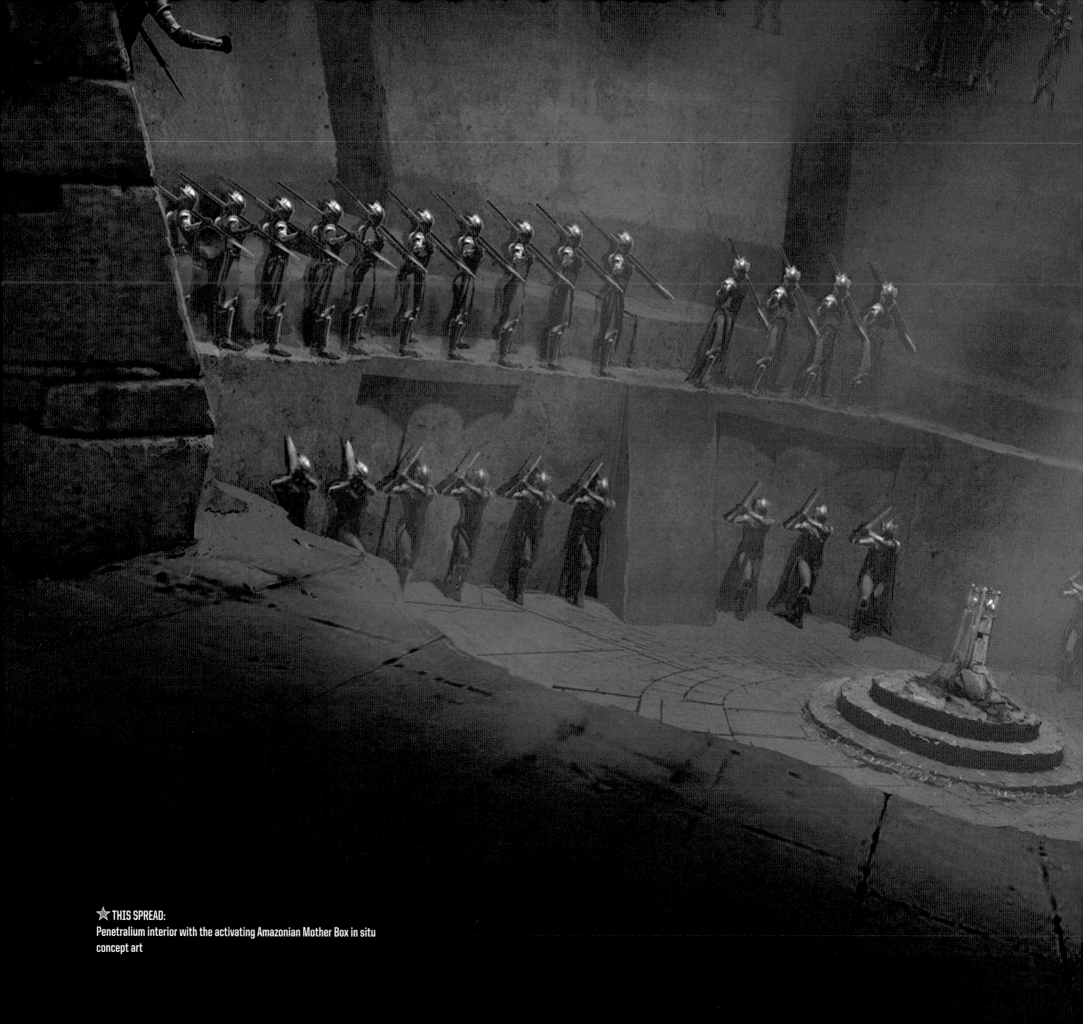

Penetralium interior with the activating Amazonian Mother Box in situ
concept art

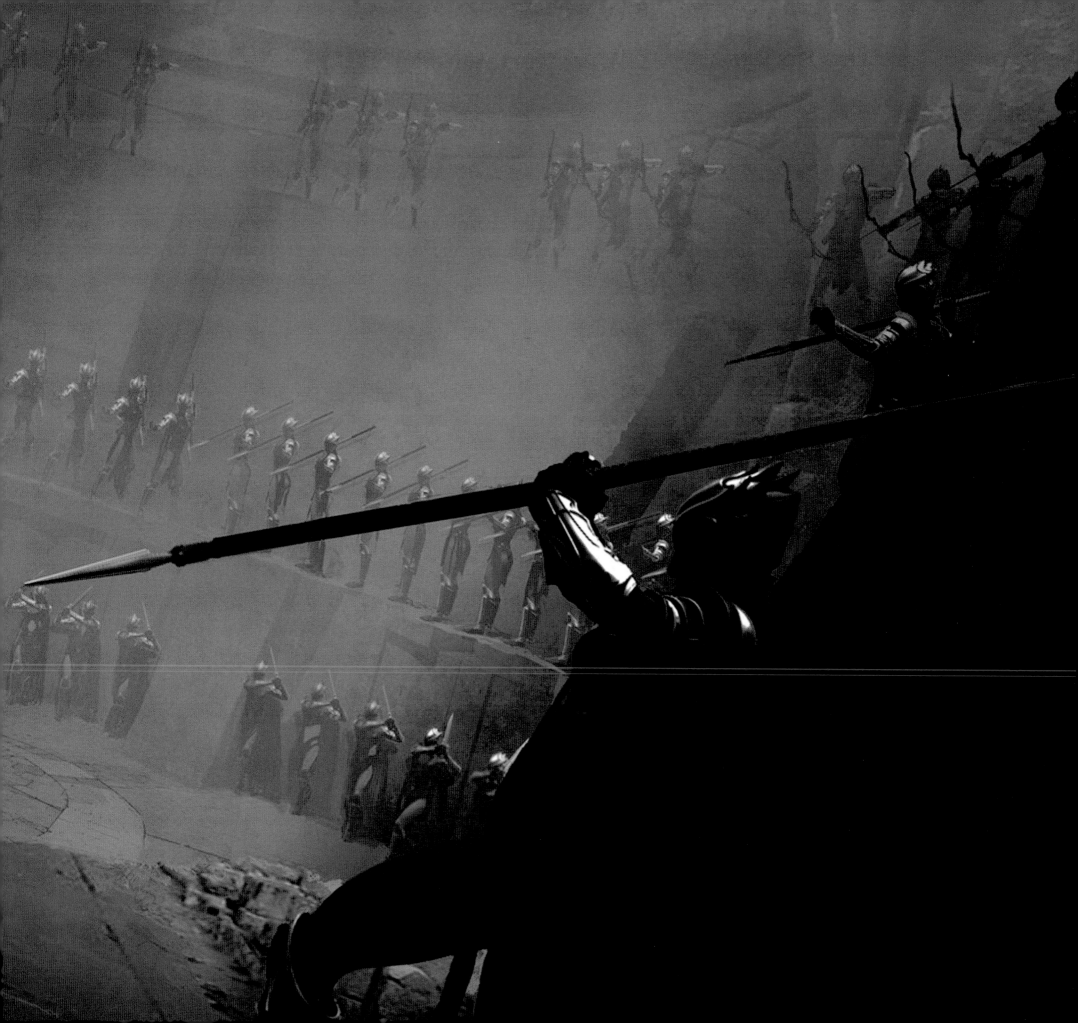

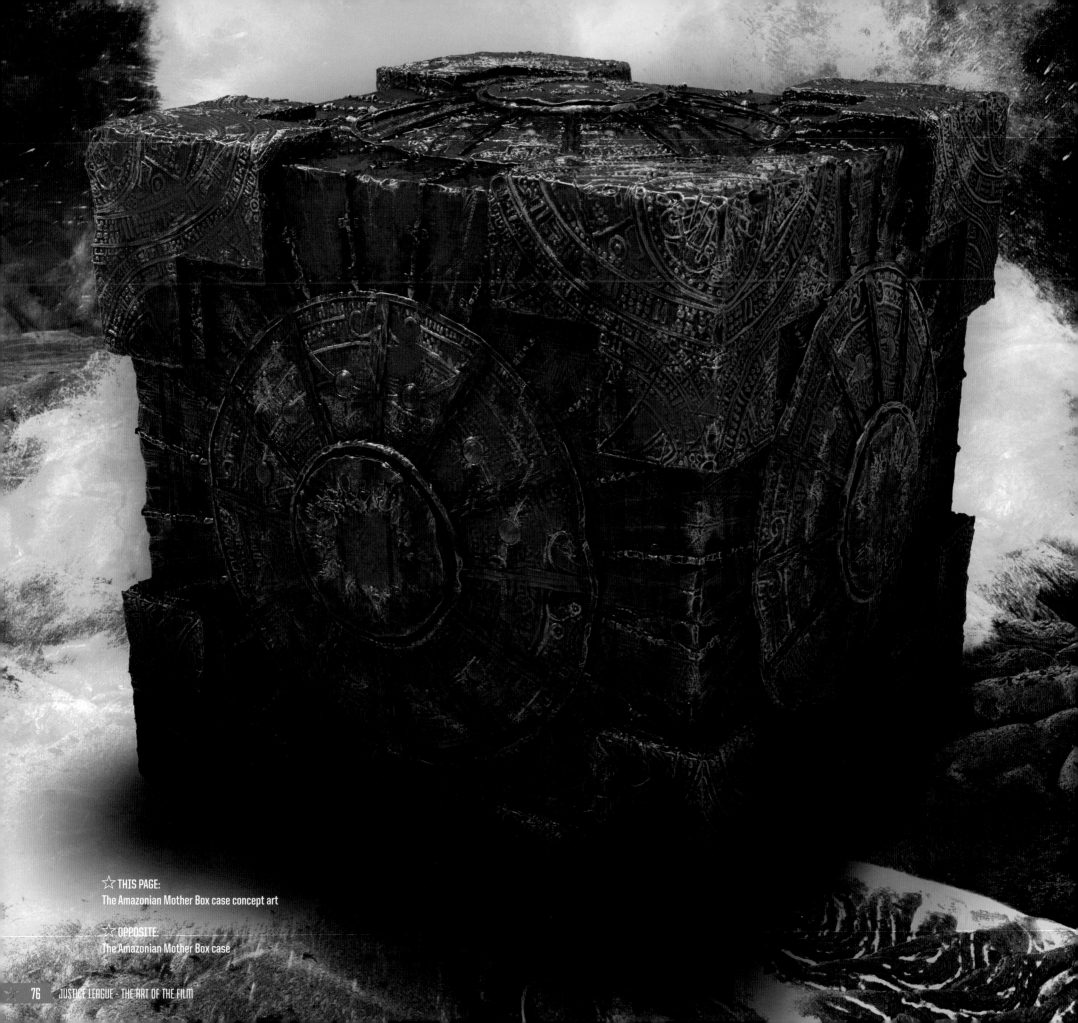

☆ THIS PAGE:
The Amazonian Mother Box case concept art

☆ OPPOSITE:
The Amazonian Mother Box case

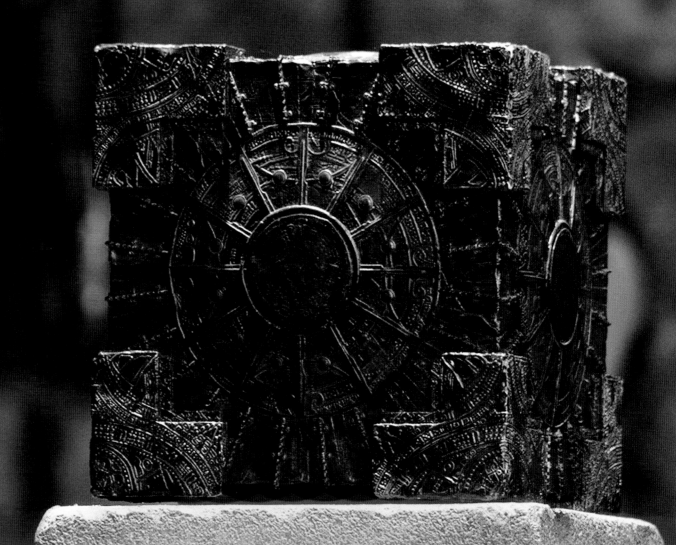

"Each Mother Box is housed in a protective shield, created by the group entrusted to guard it: the human, the Atlantean, and the Amazonian one. I designed each box, then we created them in 3D, down to every tiny detail. Even the design imperfections were recreated."

Patrick Tatopoulos, Production Designer

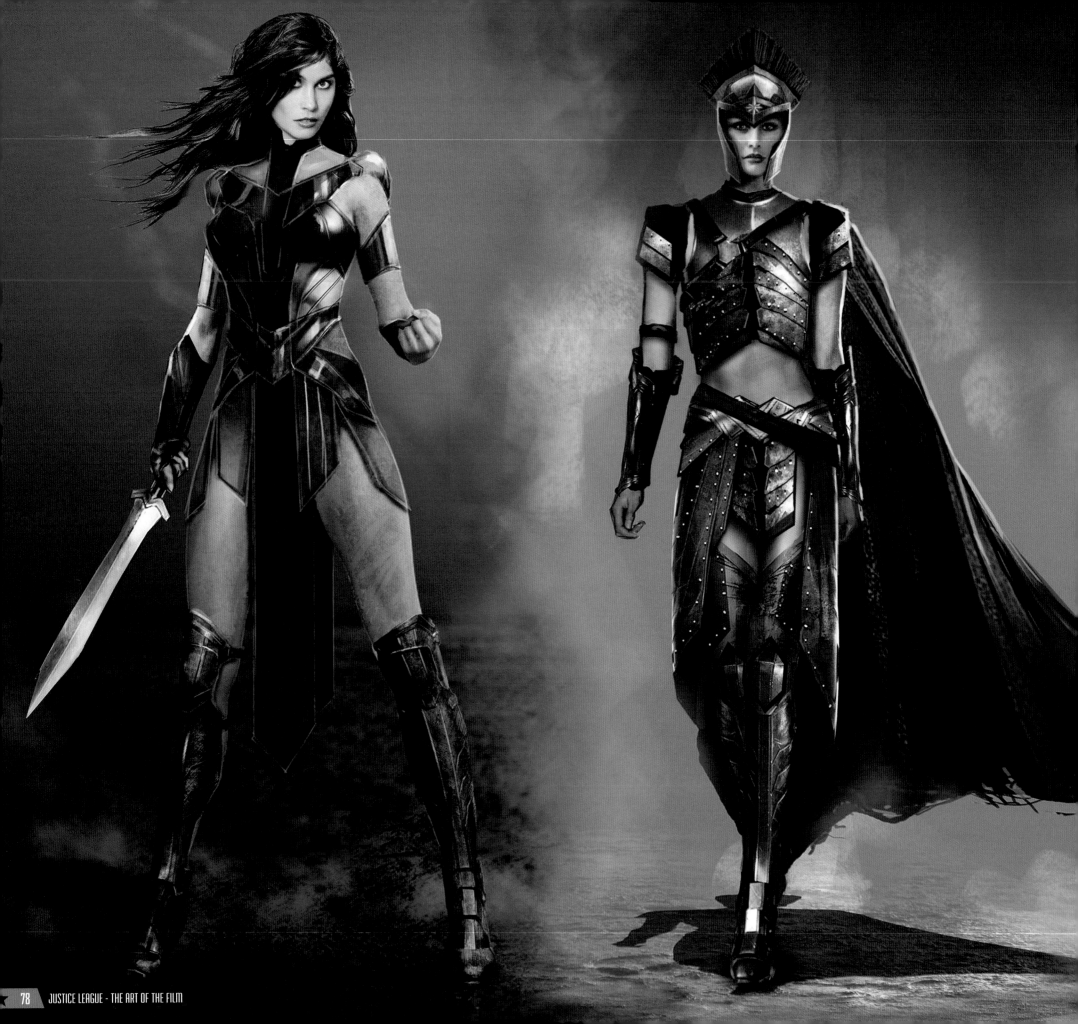

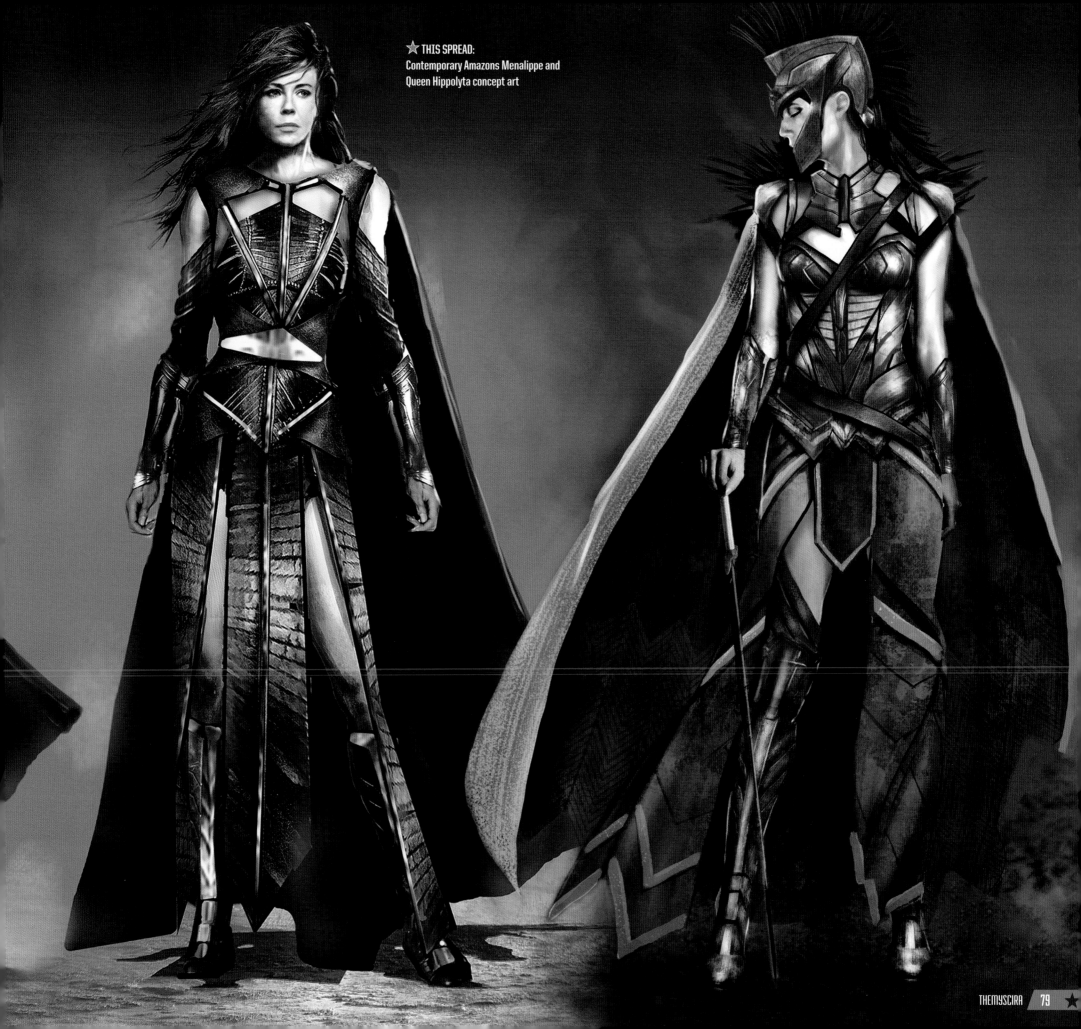

★ **THIS SPREAD:**
Contemporary Amazons Menalippe and
Queen Hippolyta concept art

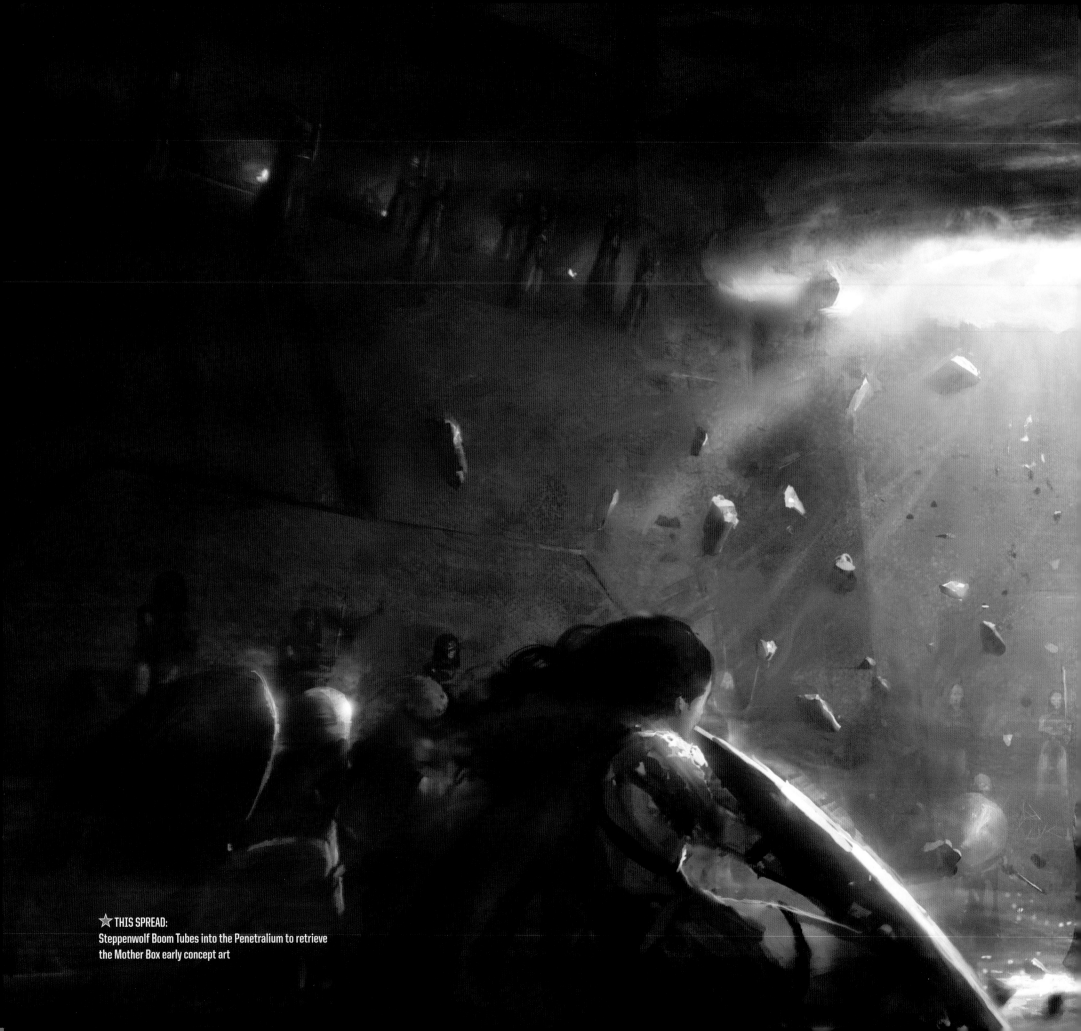

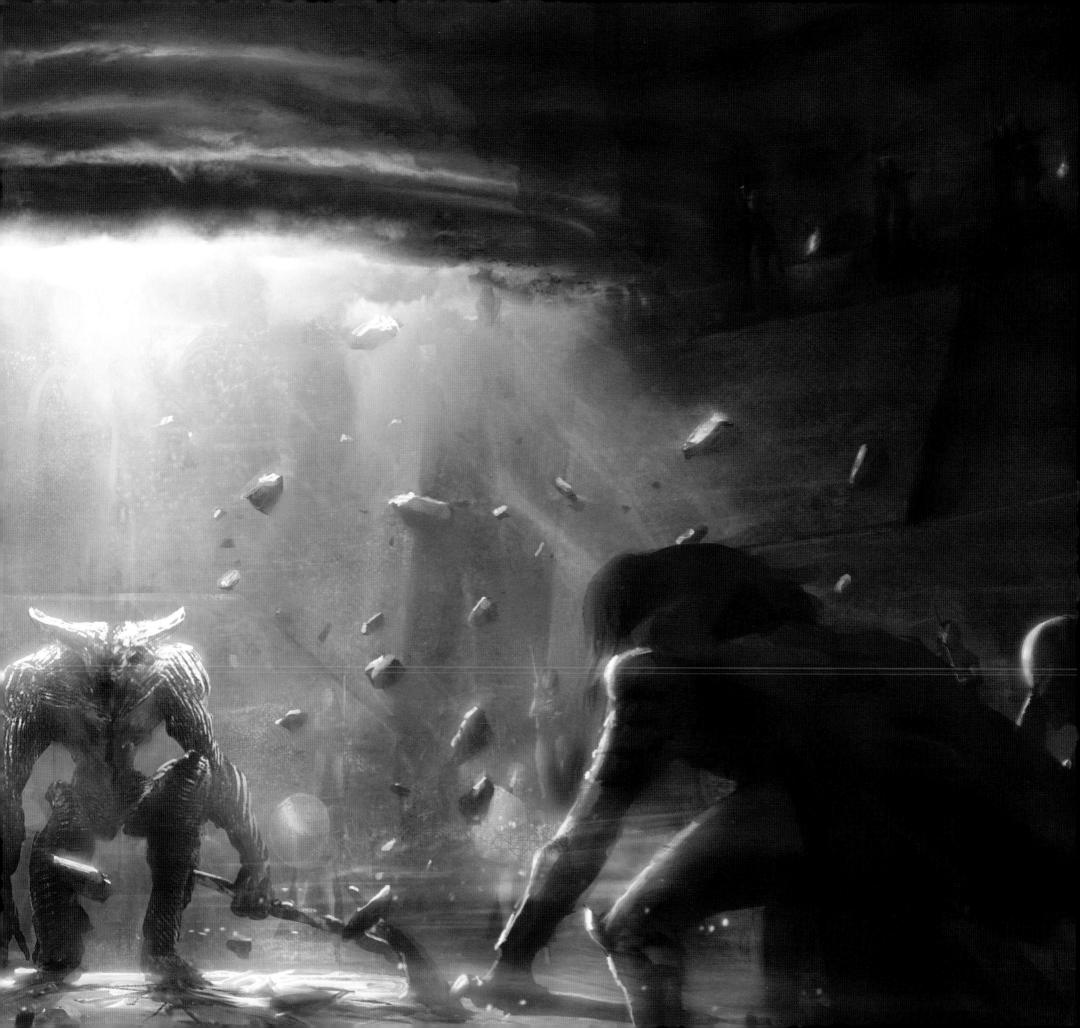

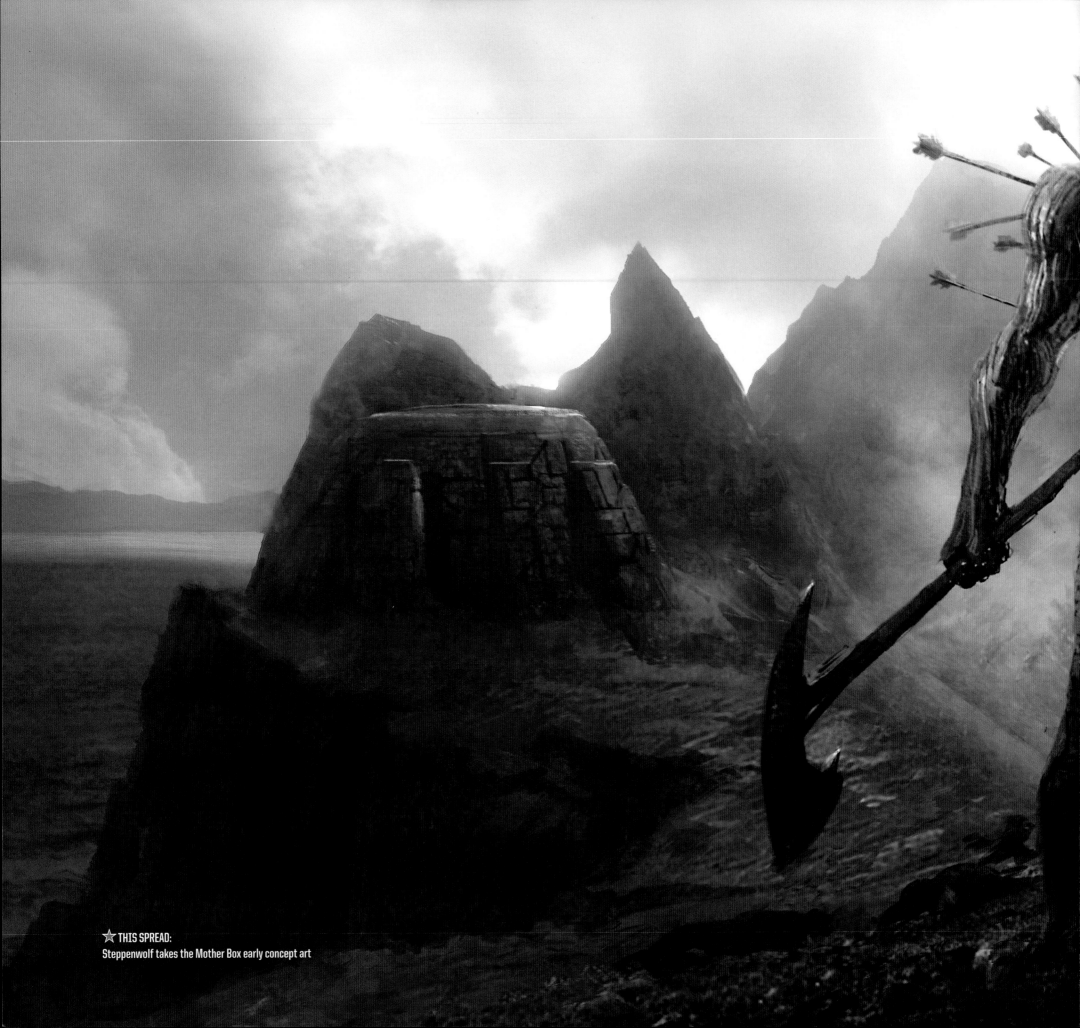

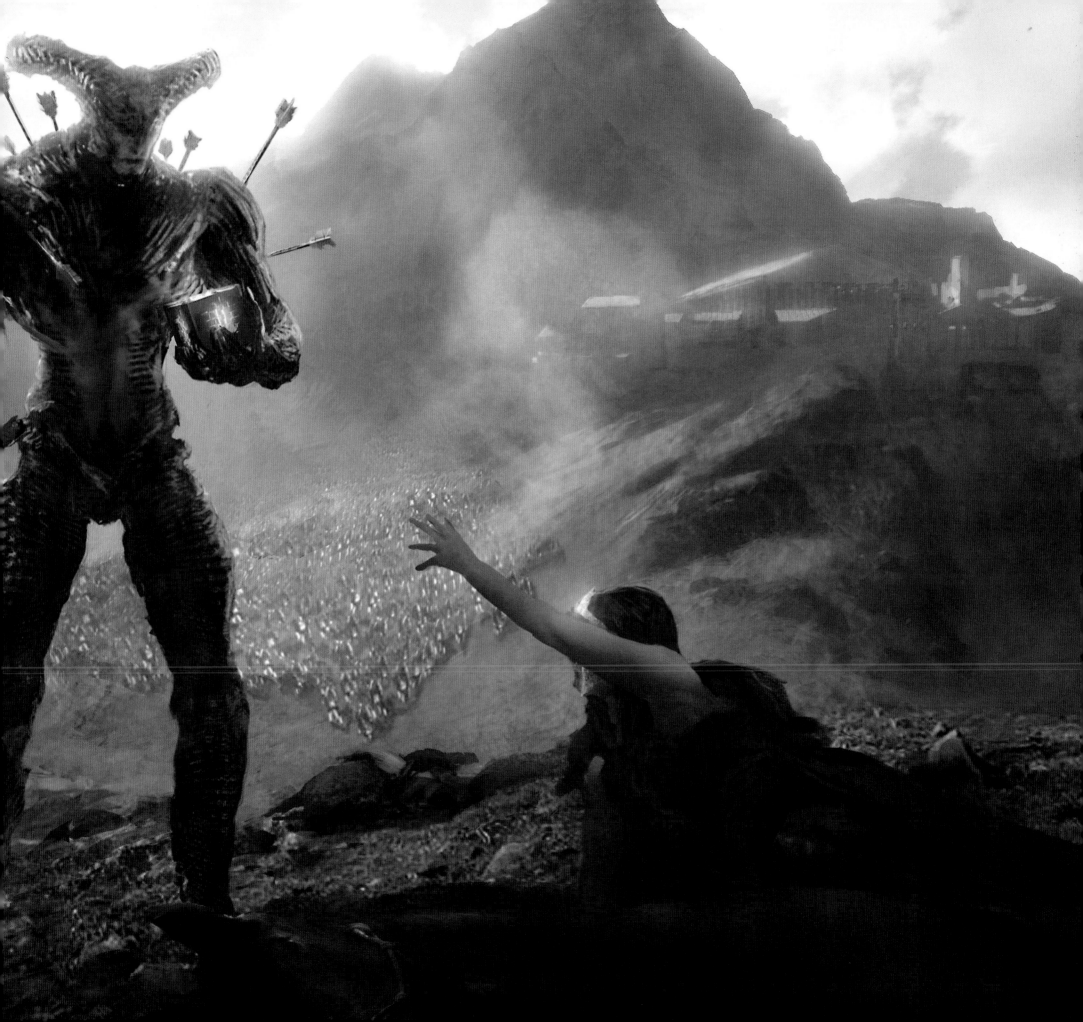

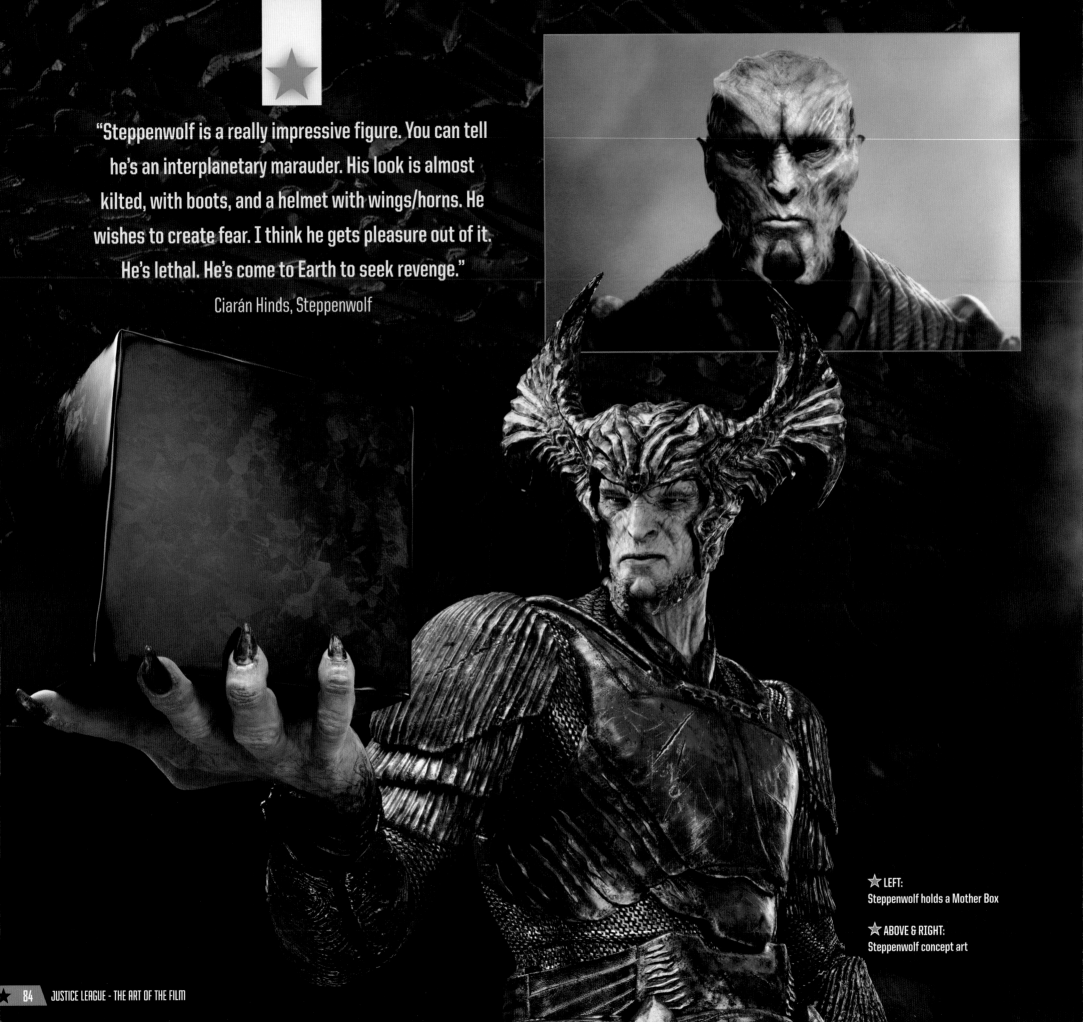

"Steppenwolf is a really impressive figure. You can tell he's an interplanetary marauder. His look is almost kilted, with boots, and a helmet with wings/horns. He wishes to create fear. I think he gets pleasure out of it. He's lethal. He's come to Earth to seek revenge."

Ciarán Hinds, Steppenwolf

⭐ LEFT:
Steppenwolf holds a Mother Box

⭐ ABOVE & RIGHT:
Steppenwolf concept art

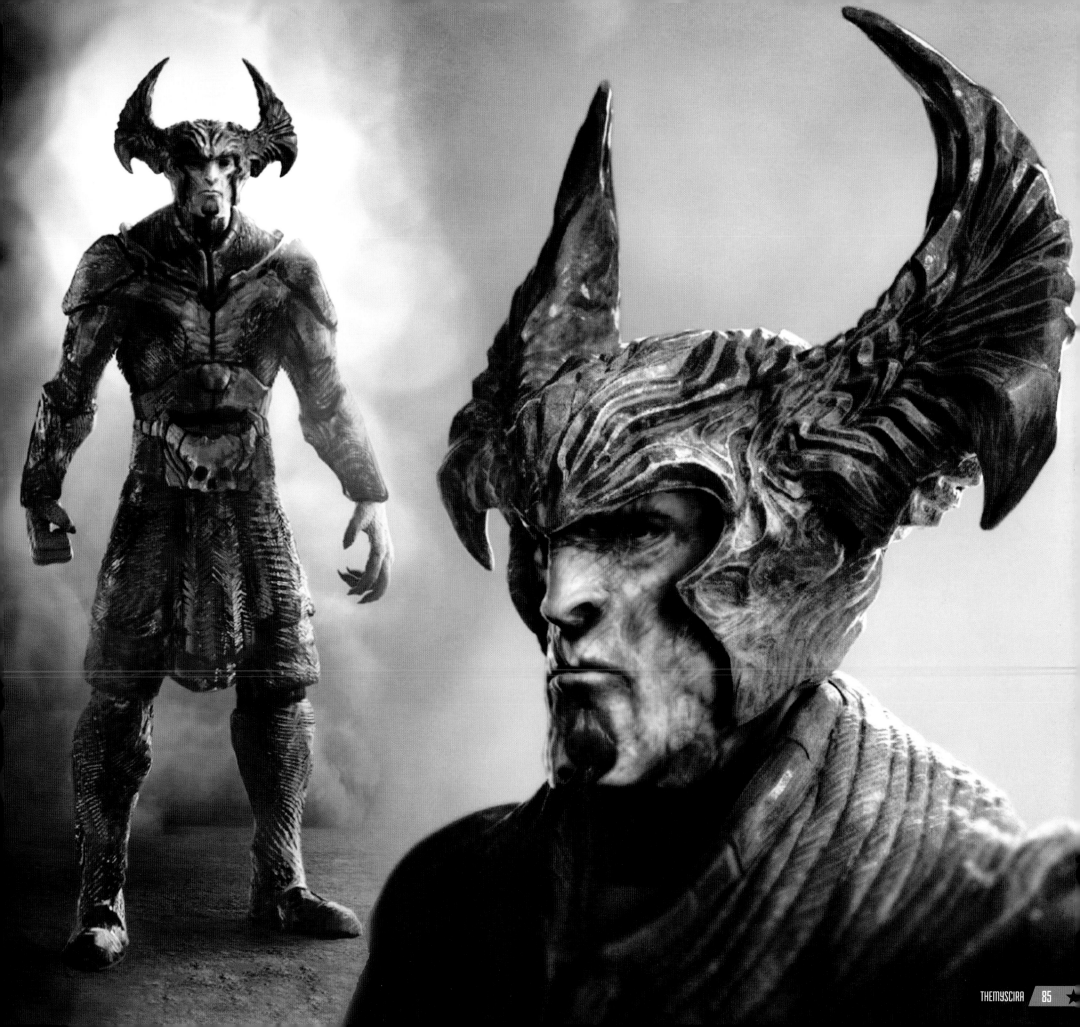

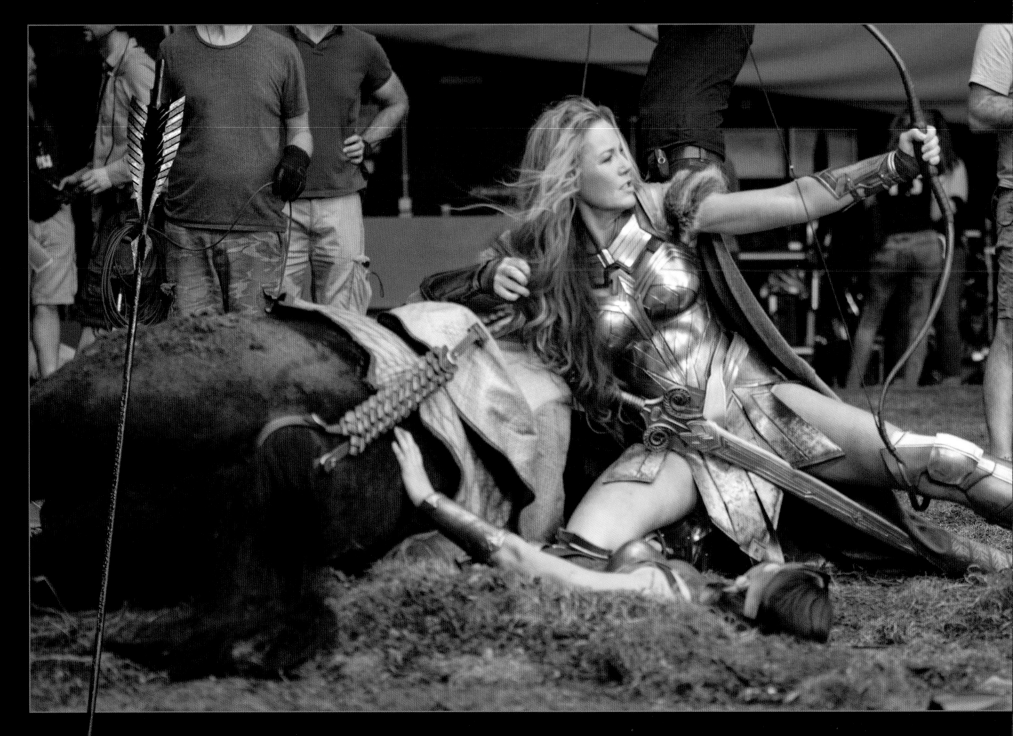

⭐ ABOVE:
Behind-the-scenes rehearsing Queen Hippolyta shooting an arrow at Steppenwolf

⭐ LEFT & ABOVE RIGHT:
The signal arrow lands at the Temple of the Amazon on the Isle of Crete

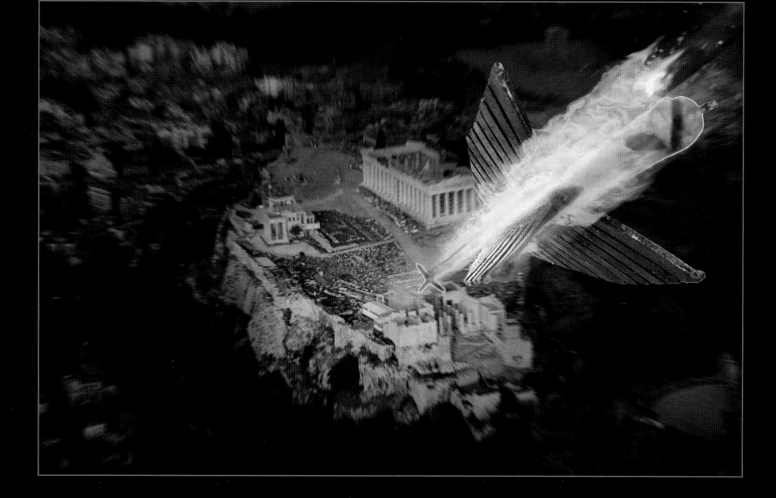

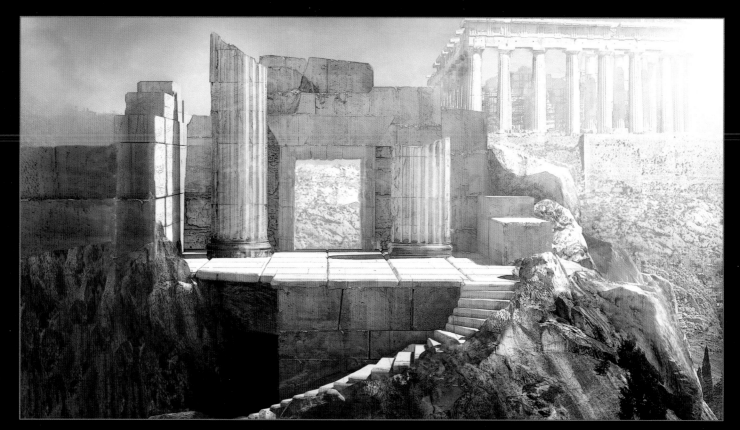

☆ **RIGHT:**
The Temple of the Amazon early
concept art

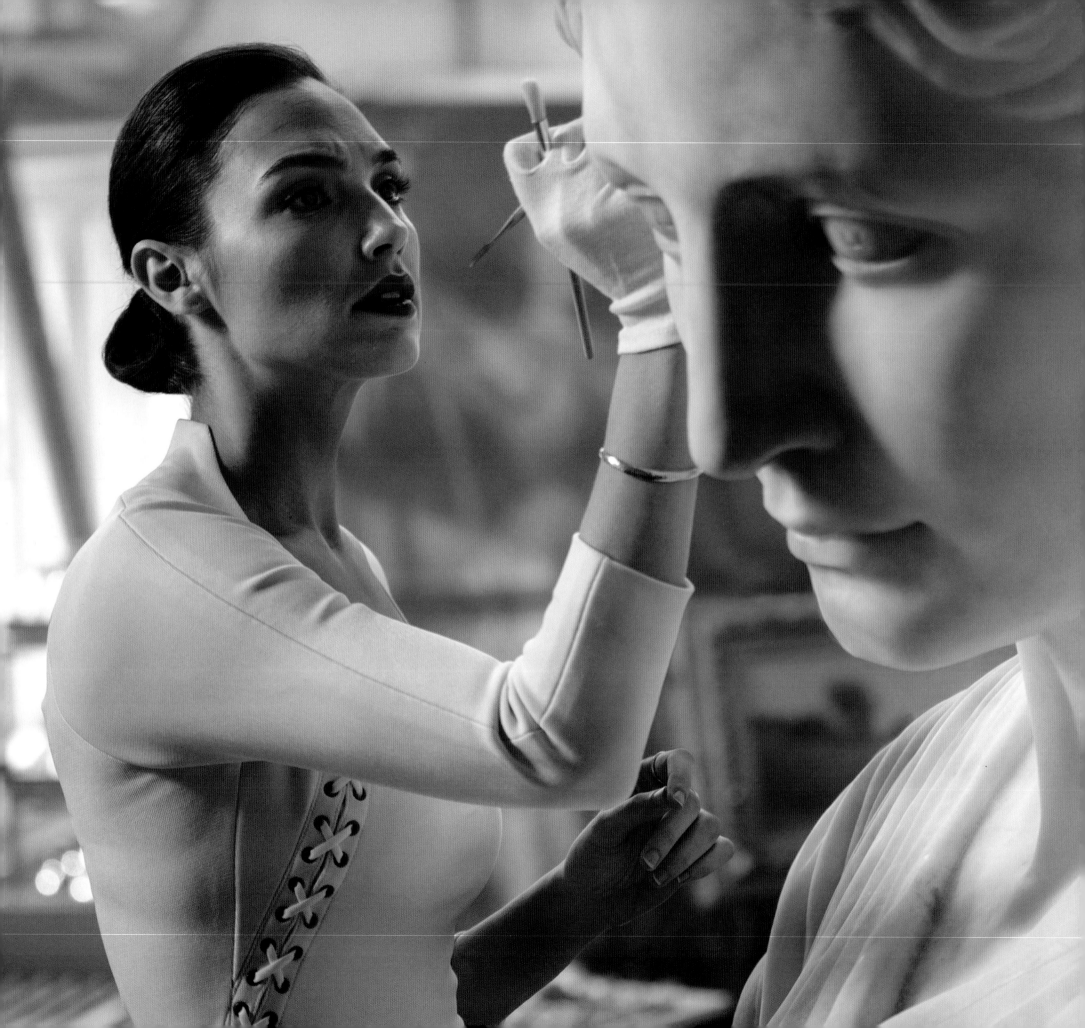

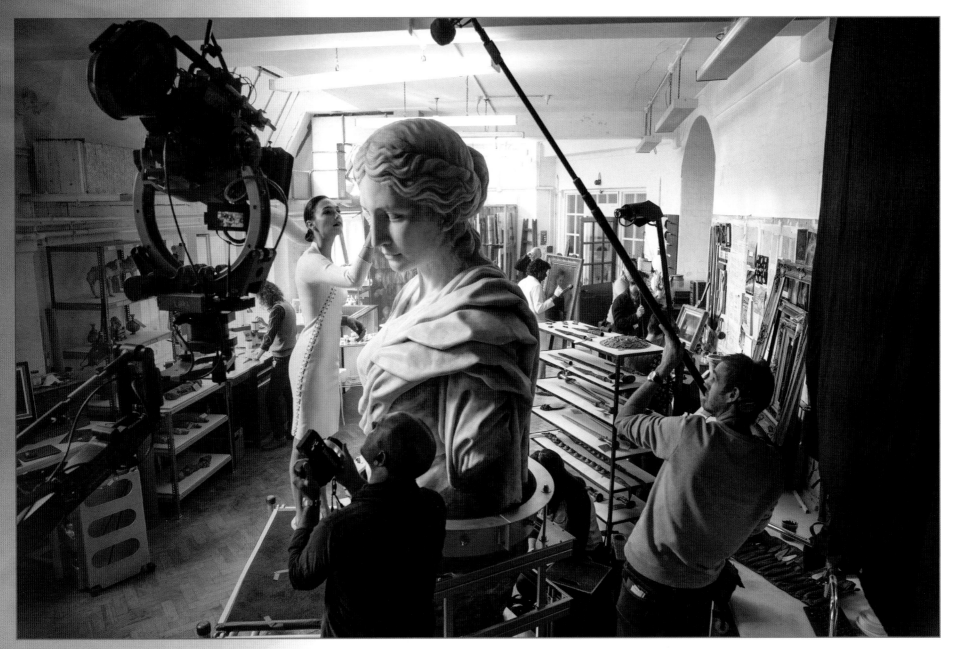

⭐ LEFT & ABOVE:
Diana working in the Louvre conservation department & Behind-the-scenes shooting

⭐ BELOW:
Details of the Louvre conservation department interior

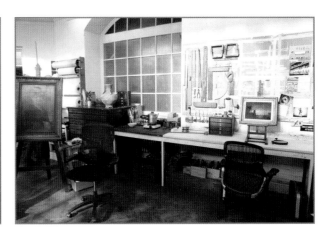

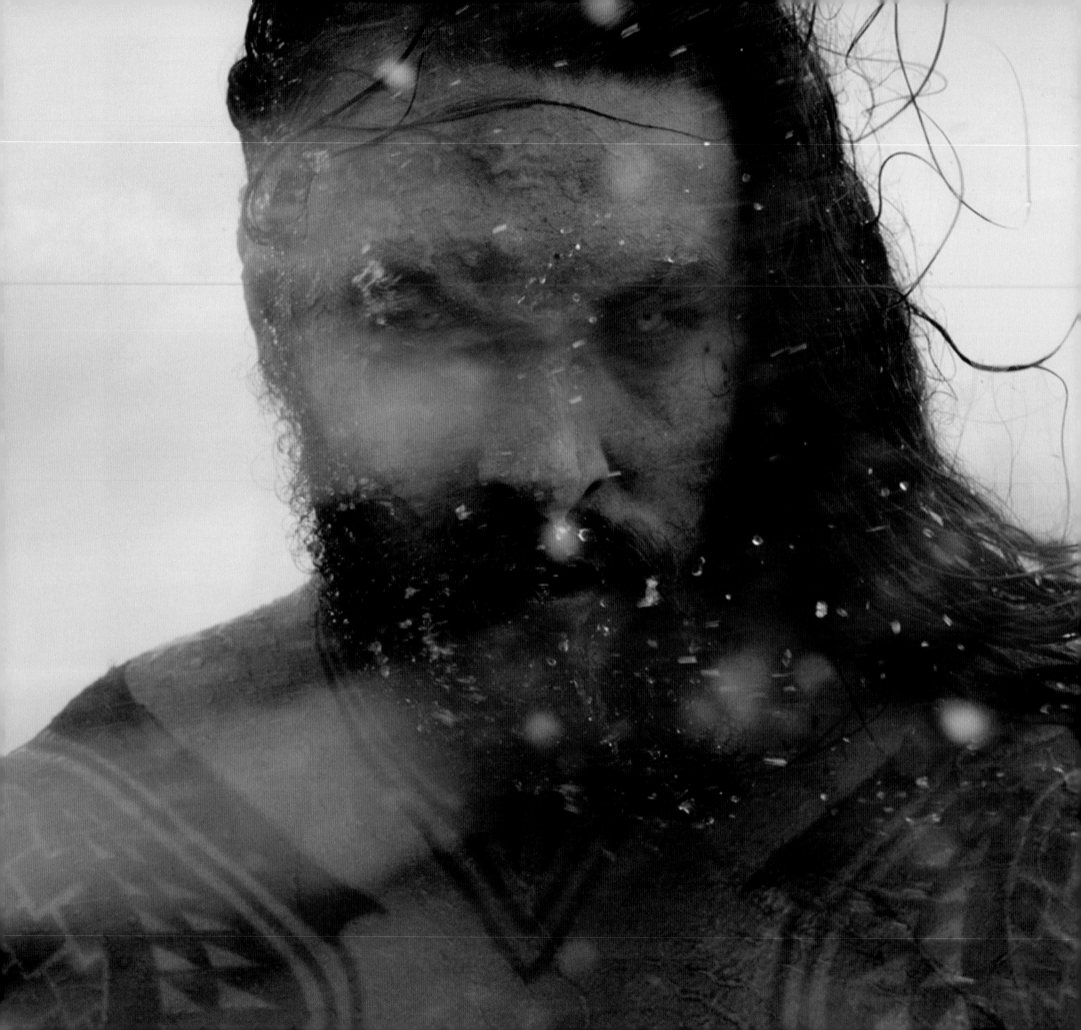

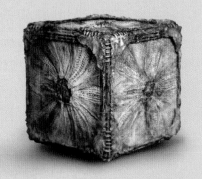

ATLANTEAN STRONGHOLD

"We were really excited to dive into (pardon the pun) the Atlantean world. It's a fantastic culture. We read all of the comics and really did our research, then came up with our own graphic language and motifs, which we applied to the costumes and the overall production design."

Michael Wilkinson, Costume Designer

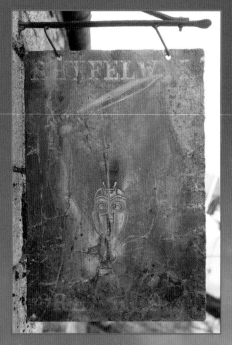
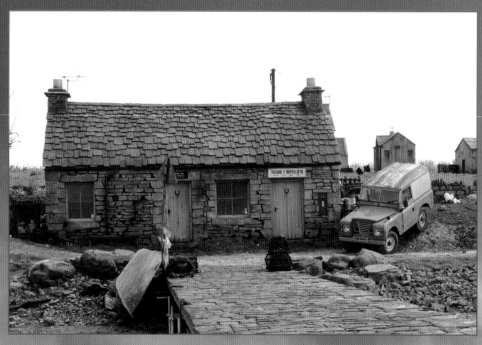
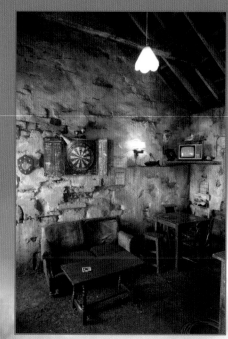

☆ PREVIOUS SPREAD:
Arthur on the Welsh fishing village pier & The Atlantean Mother Box case concept art

☆ ABOVE:
Welsh fishing village Tavern sign, exterior, and interior

☆ BELOW:
Welsh fishing village exterior concept art

☆ RIGHT:
Arthur saves the Welsh fisherman

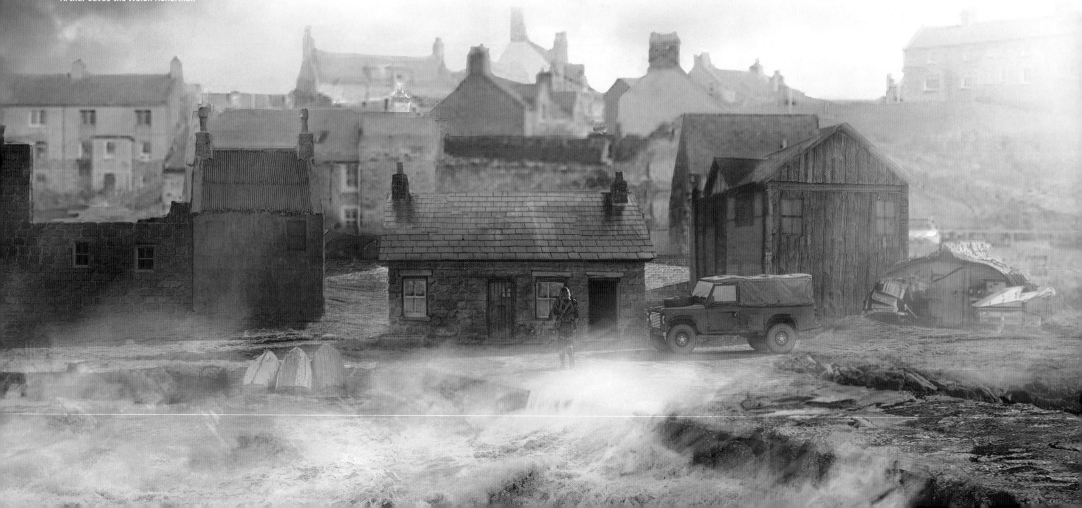

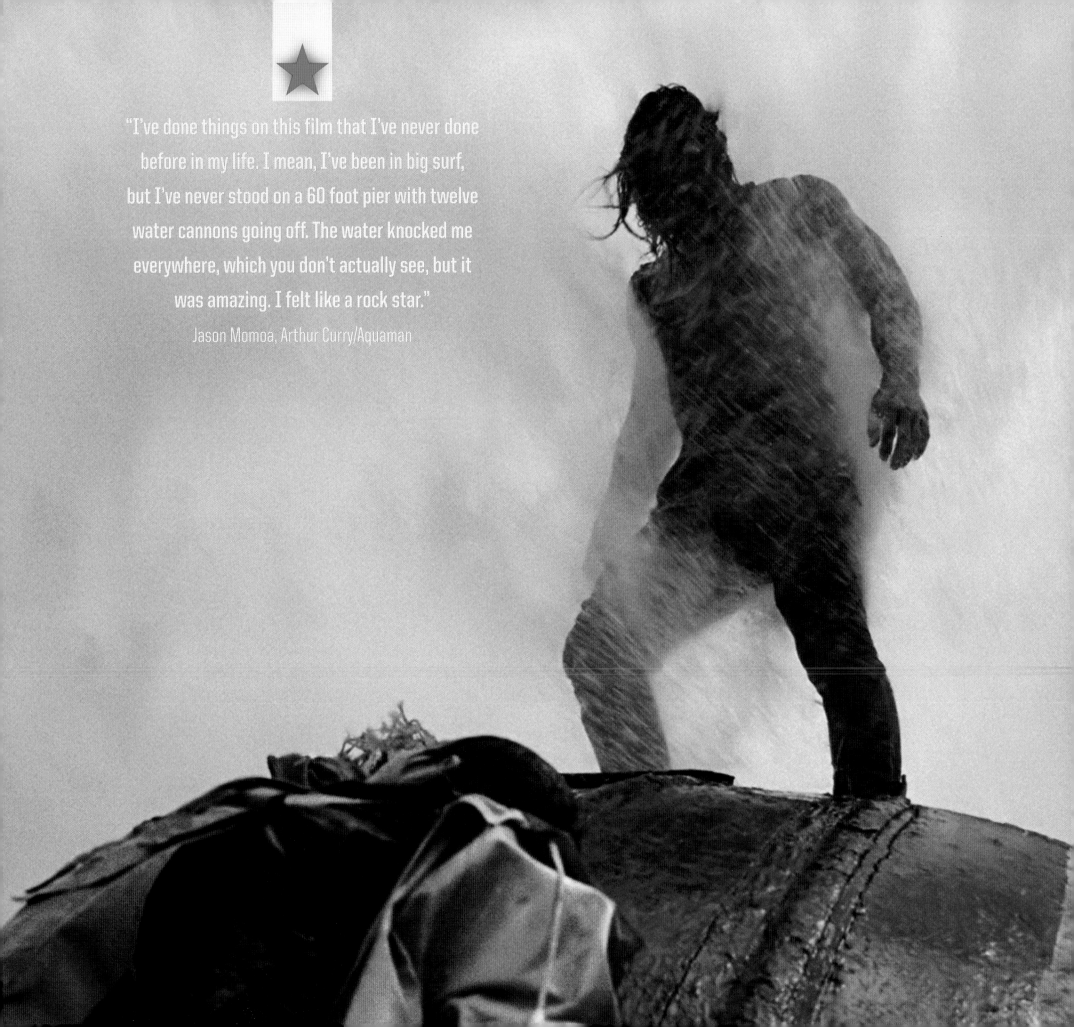

"I've done things on this film that I've never done before in my life. I mean, I've been in big surf, but I've never stood on a 60 foot pier with twelve water cannons going off. The water knocked me everywhere, which you don't actually see, but it was amazing. I felt like a rock star."

Jason Momoa, Arthur Curry/Aquaman

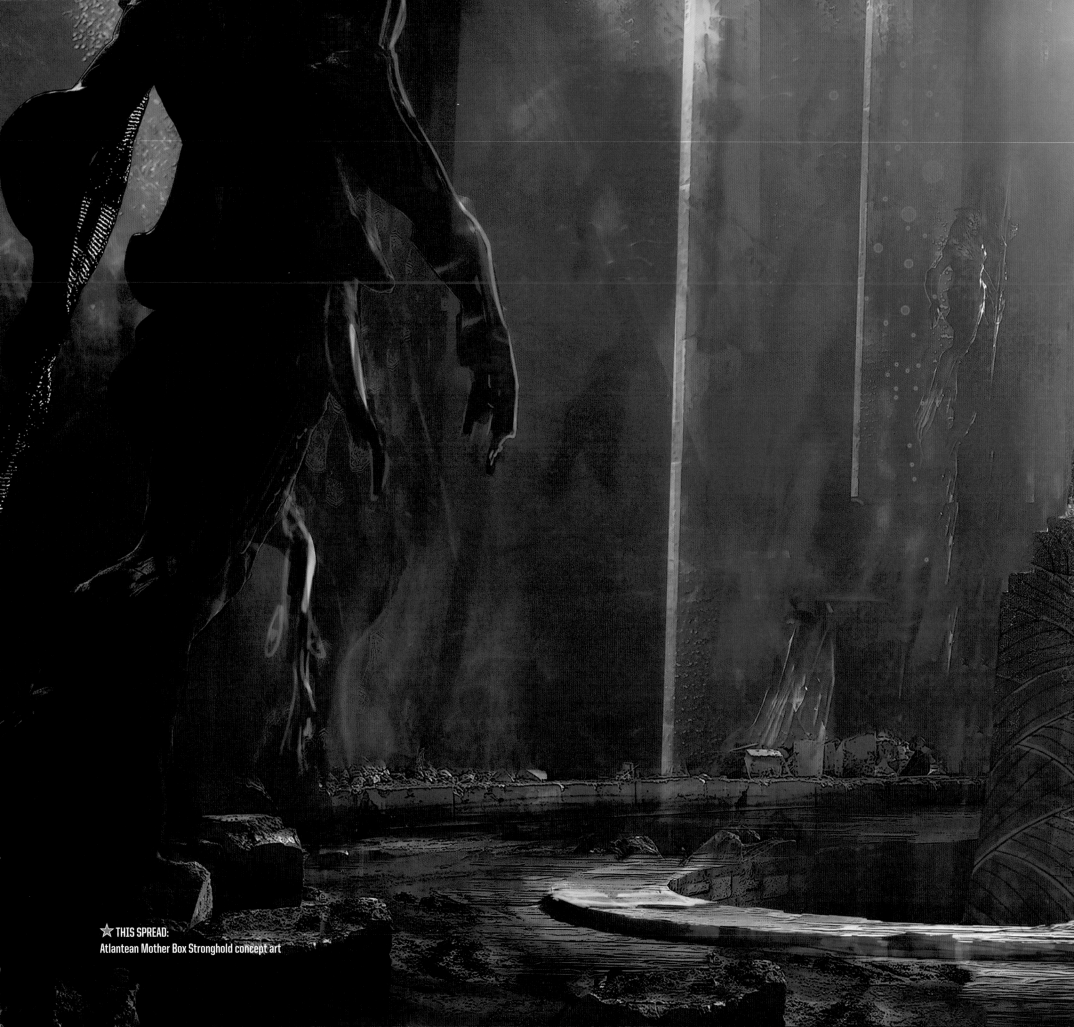

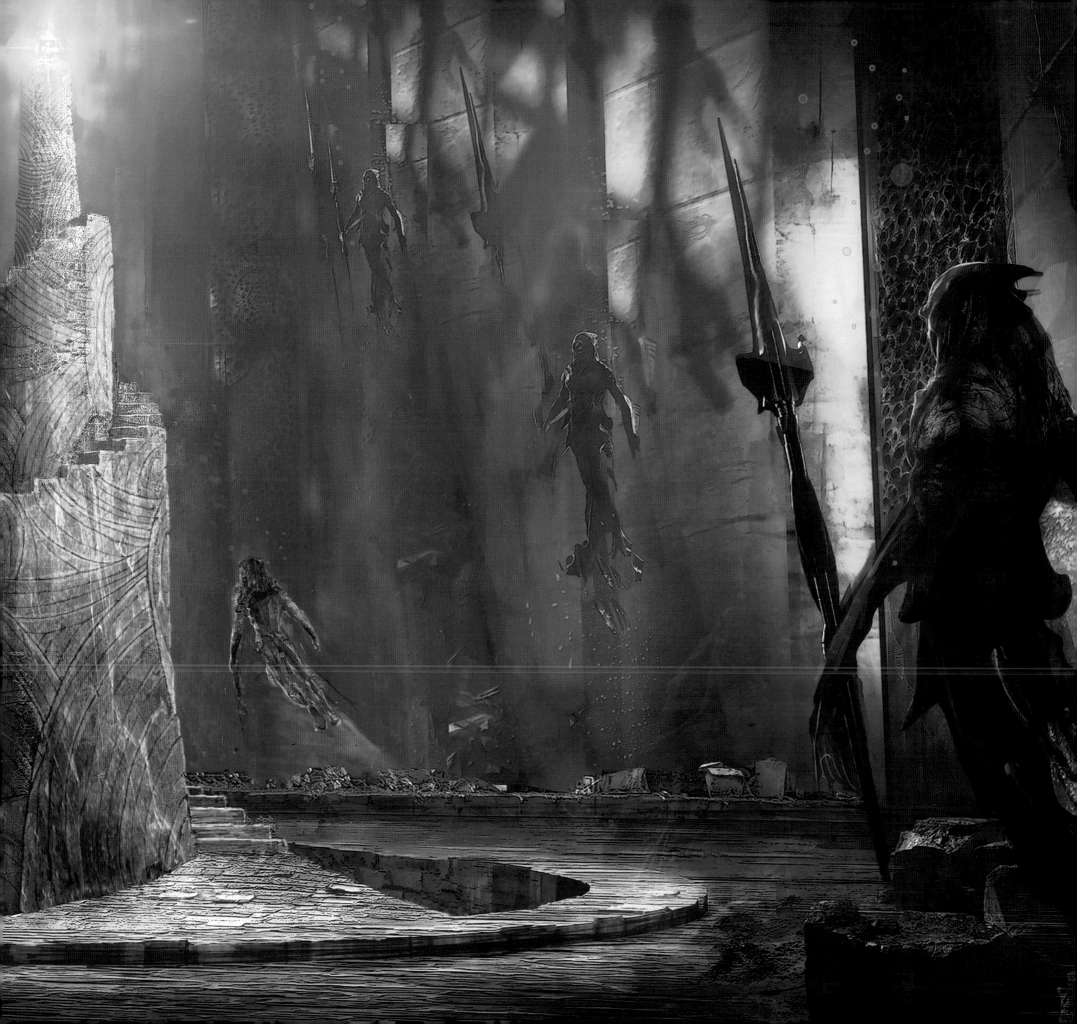

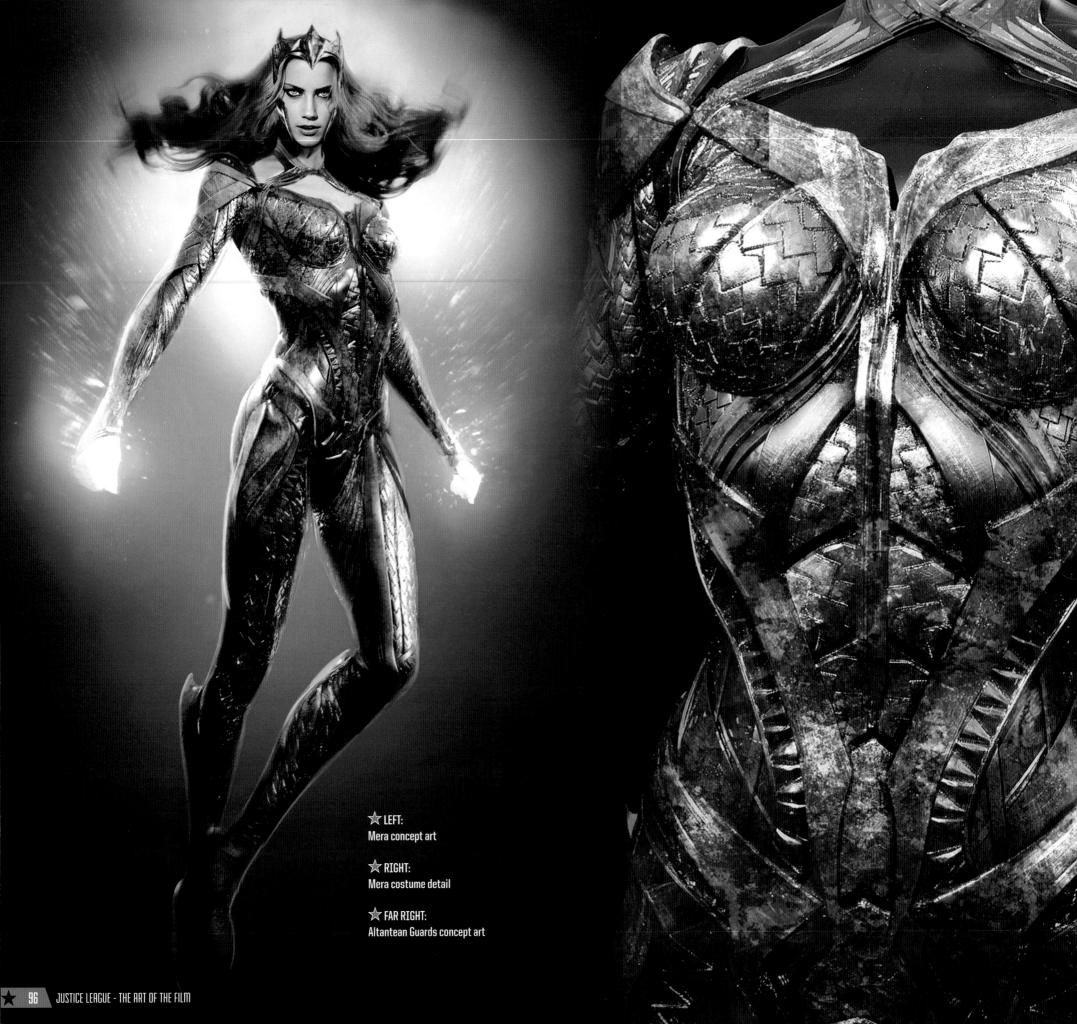

☆ LEFT:
Mera concept art

☆ RIGHT:
Mera costume detail

☆ FAR RIGHT:
Altantean Guards concept art

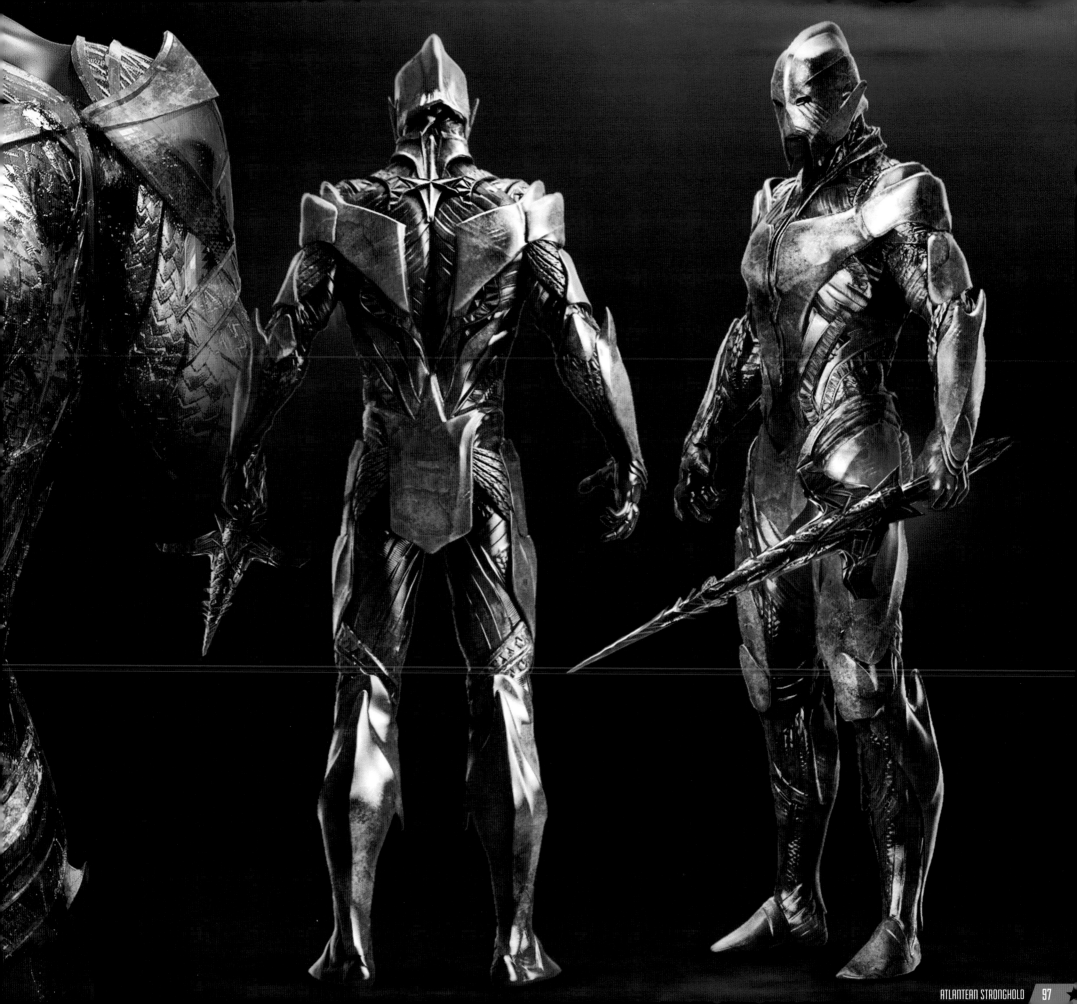

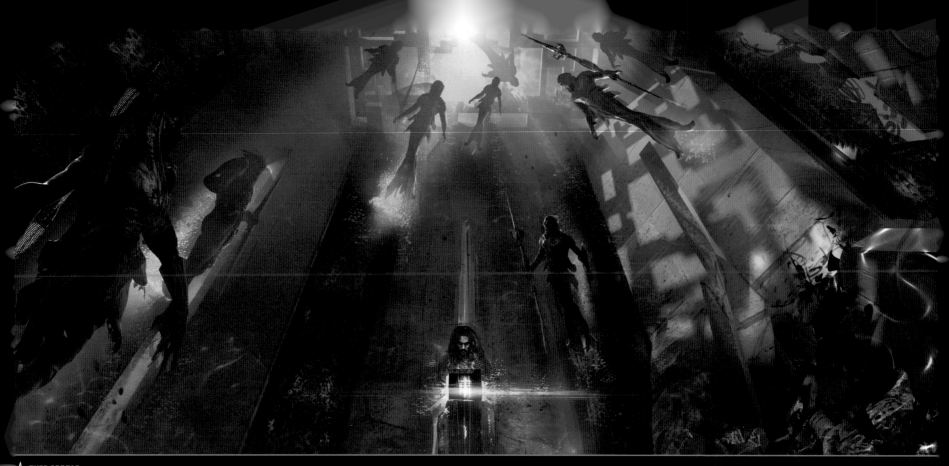

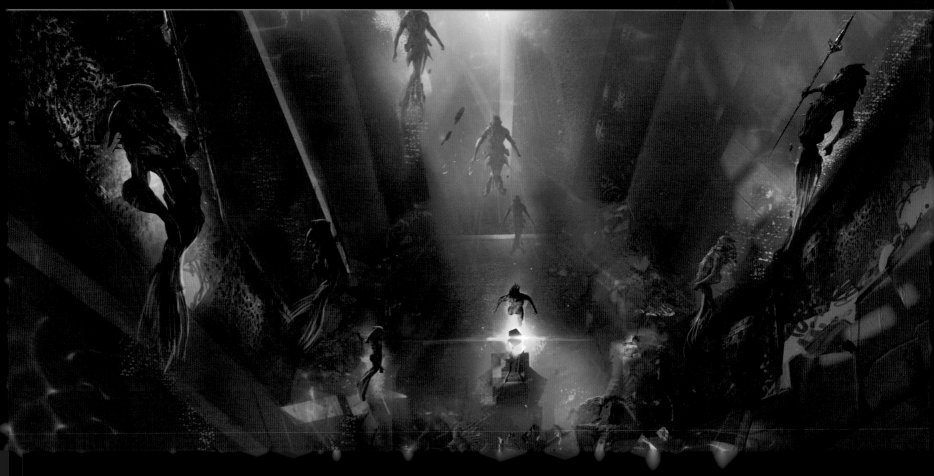

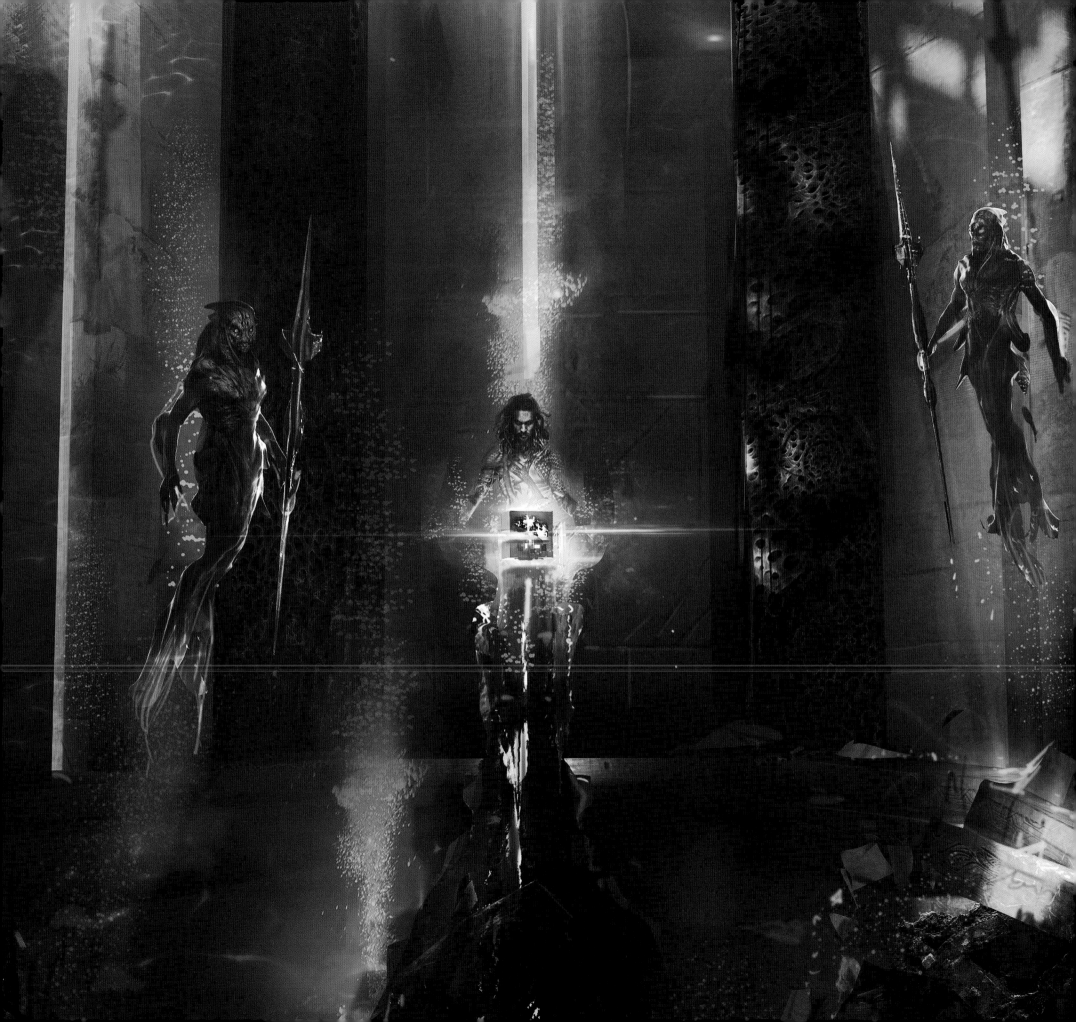

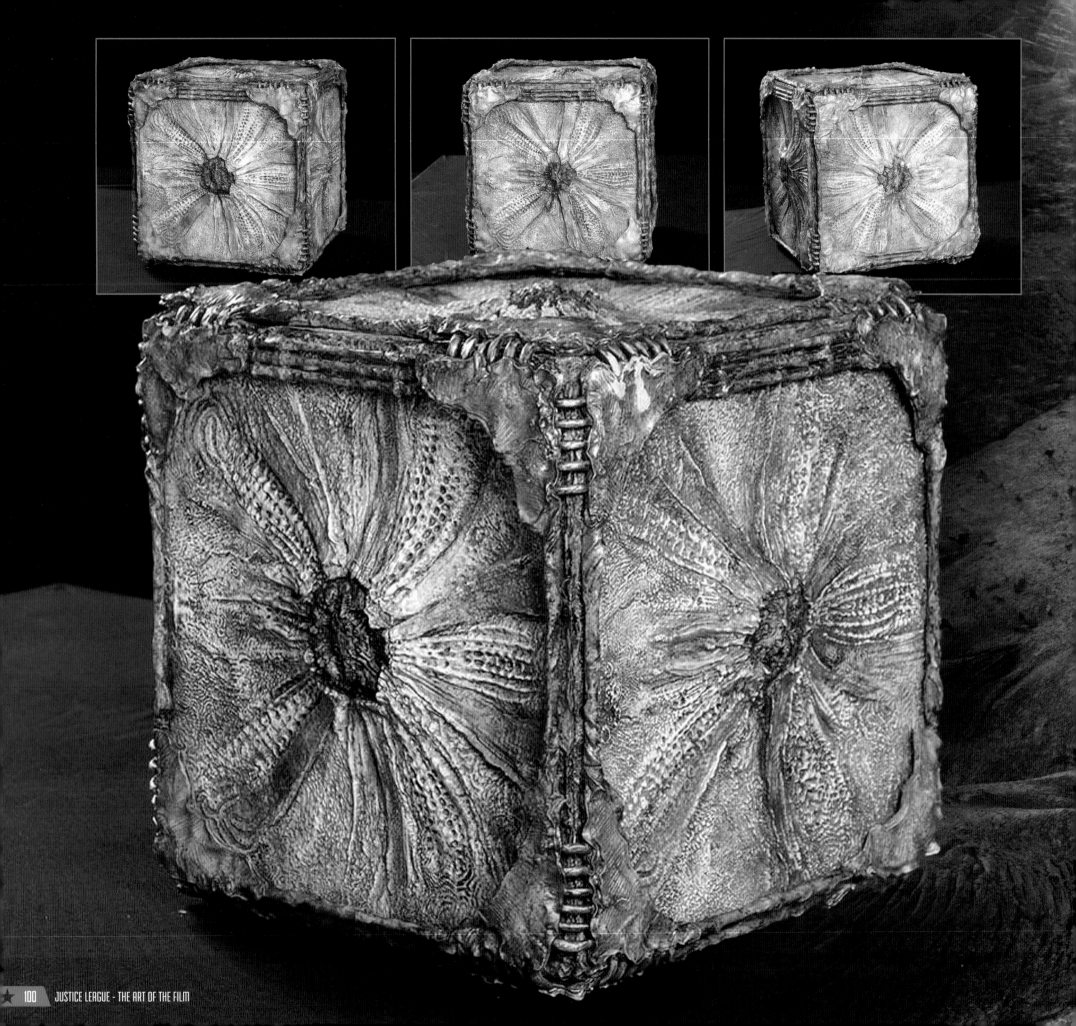

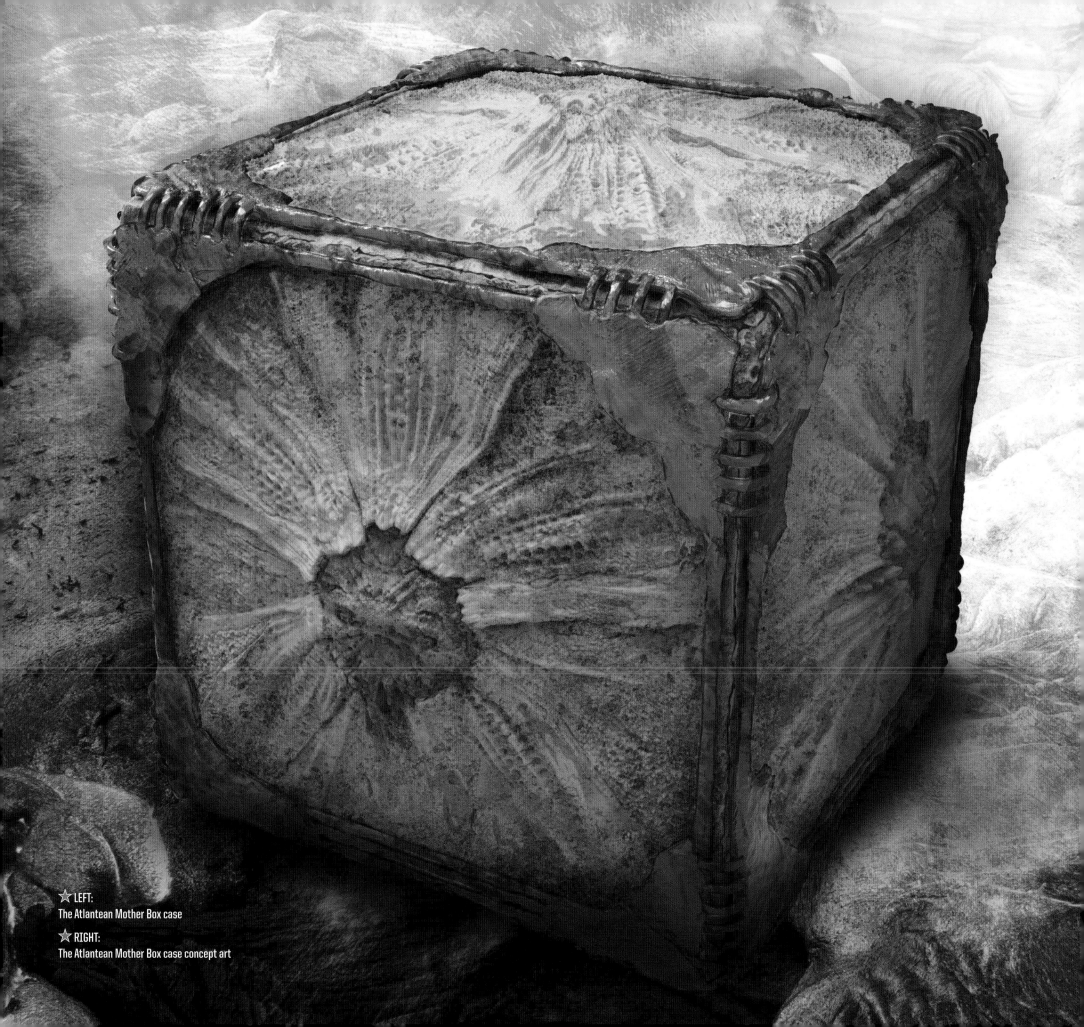

☆LEFT:
The Atlantean Mother Box case

☆RIGHT:
The Atlantean Mother Box case concept art

UNITED WE STAND

"The Parademons are holding the scientists they've abducted on an island. The island's Ventilation Tower and Tunnel are gigantic sets. We went through an intensive design process in pre-production to develop their look, then the sets were built almost like playgrounds for staging the action and stunts."

Patrick Tatopoulos, Production Designer

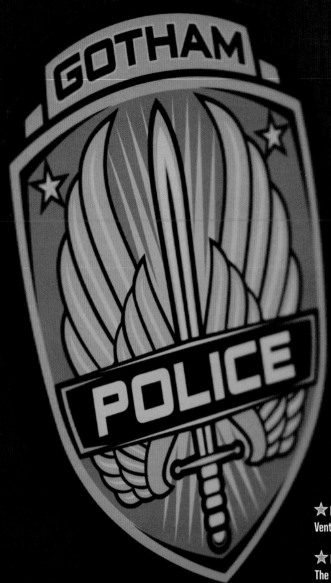

★ PREVIOUS SPREAD:
Ventilation Tower Tunnel interior

★ LEFT:
The Gotham Police symbol

★ BELOW & RIGHT:
Details of the Gotham Police Headquarters interior

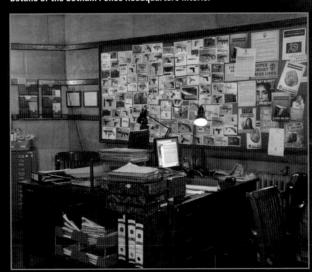

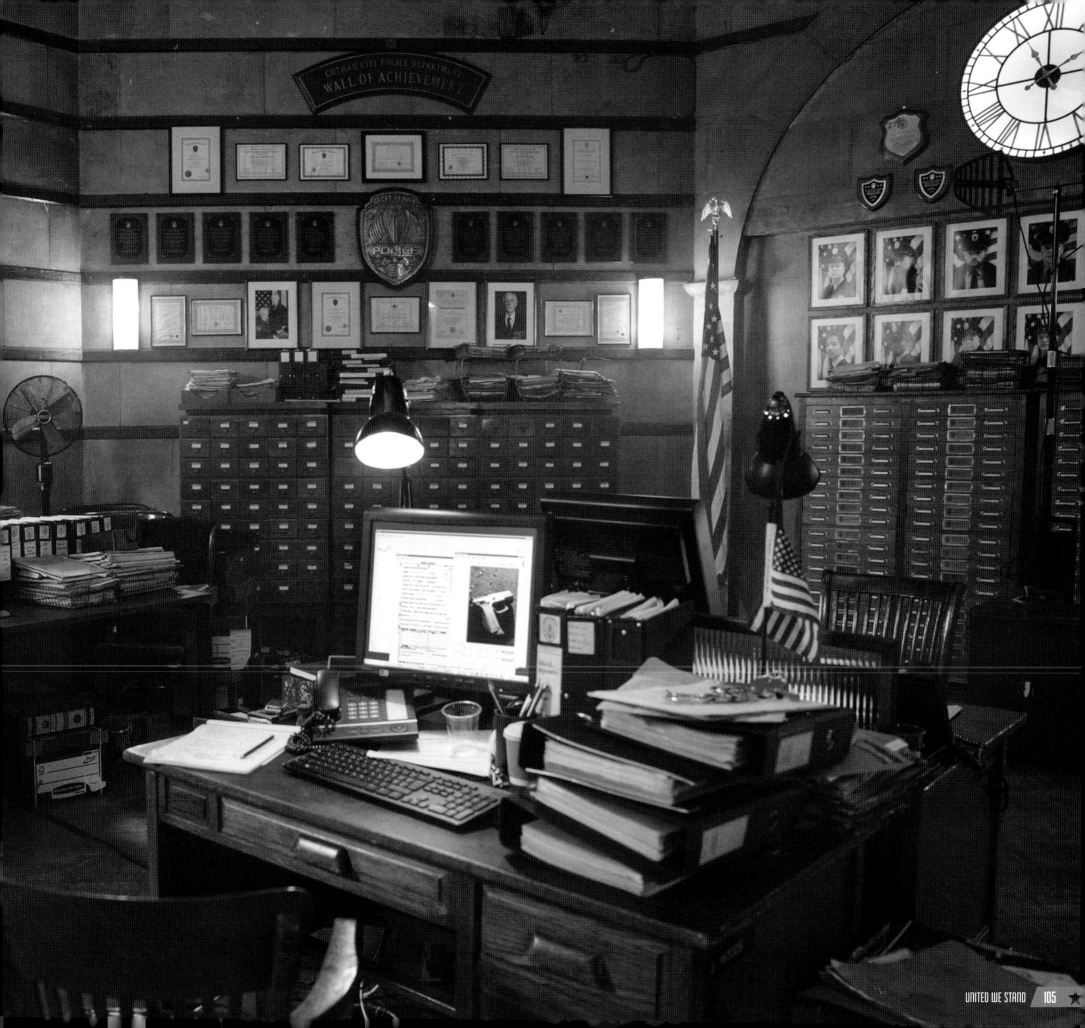

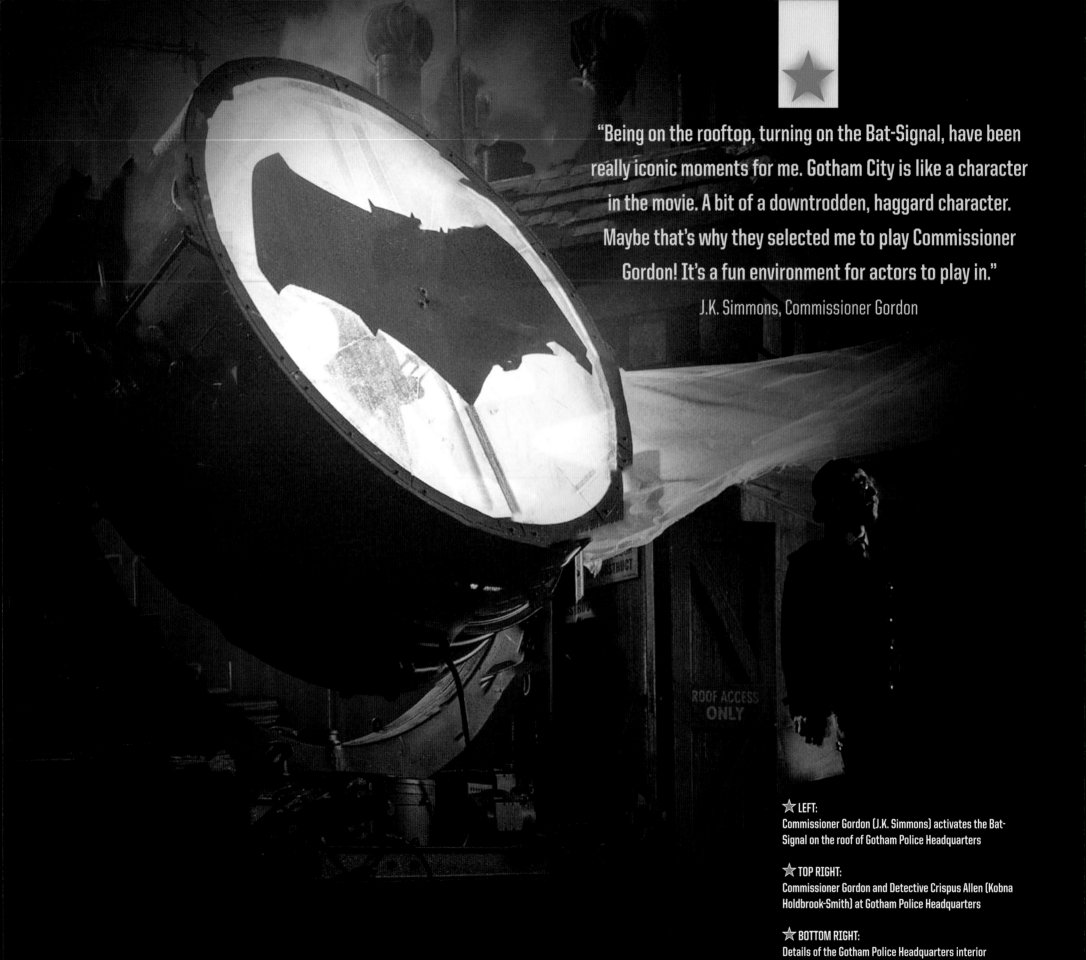

"Being on the rooftop, turning on the Bat-Signal, have been really iconic moments for me. Gotham City is like a character in the movie. A bit of a downtrodden, haggard character. Maybe that's why they selected me to play Commissioner Gordon! It's a fun environment for actors to play in."

J.K. Simmons, Commissioner Gordon

☆ LEFT:
Commissioner Gordon (J.K. Simmons) activates the Bat-Signal on the roof of Gotham Police Headquarters

☆ TOP RIGHT:
Commissioner Gordon and Detective Crispus Allen (Kobna Holdbrook-Smith) at Gotham Police Headquarters

☆ BOTTOM RIGHT:
Details of the Gotham Police Headquarters interior

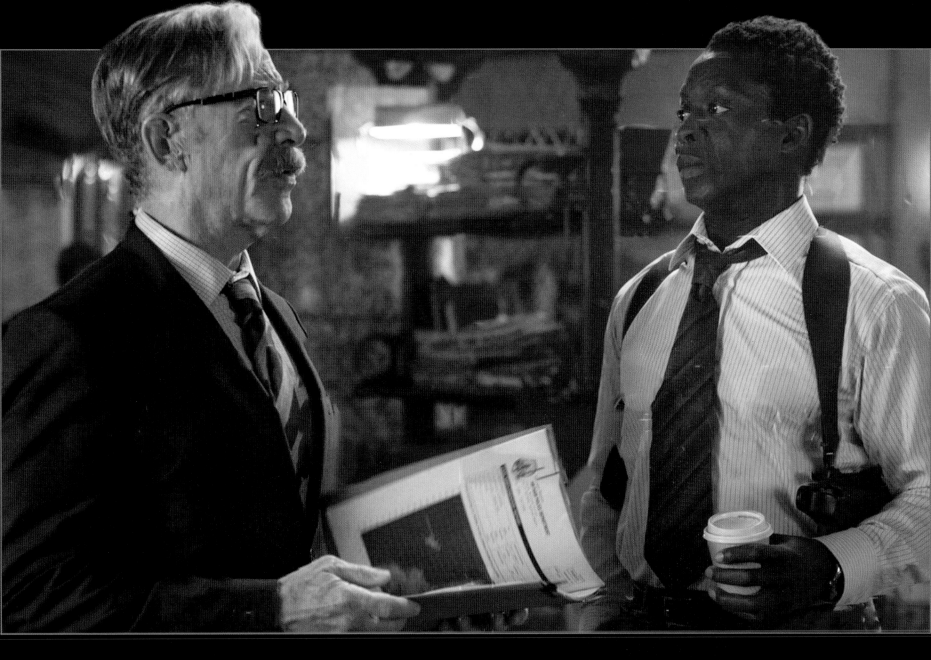

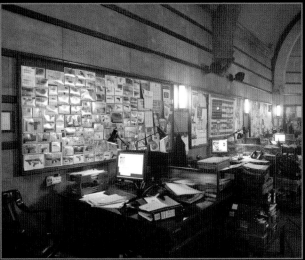

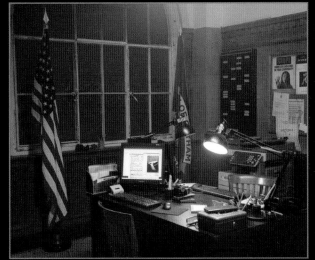

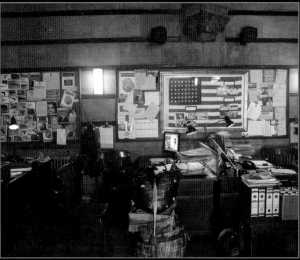

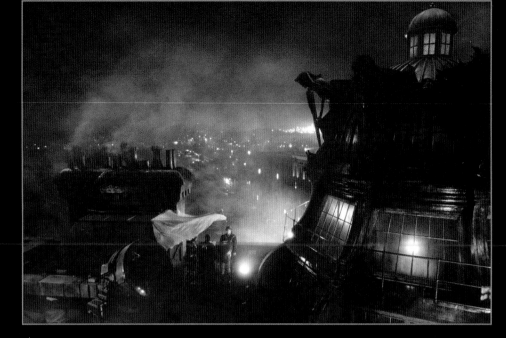

★ ABOVE:
The roof of Gotham Police Headquarters

★ RIGHT:
The roof of Gotham Police Headquarters concept art

★ BELOW:
The roof of Gotham Police Headquarters concept sketch

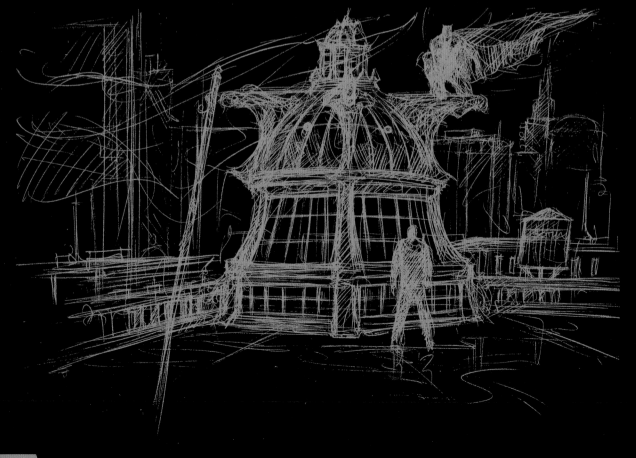

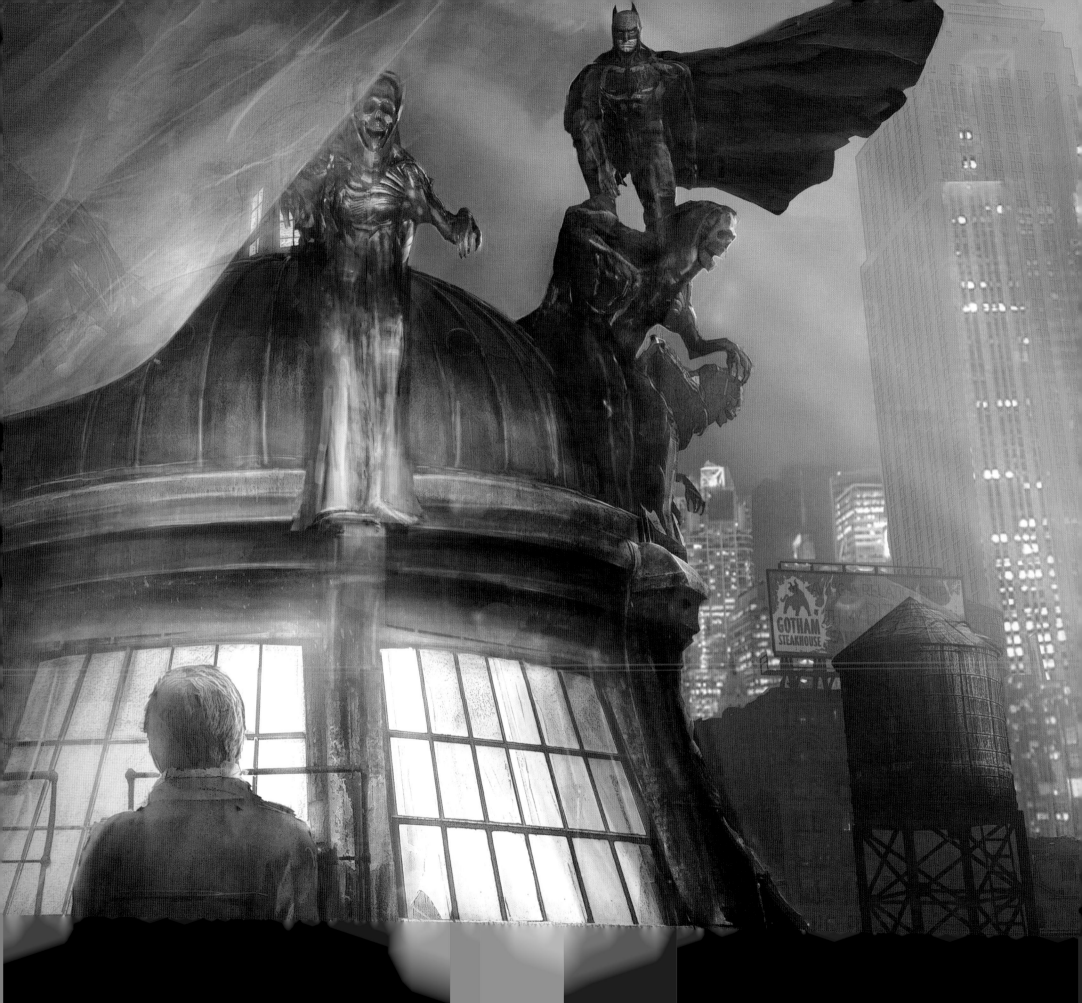

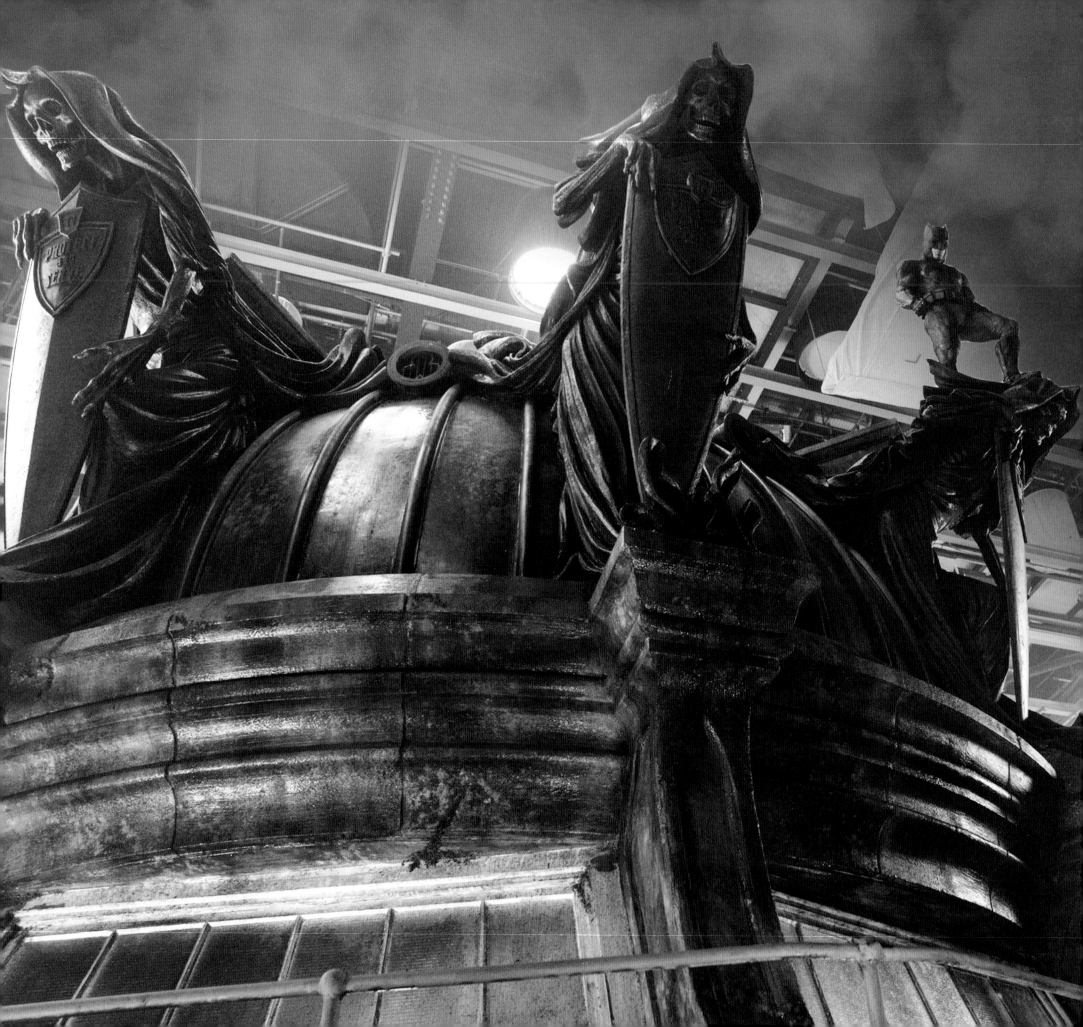

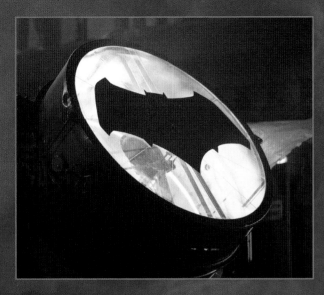

★ CLOCKWISE FROM LEFT:
The roof of Gotham Police Headquarters with Batman and the Angels of Death; The Bat-Signal; Batman and an Angel of Death & An Angel of Death

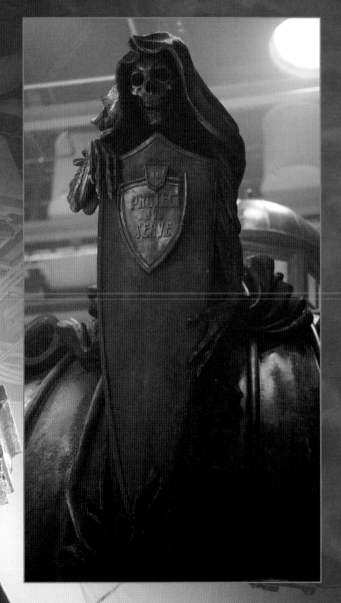

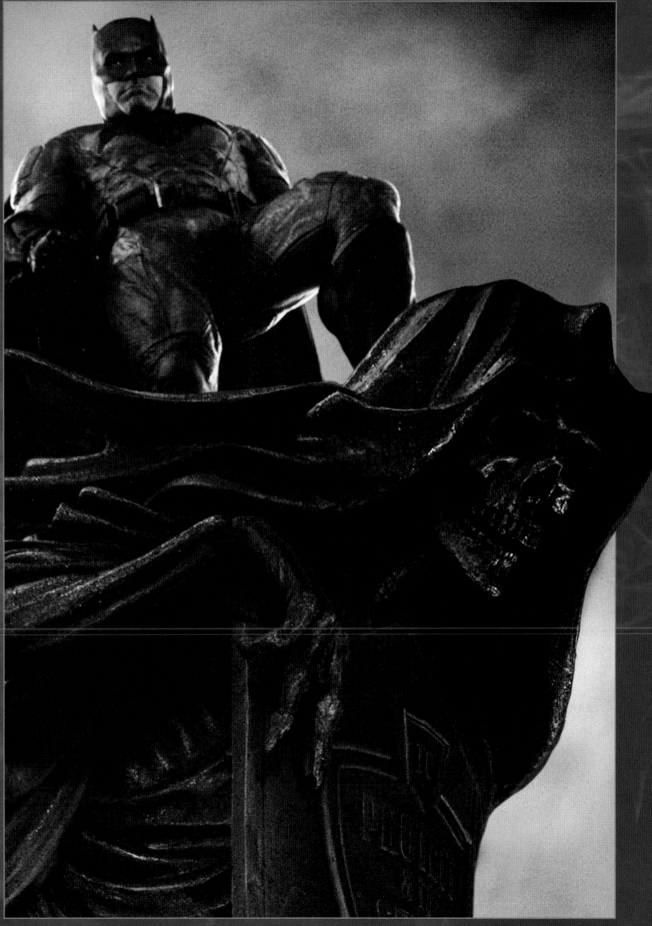

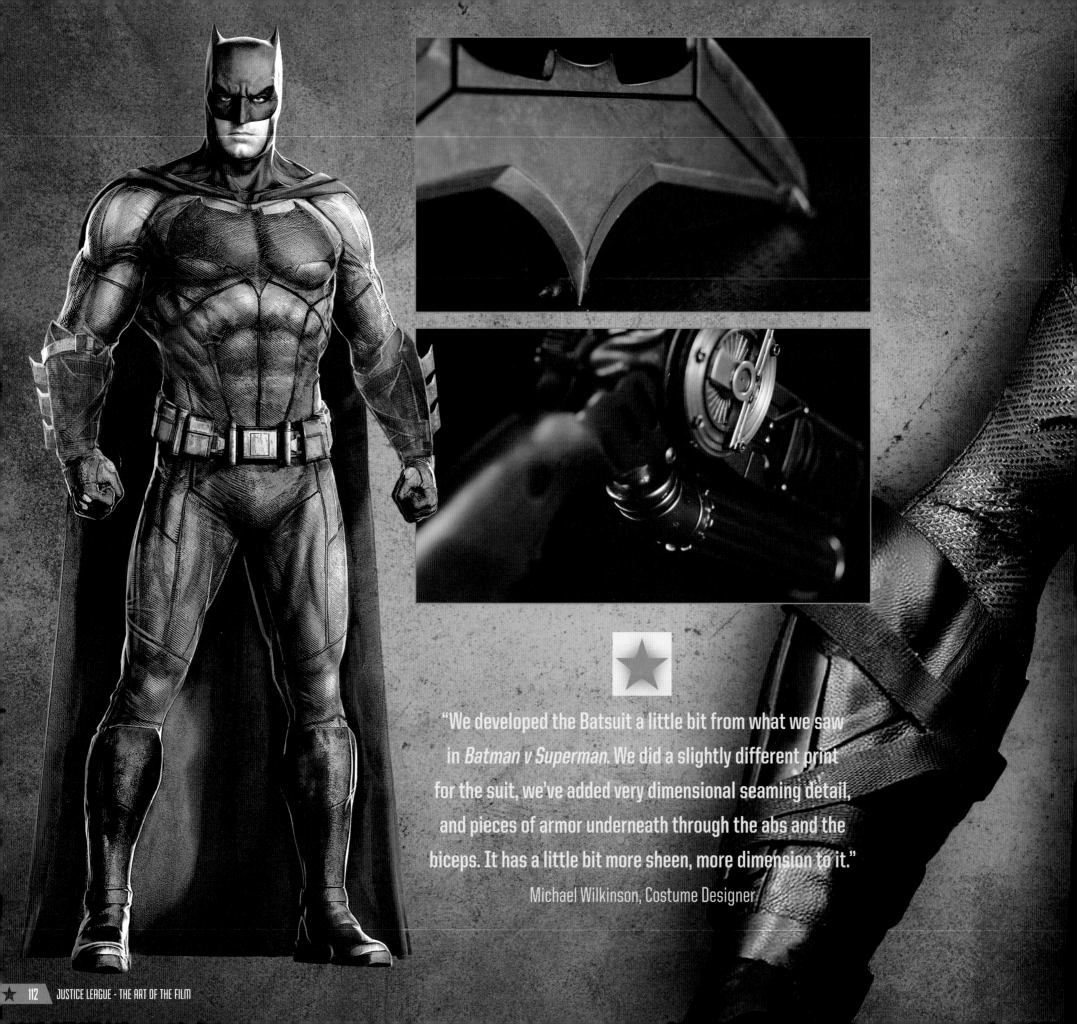

"We developed the Batsuit a little bit from what we saw in *Batman v Superman*. We did a slightly different print for the suit, we've added very dimensional seaming detail, and pieces of armor underneath through the abs and the biceps. It has a little bit more sheen, more dimension to it."

Michael Wilkinson, Costume Designer

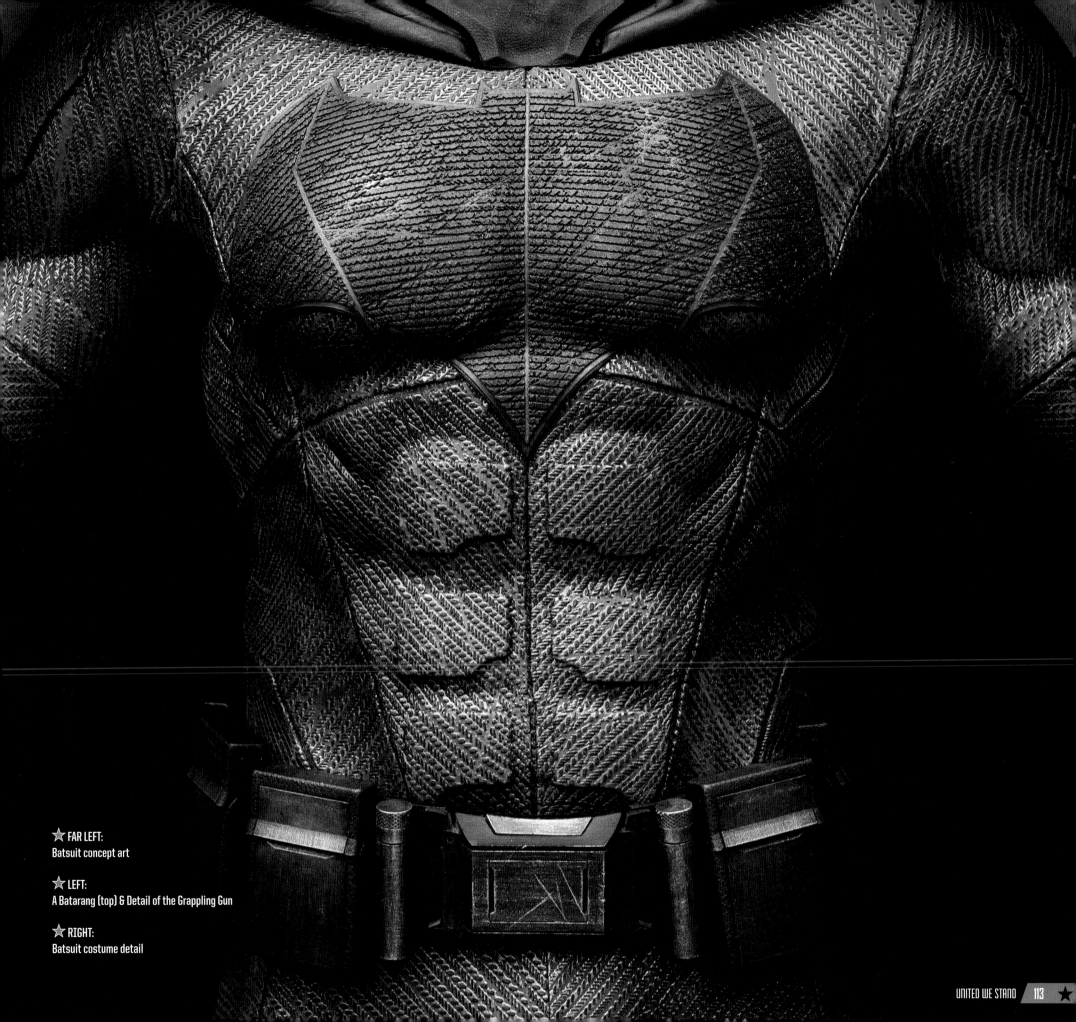

★ FAR LEFT:
Batsuit concept art

★ LEFT:
A Batarang (top) & Detail of the Grappling Gun

★ RIGHT:
Batsuit costume detail

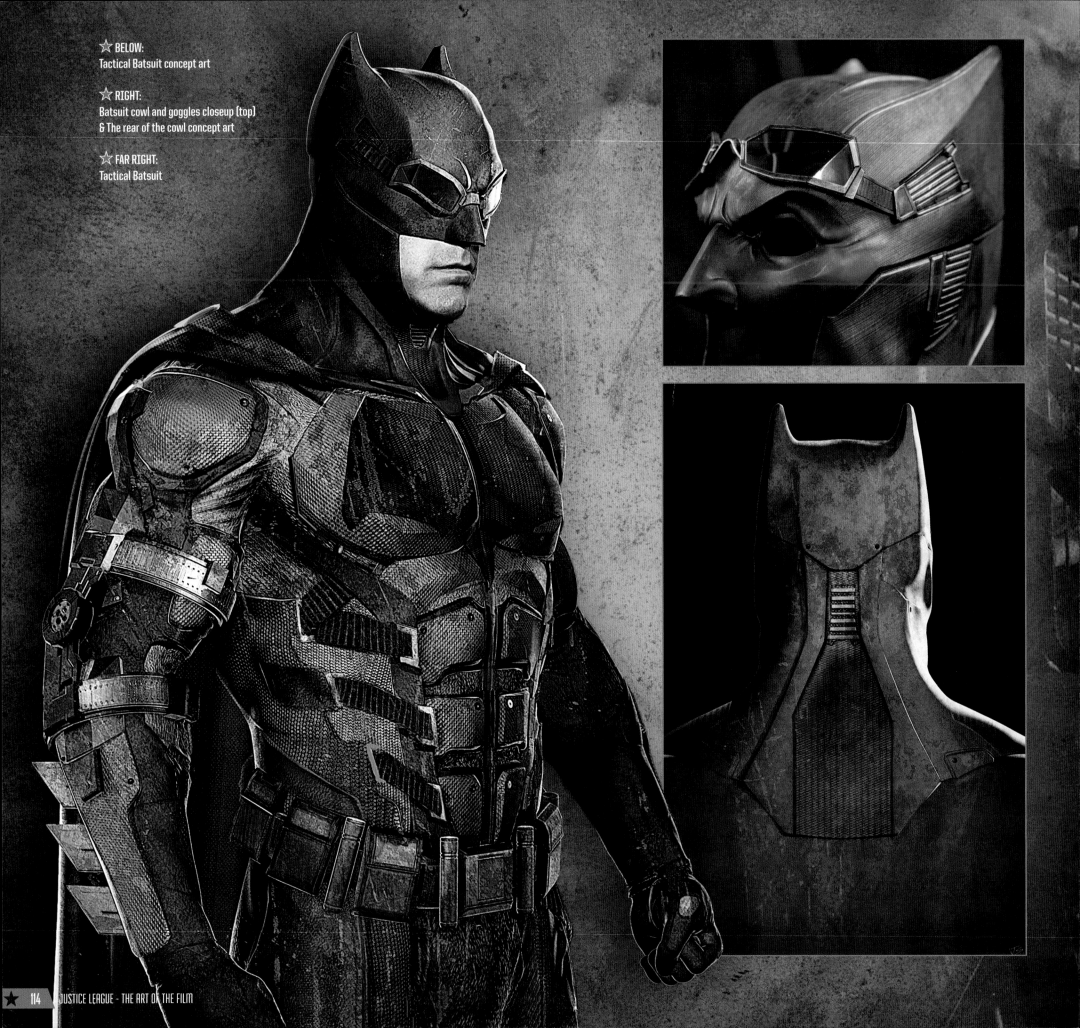

☆ BELOW:
Tactical Batsuit concept art

☆ RIGHT:
Batsuit cowl and goggles closeup (top)
& The rear of the cowl concept art

☆ FAR RIGHT:
Tactical Batsuit

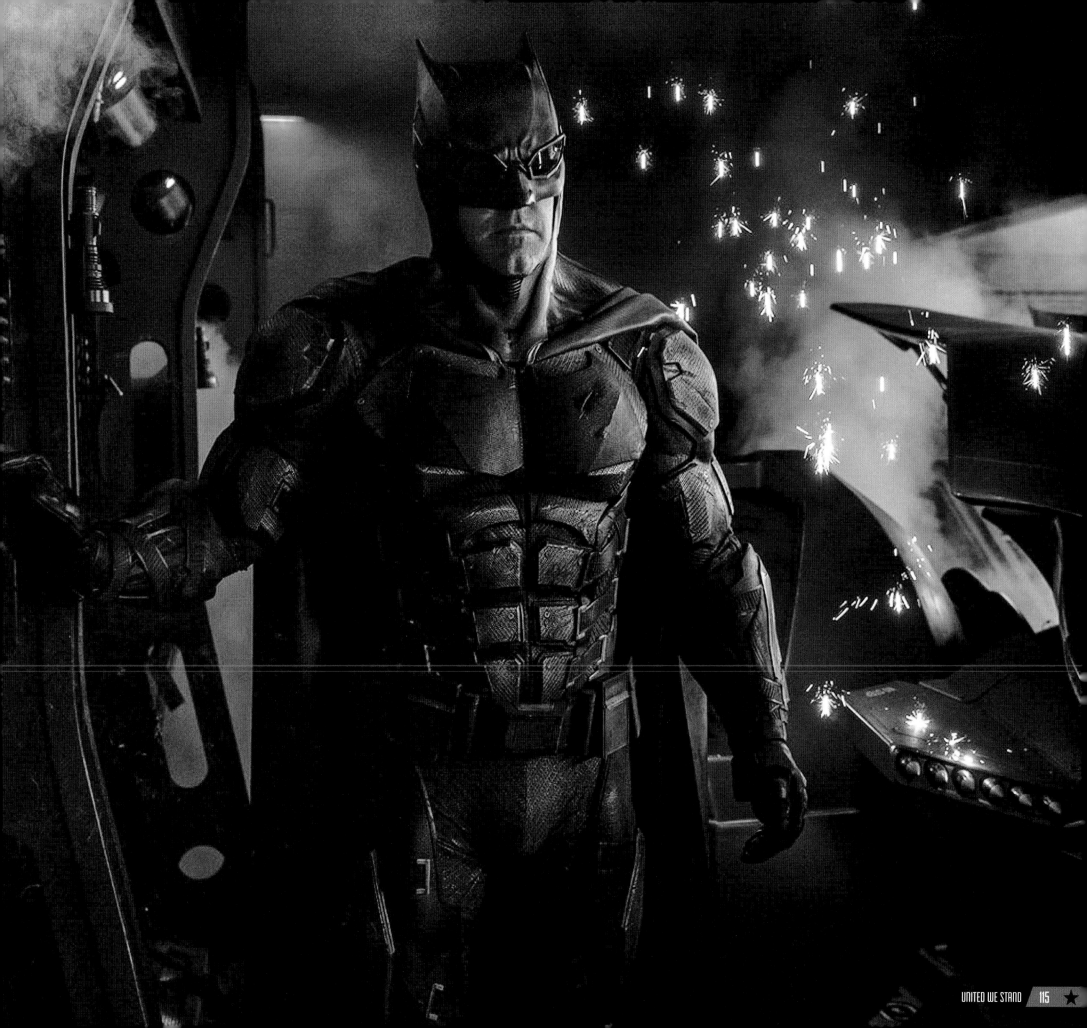

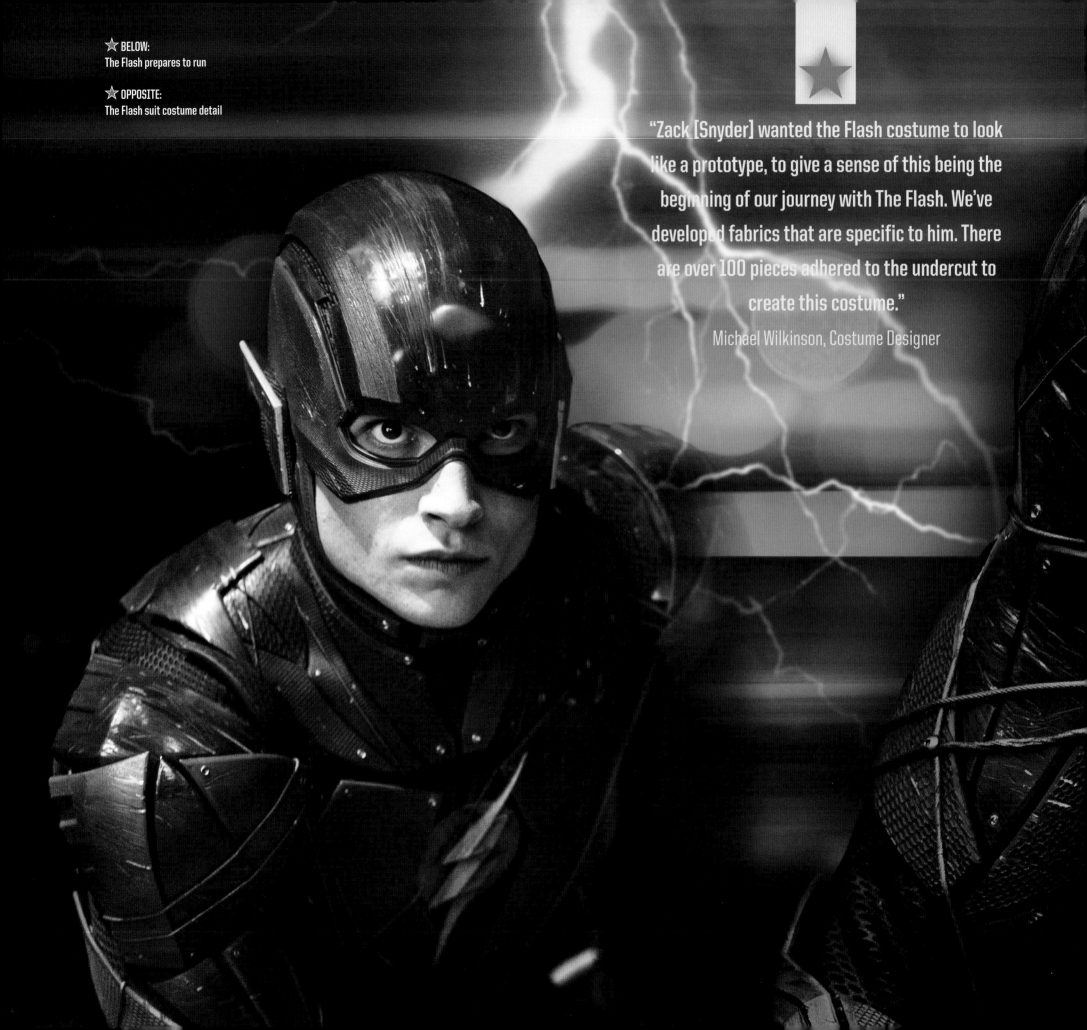

★ BELOW:
The Flash prepares to run

★ OPPOSITE:
The Flash suit costume detail

"Zack [Snyder] wanted the Flash costume to look like a prototype, to give a sense of this being the beginning of our journey with The Flash. We've developed fabrics that are specific to him. There are over 100 pieces adhered to the undercut to create this costume."

Michael Wilkinson, Costume Designer

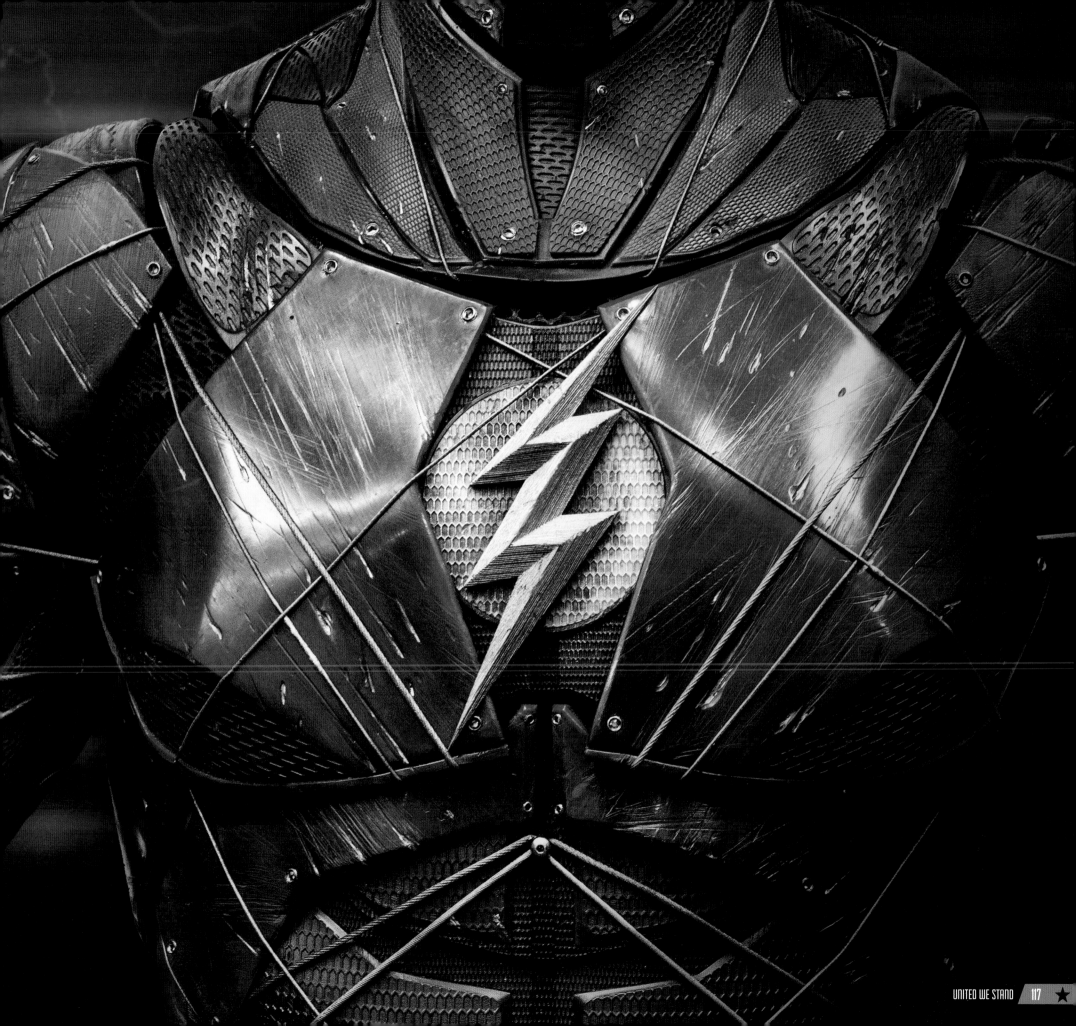

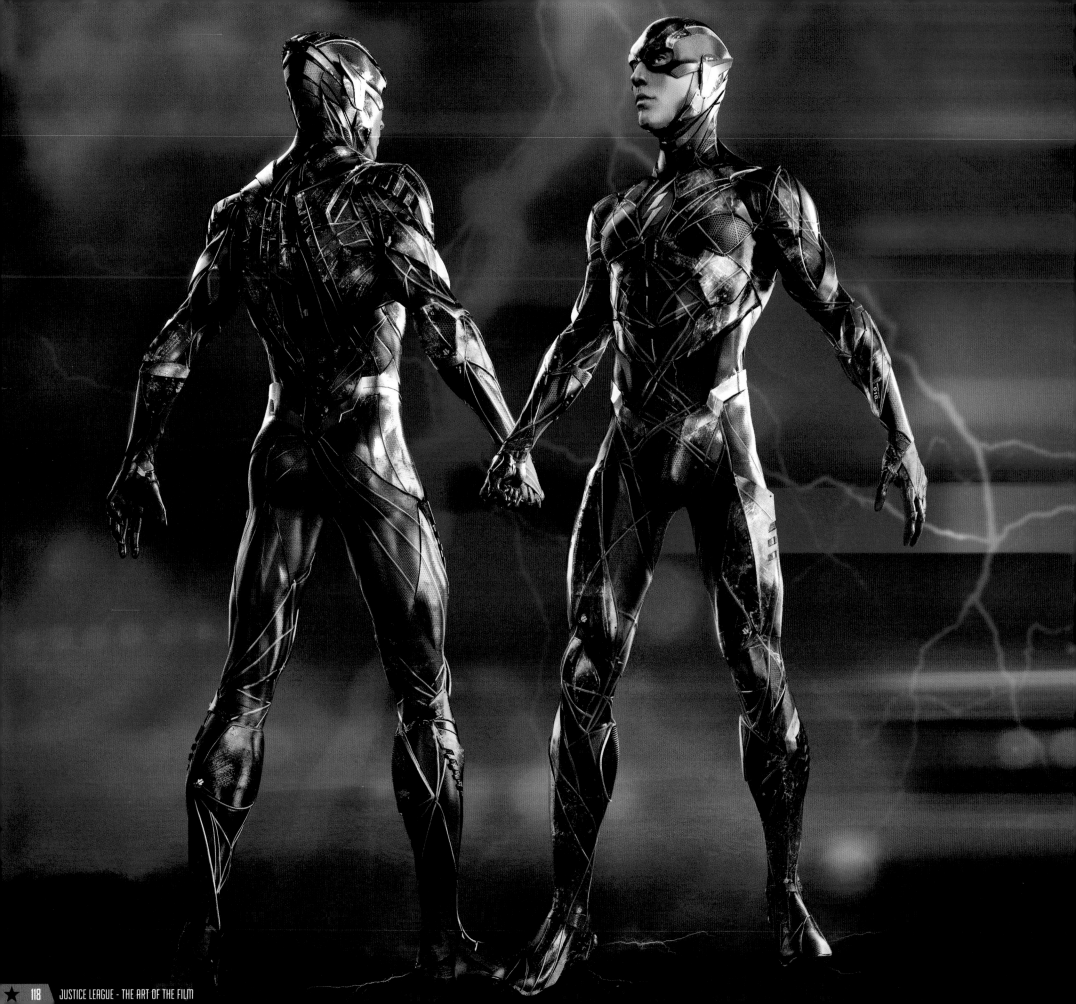

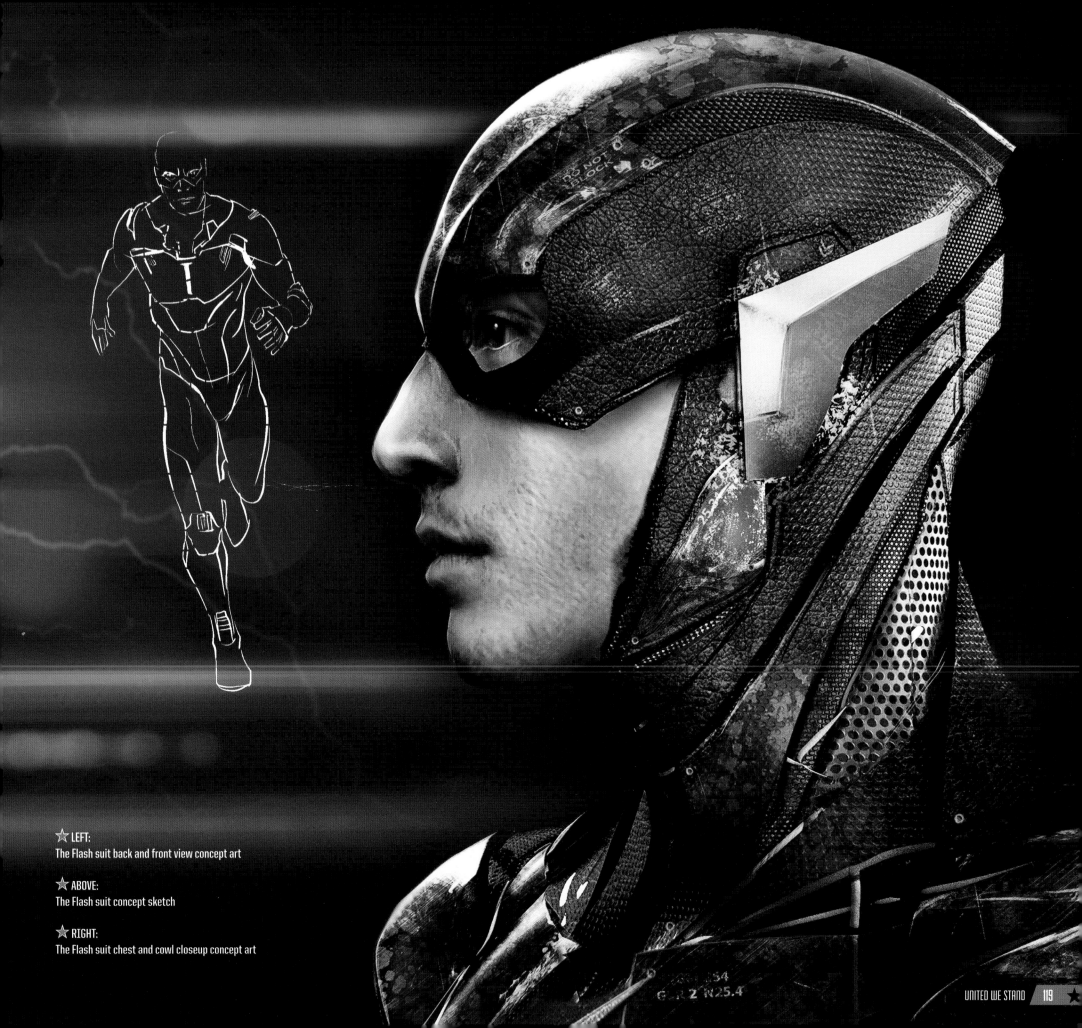

★ LEFT:
The Flash suit back and front view concept art

★ ABOVE:
The Flash suit concept sketch

★ RIGHT:
The Flash suit chest and cowl closeup concept art

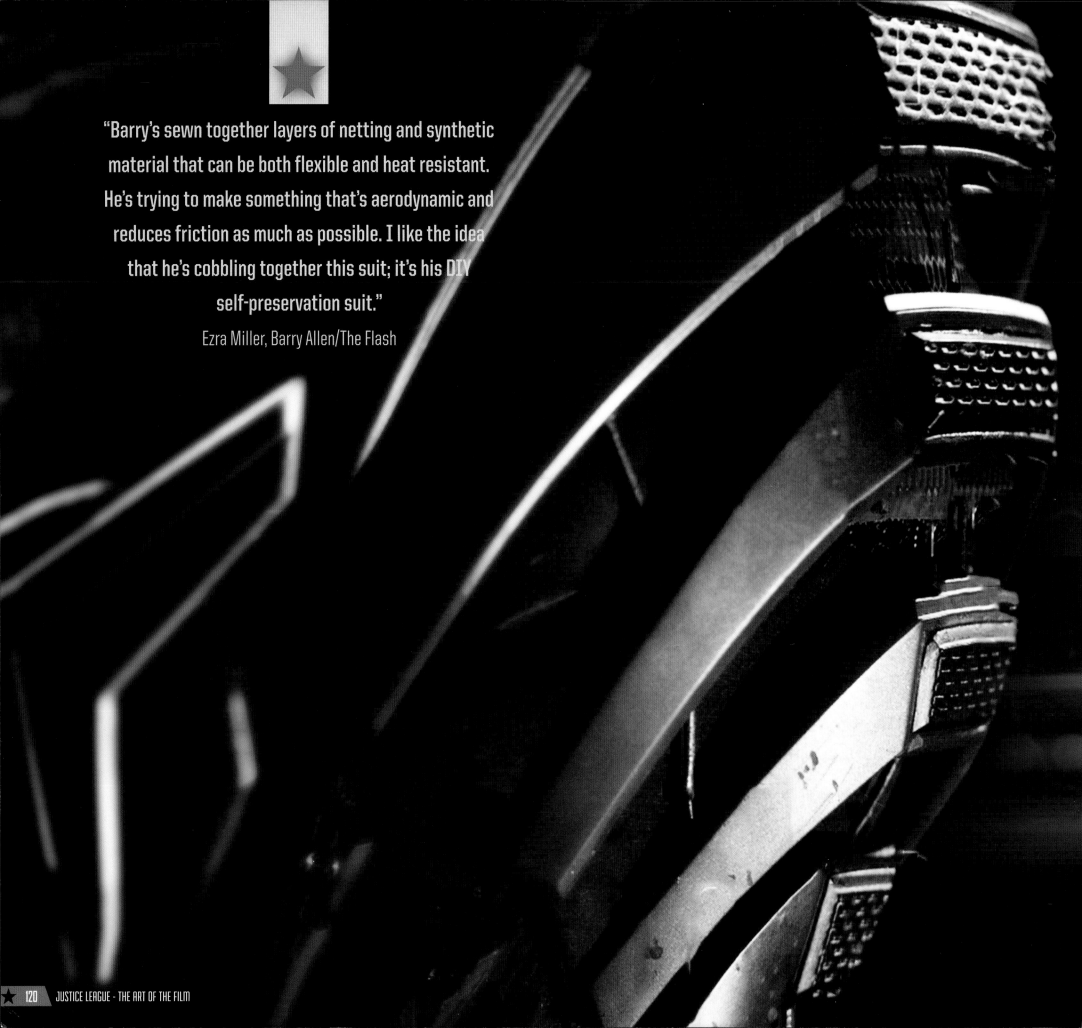

"Barry's sewn together layers of netting and synthetic material that can be both flexible and heat resistant. He's trying to make something that's aerodynamic and reduces friction as much as possible. I like the idea that he's cobbling together this suit; it's his DIY self-preservation suit."

Ezra Miller, Barry Allen/The Flash

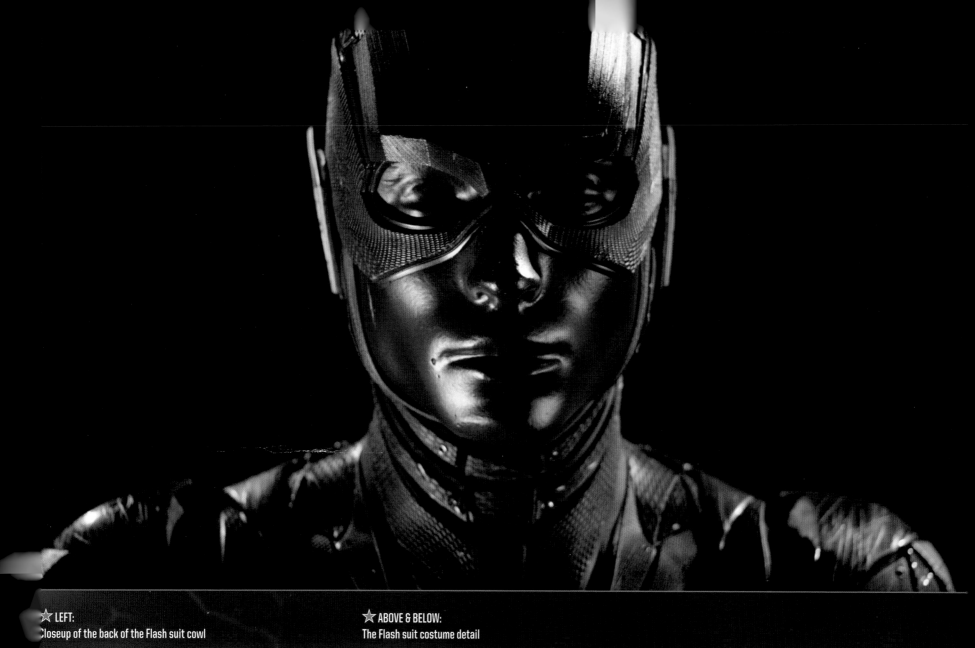

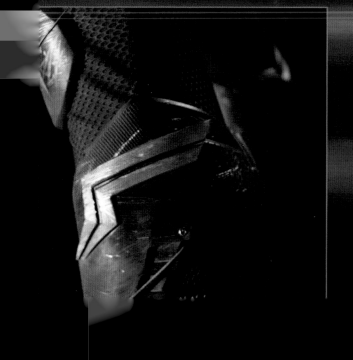

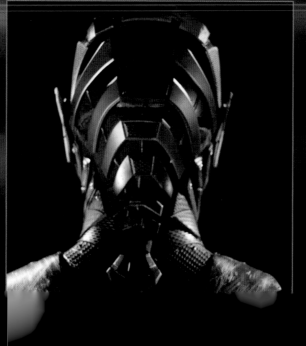

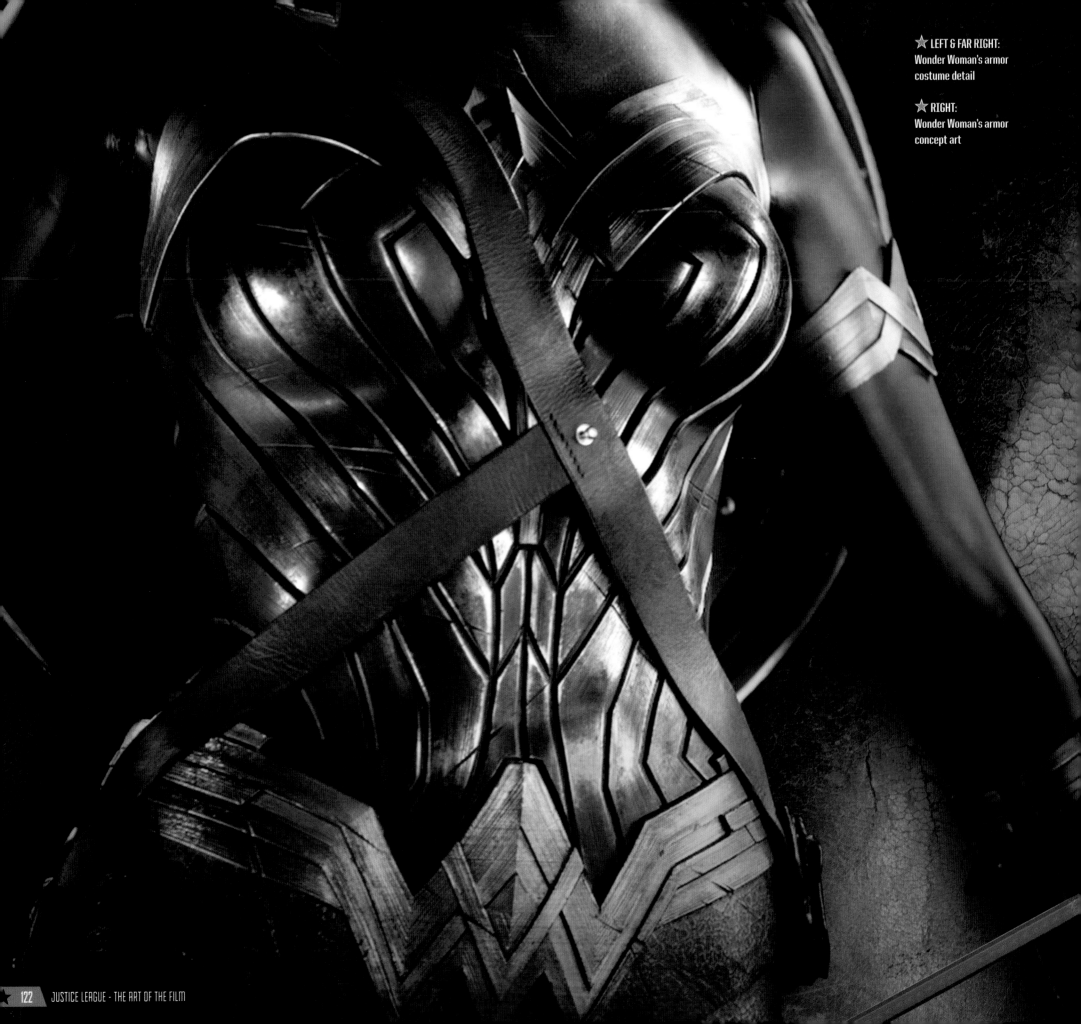

★ LEFT & FAR RIGHT:
Wonder Woman's armor
costume detail

★ RIGHT:
Wonder Woman's armor
concept art

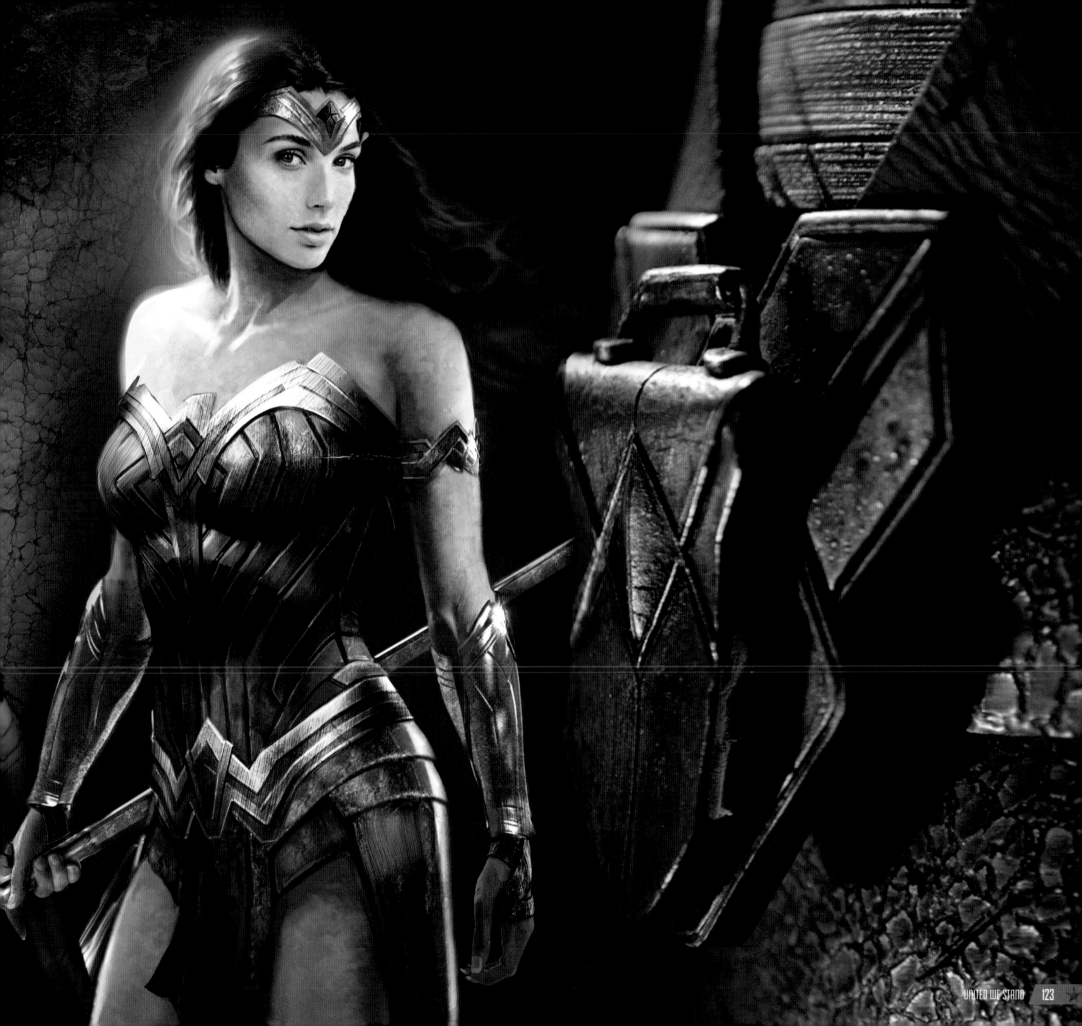

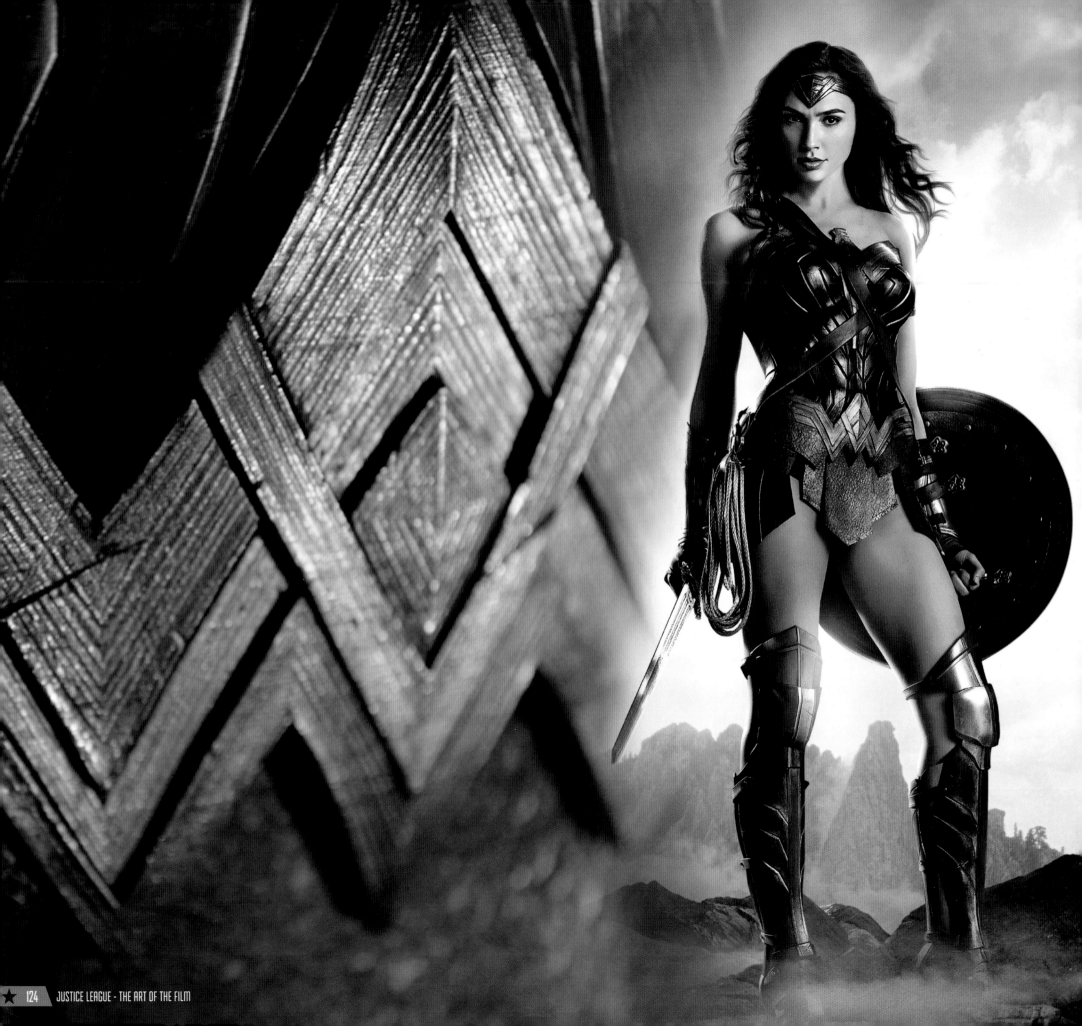

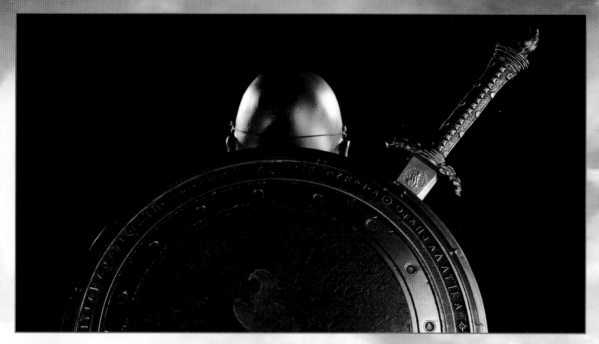

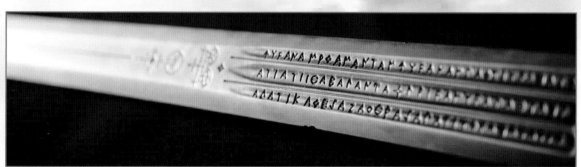

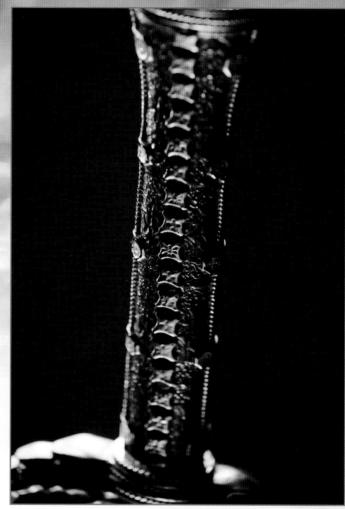

"Coming to *Justice League* wearing my own costume felt like the most normal thing, because I've been doing it for six months before [for *Wonder Woman*]. So it just felt like I was being me again. But, wearing the costume and having everyone else wearing their own hero costumes was great."

Gal Gadot, Diana Prince/Wonder Woman

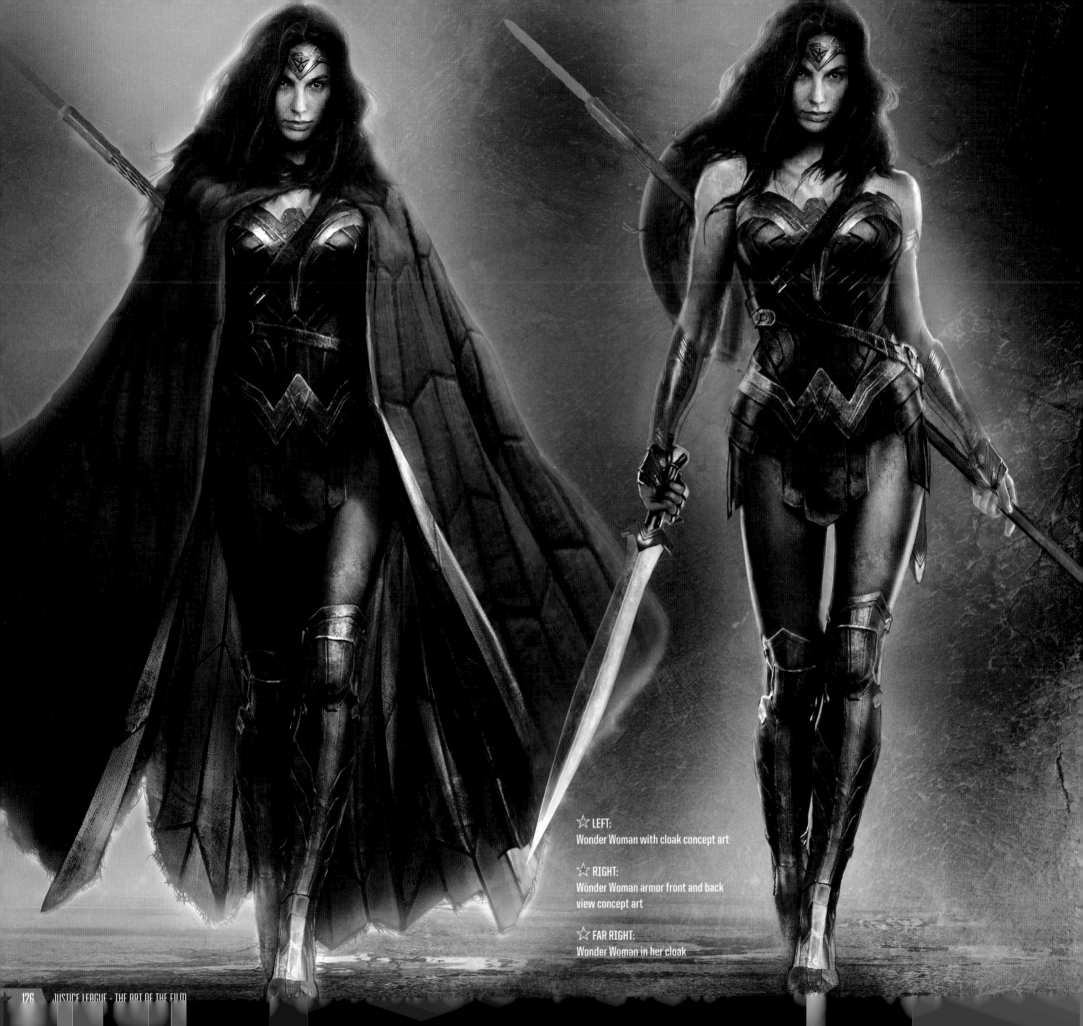

☆ **LEFT:**
Wonder Woman with cloak concept art

☆ **RIGHT:**
Wonder Woman armor front and back
view concept art

☆ **FAR RIGHT:**
Wonder Woman in her cloak

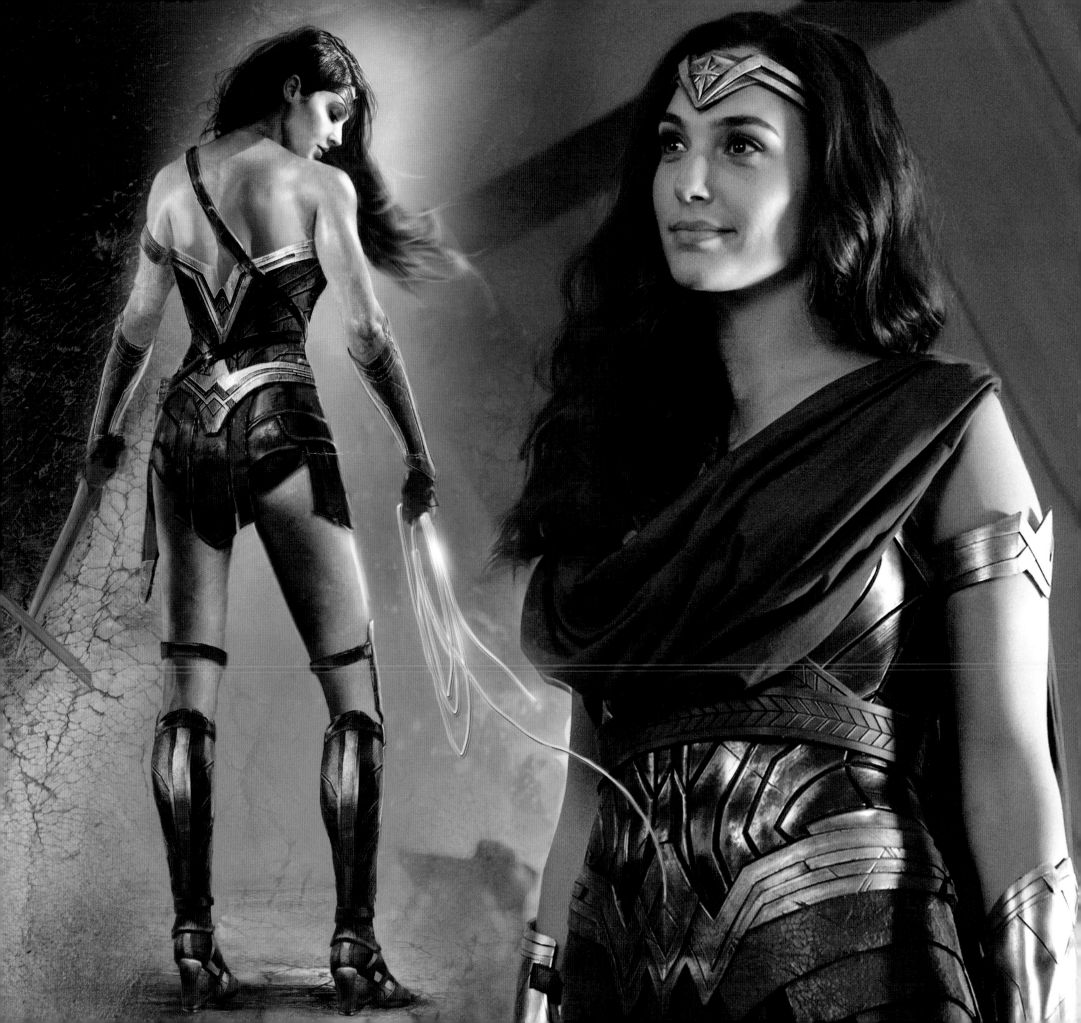

"I worked with my concept artist to create lots of different artwork to inspire the final look for Cyborg. Then we handed it over to the visual effects department and they took that idea and kept developing it with the director and with the actor's performance to create his final look in the computer."

Michael Wilkinson, Costume Designer

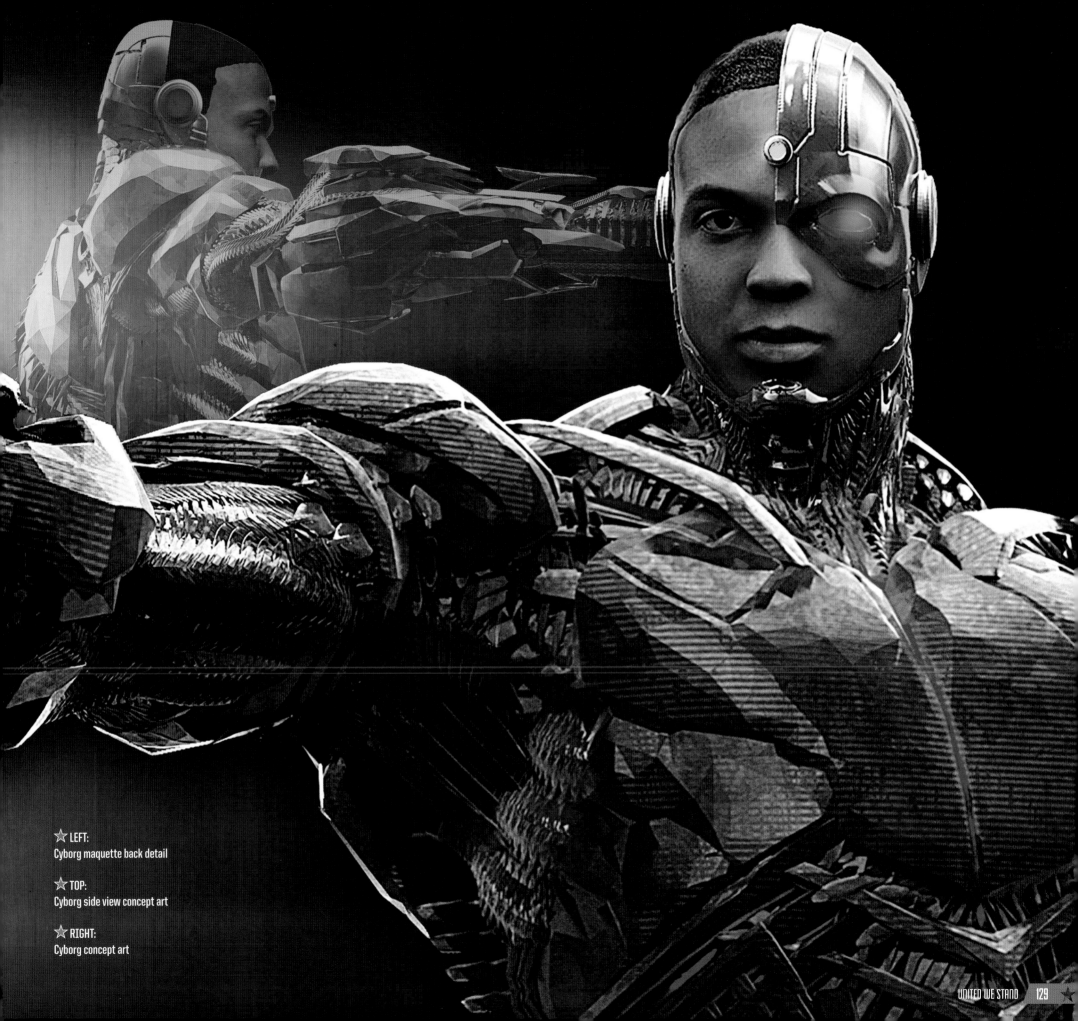

☆ **LEFT:**
Cyborg maquette back detail

☆ **TOP:**
Cyborg side view concept art

☆ **RIGHT:**
Cyborg concept art

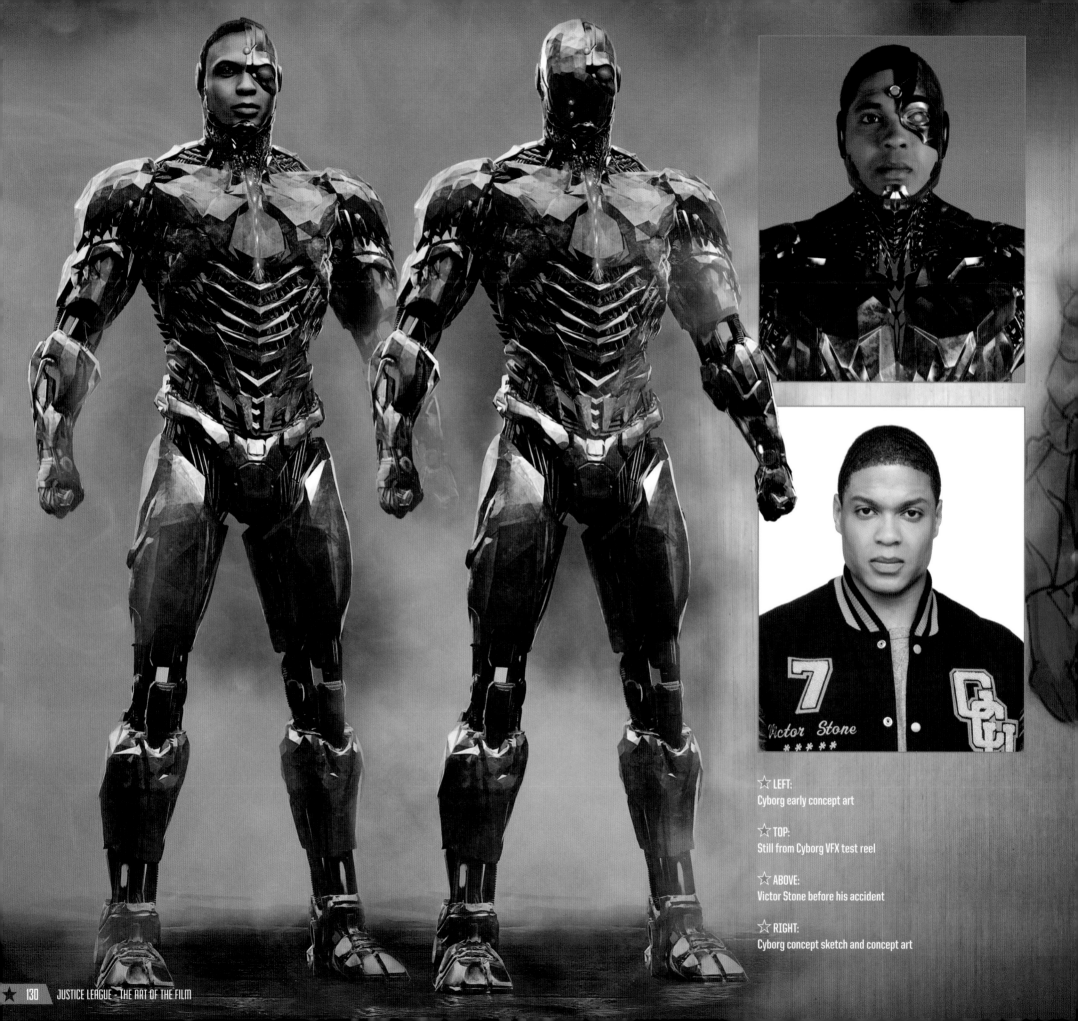

☆ LEFT:
Cyborg early concept art

☆ TOP:
Still from Cyborg VFX test reel

☆ ABOVE:
Victor Stone before his accident

☆ RIGHT:
Cyborg concept sketch and concept art

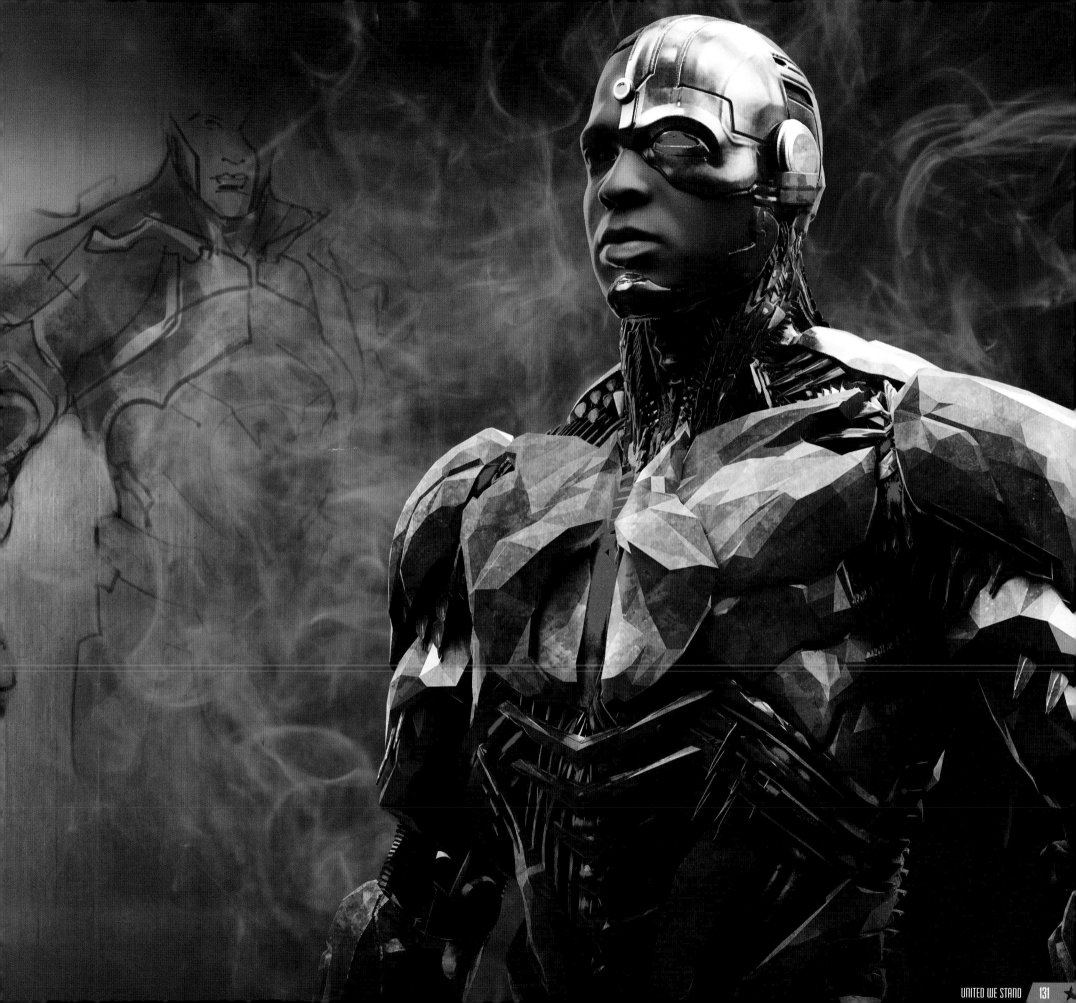

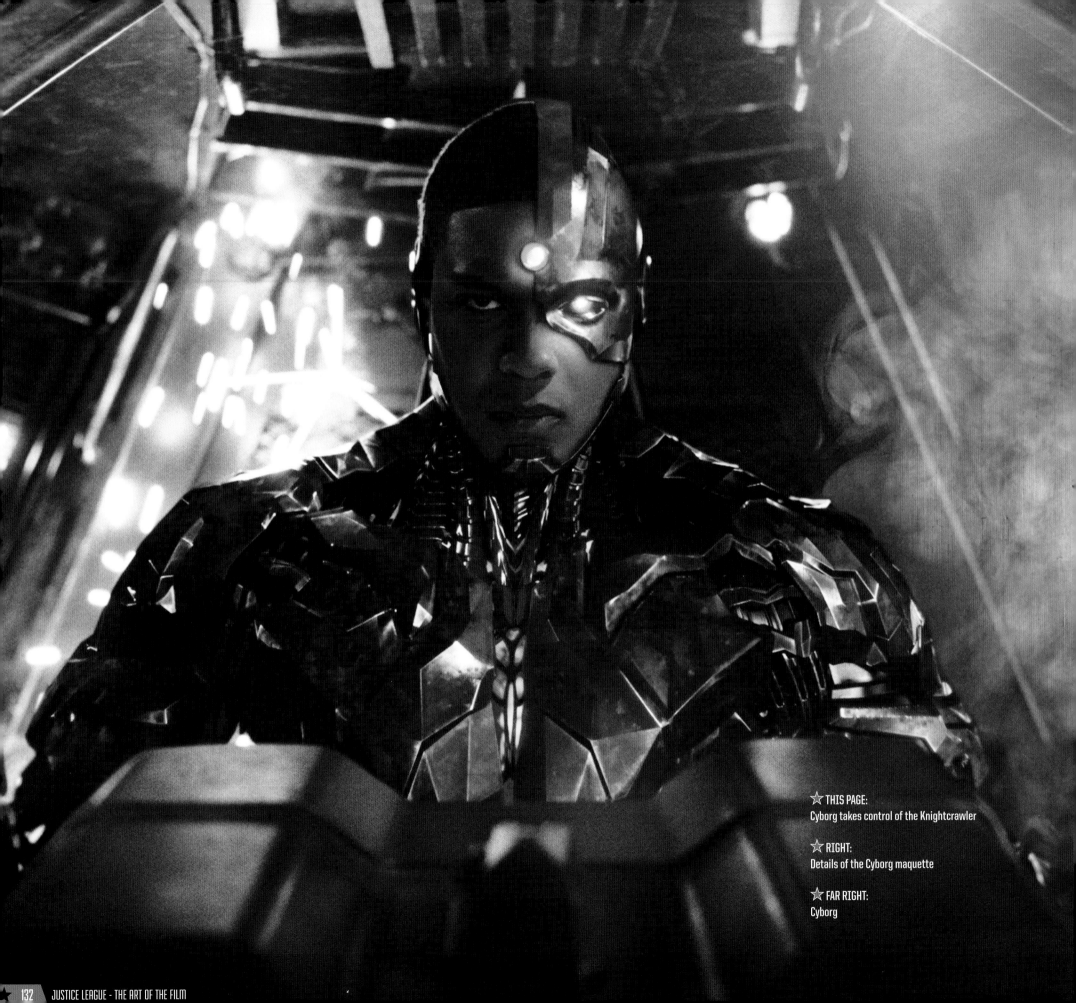

☆ THIS PAGE:
Cyborg takes control of the Knightcrawler

☆ RIGHT:
Details of the Cyborg maquette

☆ FAR RIGHT:
Cyborg

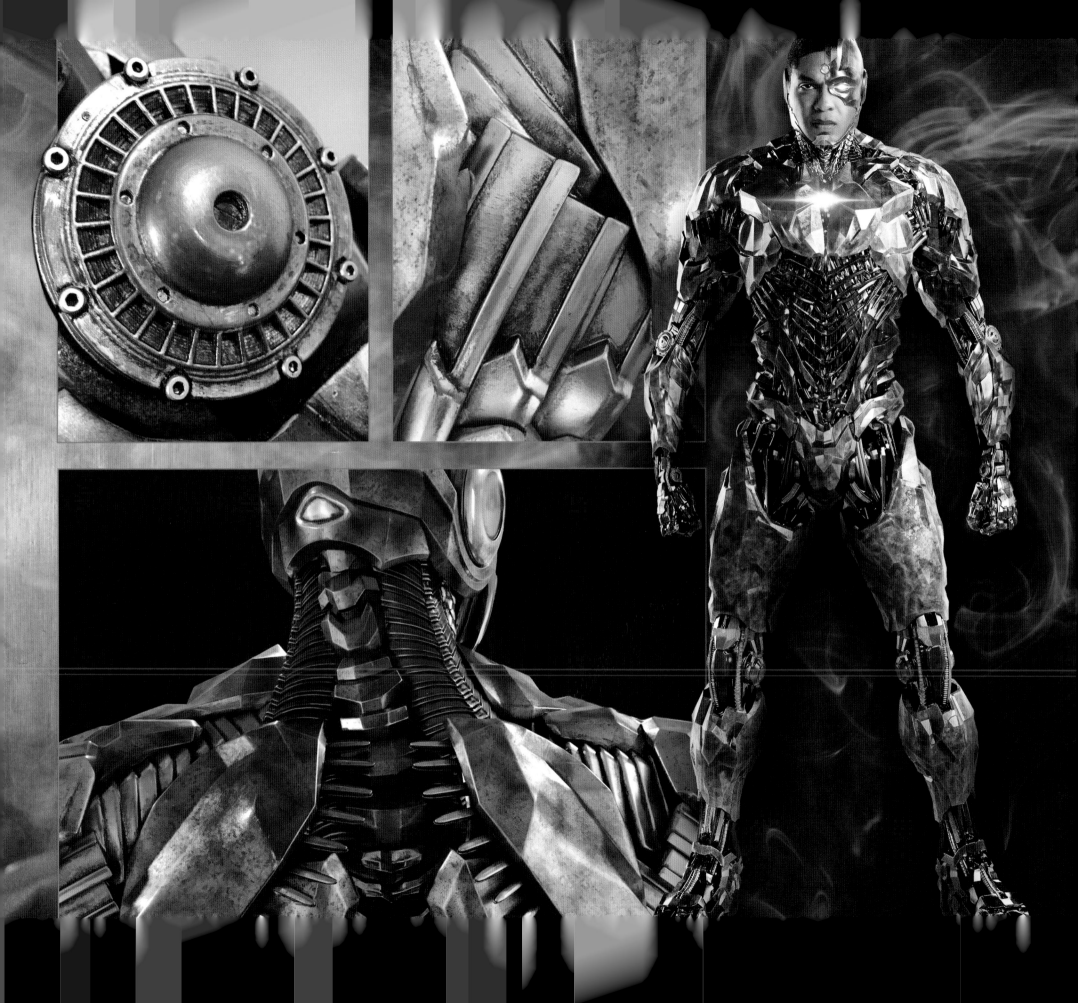

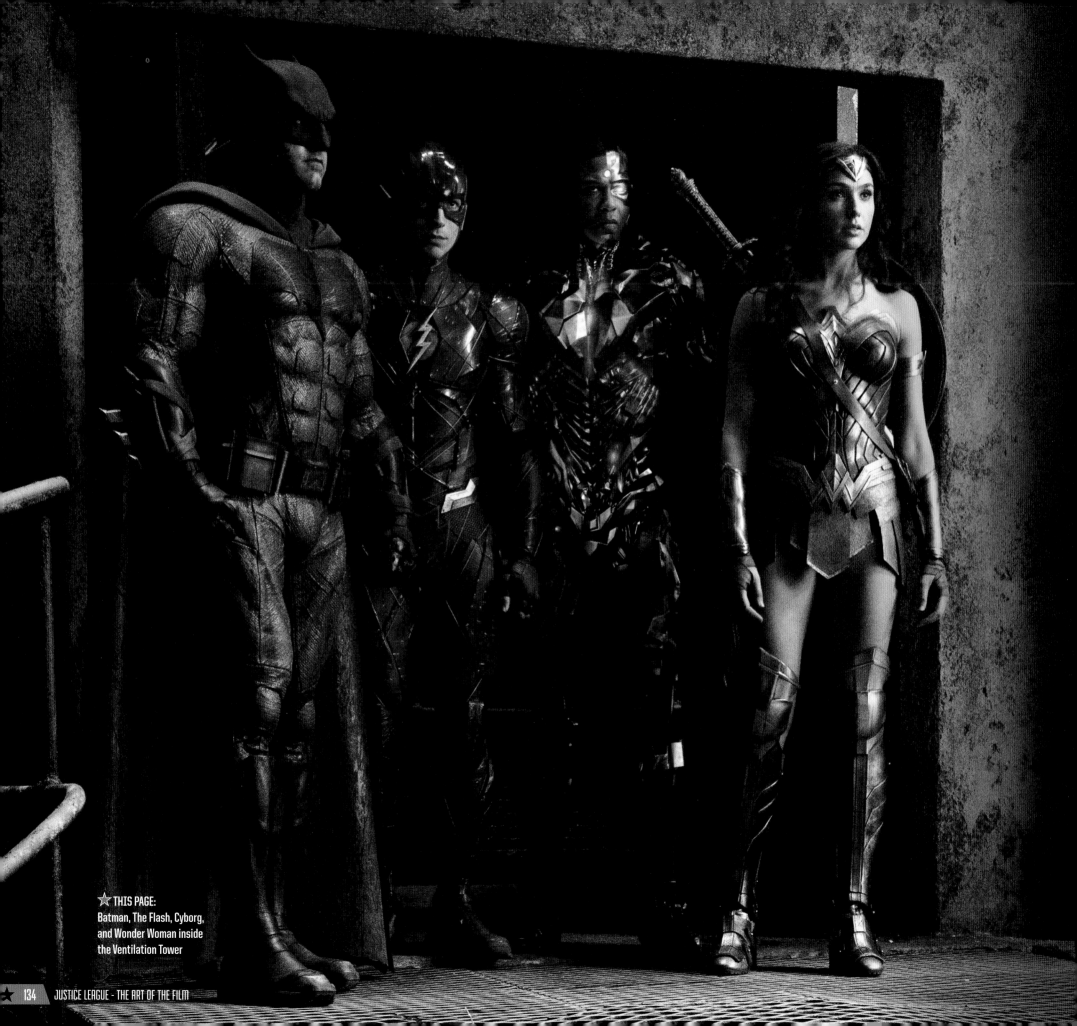

★THIS PAGE:
Batman, The Flash, Cyborg,
and Wonder Woman inside
the Ventilation Tower

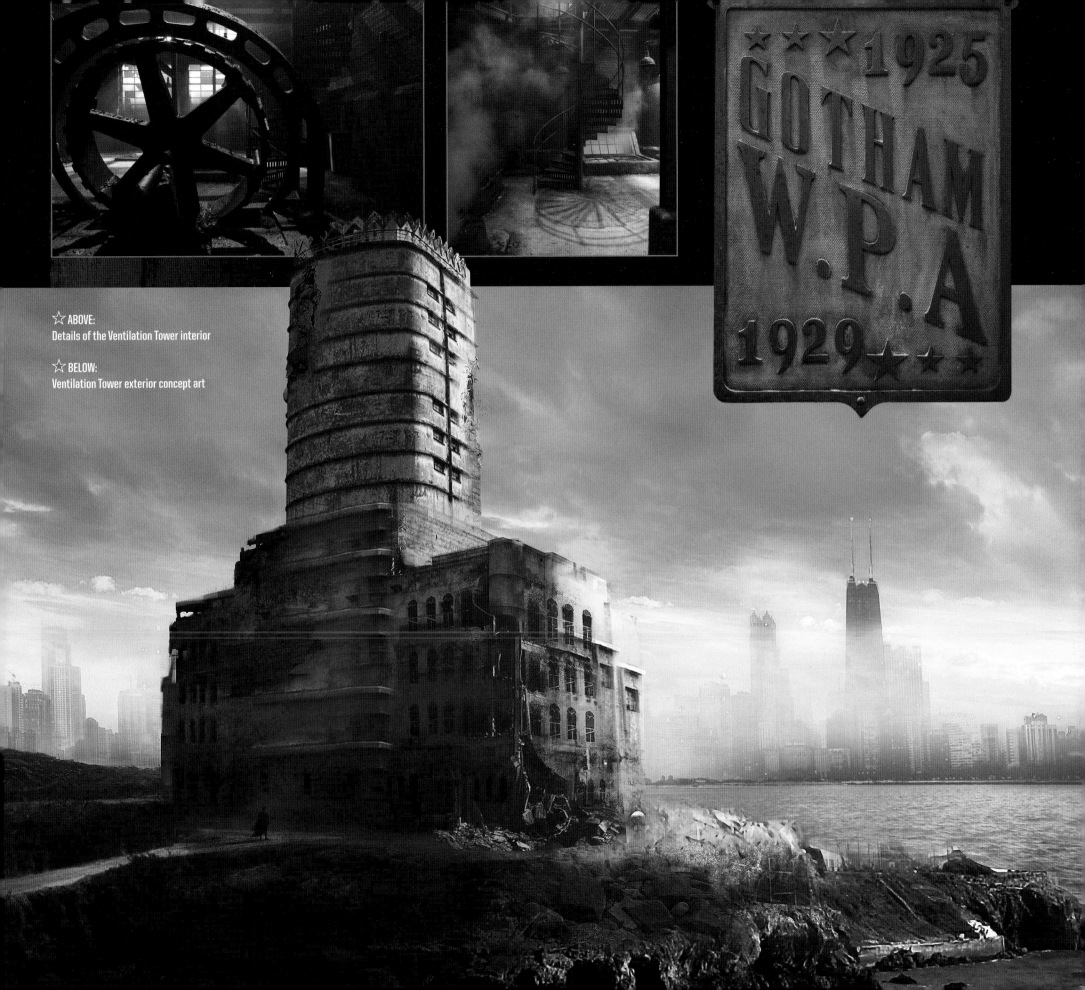

☆ ABOVE:
Details of the Ventilation Tower interior

☆ BELOW:
Ventilation Tower exterior concept art

★★★ 1925
GOTHAM
W.P.A
1929 ★★★

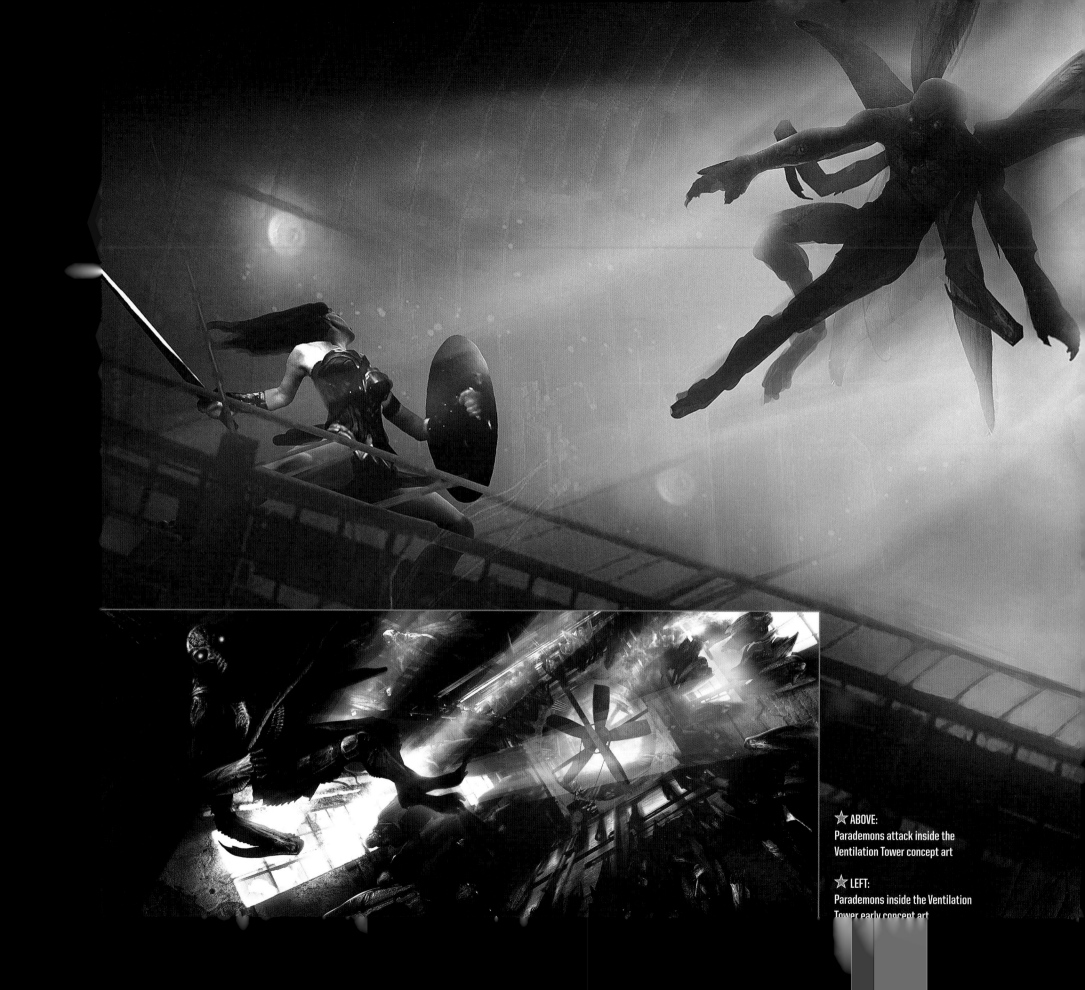

☆ ABOVE:
Parademons attack inside the
Ventilation Tower concept art

☆ LEFT:
Parademons inside the Ventilation
Tower early concept art

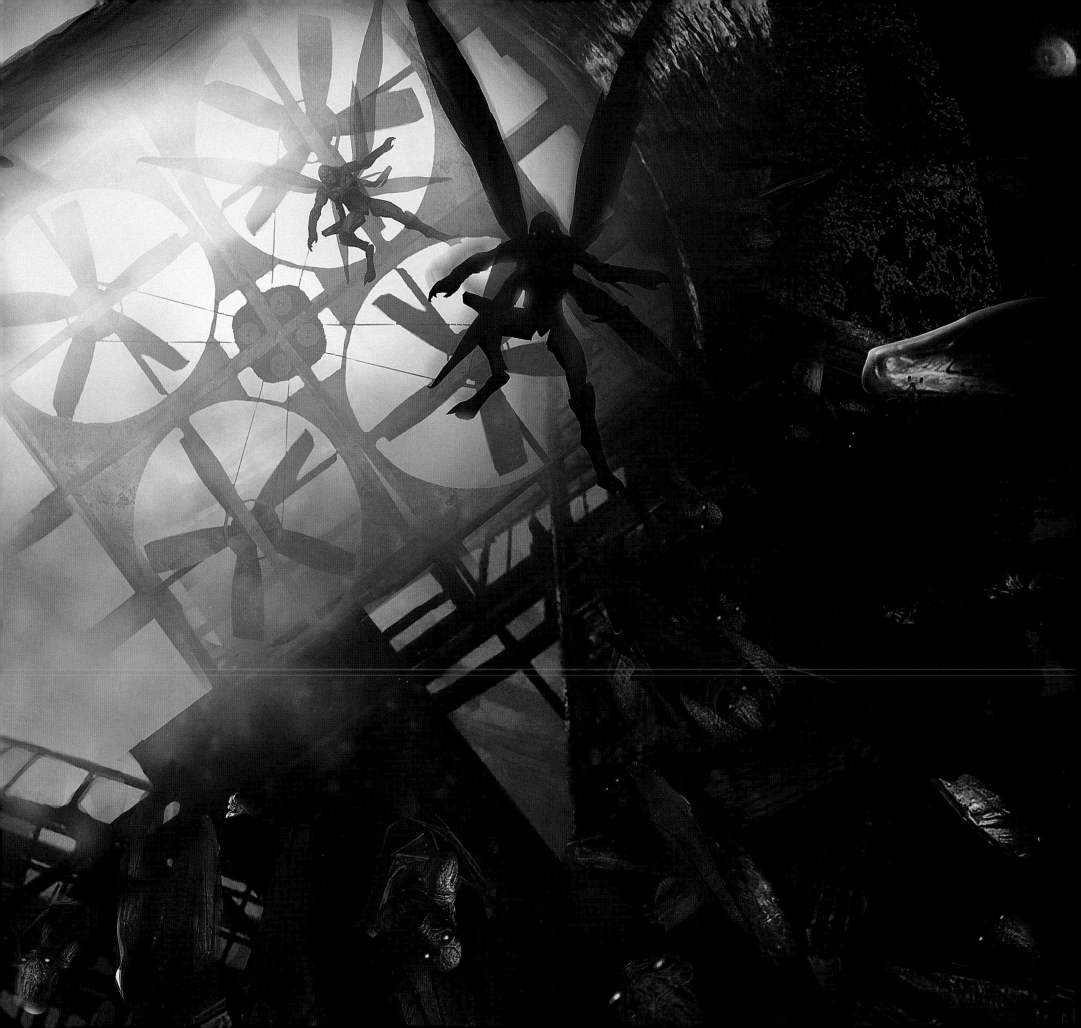

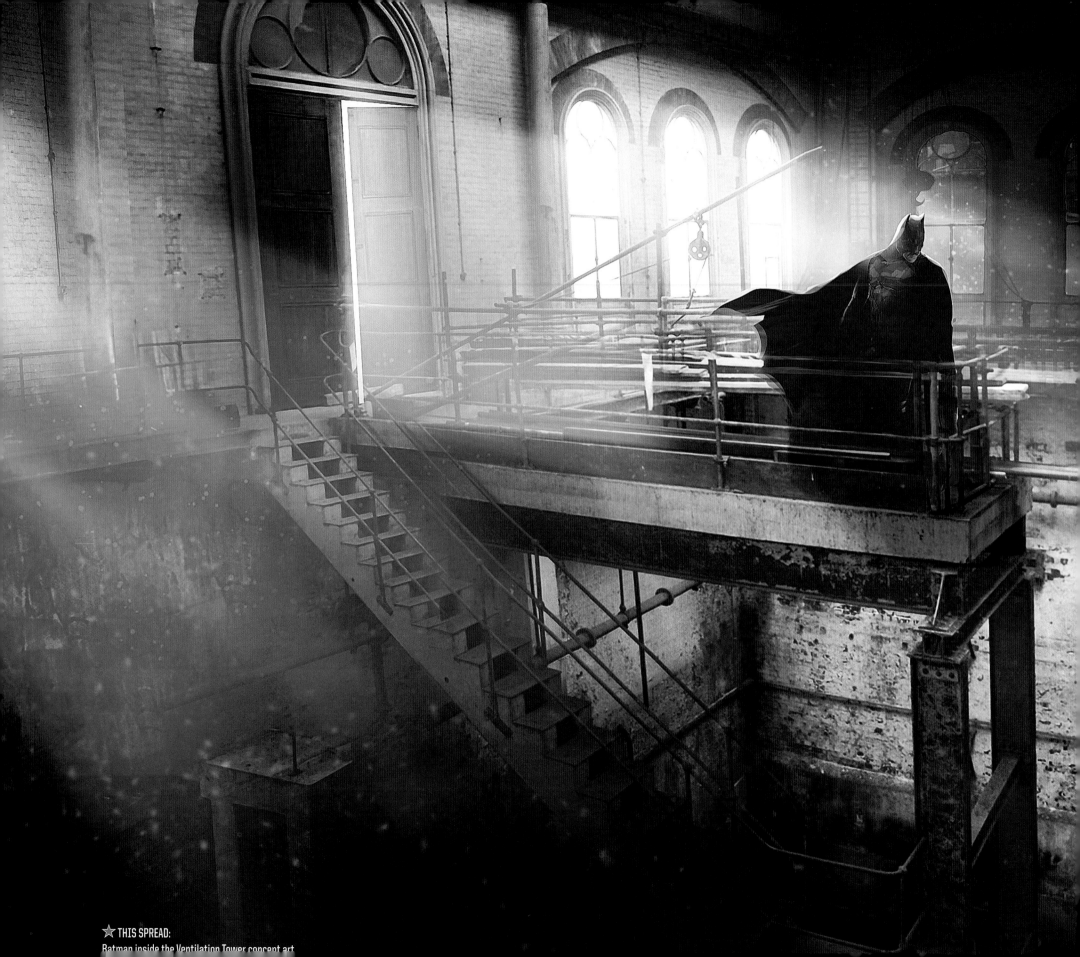

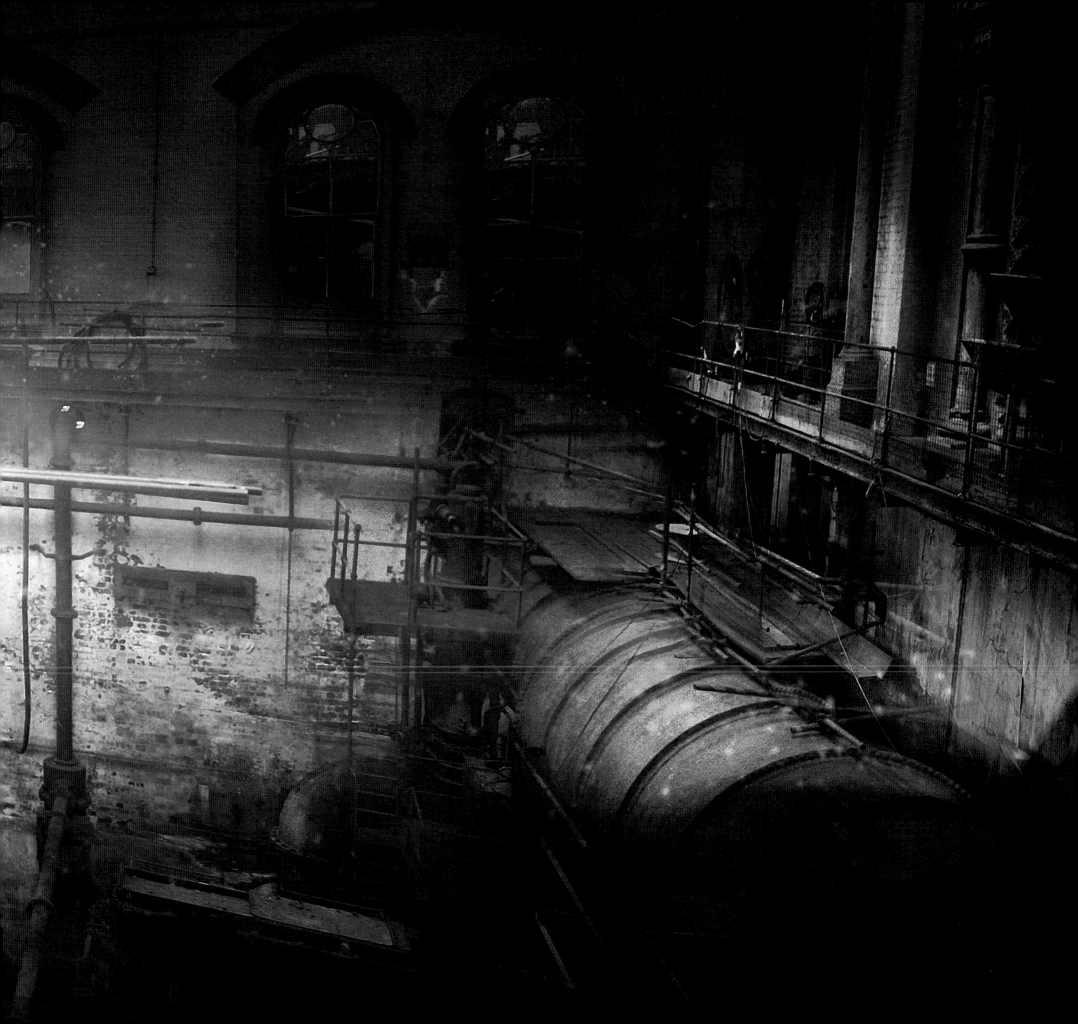

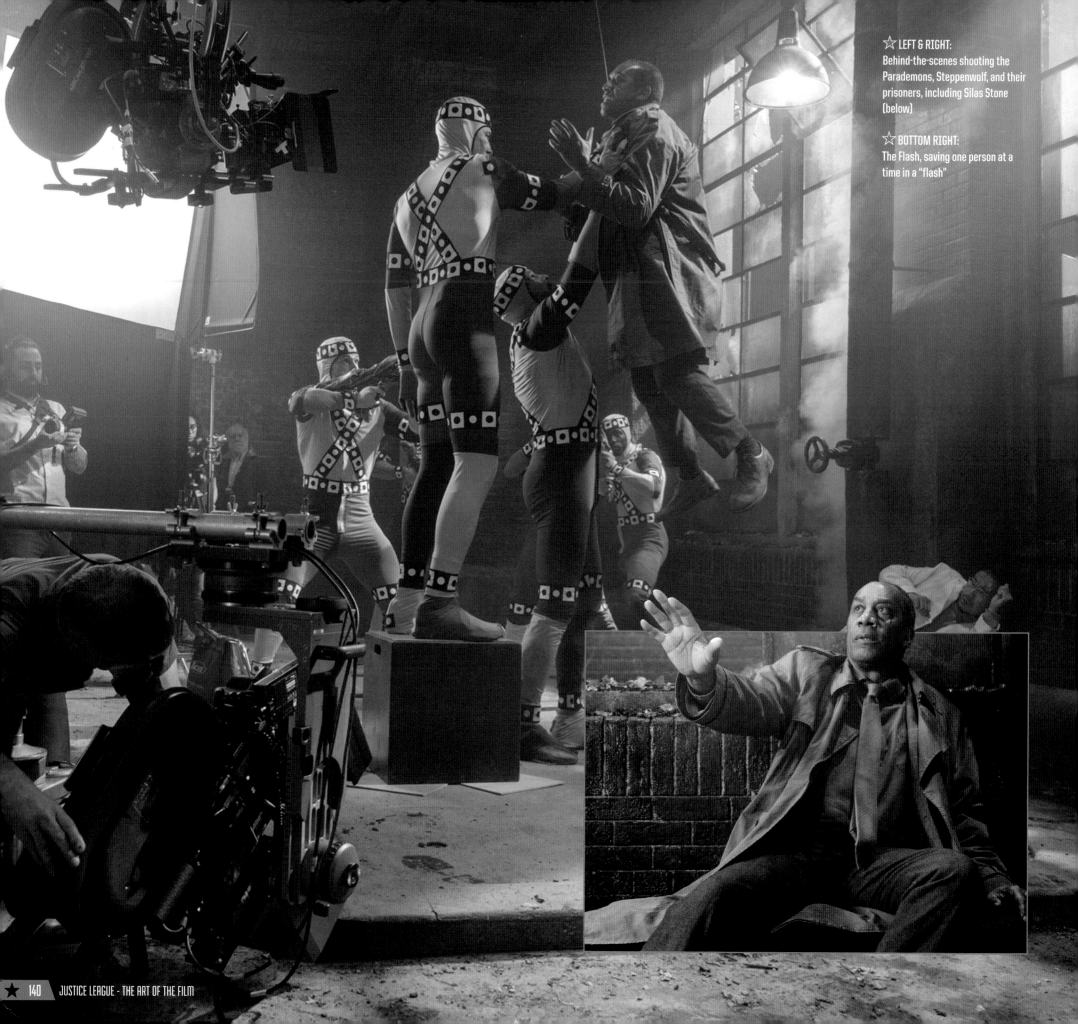

☆ LEFT & RIGHT:
Behind-the-scenes shooting the
Parademons, Steppenwolf, and their
prisoners, including Silas Stone
(below)

☆ BOTTOM RIGHT:
The Flash, saving one person at a
time in a "flash"

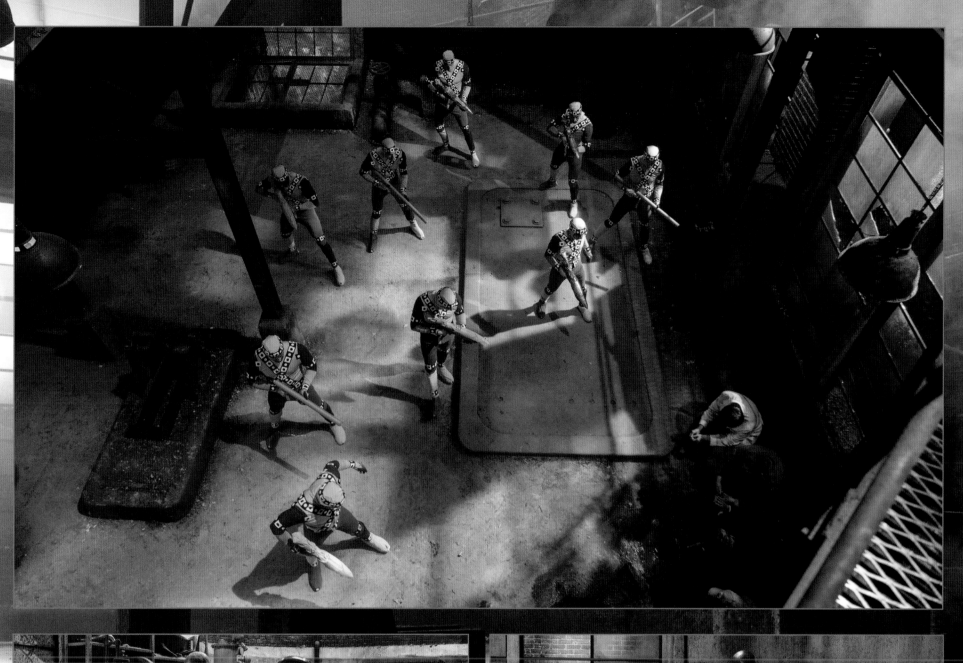

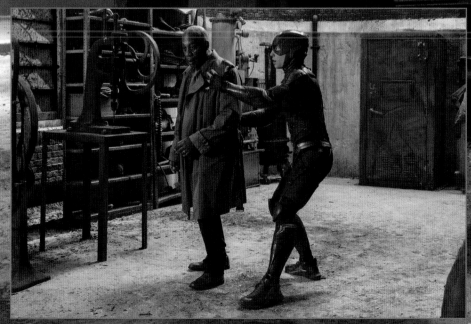

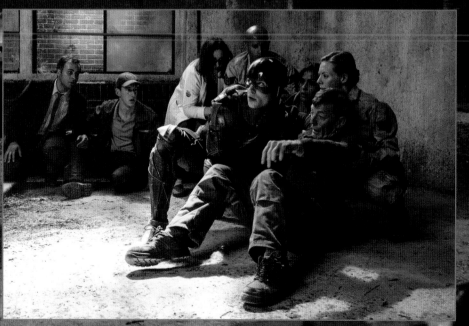

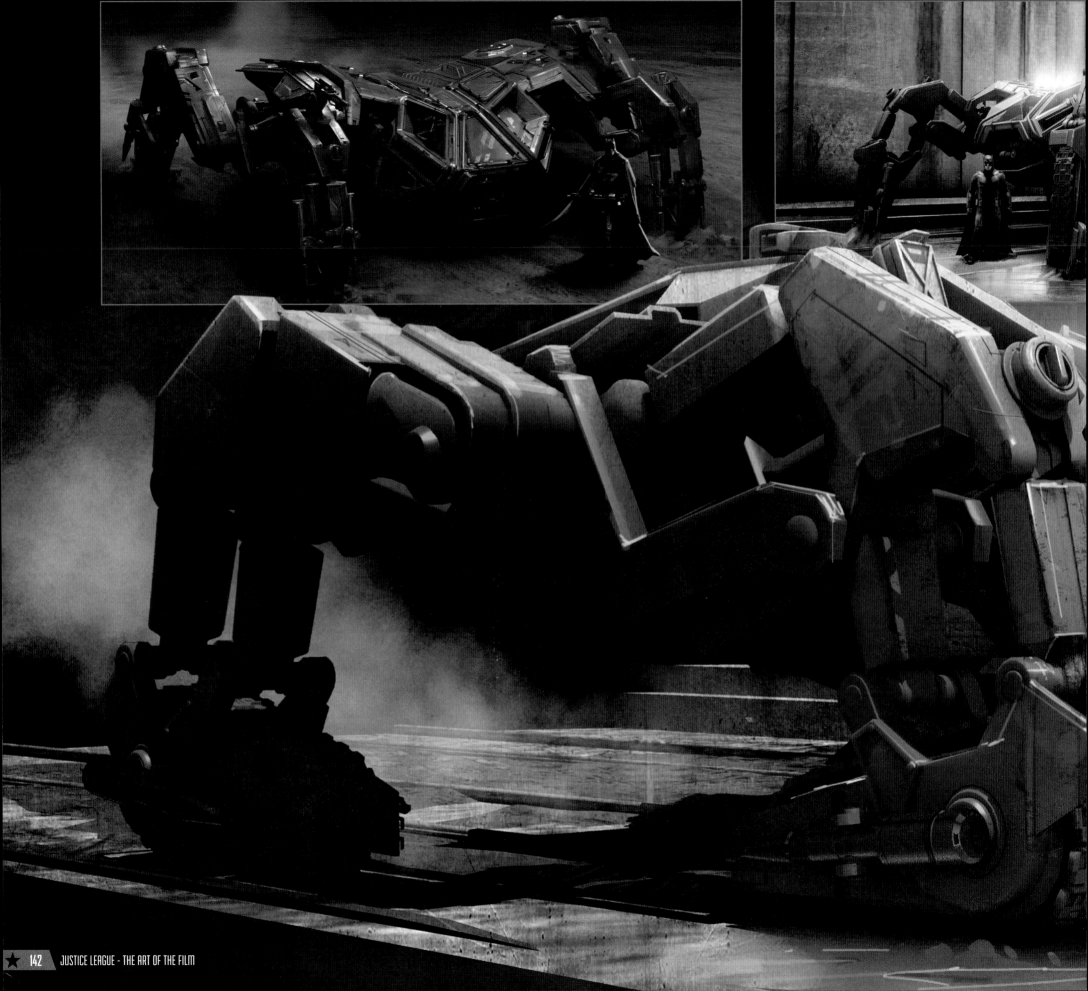

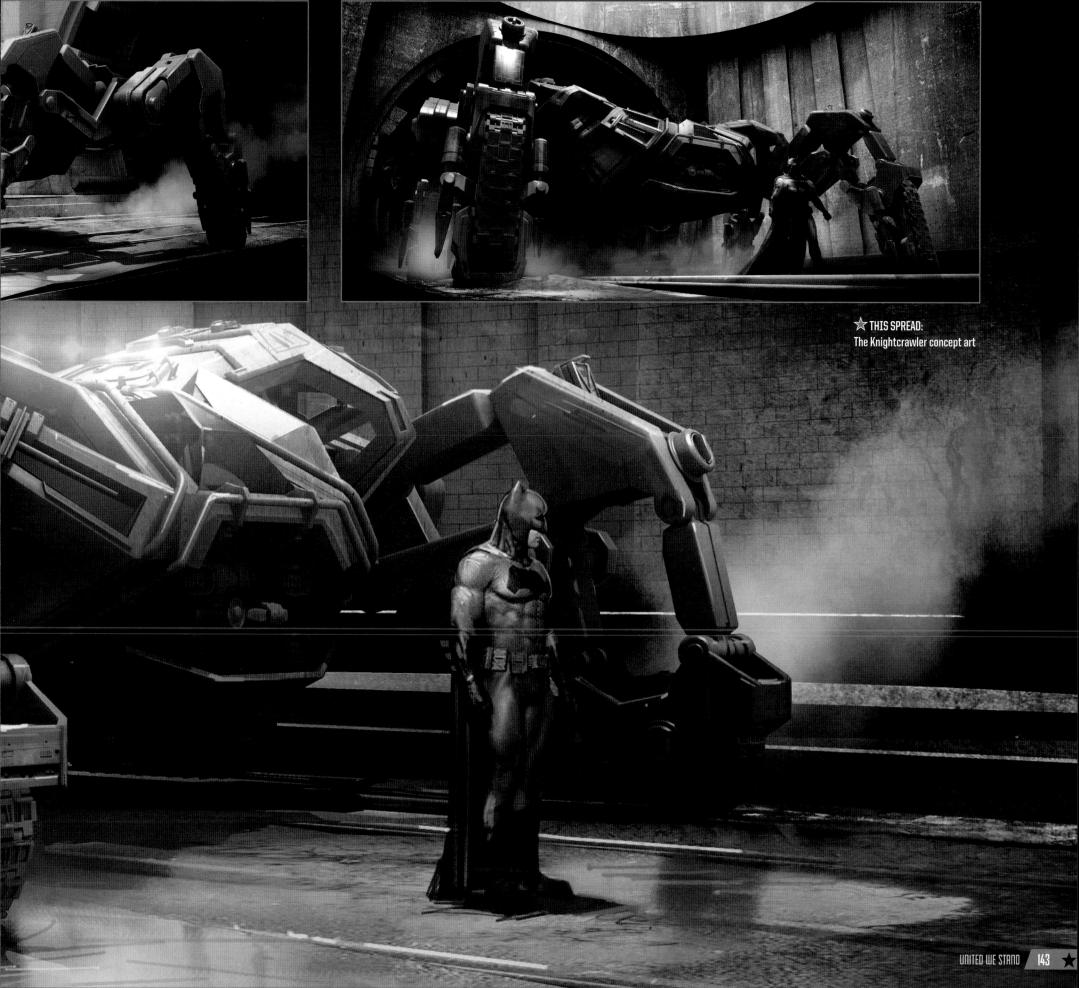

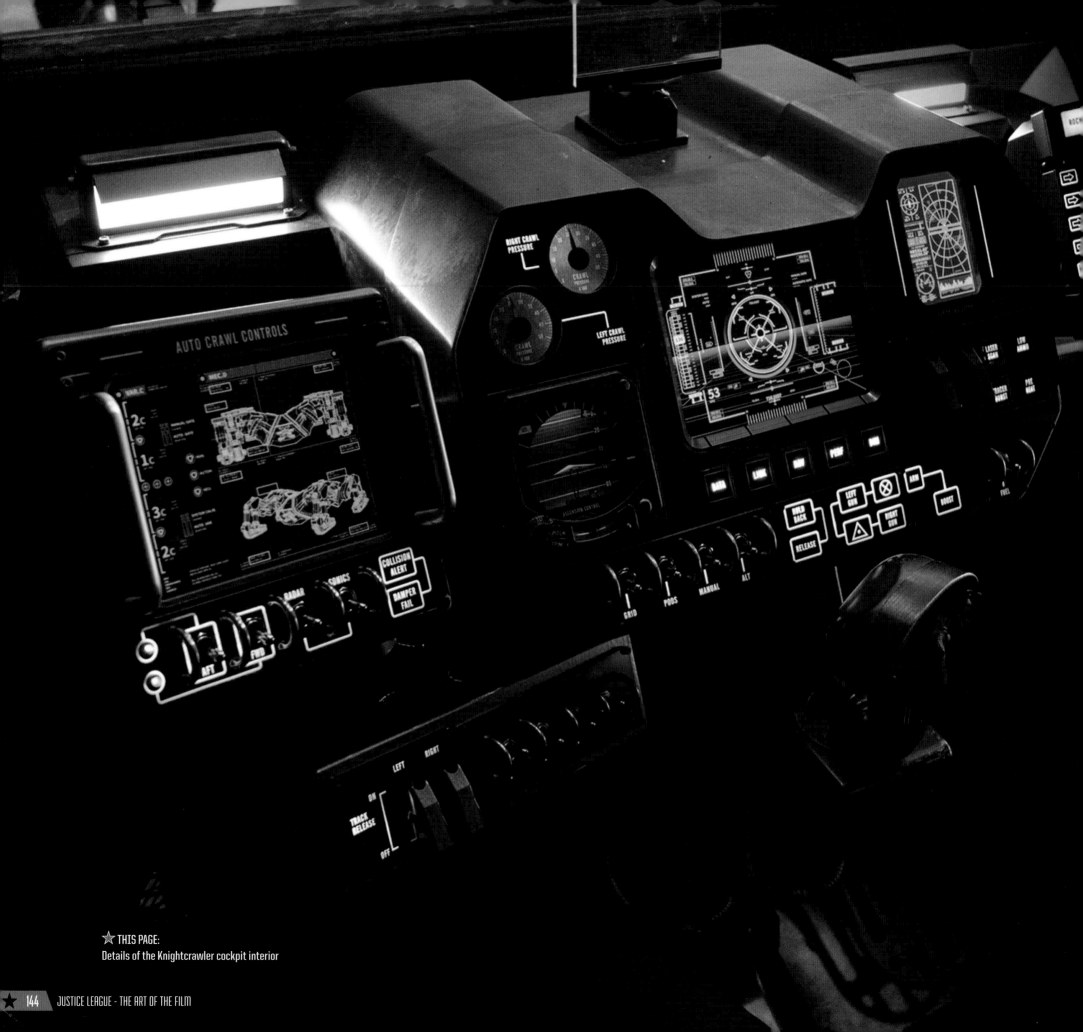

AUTO CRAWL CONTROLS

RIGHT CRAWL PRESSURE

LEFT CRAWL PRESSURE

CRAWL PRESSURE x 100

CRAWL PRESSURE x 100

LASER SCAN

LOW AMMO

TRACER BURST

PRE HEAT

HOLD BACK

RELEASE

LEFT GUN

BURST GUN

ARM

BOOST

FUEL

RADAR

SONICS

COLLISION ALERT

DAMPER FAIL

GRID

PODS

MANUAL

ALT

AFT

FWD

TRACK RELEASE

ON

OFF

LEFT

RIGHT

53

★ THIS PAGE:
Details of the Knightcrawler cockpit interior

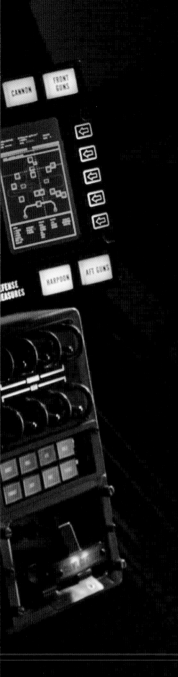

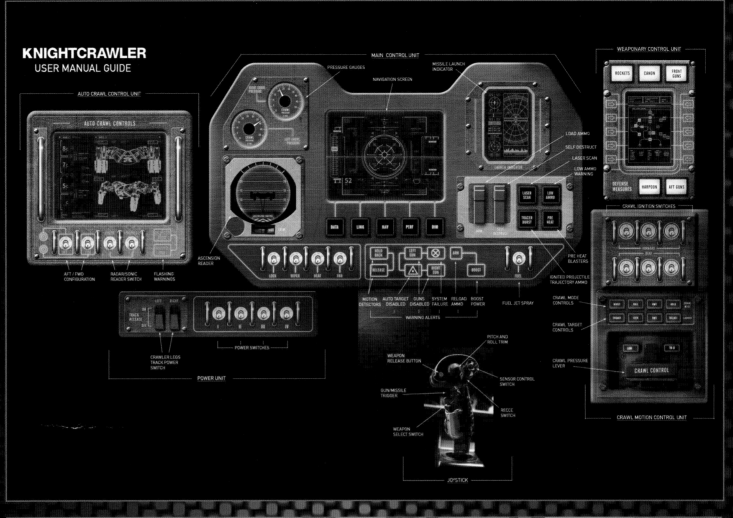

KNIGHTCRAWLER
USER MANUAL GUIDE

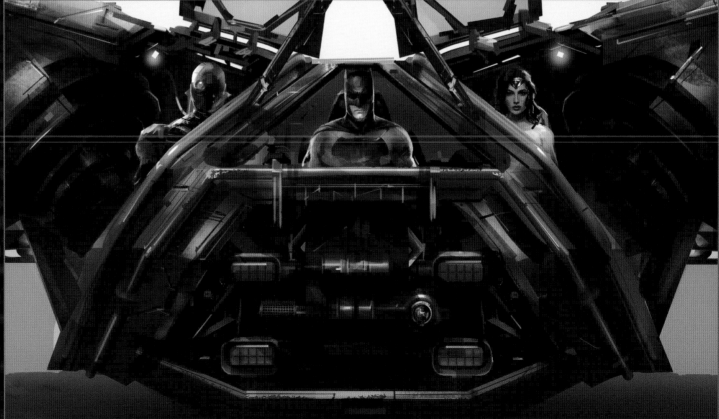

☆ TOP RIGHT:
The Knightcrawler user manual guide cockpit schematic

☆ RIGHT:
The Knightcrawler cockpit exterior concept art

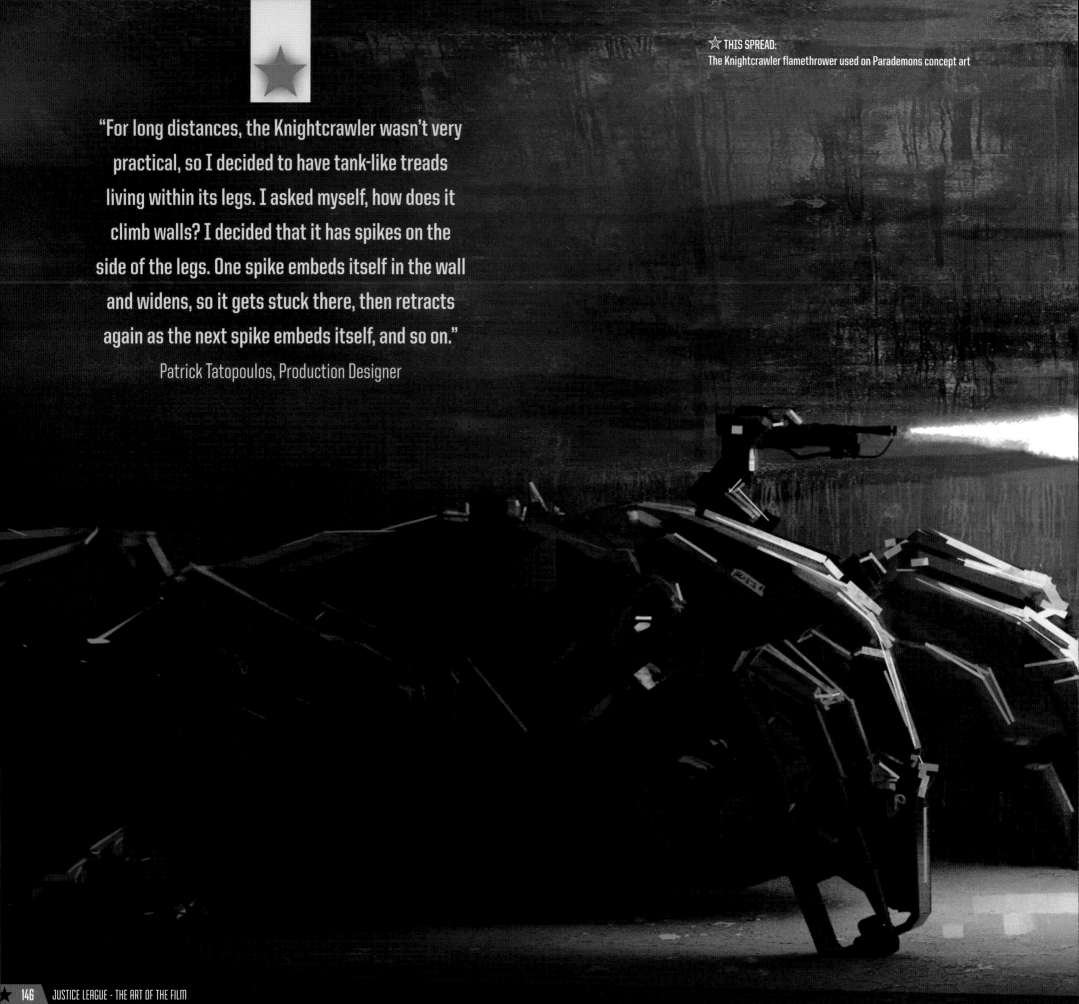

"For long distances, the Knightcrawler wasn't very practical, so I decided to have tank-like treads living within its legs. I asked myself, how does it climb walls? I decided that it has spikes on the side of the legs. One spike embeds itself in the wall and widens, so it gets stuck there, then retracts again as the next spike embeds itself, and so on."

Patrick Tatopoulos, Production Designer

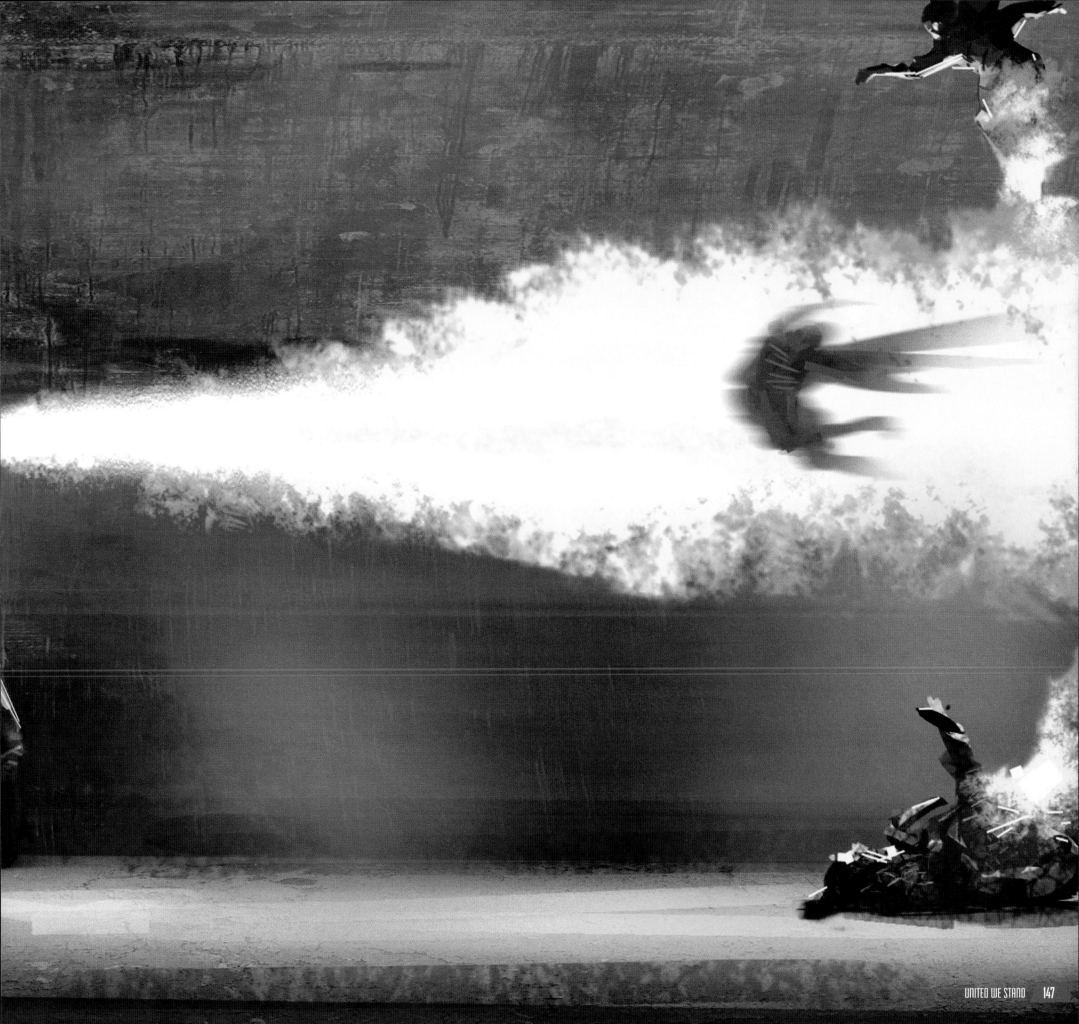

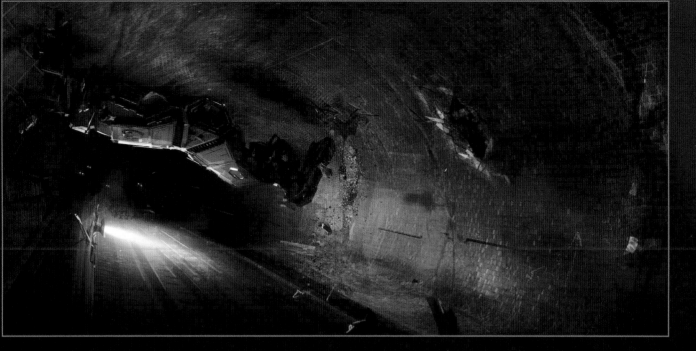

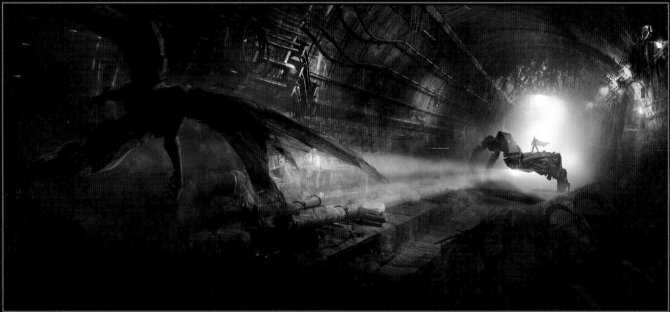

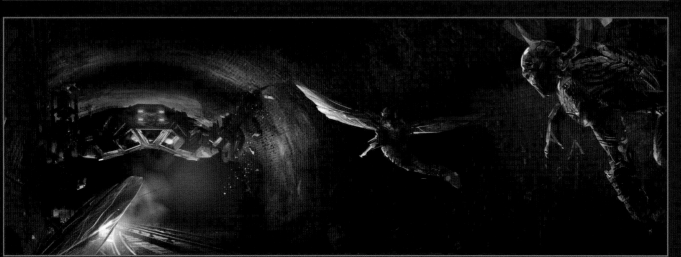

⭐ LEFT:
The Knightcrawler in the Ventilation Tower Tunnel concept art

⭐ RIGHT:
The Knightcrawler in the Ventilation Tower concept art

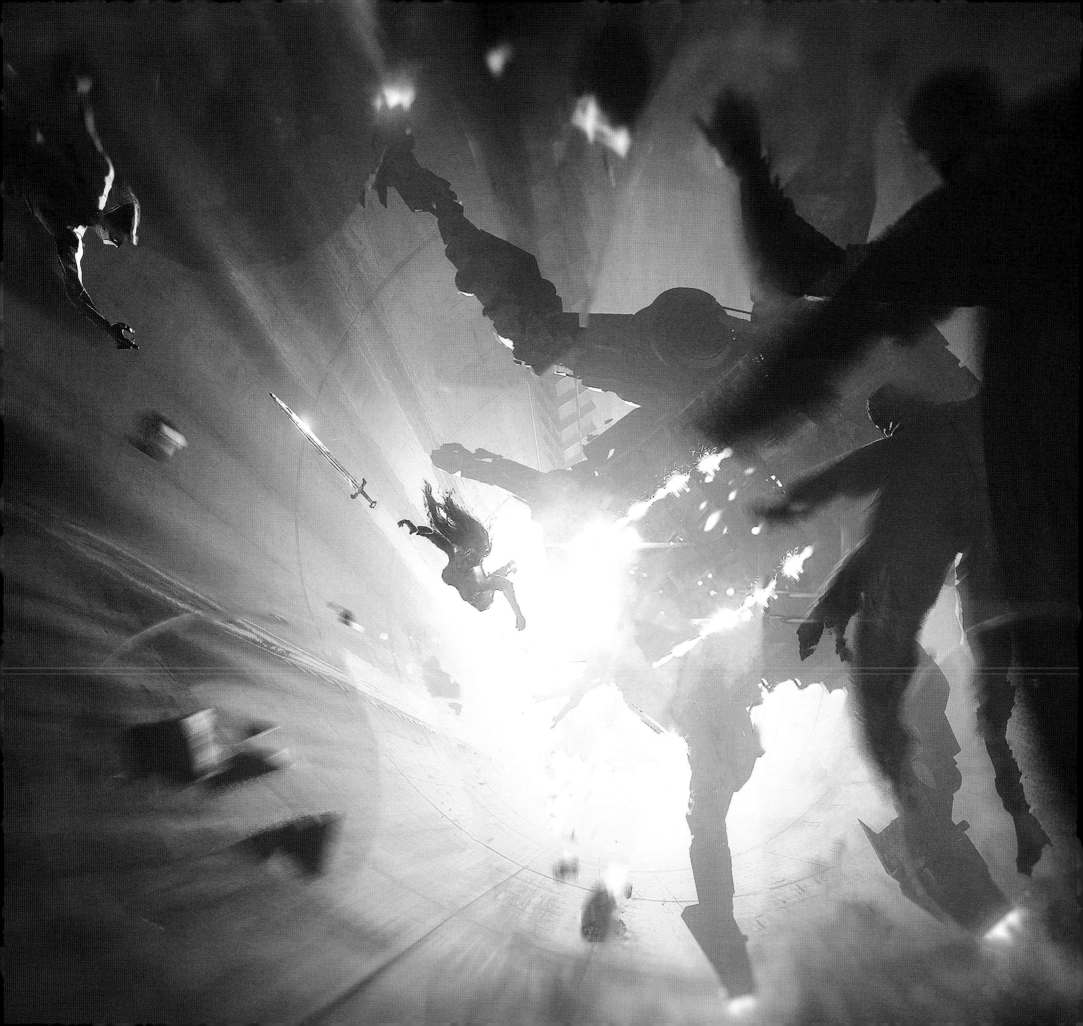

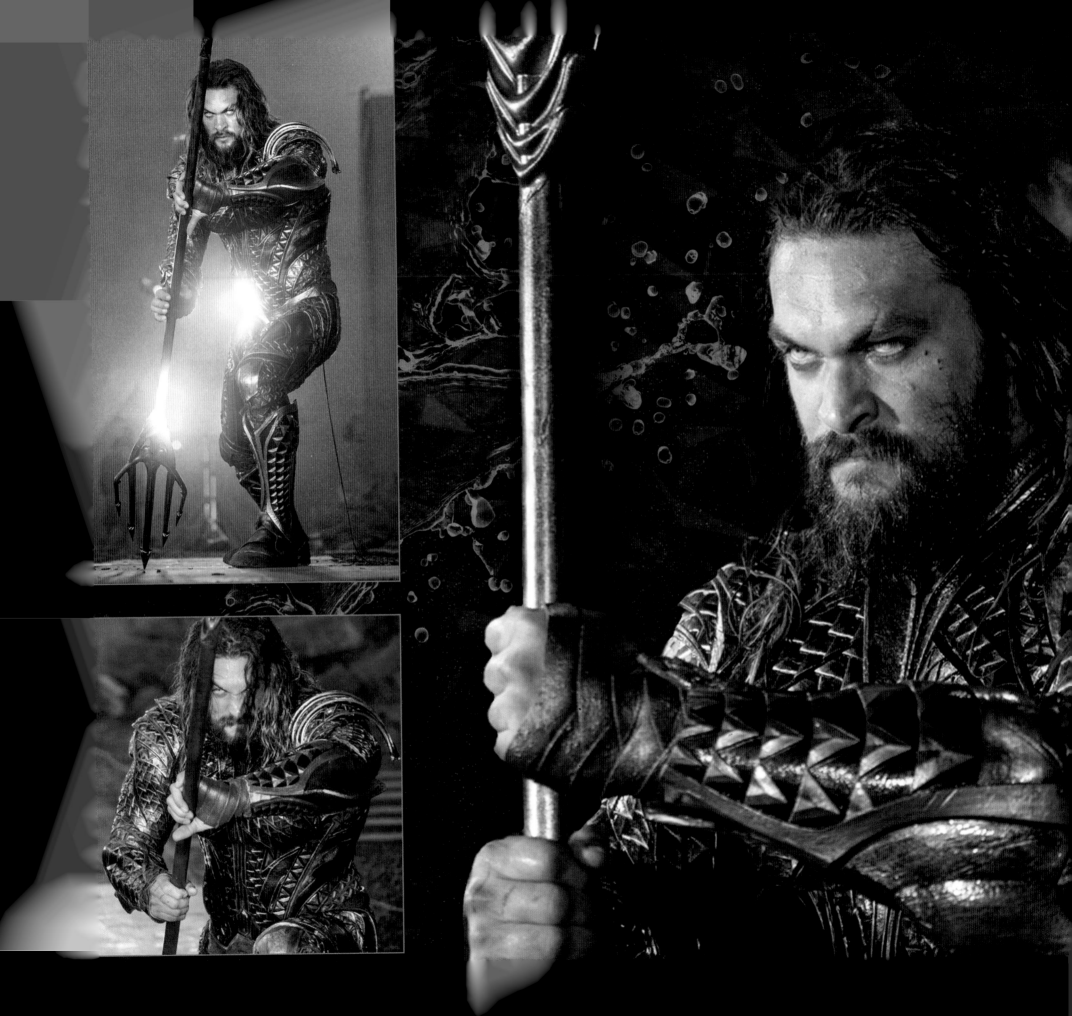

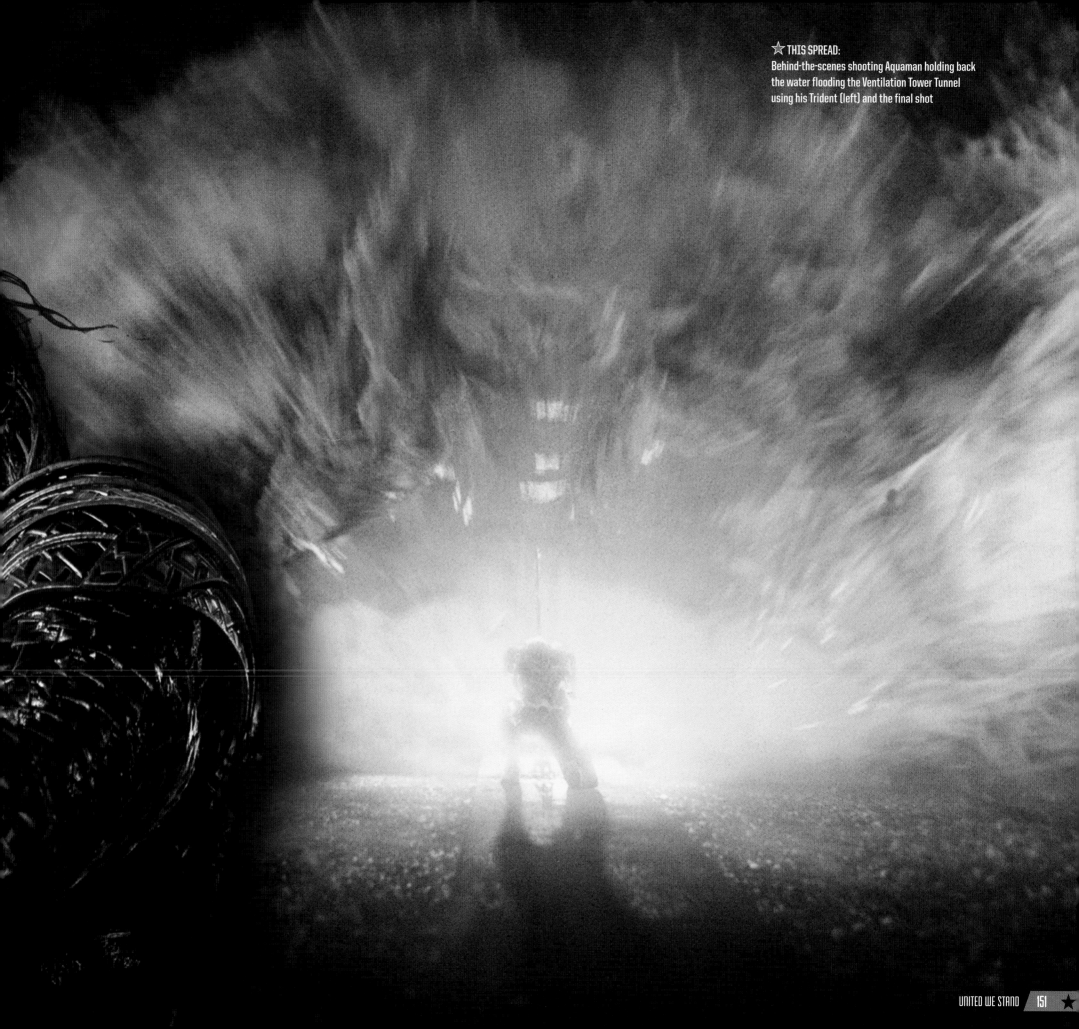

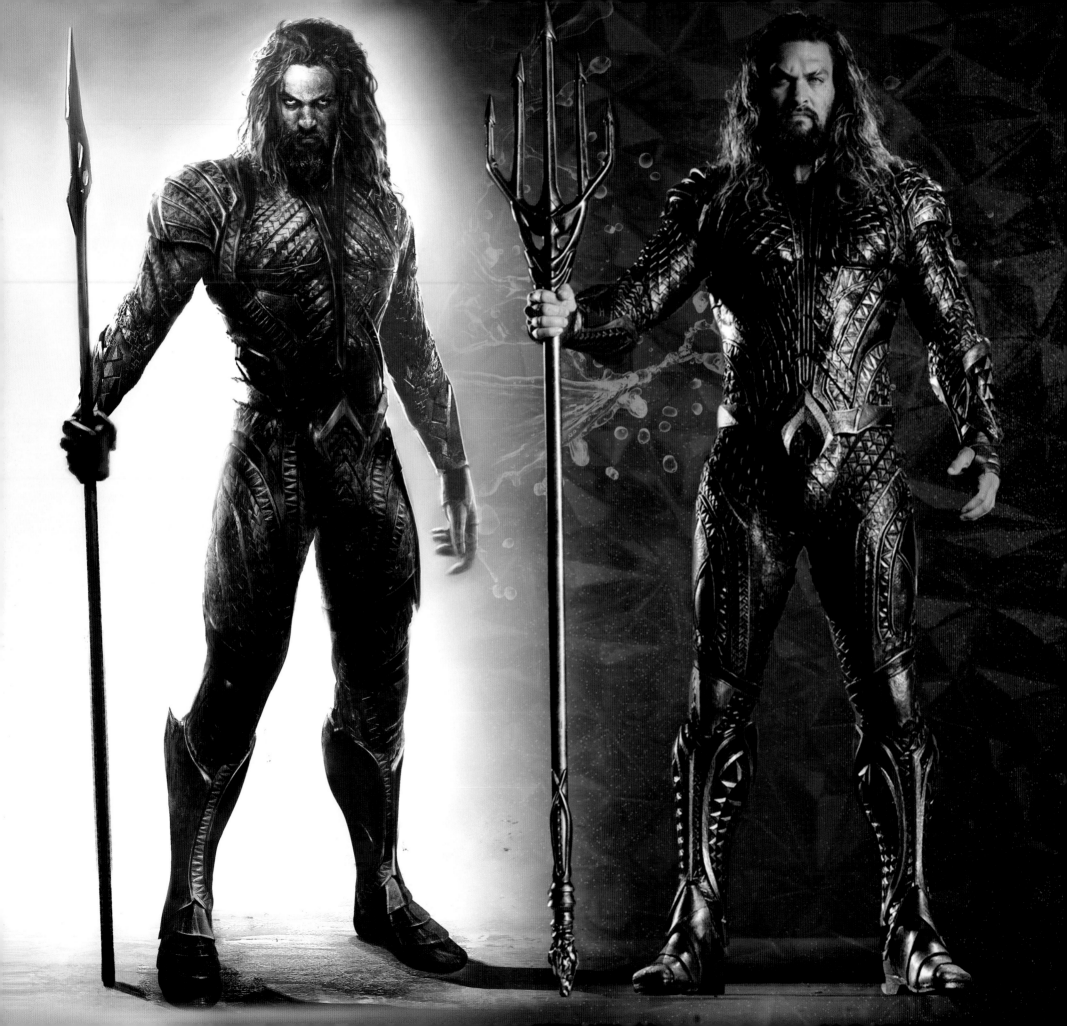

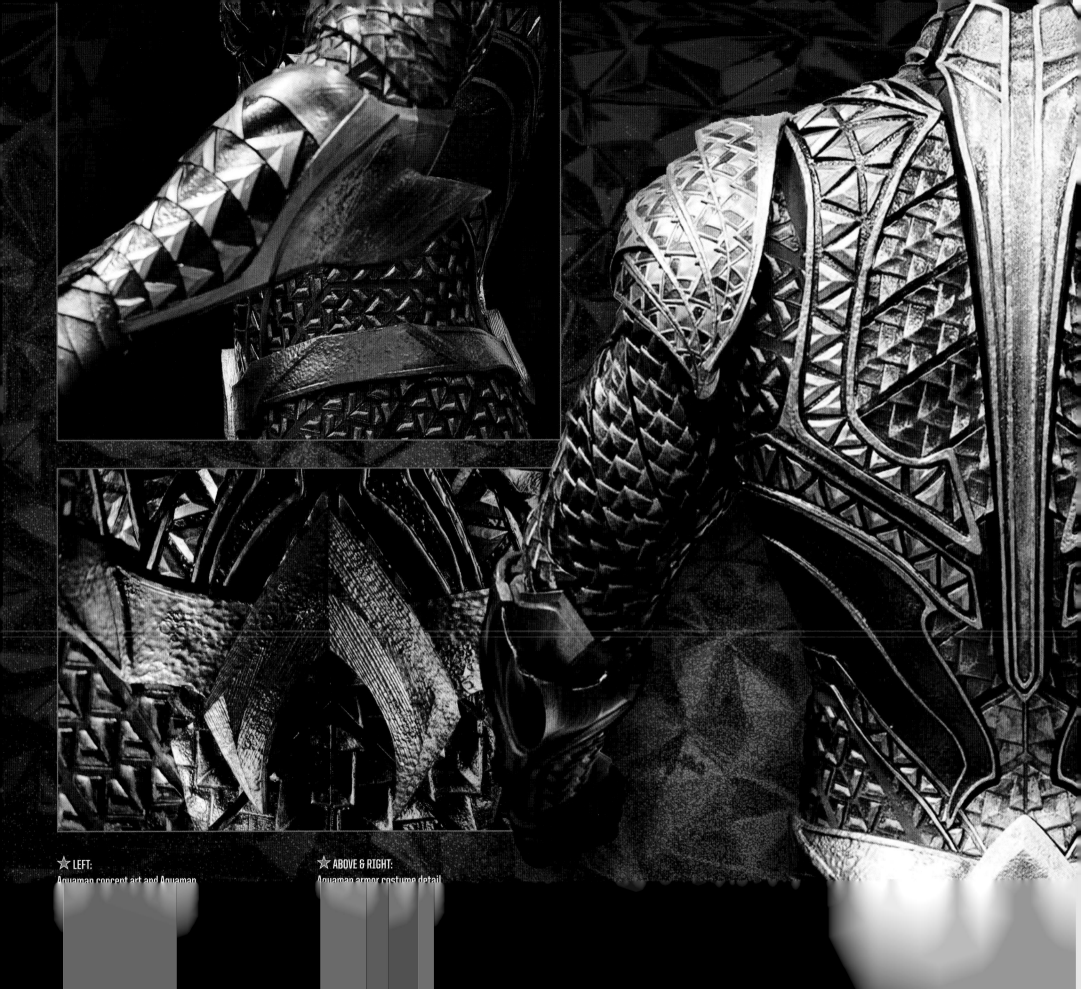

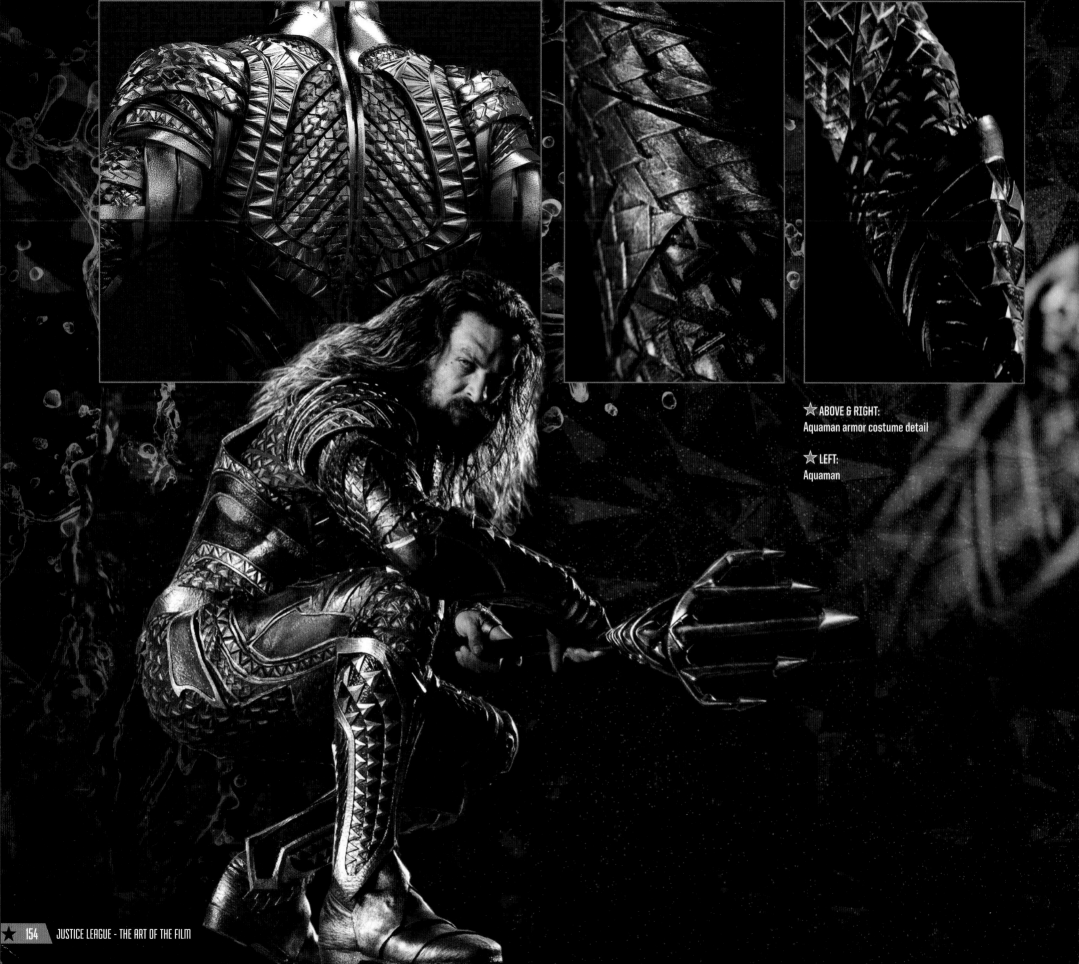

★ABOVE & RIGHT:
Aquaman armor costume detail

★LEFT:
Aquaman

HOPE
AWAKENED

"Superman's return is both physical and symbolic. The first two movies were his origin story: h

Earth, realized his powers and started to use them, but he was looking for his place in the wo

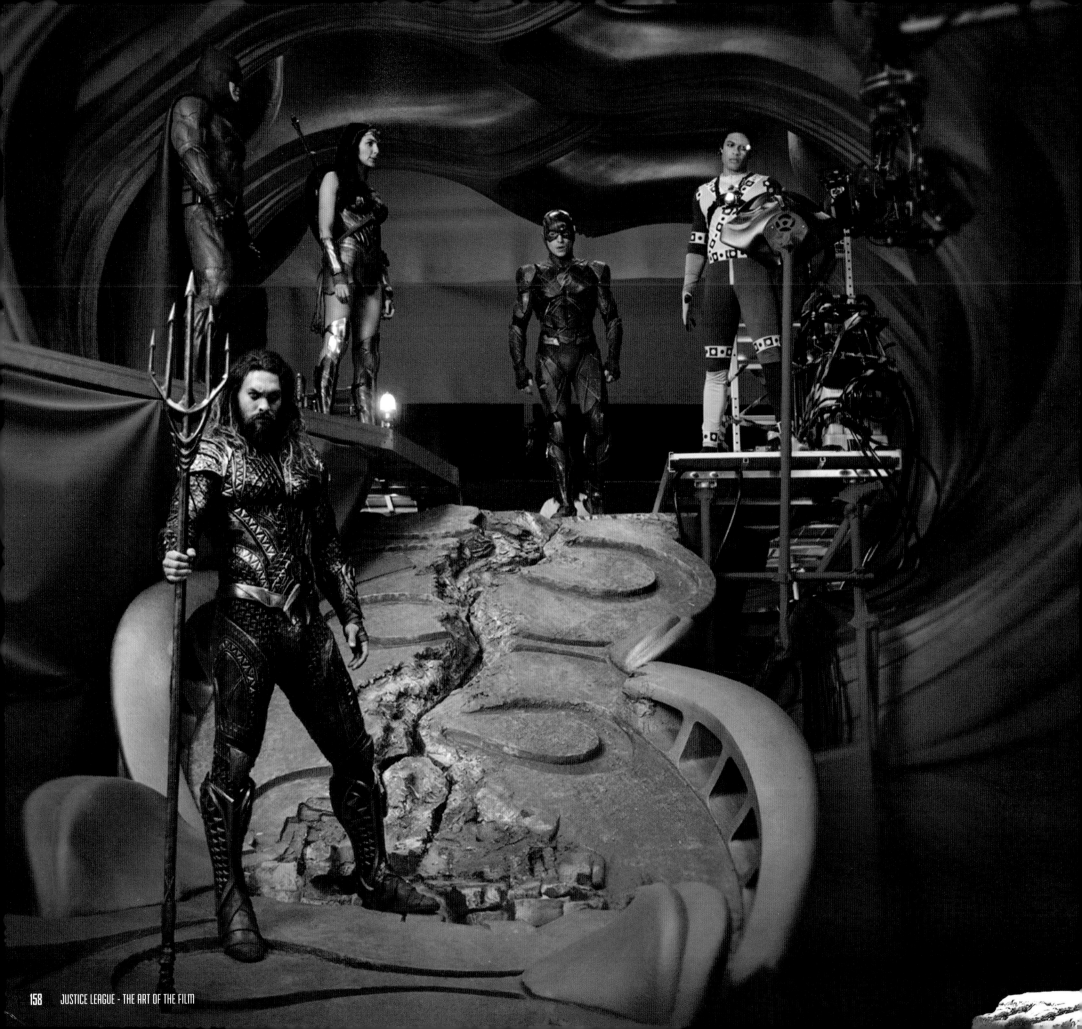

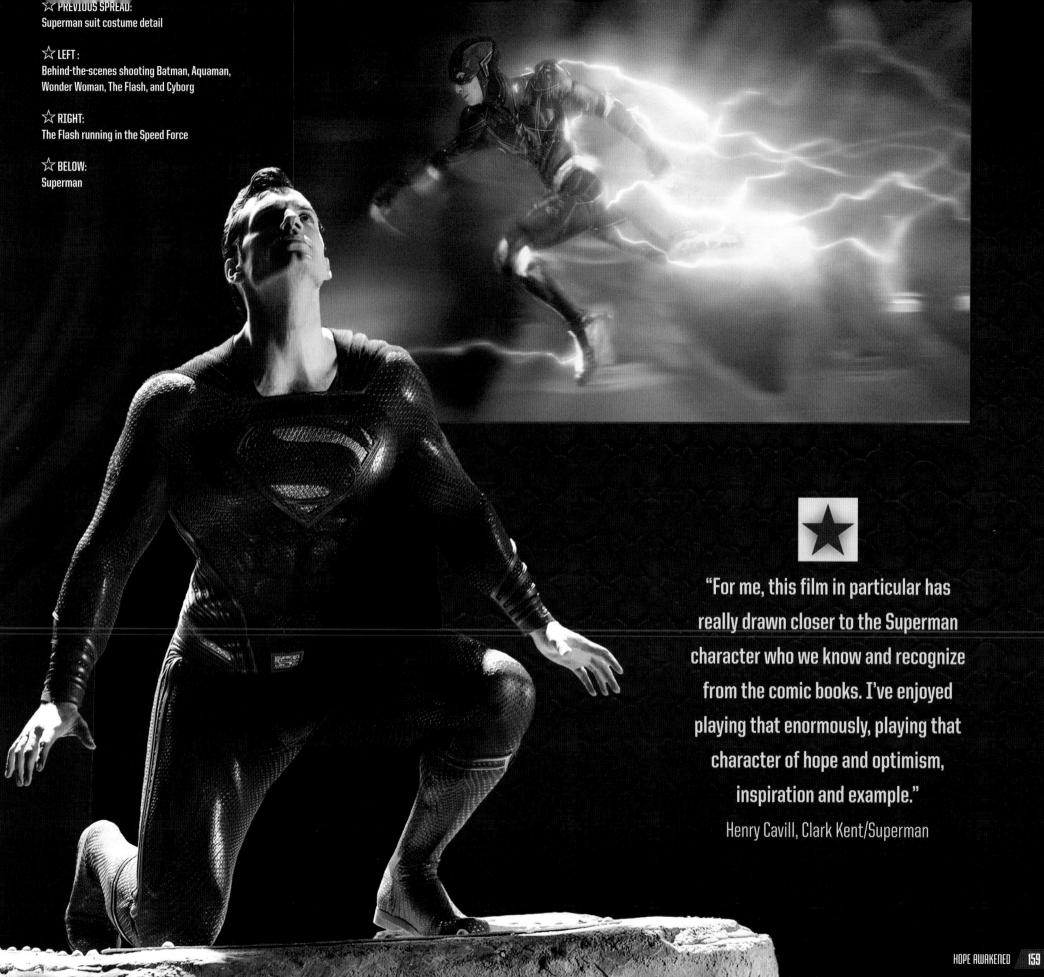

☆ PREVIOUS SPREAD:
Superman suit costume detail

☆ LEFT :
Behind-the-scenes shooting Batman, Aquaman,
Wonder Woman, The Flash, and Cyborg

☆ RIGHT:
The Flash running in the Speed Force

☆ BELOW:
Superman

"For me, this film in particular has really drawn closer to the Superman character who we know and recognize from the comic books. I've enjoyed playing that enormously, playing that character of hope and optimism, inspiration and example."

Henry Cavill, Clark Kent/Superman

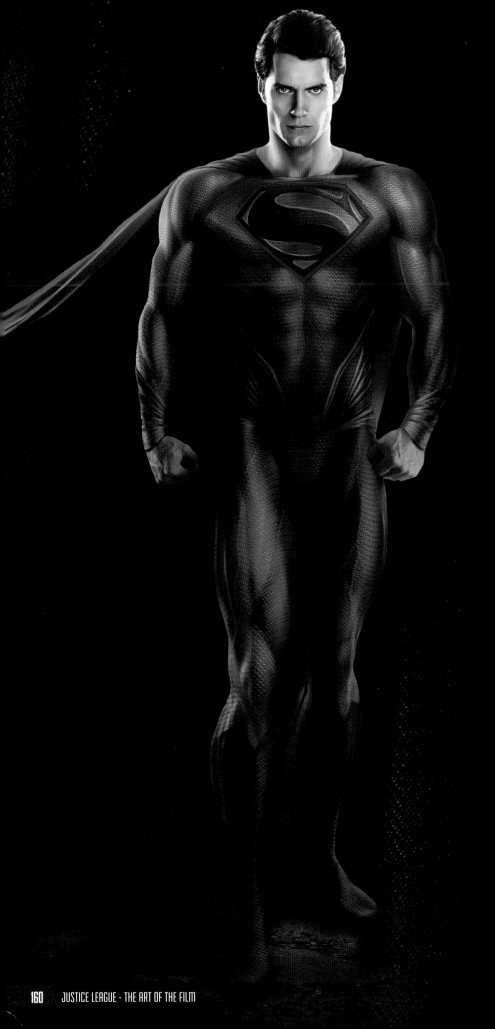

☆ LEFT:
Superman concept art

☆ ABOVE & RIGHT:
Superman's suit costume detail with Kryptonian scripture

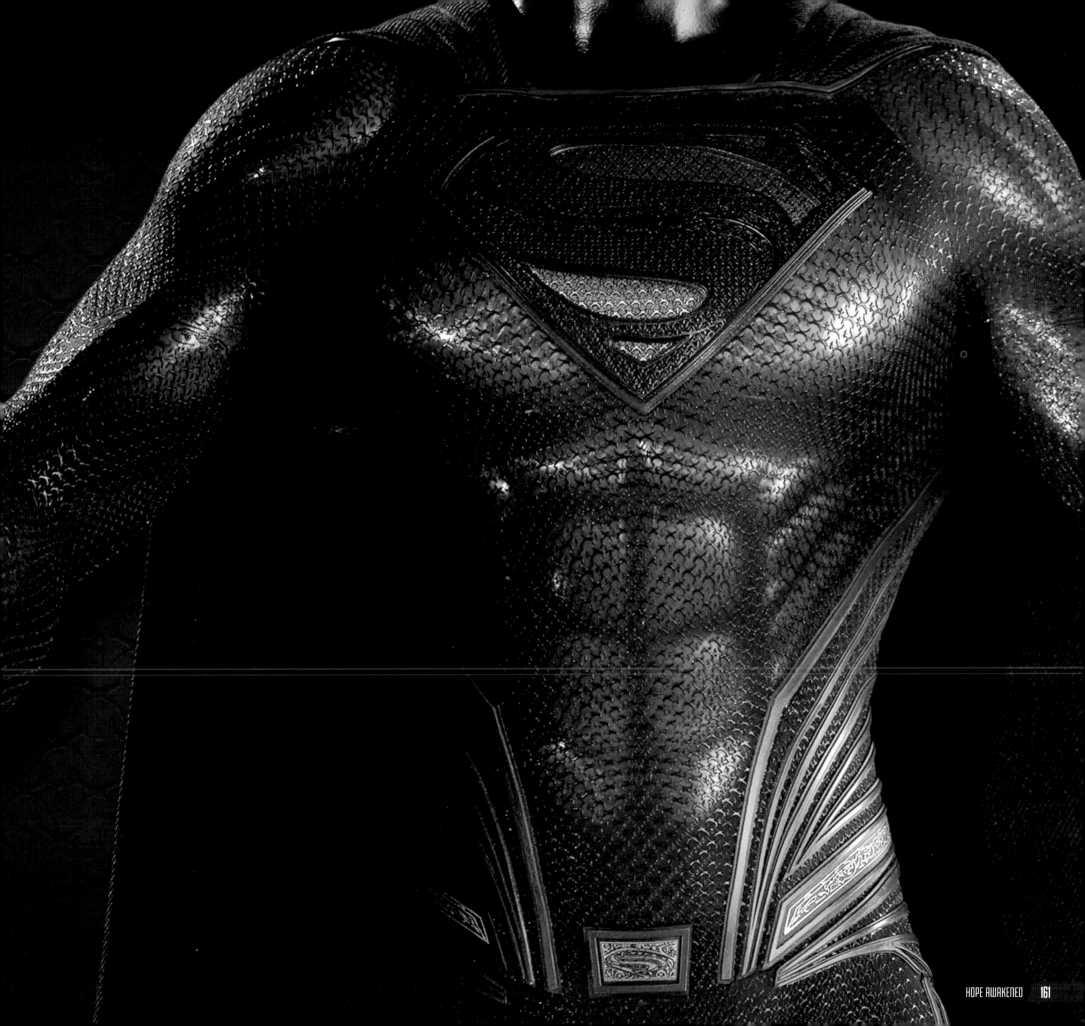

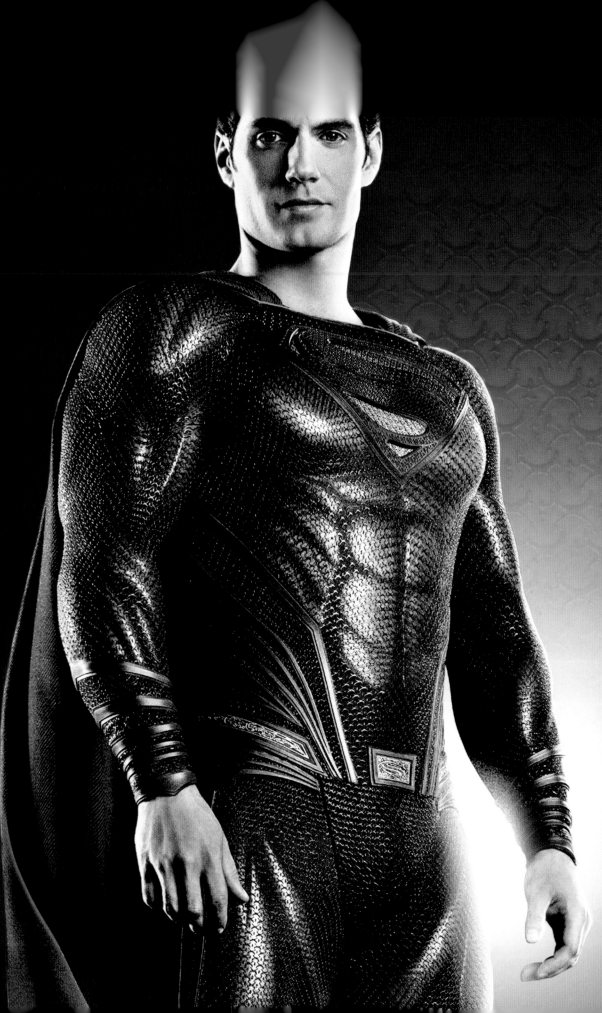

"Superman really jumps off the screen in such a heroic way when he finally makes his appearance in this film. His suit has a slightly bolder blue. It's a little more lustrous. We found new printing inks that make a dimensional high-raised surface and new paints and materials that make the undersuit incredibly chromed and shiny."

Michael Wilkinson, Costume Designer

☆ ABOVE:
Superman's cape costume detail

☆ RIGHT:
Superman

☆ OPPOSITE:
Superman concept art

☆ NEXT SPREAD:
Wonder Woman, Cyborg, and the Batmobile concept art

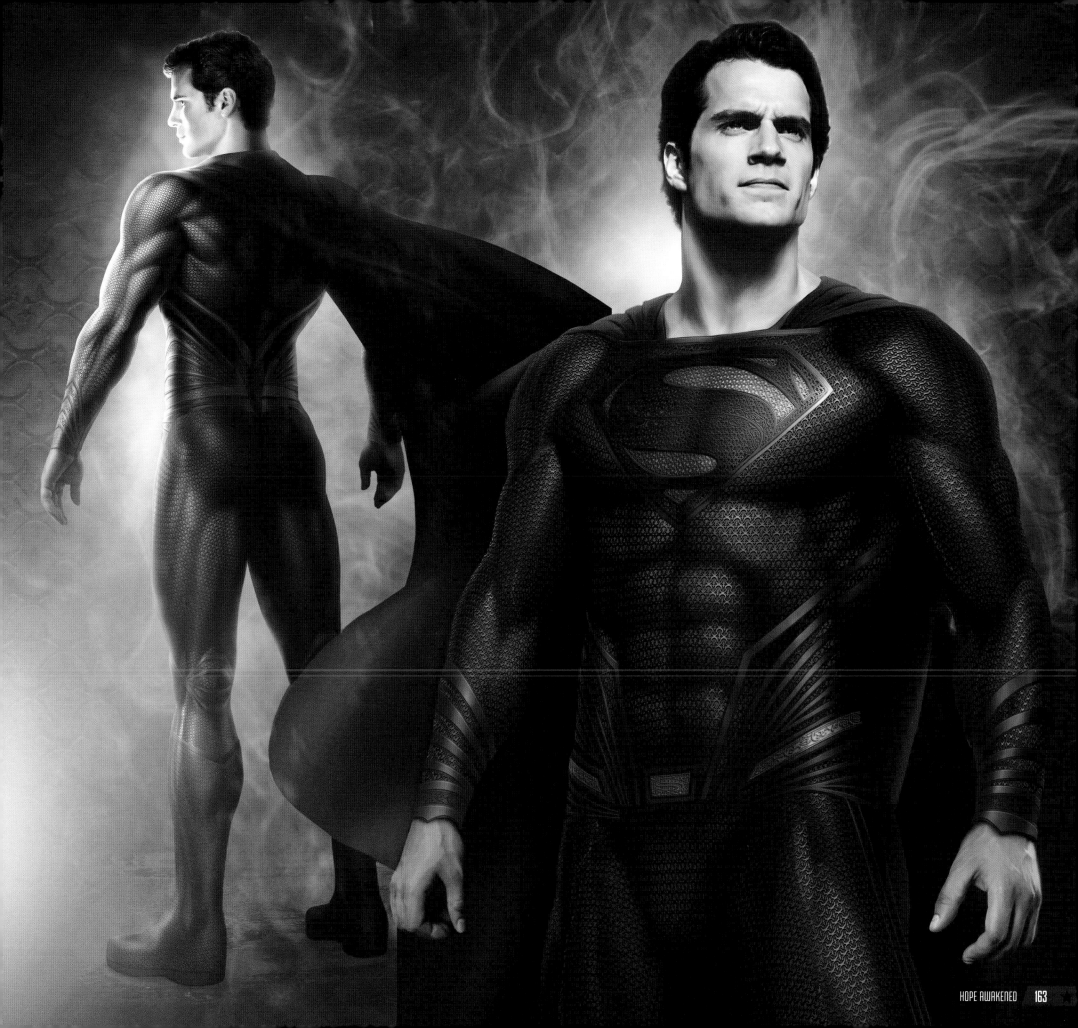

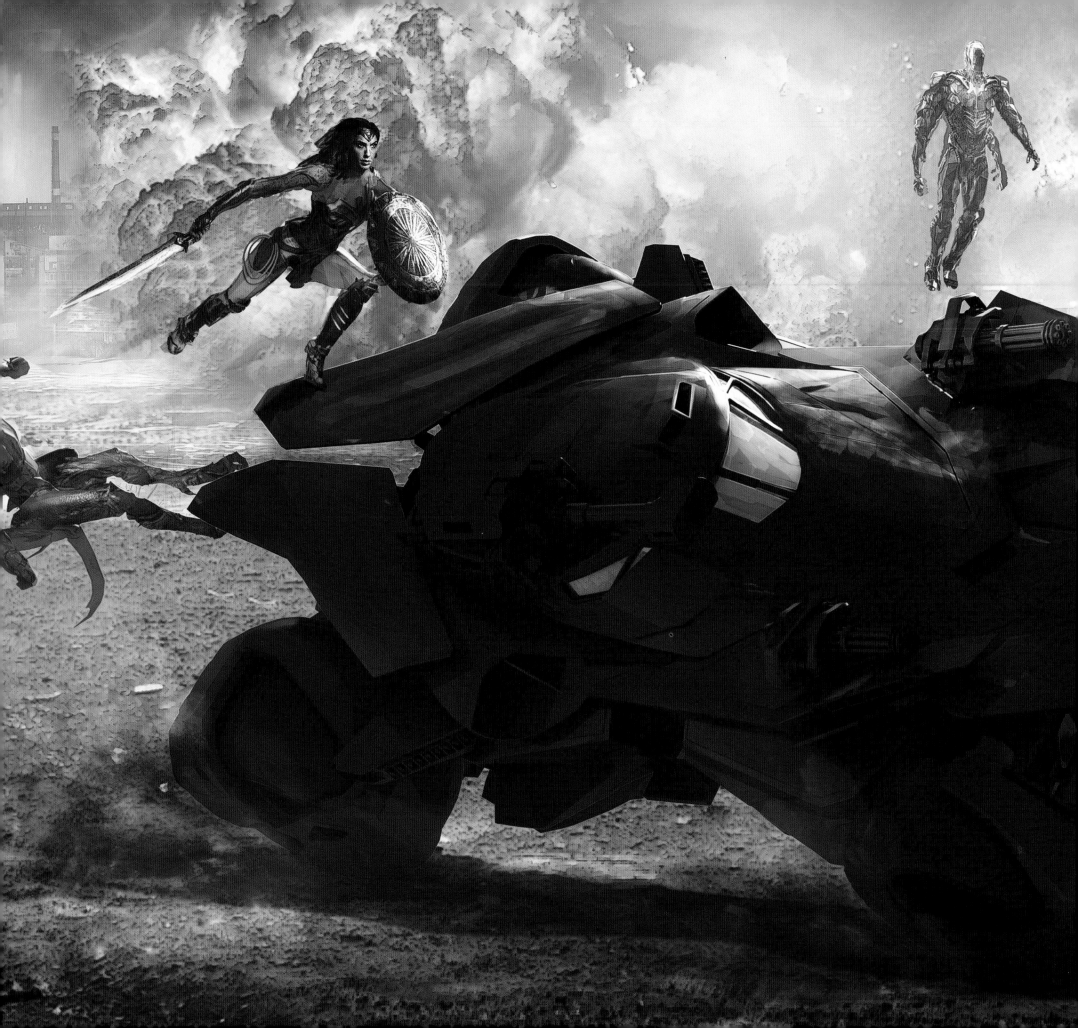

JUSTICE FOR ALL

"Pozharnov is where the Parademons and Steppenwolf have their base and where the third act of the film takes place, so it's a very important set. It's where the whole team, the complete Justice League, come together to stop Steppenwolf from conquering the world."

Patrick Tatopoulos, Production Designer

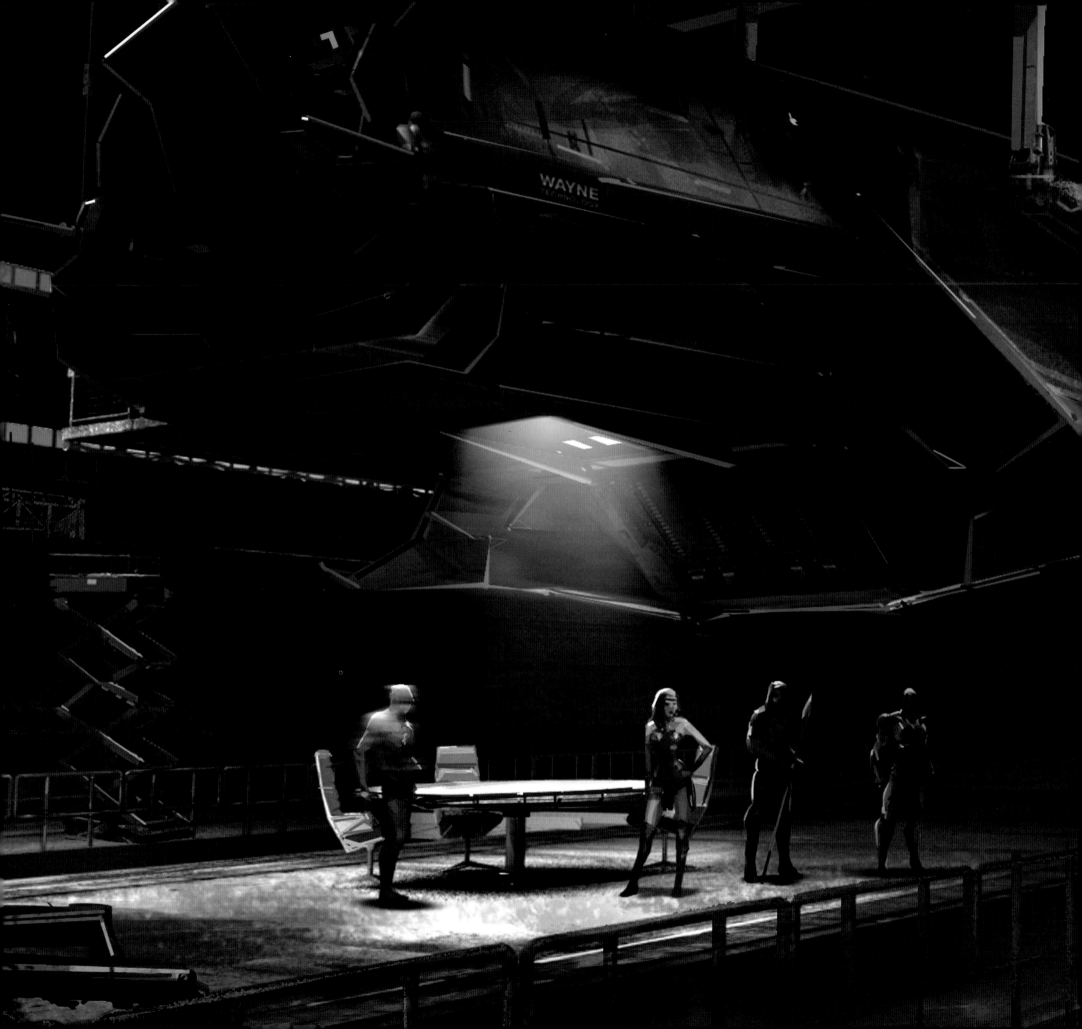

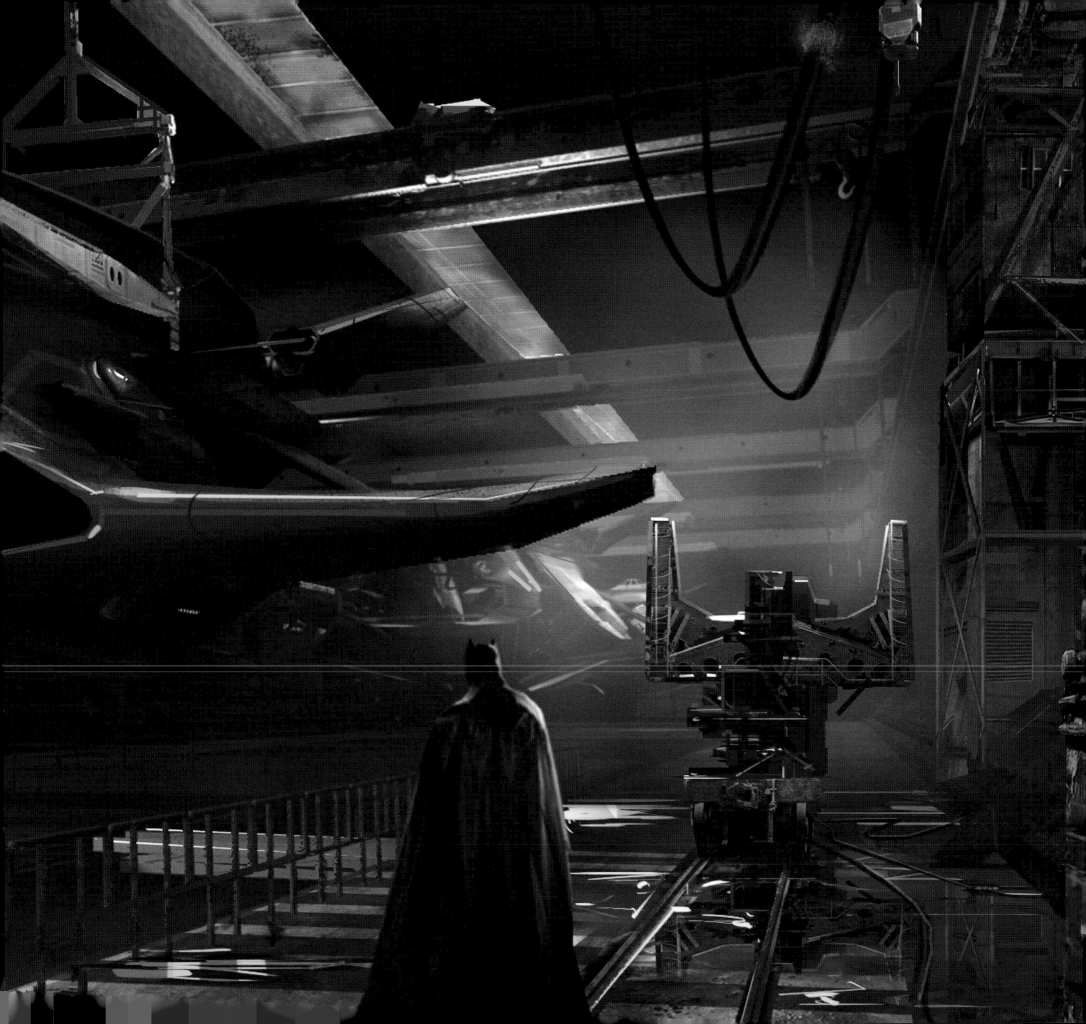

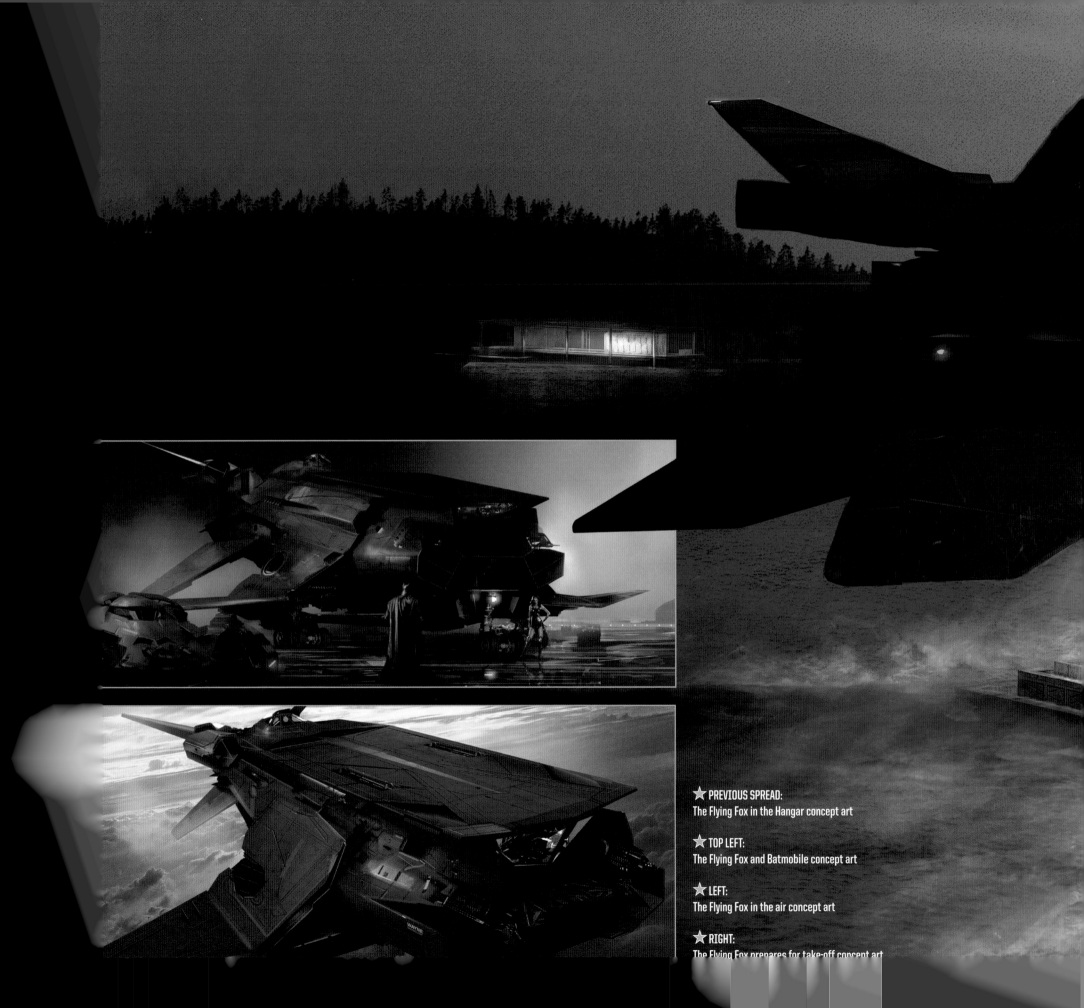

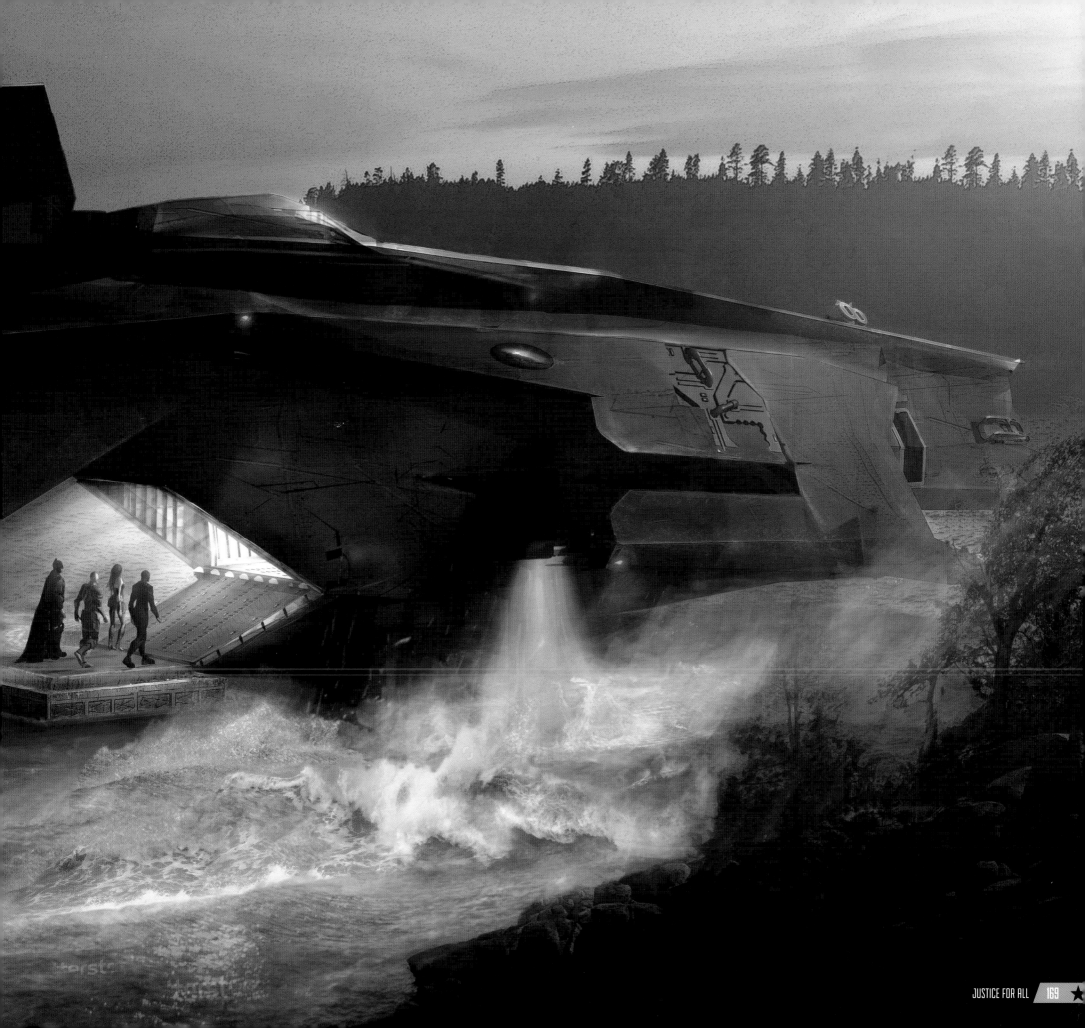

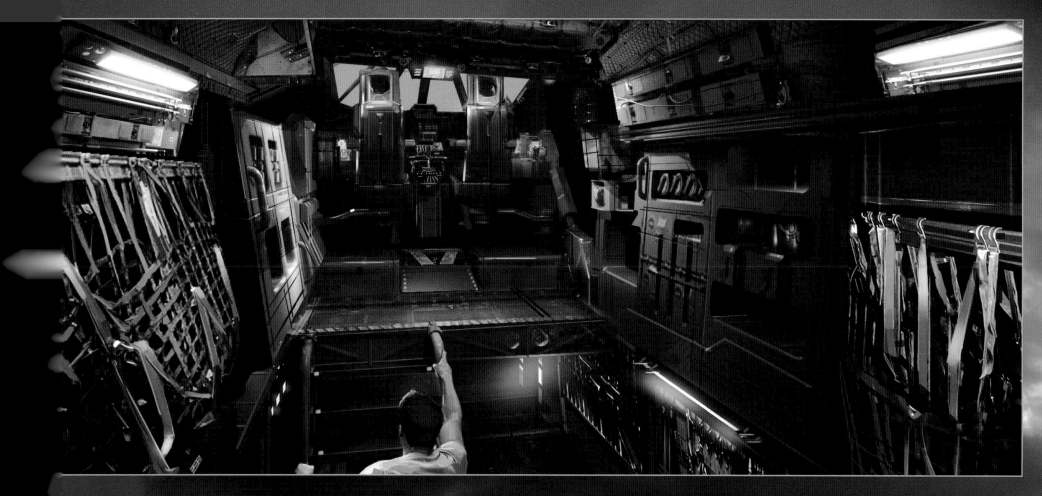

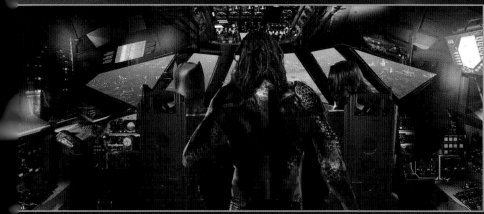

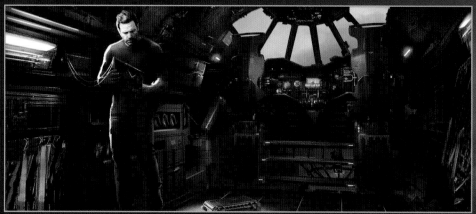

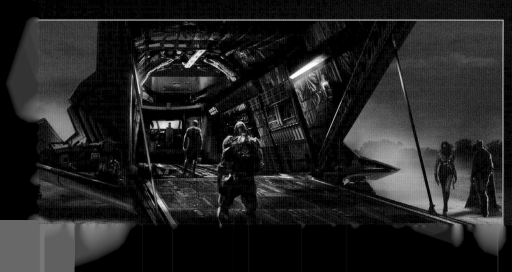

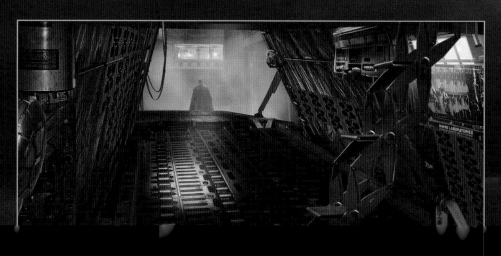

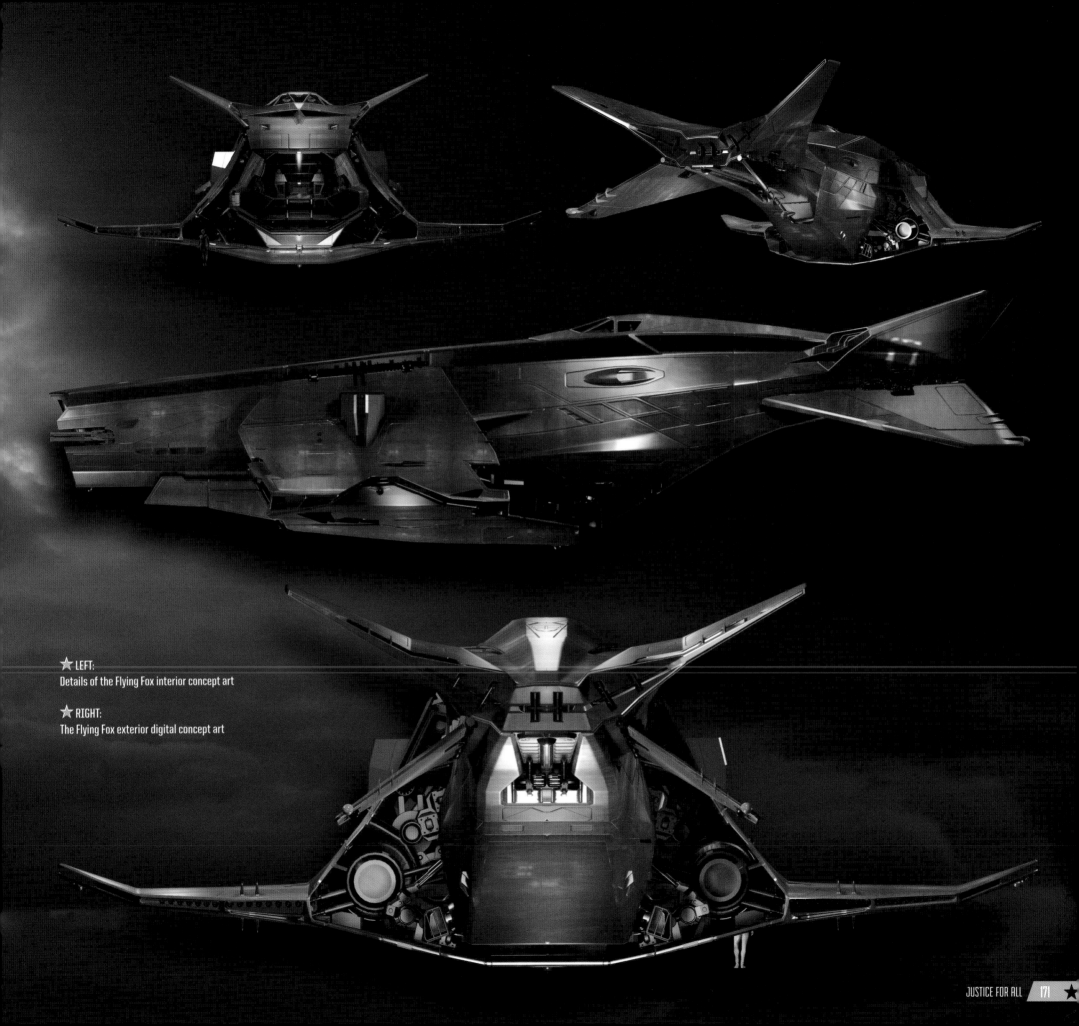

⭐ LEFT:
Details of the Flying Fox interior concept art

⭐ RIGHT:
The Flying Fox exterior digital concept art

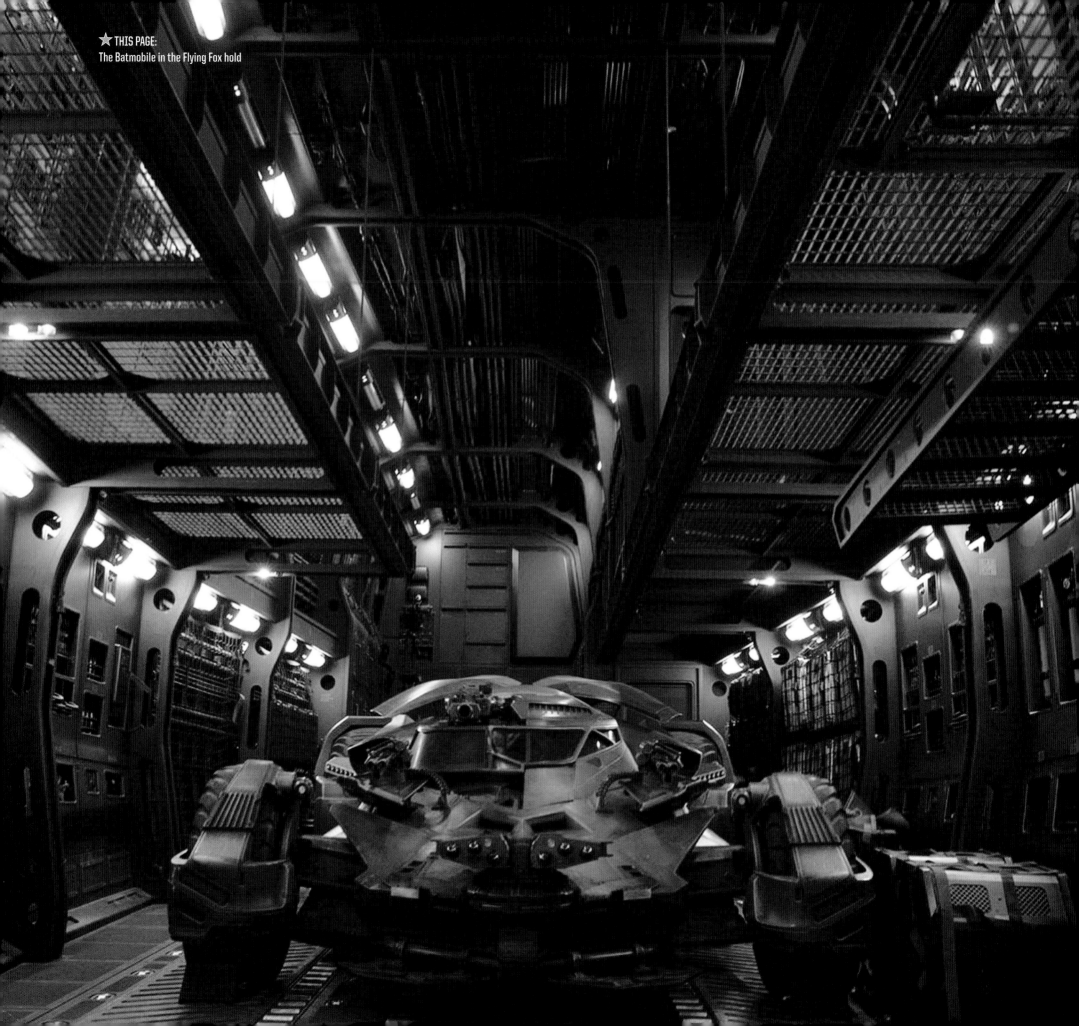

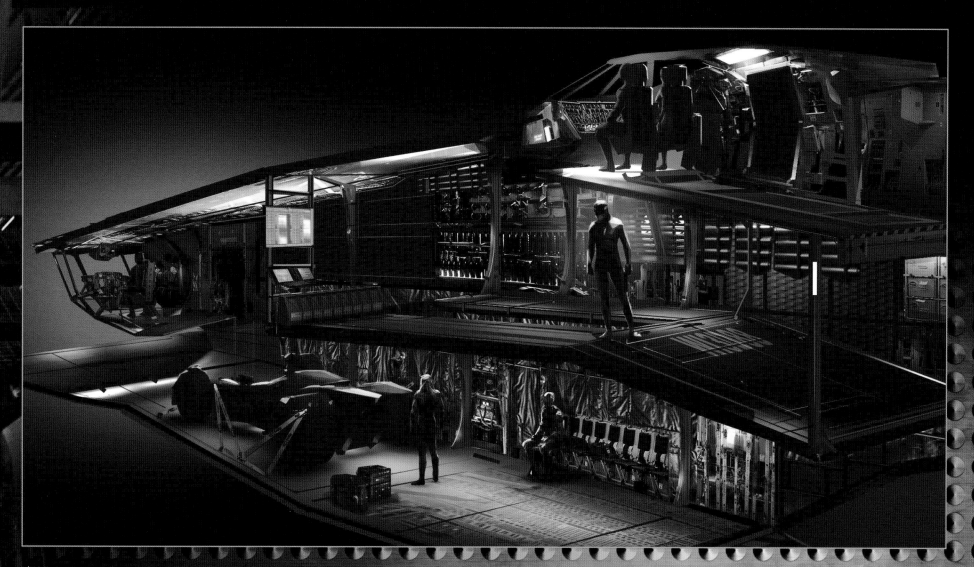

★ ABOVE:
The Flying Fox interior cutaway concept art

☆ BELOW:
The Flying Fox interior detail

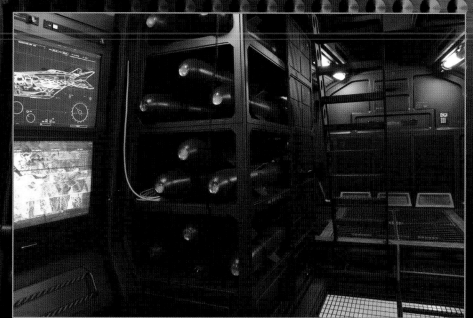

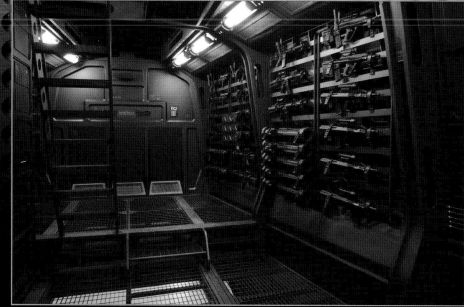

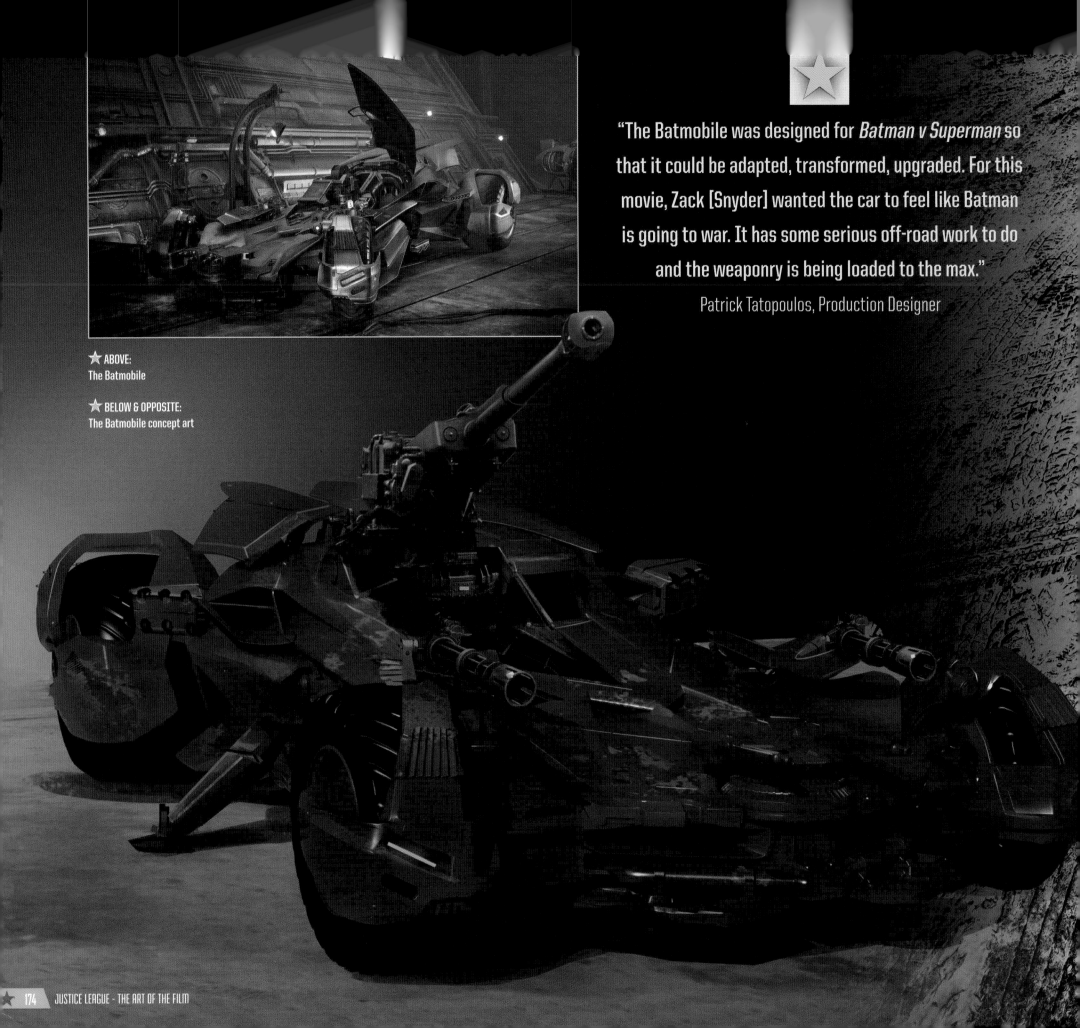

"The Batmobile was designed for *Batman v Superman* so that it could be adapted, transformed, upgraded. For this movie, Zack [Snyder] wanted the car to feel like Batman is going to war. It has some serious off-road work to do and the weaponry is being loaded to the max."

Patrick Tatopoulos, Production Designer

★ ABOVE:
The Batmobile

★ BELOW & OPPOSITE:
The Batmobile concept art

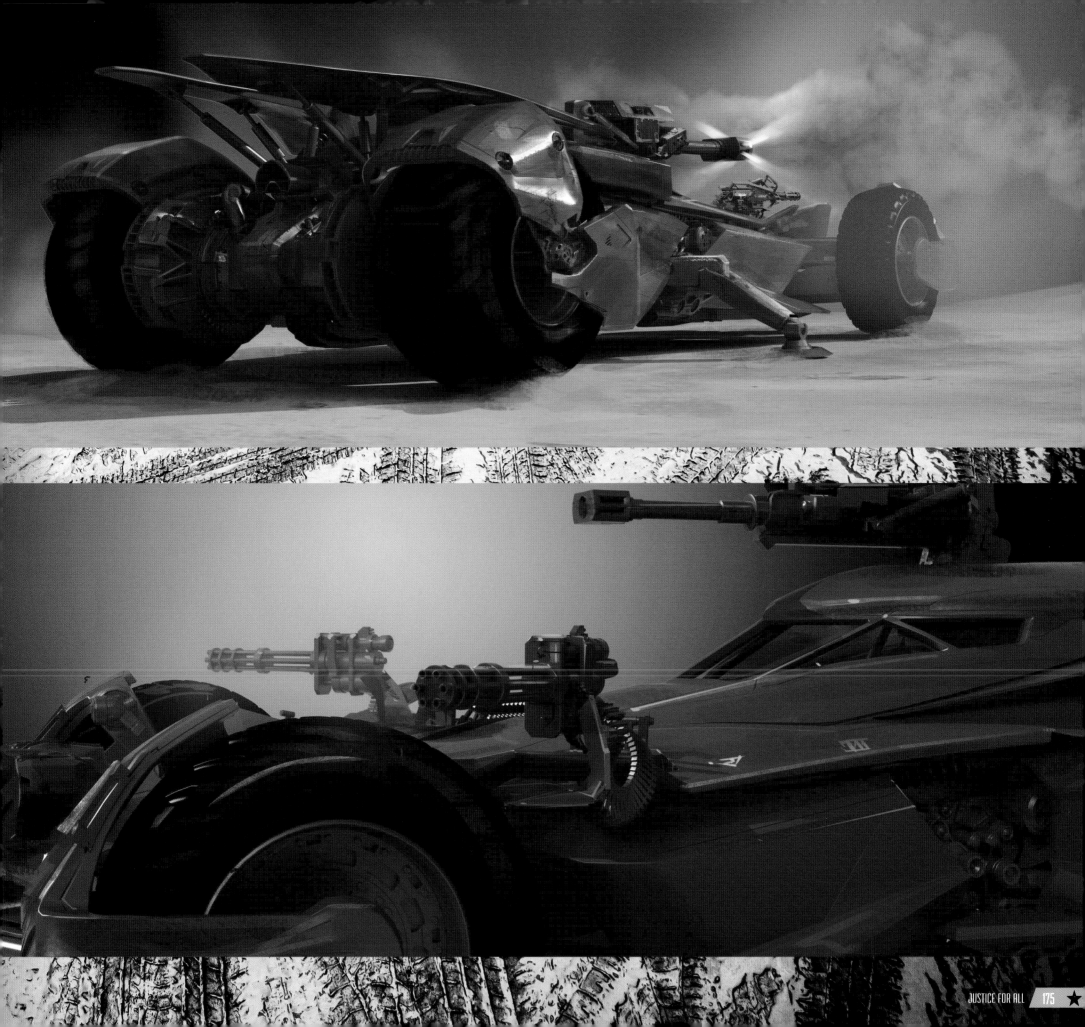

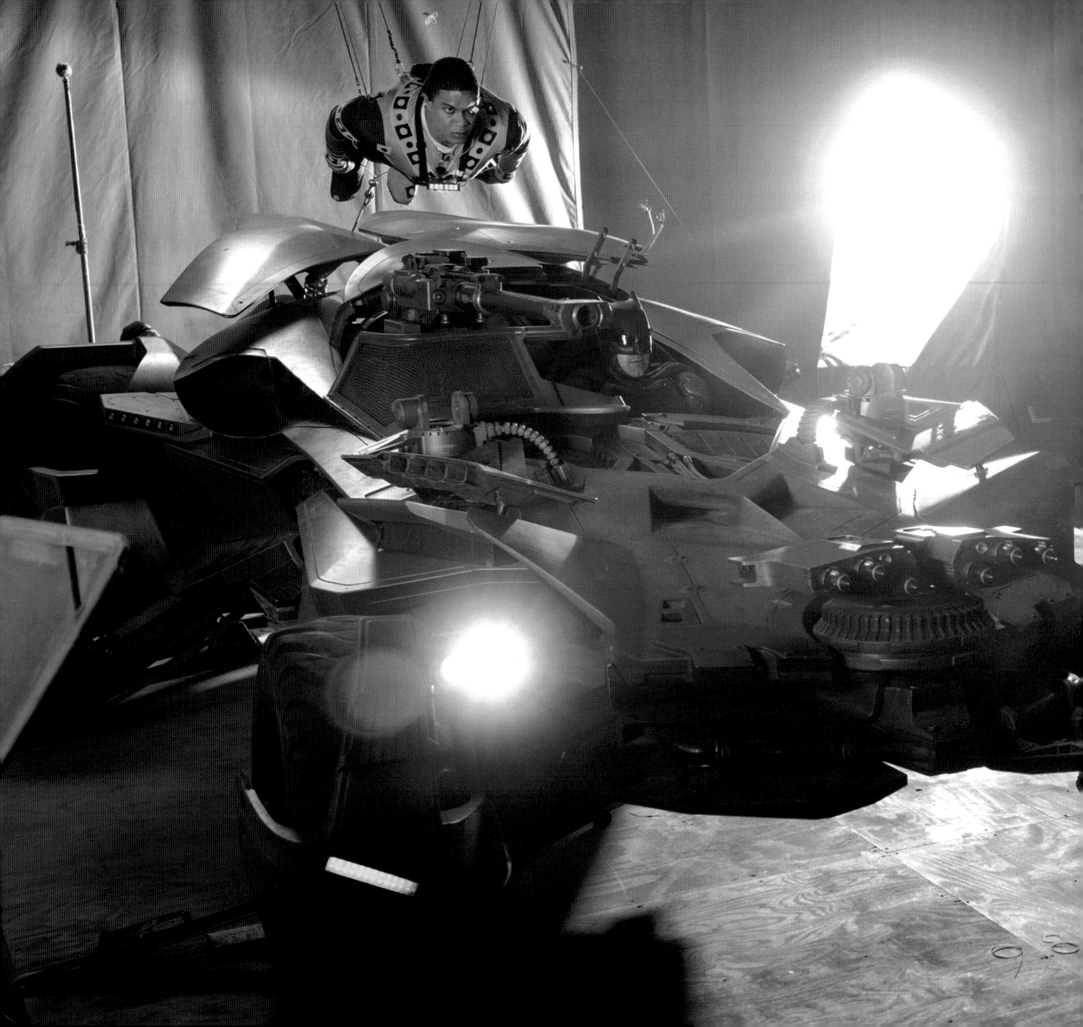

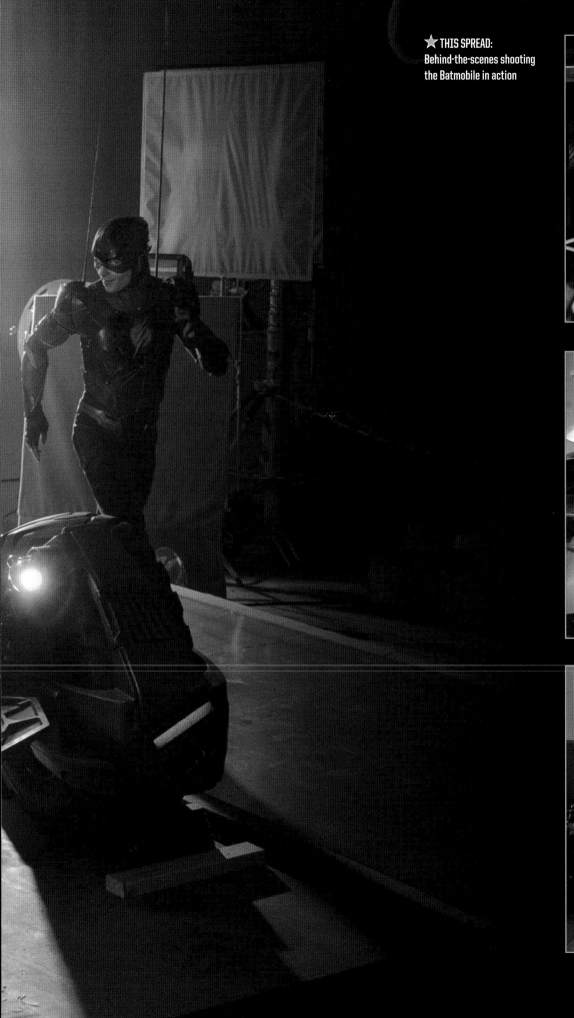

★ THIS SPREAD:
Behind-the-scenes shooting
the Batmobile in action

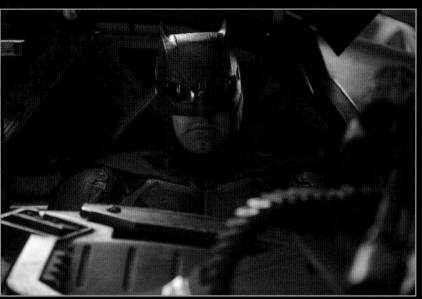

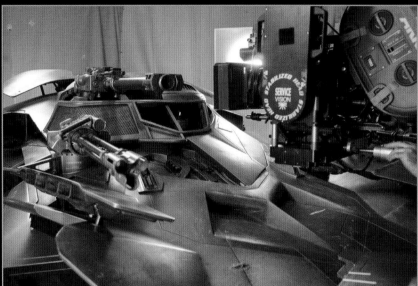

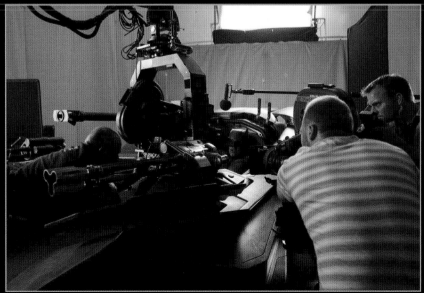

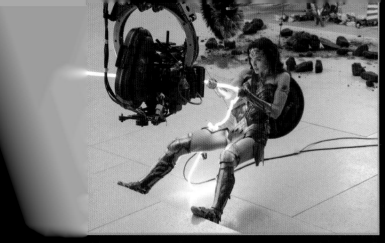
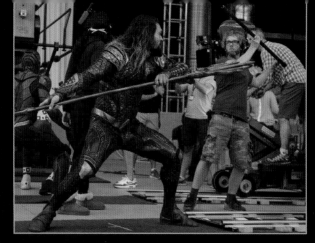
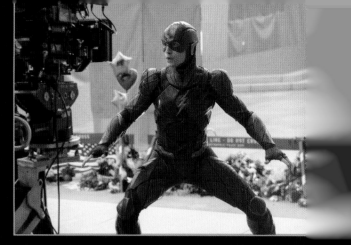

⭐ ABOVE:
Behind-the-scenes shooting a Heroes Park sequence

⭐ BELOW & RIGHT:
Aquaman, Wonder Woman, The Flash, and Cyborg in Heroes Park

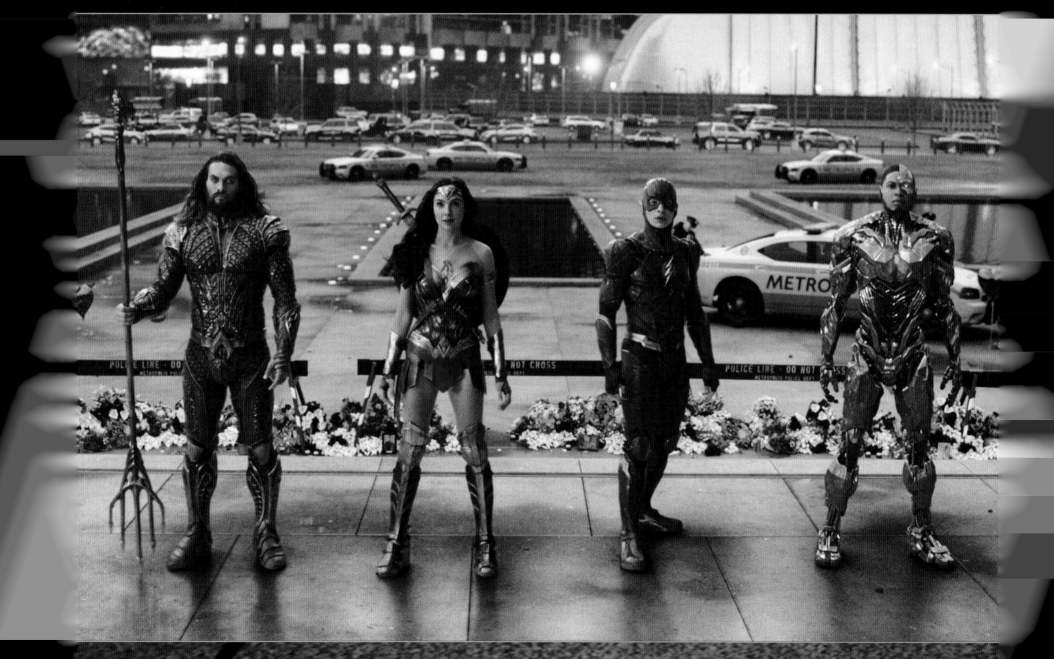

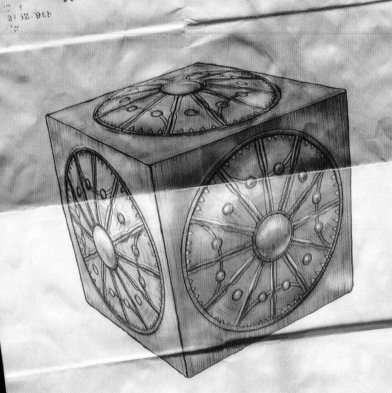

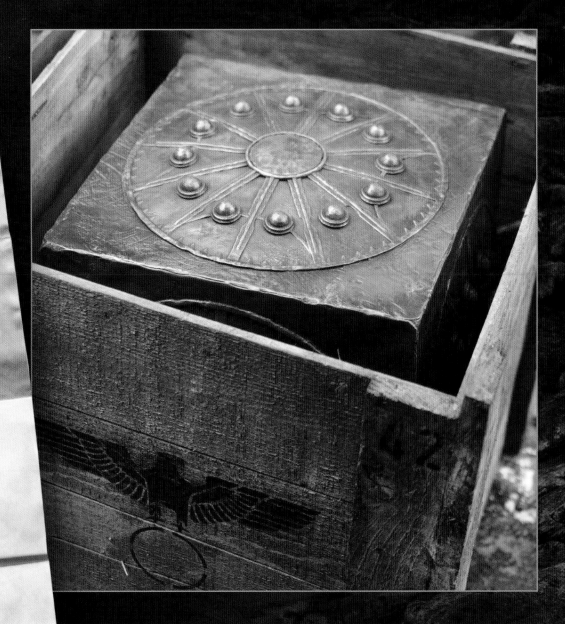

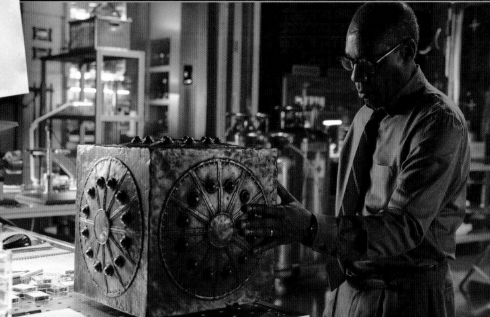

★ ABOVE:
A document about the human Mother Box

★ ABOVE RIGHT:
The human Mother Box case

★ RIGHT:
Silas tries to figure out the Mother Box at
S.T.A.R. Labs

★ OPPOSITE:
The human Mother Box case concept art

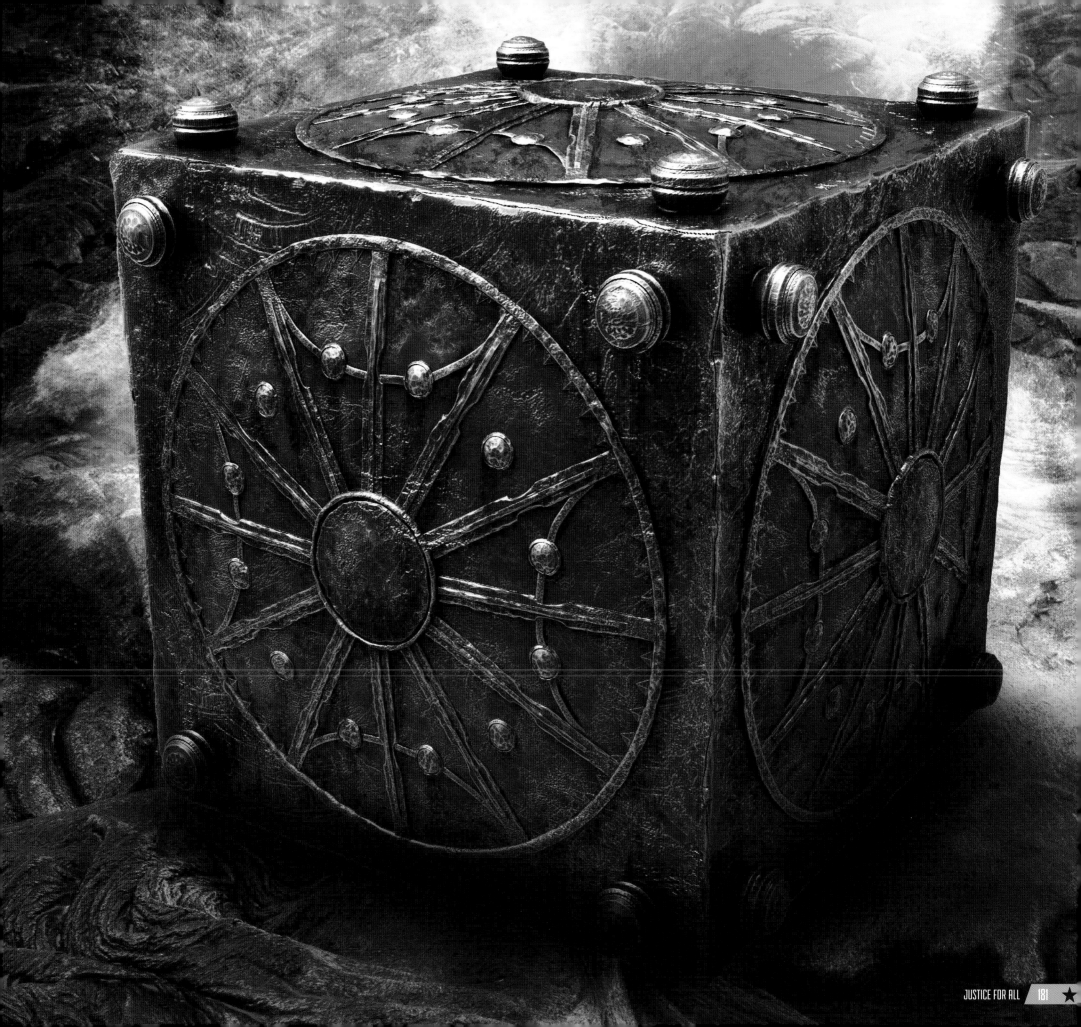

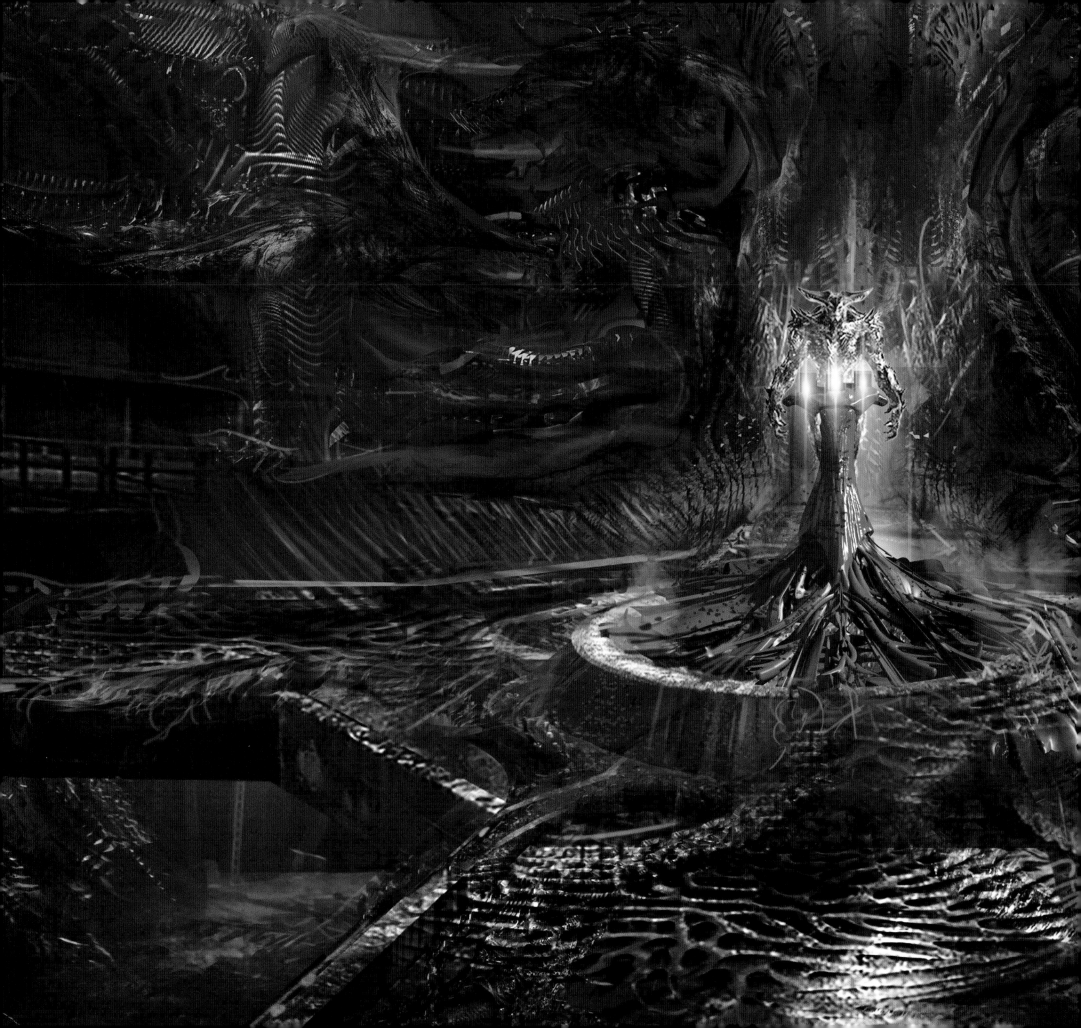

★ THIS SPREAD:
Steppenwolf and the three Mother
Boxes early concept art

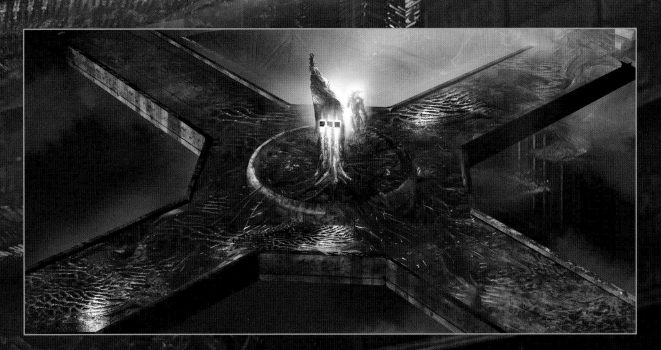

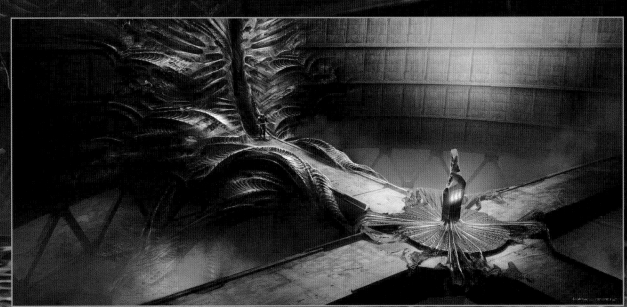

"The Mother Boxes were created on Steppenwolf's home planet. They are instruments that can convert energy to create or reform matter. Then, if you put the three Mother Boxes together, they become an unstoppable force, the Unity, which Steppenwolf uses to conquer planets."

Charles Roven, Producer

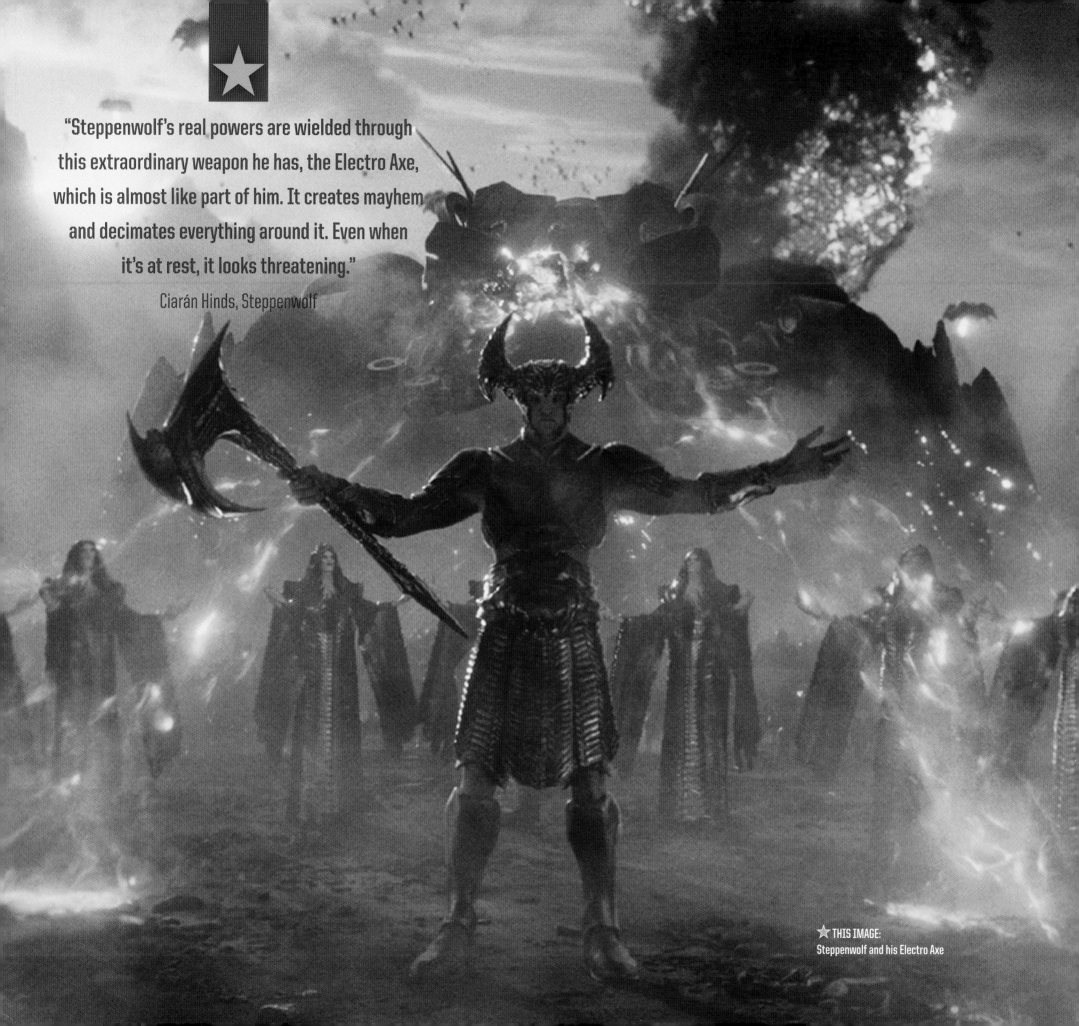

"Steppenwolf's real powers are wielded through this extraordinary weapon he has, the Electro Axe, which is almost like part of him. It creates mayhem and decimates everything around it. Even when it's at rest, it looks threatening."

Ciarán Hinds, Steppenwolf

★ THIS IMAGE:
Steppenwolf and his Electro Axe

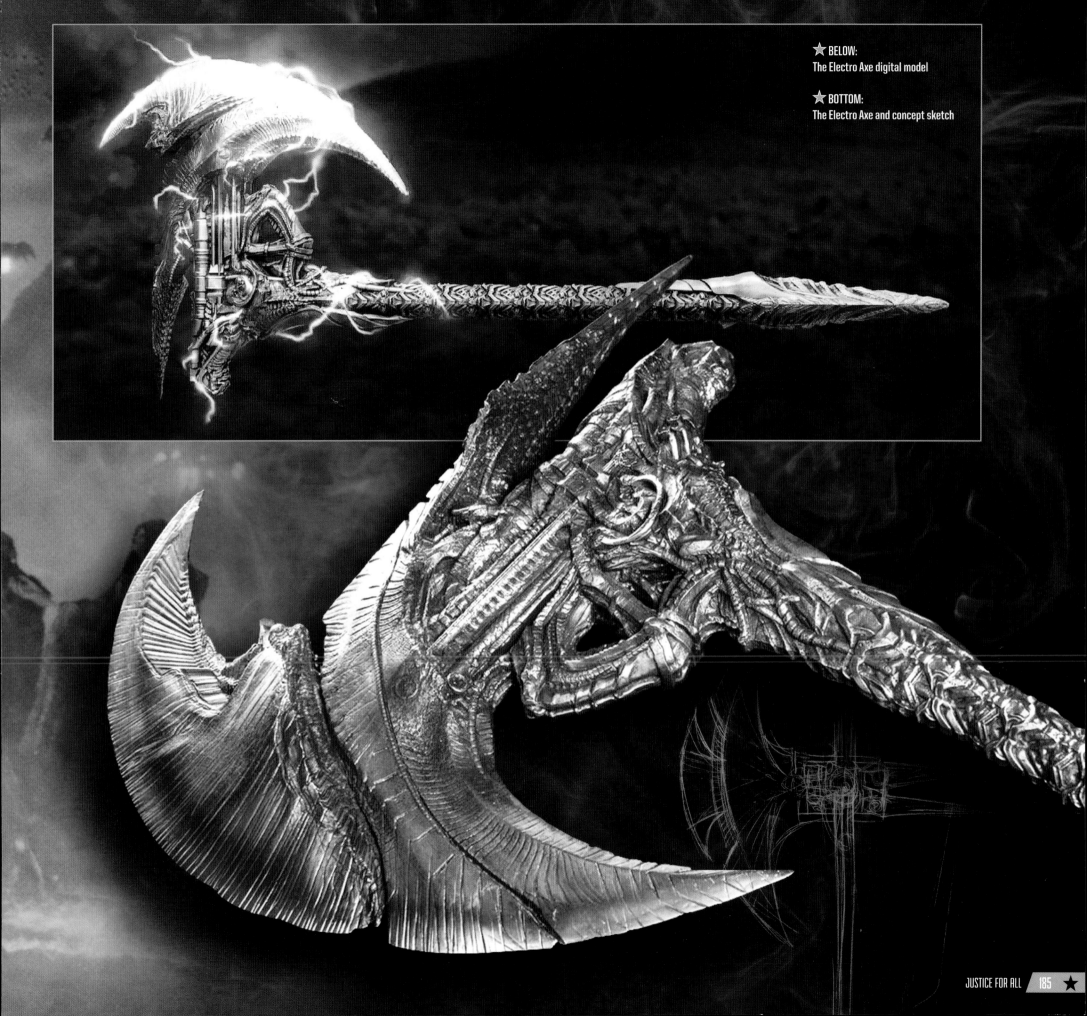

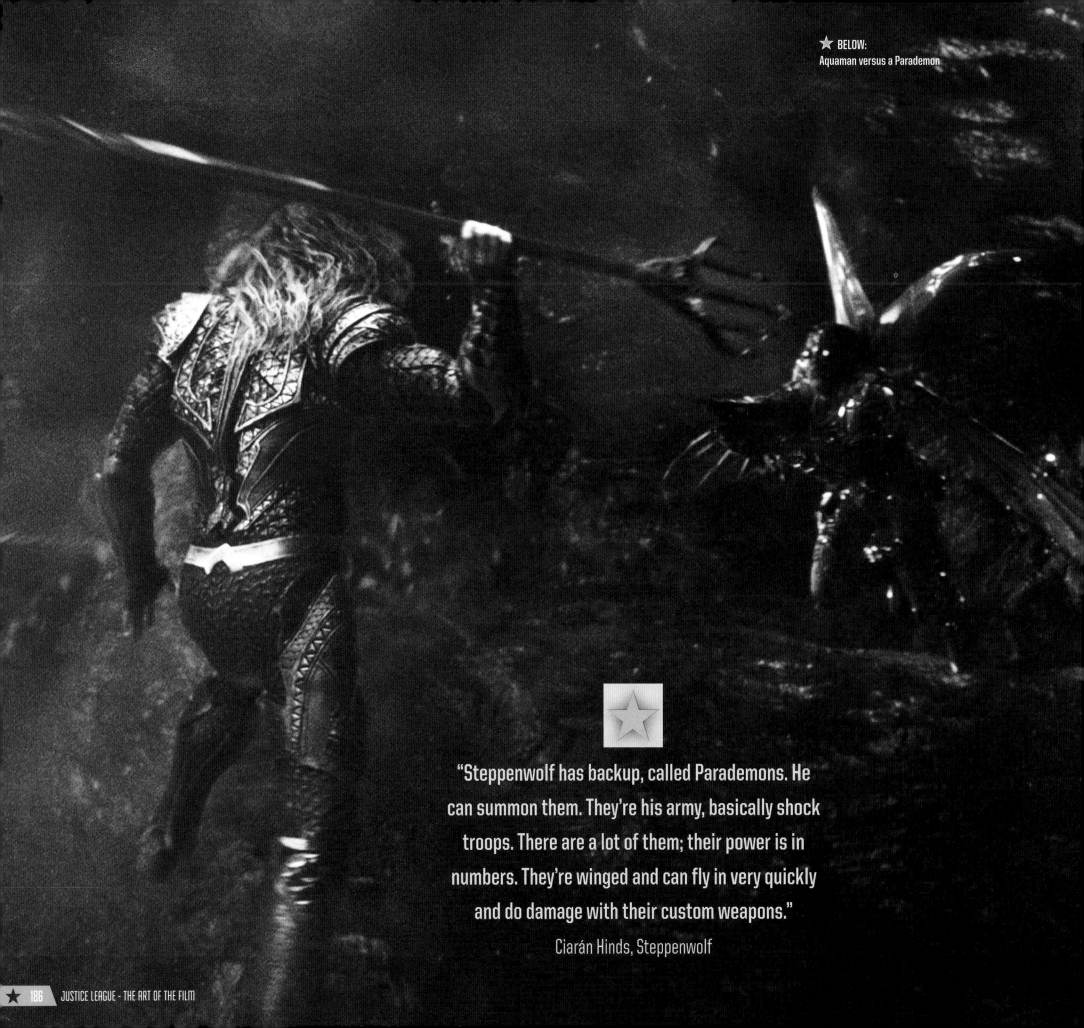

"Steppenwolf has backup, called Parademons. He can summon them. They're his army, basically shock troops. There are a lot of them; their power is in numbers. They're winged and can fly in very quickly and do damage with their custom weapons."

Ciarán Hinds, Steppenwolf

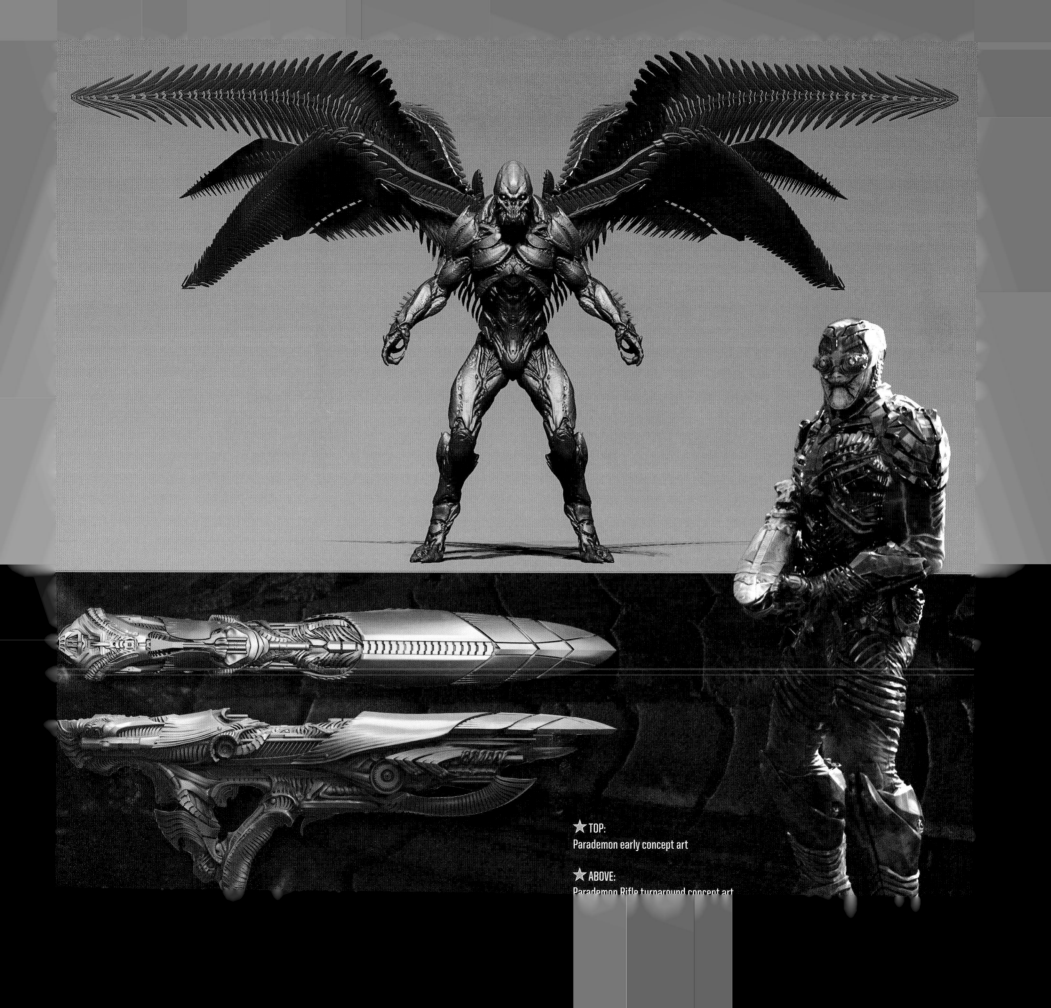

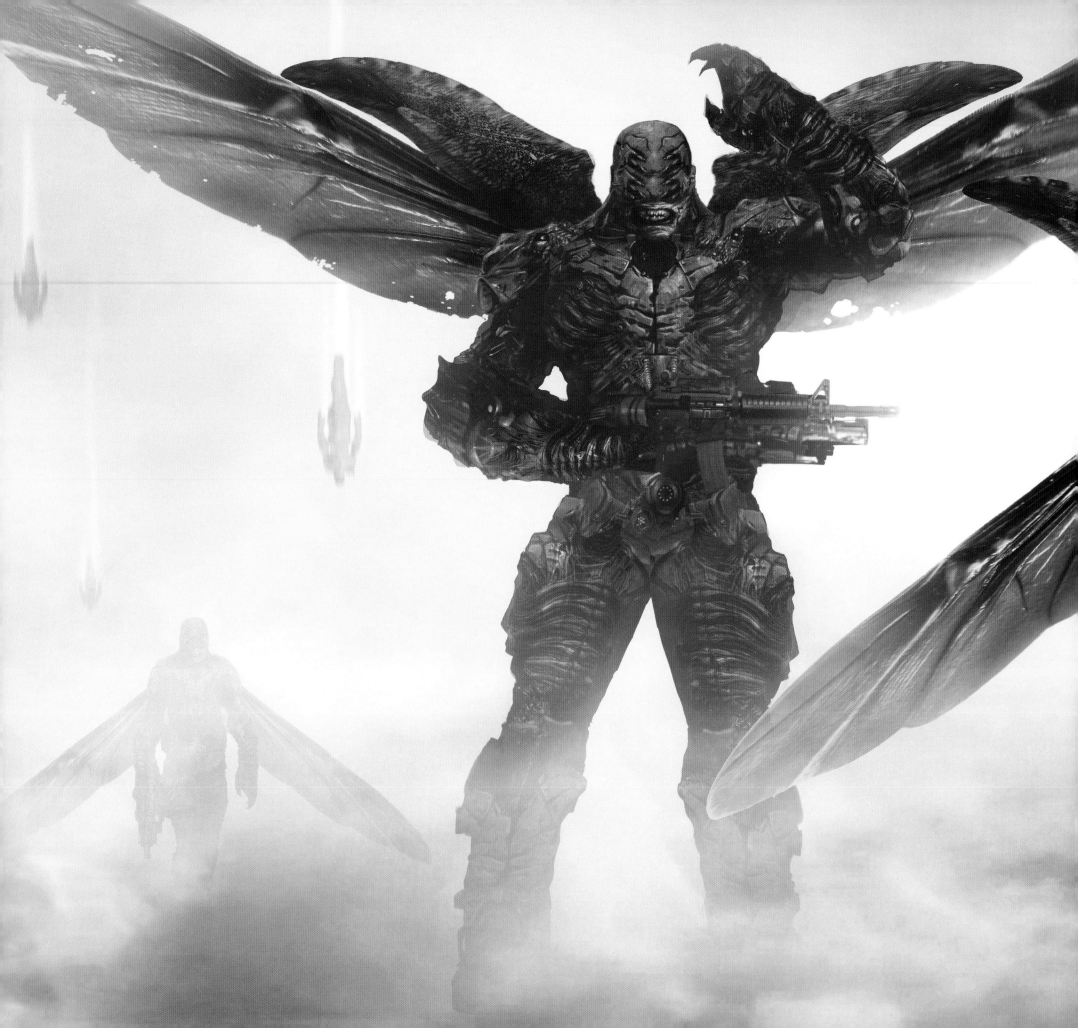

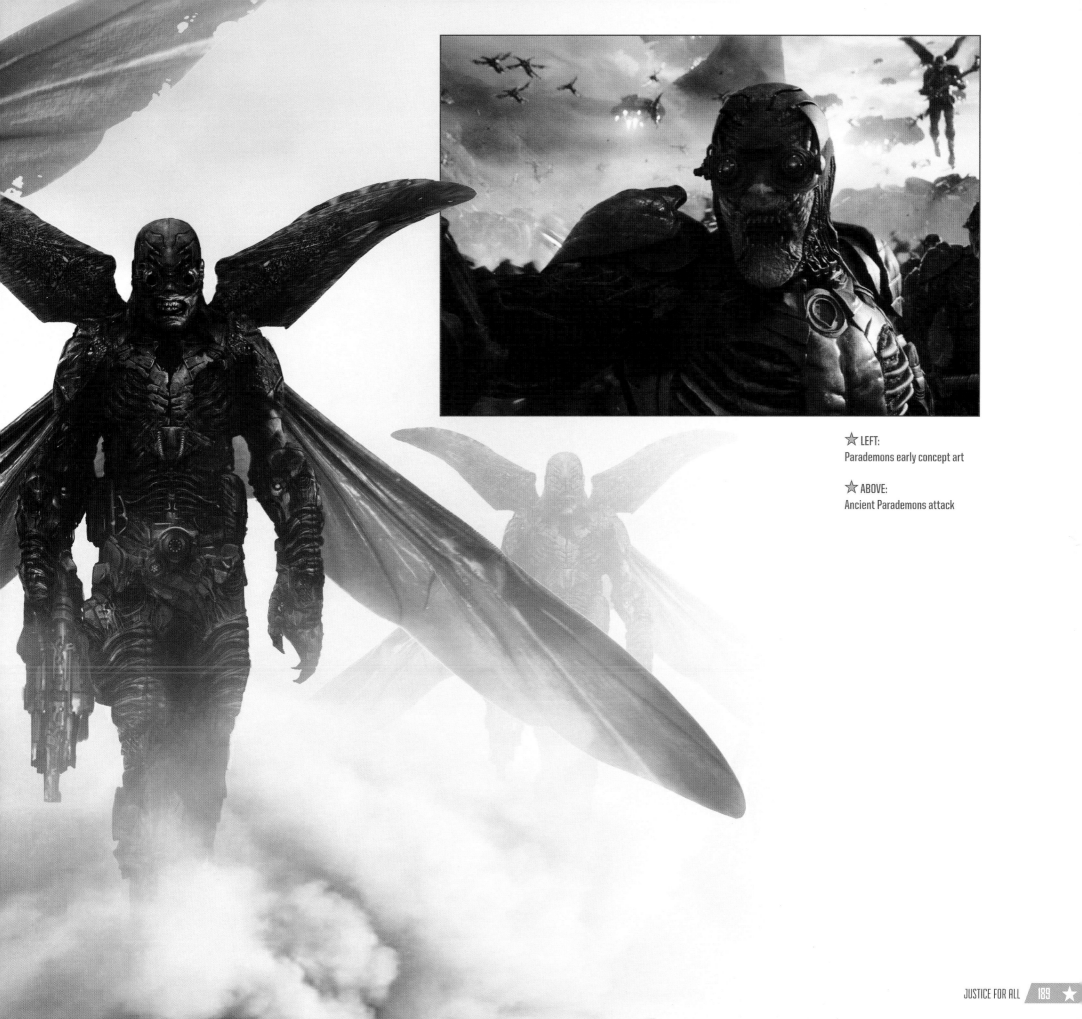

☆ LEFT:
Parademons early concept art

☆ ABOVE:
Ancient Parademons attack

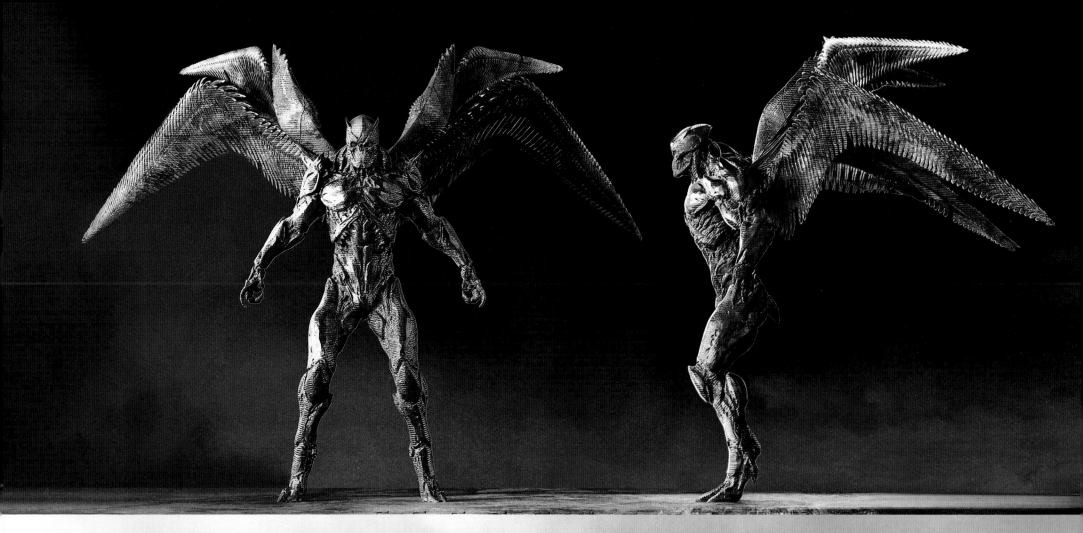

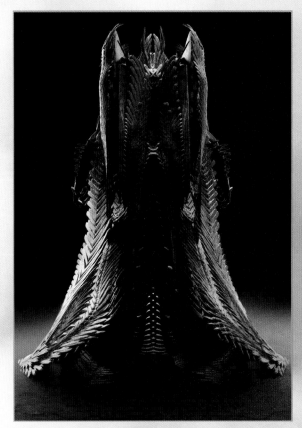

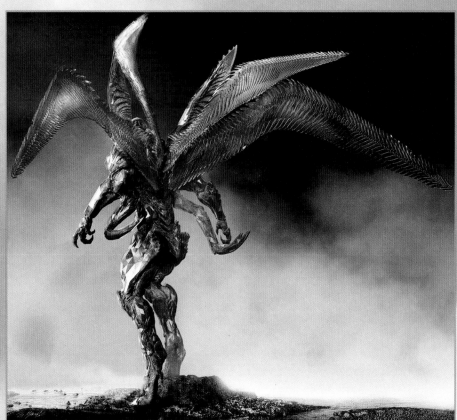

☆ **ABOVE:**
Parademon turnaround early concept art

☆ **LEFT & RIGHT:**
Parademon early concept art

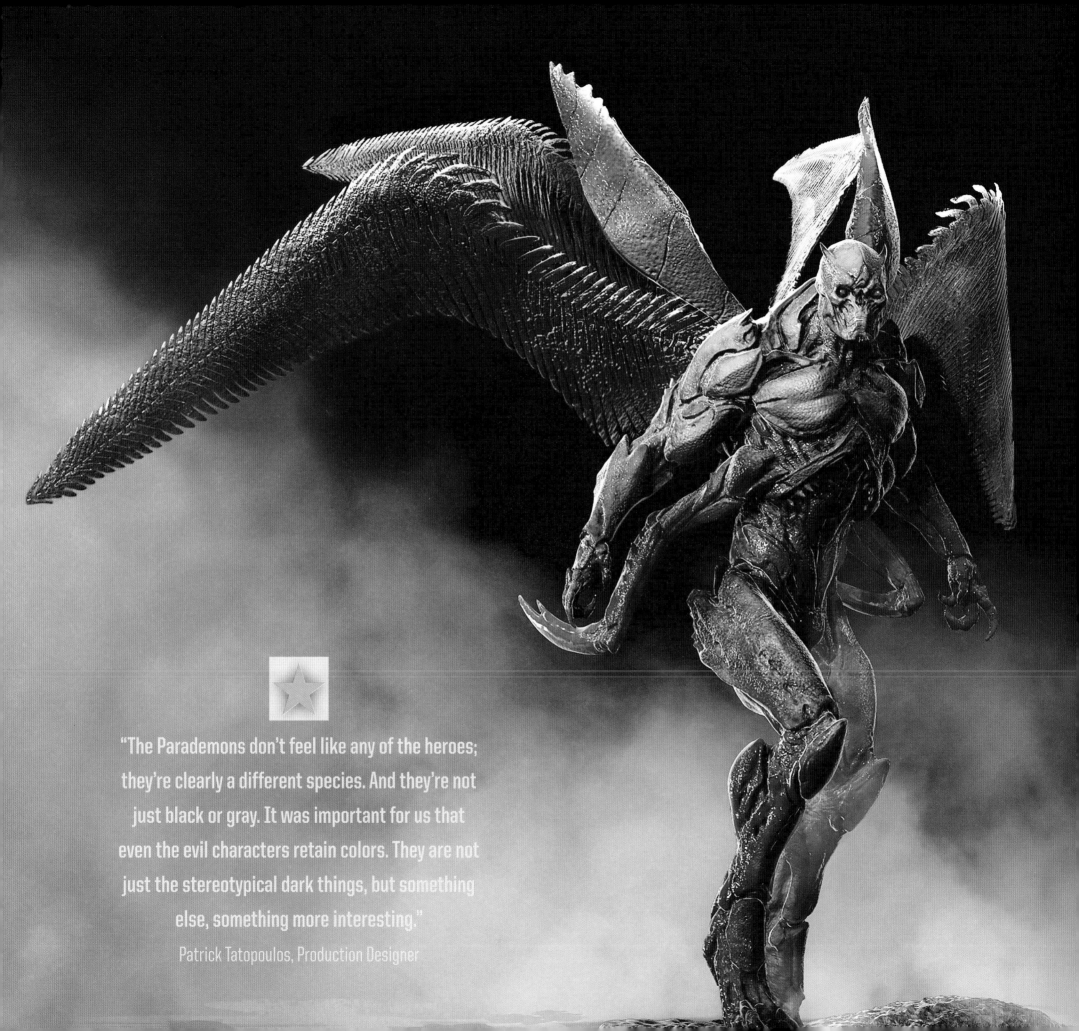

"The Parademons don't feel like any of the heroes; they're clearly a different species. And they're not just black or gray. It was important for us that even the evil characters retain colors. They are not just the stereotypical dark things, but something else, something more interesting."

Patrick Tatopoulos, Production Designer

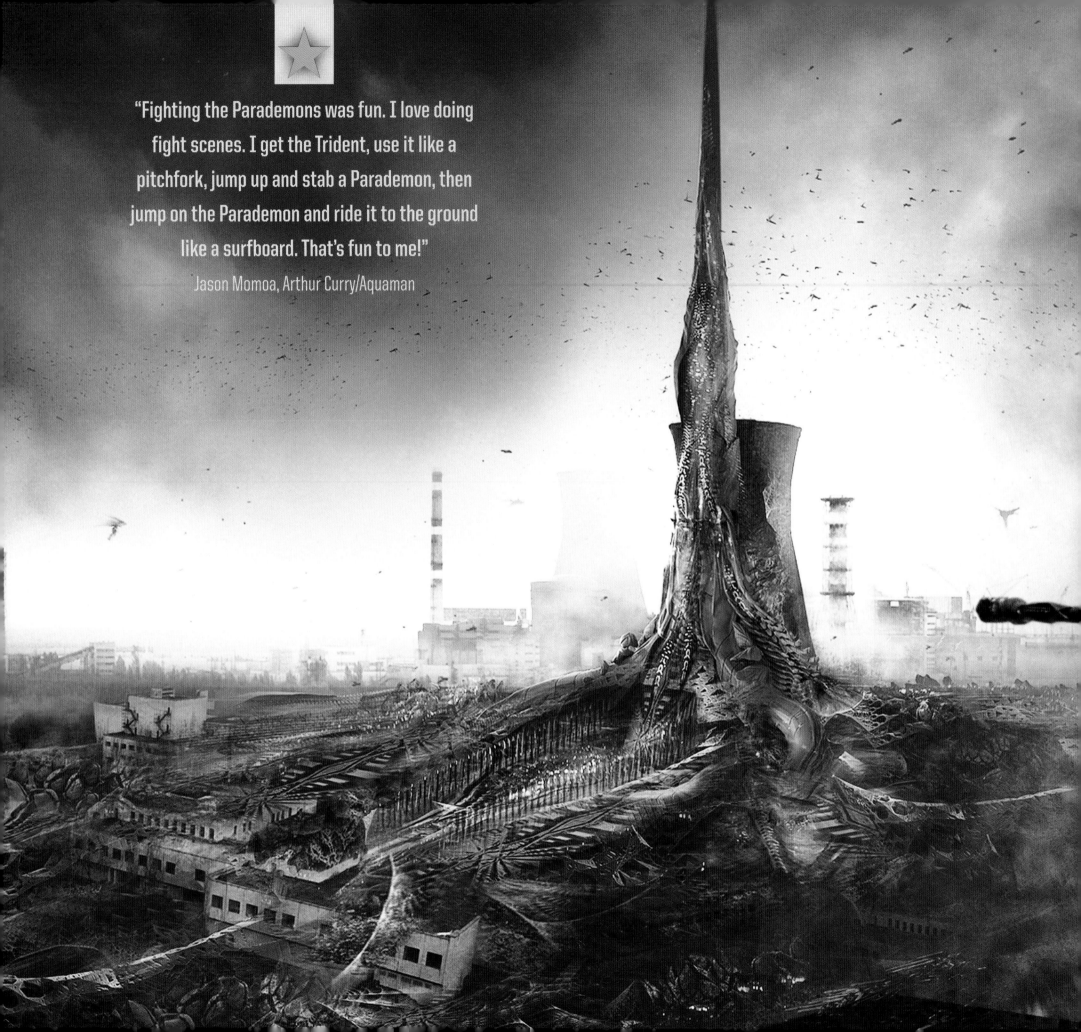

"Fighting the Parademons was fun. I love doing fight scenes. I get the Trident, use it like a pitchfork, jump up and stab a Parademon, then jump on the Parademon and ride it to the ground like a surfboard. That's fun to me!"

Jason Momoa, Arthur Curry/Aquaman

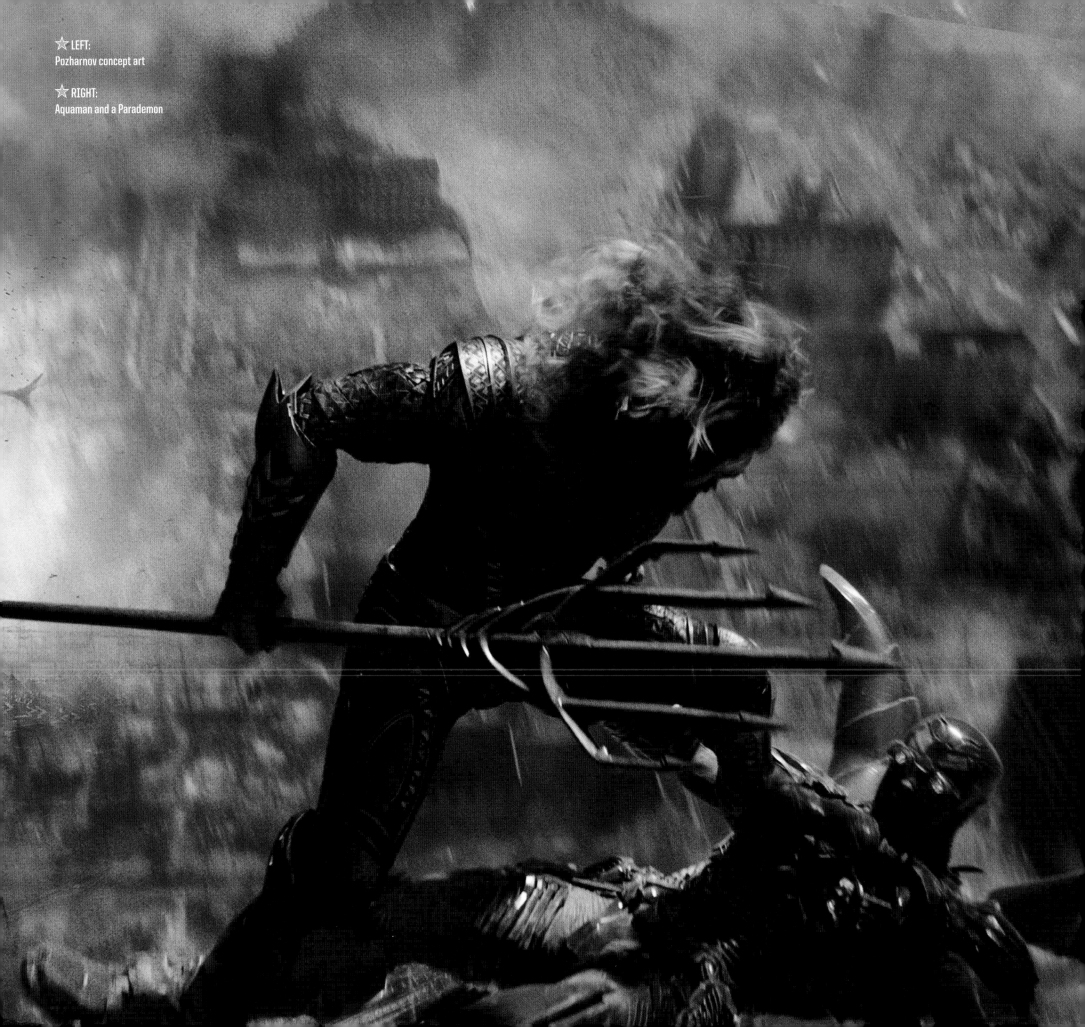

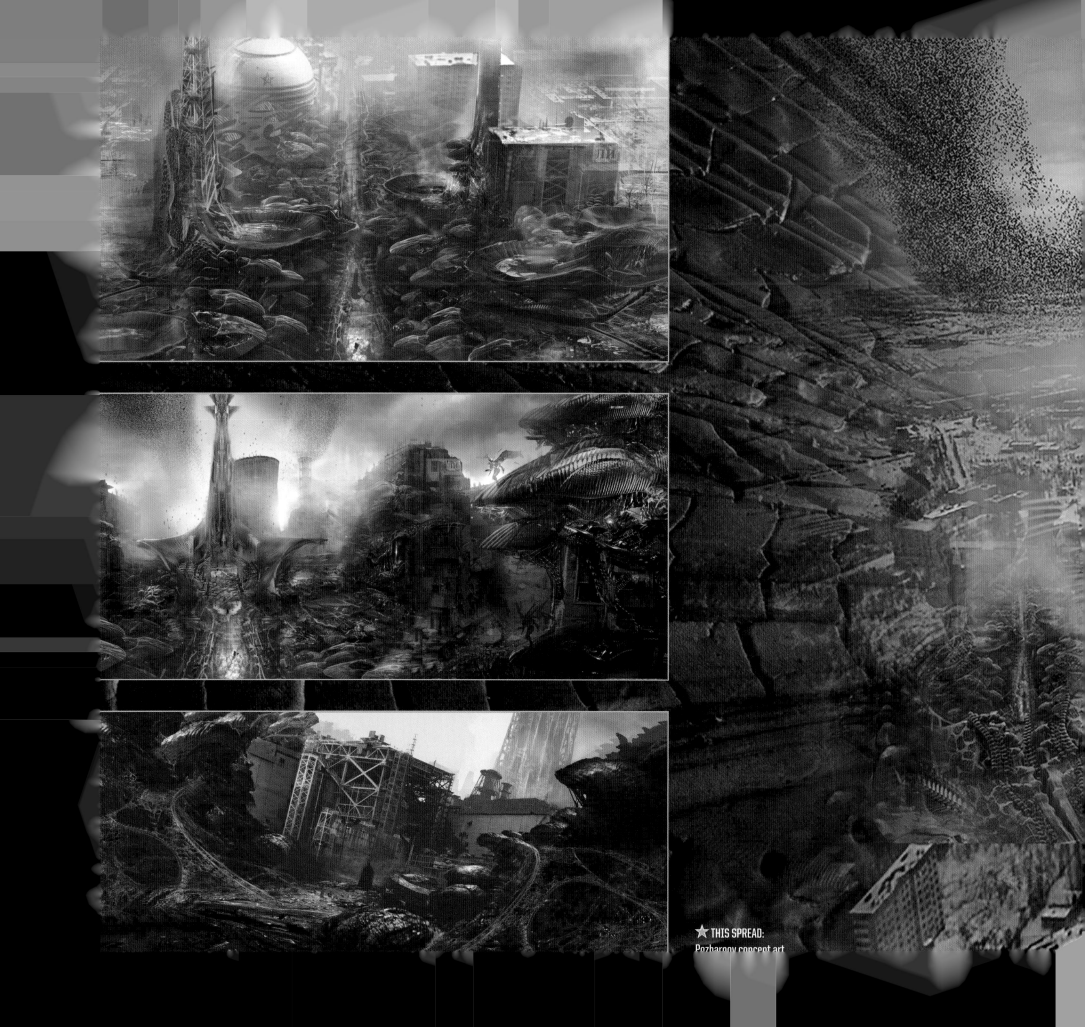

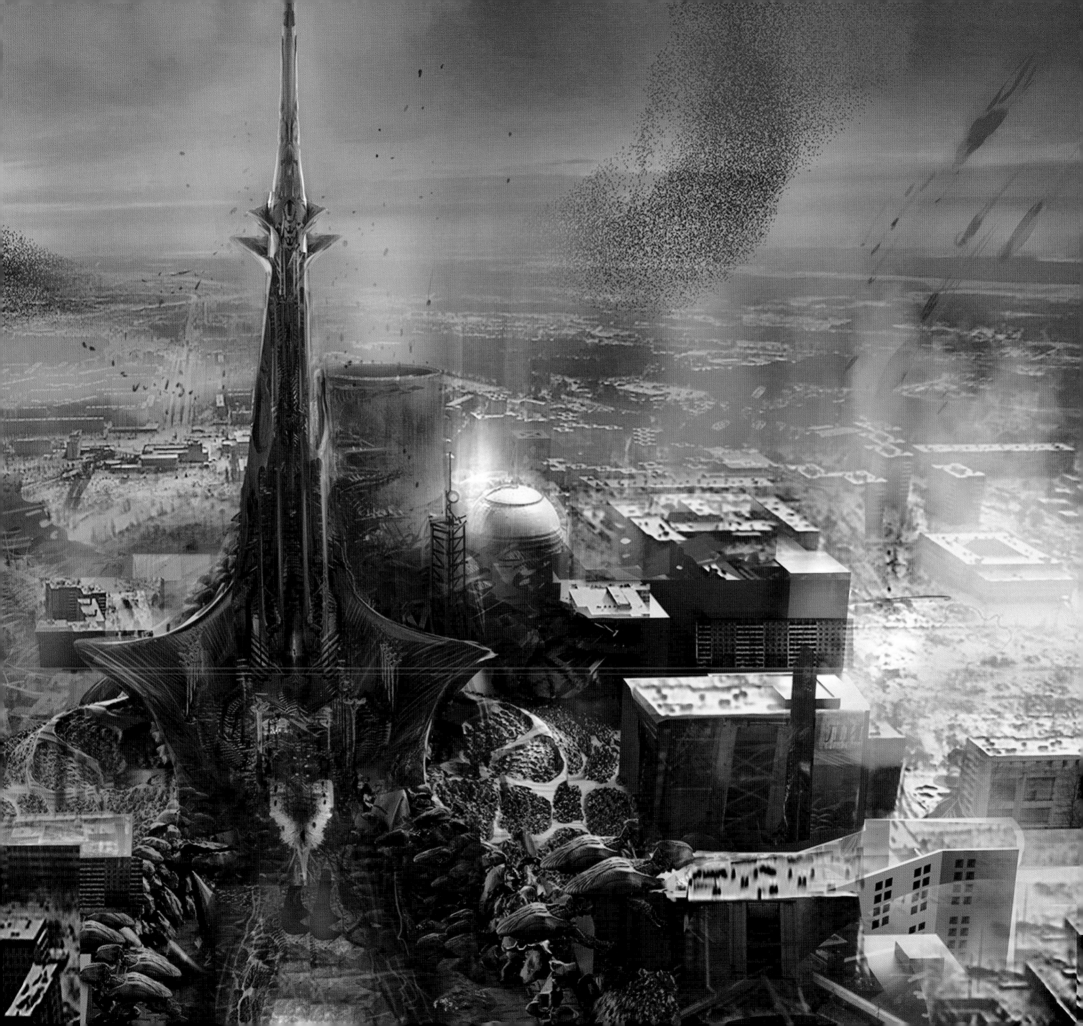

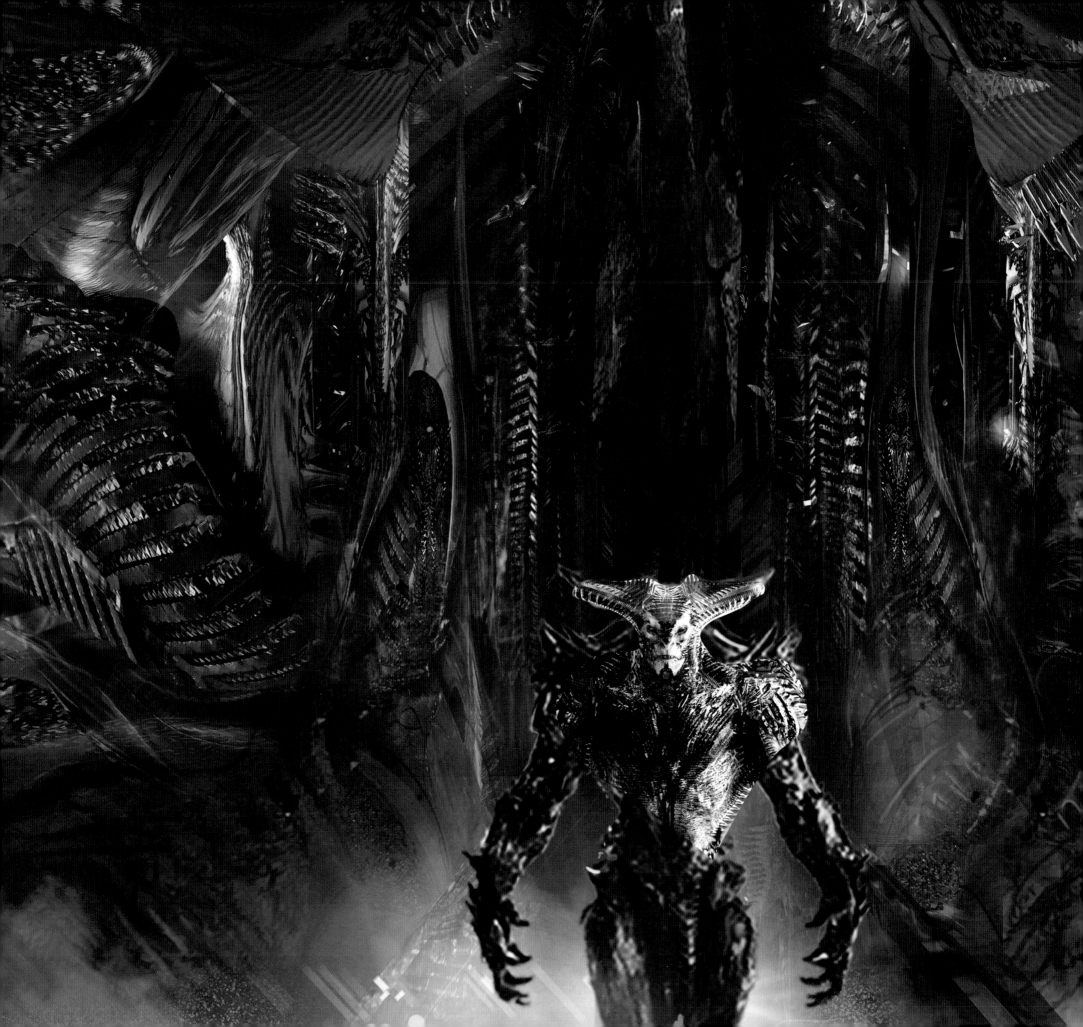

"For Pozharnov, the textures of the world, the way this crazy, organic landscape works, I designed the concept, but then one of the sculptors developed it. The detail of that world was completely defined by the sculptor and when we looked at the sculpture, we knew it was exactly what we wanted."

Patrick Tatopoulos, Production Designer

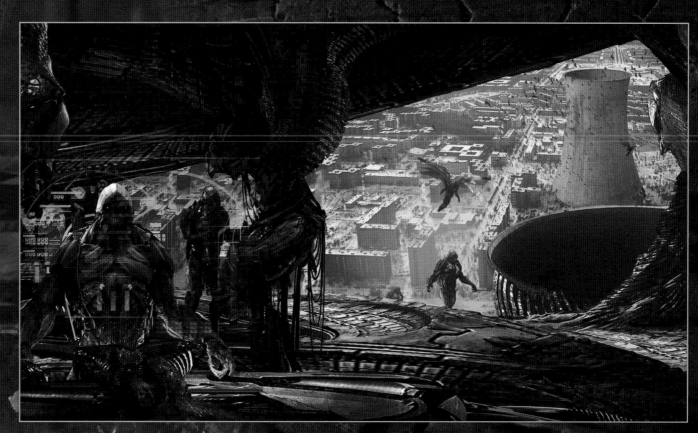

☆ LEFT:
Steppenwolf in Pozharnov early concept art

☆ RIGHT:
Pozharnov interior early concept art

☆ NEXT SPREAD:
The Flying Fox in Pozharnov concept art

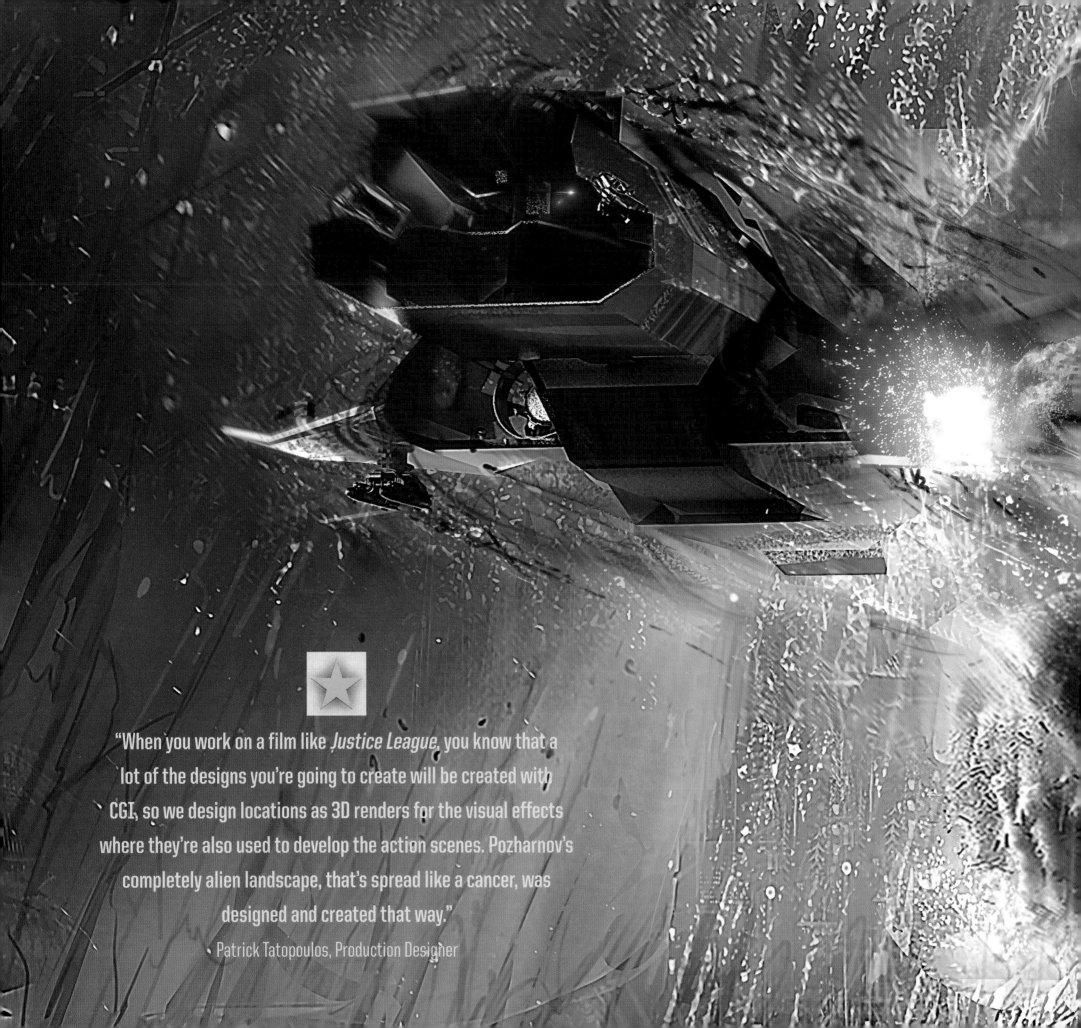

"When you work on a film like *Justice League,* you know that a lot of the designs you're going to create will be created with CGI, so we design locations as 3D renders for the visual effects where they're also used to develop the action scenes. Pozharnov's completely alien landscape, that's spread like a cancer, was designed and created that way."

Patrick Tatopoulos, Production Designer

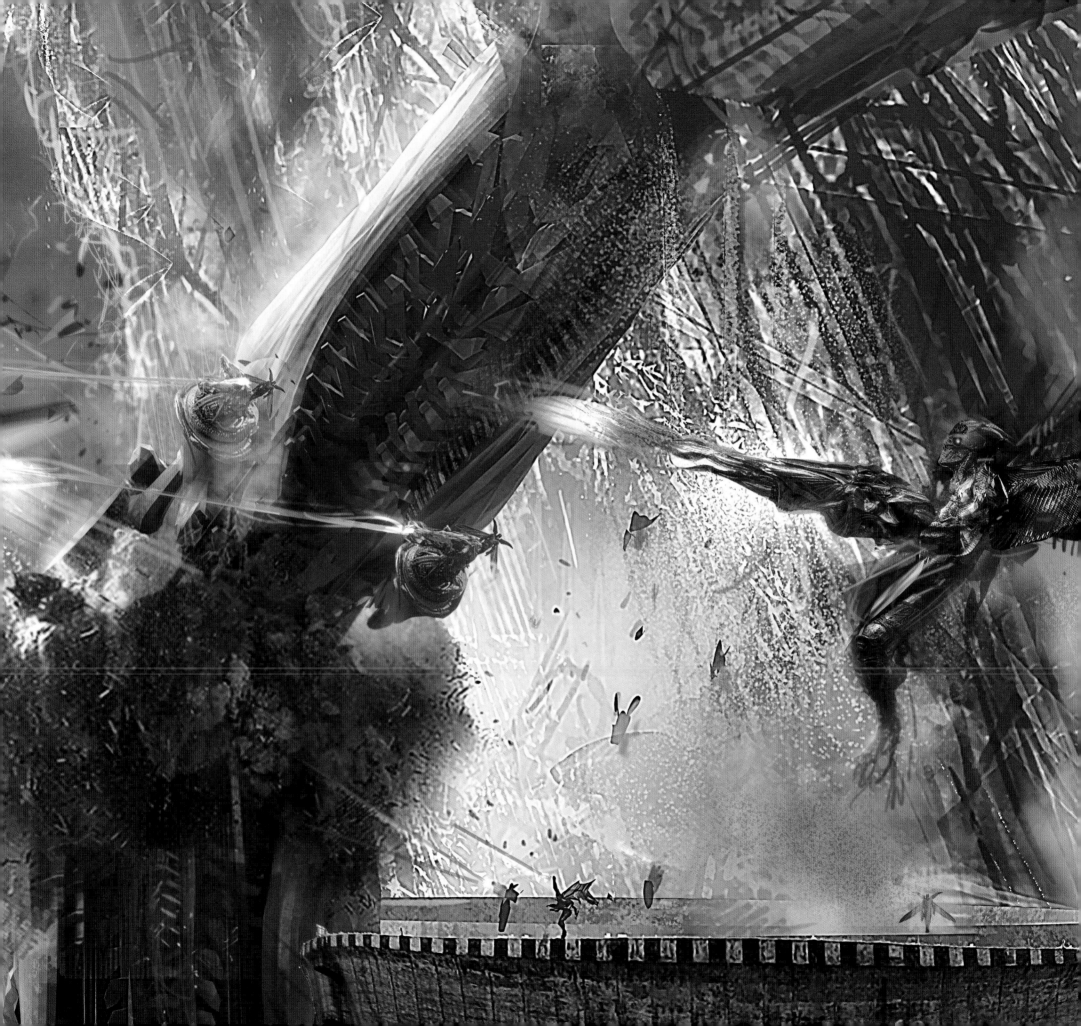

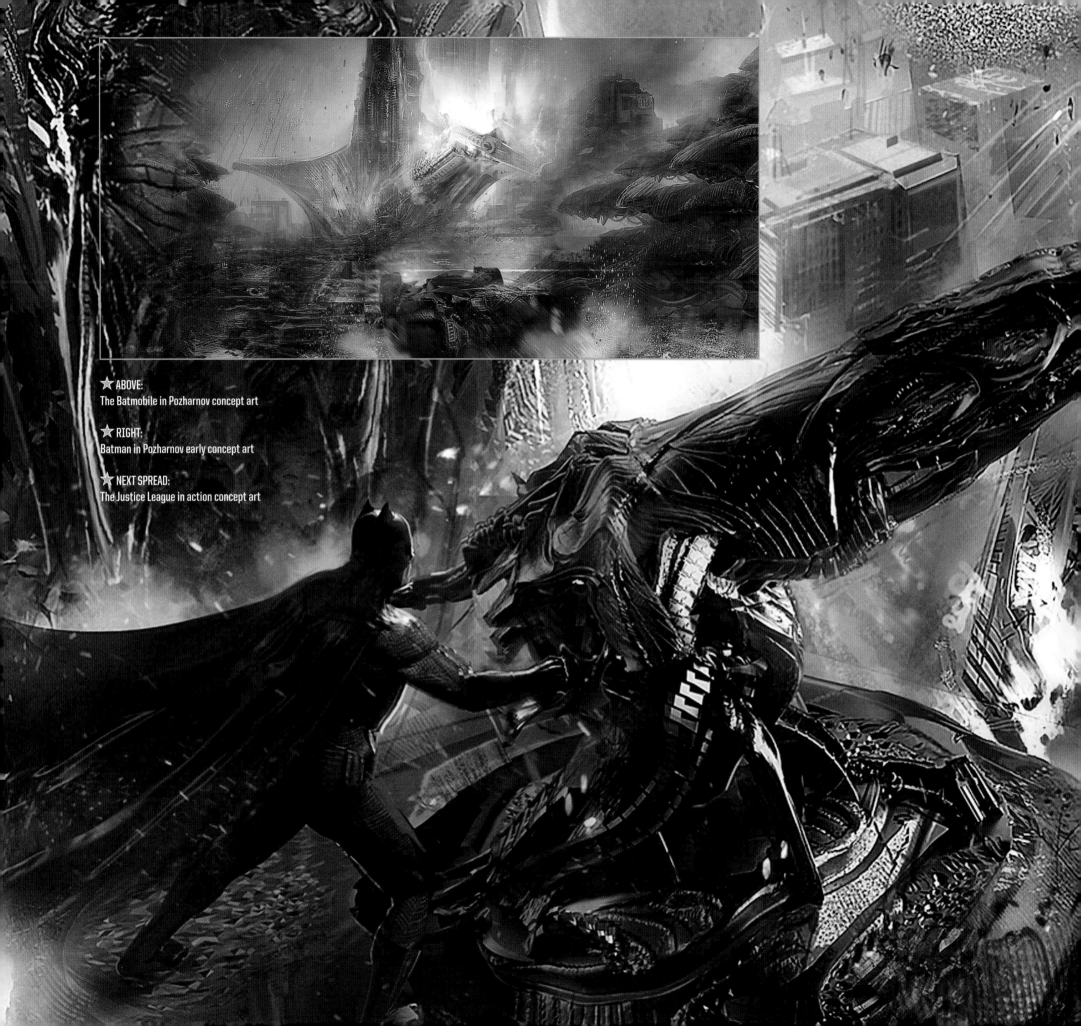

★ ABOVE:
The Batmobile in Pozharnov concept art

★ RIGHT:
Batman in Pozharnov early concept art

★ NEXT SPREAD:
The Justice League in action concept art

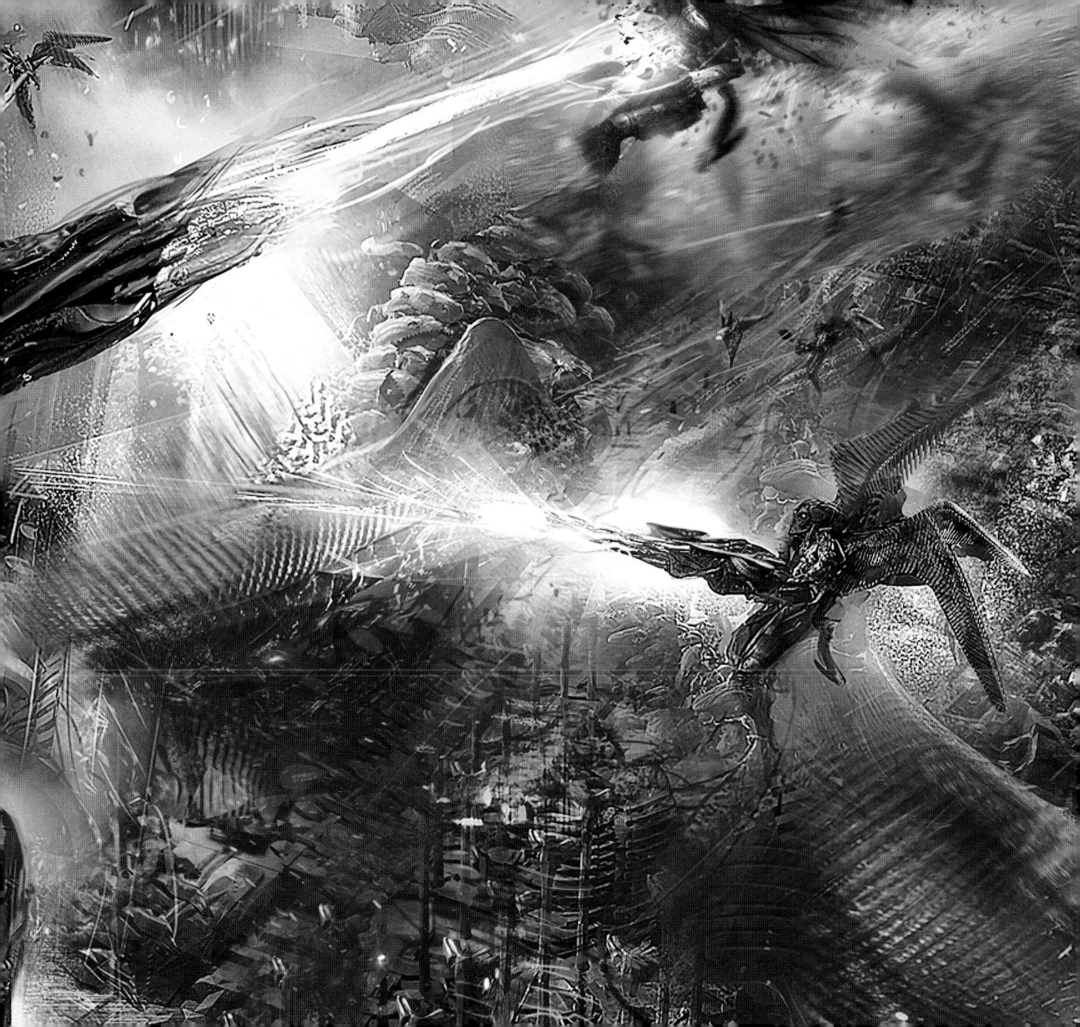

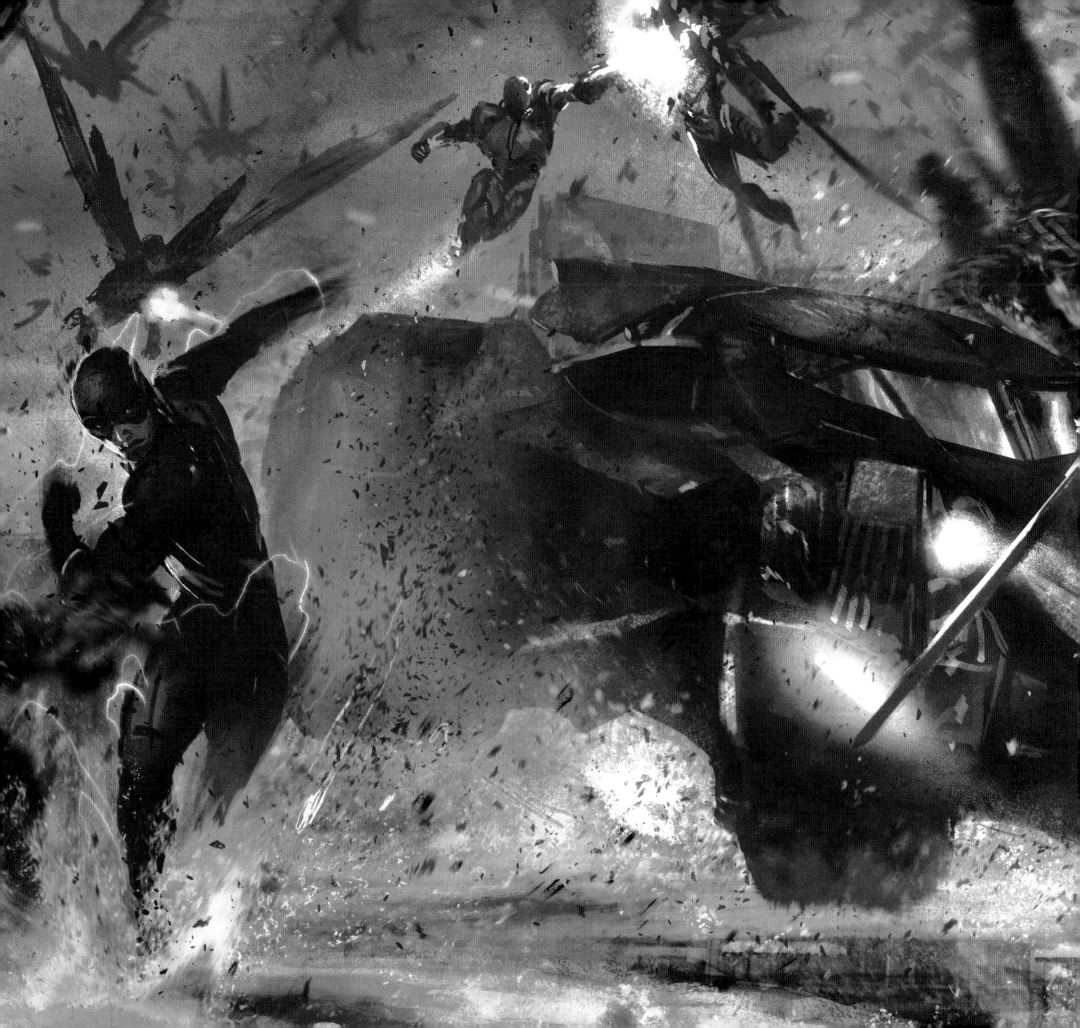

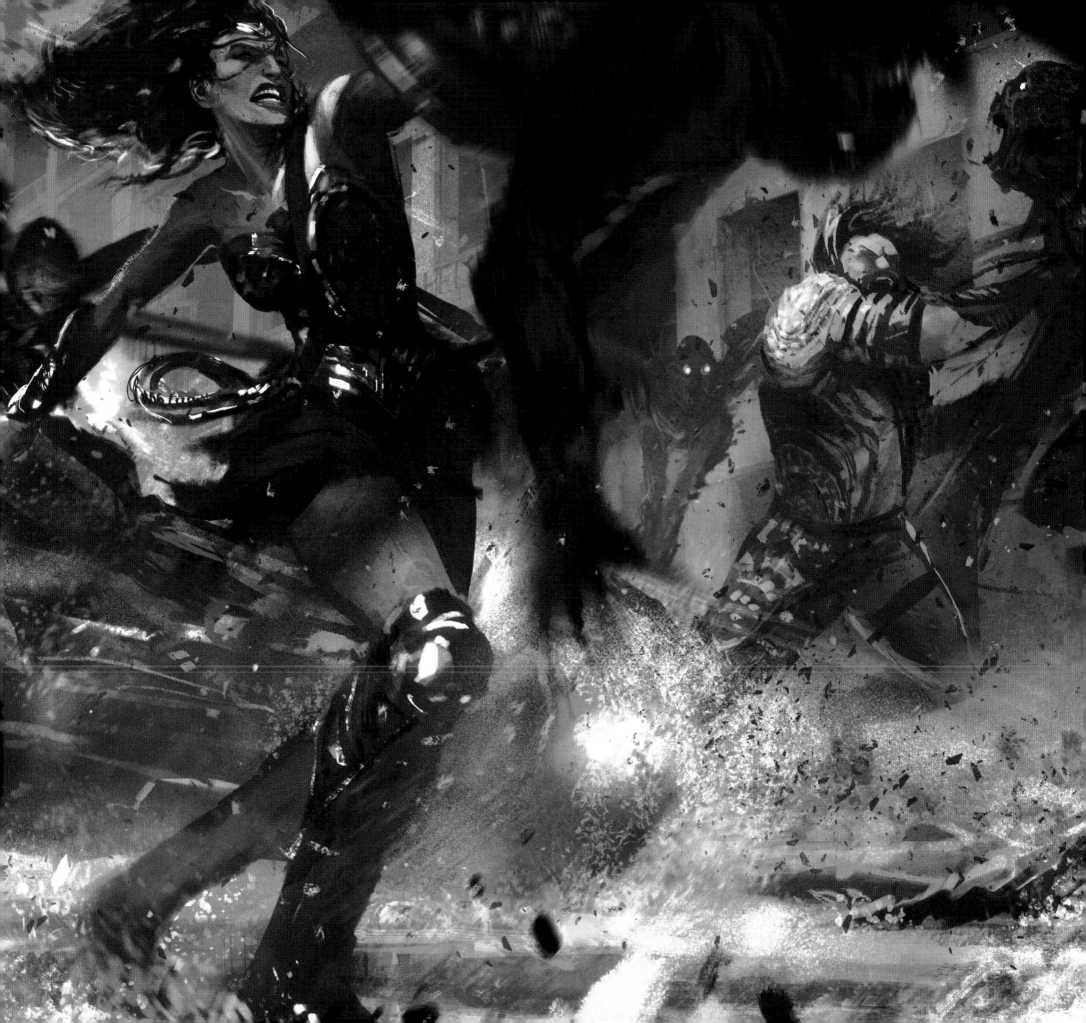

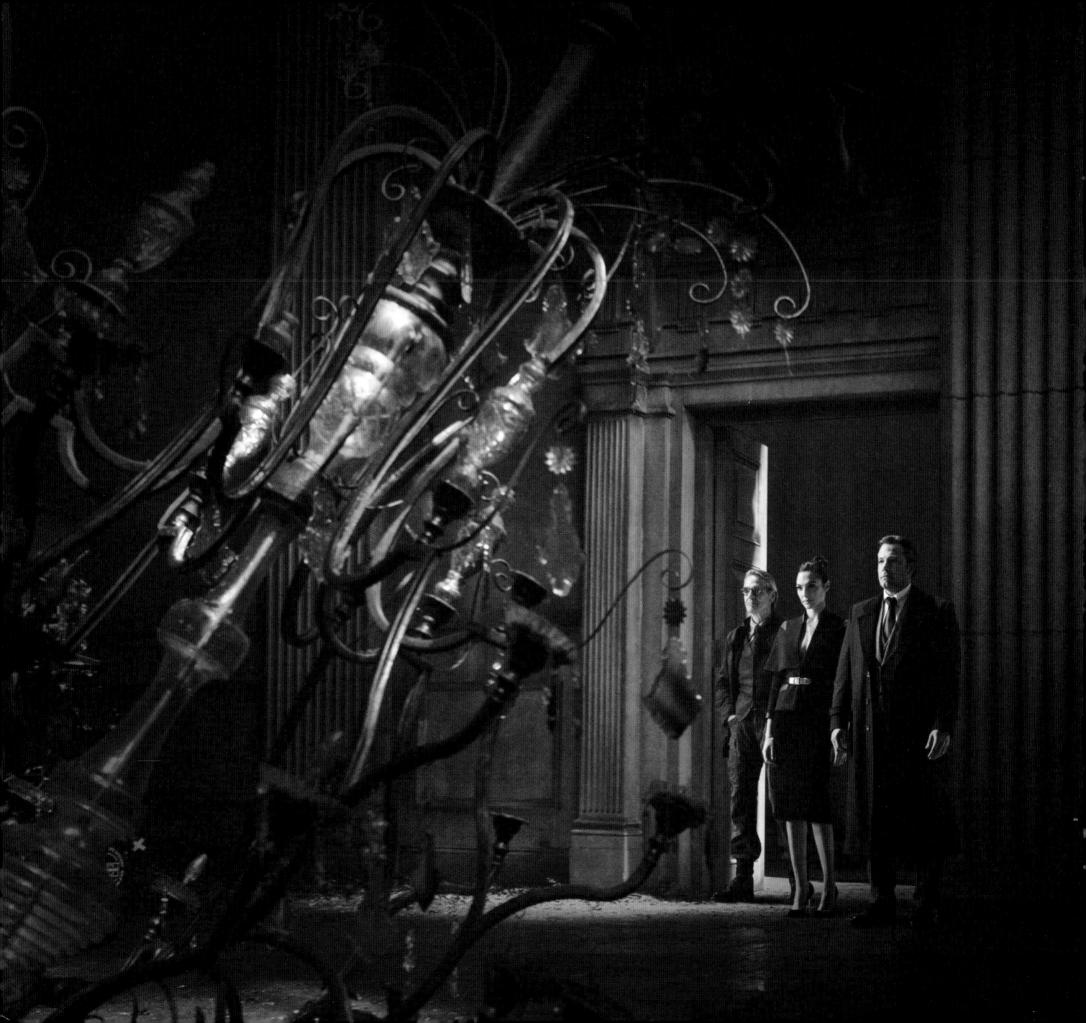

THE BRAVE & THE BOLD

"We painstakingly cast each member of the Justice League, based a lot on each actor's qualities. So, as a fan of the Justice League, or the DC Universe in general, it's really something to see the dynamic as these iconic characters come together for the first time on the big screen, embarking on an amazing adventure."

Zack Snyder, Director

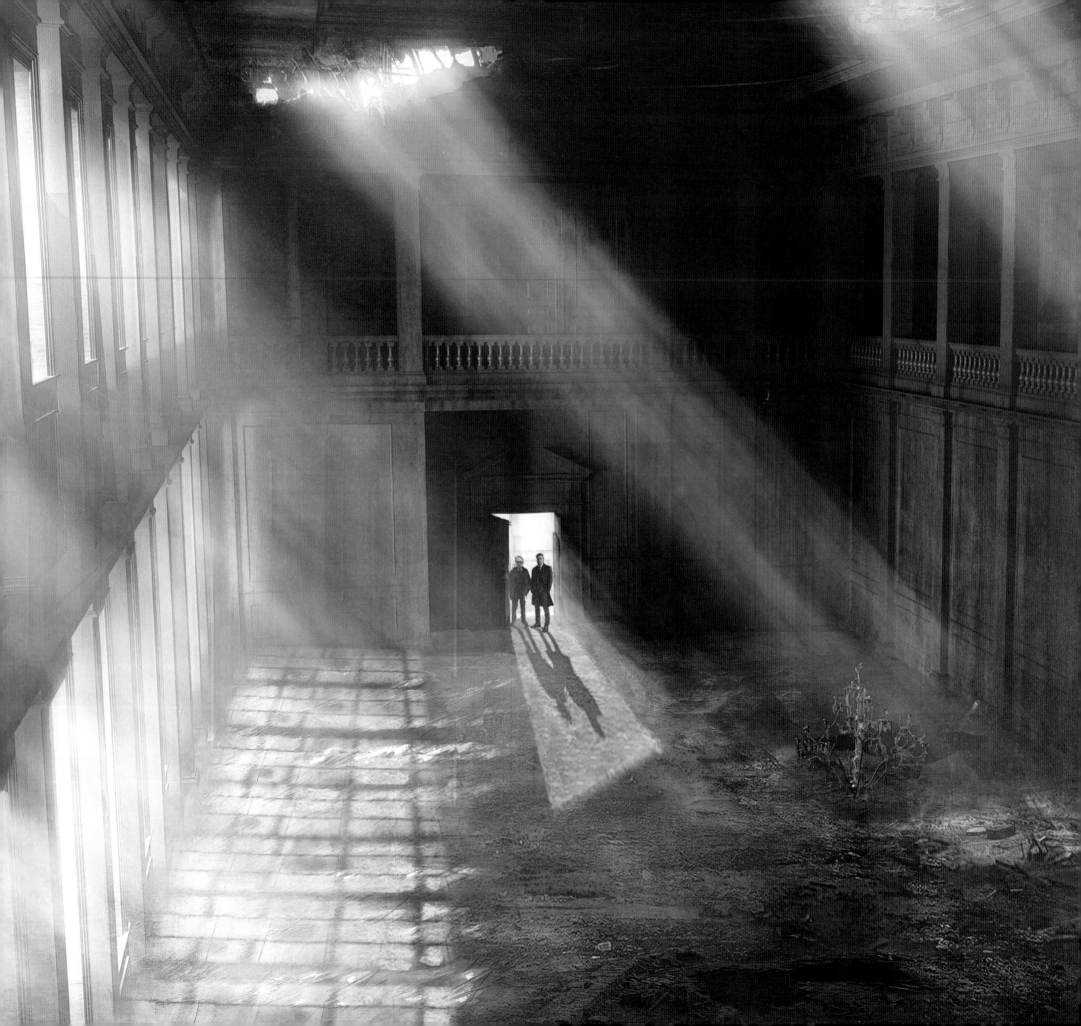

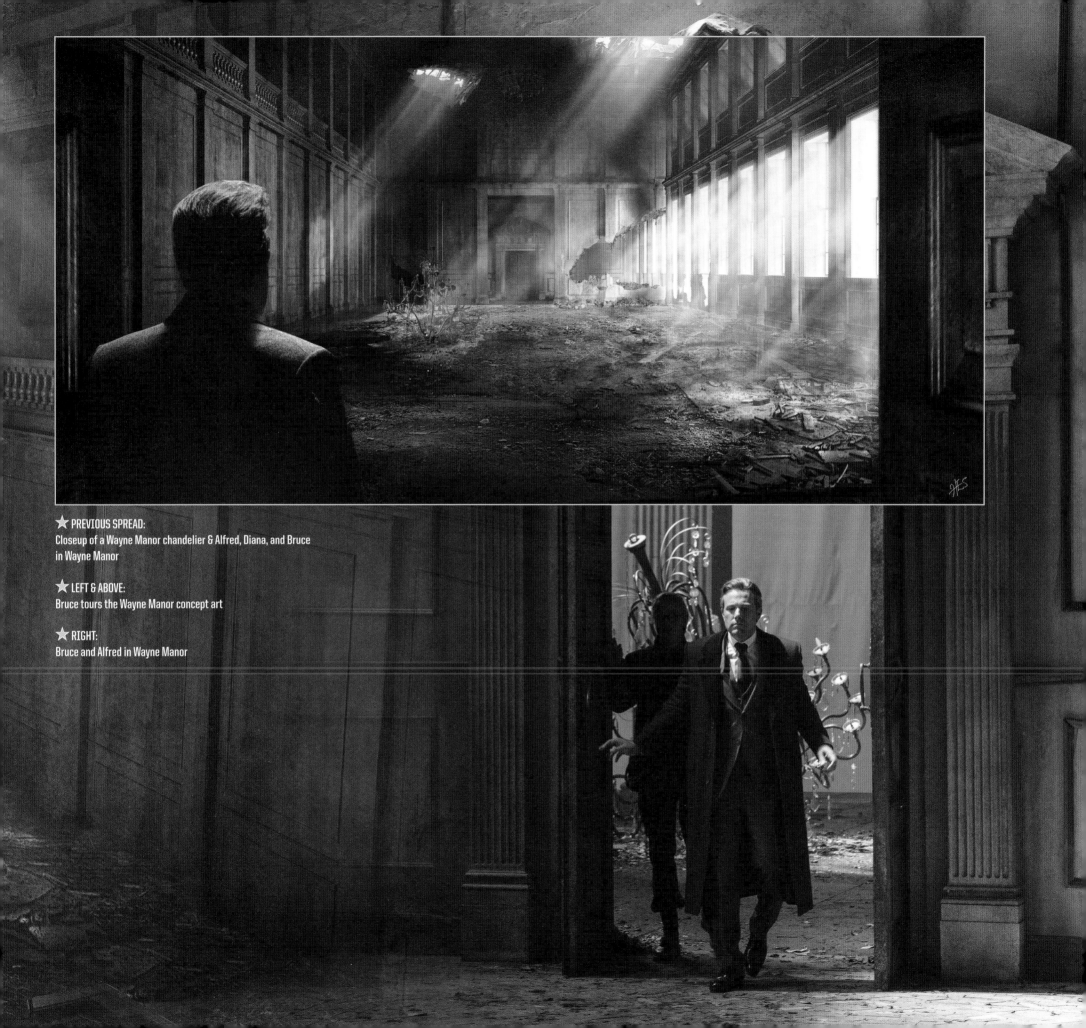

★ PREVIOUS SPREAD:
Closeup of a Wayne Manor chandelier & Alfred, Diana, and Bruce
in Wayne Manor

★ LEFT & ABOVE:
Bruce tours the Wayne Manor concept art

★ RIGHT:
Bruce and Alfred in Wayne Manor

ACKNOWLEDGEMENTS

Thank you to Amy Weingartner, Alisha Stevens, Josh Anderson, Charles Roven, Deborah Snyder, Zack Snyder, Geoff
Johns, Jon Berg, Wesley Coller, Curtis Kanemoto, Madison Weireter, Adam Schlagman, Galen Vaisman, Shane
Thompson, Spencer Douglas, Michael Wilkinson, Patrick Tatopoulos, Clay Enos, and all of the cast and crew of the
Justice League movie for giving up their valuable time to help with this publication.

Special thanks to David Ahern, Tony Barbera, Laura Barden, Phil Boutte, Sophie Bridgeman, Dominic Capon,
Emma Clough, Celeste Coller, Kelton Cram, Joe Dalton, Helen Dawson, Gavin Dean, Julia Dehoff-Bourne, John "DJ"
DesJardin, Anita Dhillon, Brooke Dibble, Jack Dudman, Tim Dutton, Hayley Easton Street, Blake Fabian, Jools Faiers,
Simon Firsht, Matt Gray, Kathey Heaser, Bryan Hirota, Andy Hodgson, Mark Holt, Phil Hope, Christian Huband, Josh
Jaggars, Peter James, Helen Jarvis, Kelly Jones, Ian Joyner, Vicki Kisner, Allison Klein, Sean Konard, Helen Koutas, Paul
Laugier, Sam Leake, Warren Manser, Jerad Marantz, Victor Martinez, Eric Matthies, Seth Maury, Celene Mcdowell,
Robert McKinnon, Keith Miller, Lee Anne Muldoon, Craig Mullins, Ed Natividad, Daniel Nussbaumer, Tunbi Oluyede,
Keith Pain, Andrew Palmer, Stephanie Porter, Anshuman Prasad, Nikolas Primack, Marshall Rainey, Eren Ramadan,
Owen Robertson, Thomas Proctor, Elicia Scales, Christian Scheurer, Constantine Sekeris, Courtney Simmons, Grace
Taylor, Emma Vane, Jason Virok, Dan Walker, Hannah Wiessler-Leas, Ben Wilkinson, Robin Williams, Eric Wolf,
Sophie Worley, Helen Xenopoulos, Dora Yoshimoto, Dorrie Young, and the *Justice League* team at Warner Bros.